La Pocha Nostra

La Pocha Nostra: A Handbook for the Rebel Artist in a Post-Democratic Society marks a transformation from its sister book, *Exercises for Rebel Artists*, into a pedagogical matrix suited for use as a performance handbook and conceptual tool for artists, activists, theorists, pedagogues, and trans-disciplinary border crossers of all stripes.

Featuring a newly reworked outline of La Pocha Nostra's overall pedagogy, and how it has evolved in the time of Trump, cartel violence, and the politics of social media, this new handbook presents deeper explanations of the interdisciplinary pedagogical practices developed by the group that has been labeled "the most influential Latino/a performance troupe of the past ten years."

Co-written by Guillermo Gómez-Peña in collaboration with La Pocha Nostra's artistic co-director Saúl García-López and edited by Paloma Martinez-Cruz, this highly anticipated follow-up volume raises crucial questions in the new neo-nationalist era. Drawing on field experience from ten years of touring, the authors blend original methods with updated and revised exercises, providing new material for teachers, universities, radical artists, curators, producers, and students.

This book features:

- Introductions by the authors and editor to Pocha Nostra practice in a post-democratic society.
- Theoretical, historical, poetic, and pedagogical contexts for the methodology.
- Suggestions for how to use the book in the classroom and many other scenarios.
- Detailed, hands-on exercises for using Pocha Nostra-inspired methods in workshops.
- A step-by-step guide to creating large-scale group performances.
- New, unpublished photos of the Pocha Nostra methods in practice.
- Additional texts by Reverend Billy and Savitri D., Dragonfly, Francesca Carol Rolla, VestAndPage, Micha Espinosa, Zulfikar Ali Bhutto, Praba Pilar, L. M. Bogad, Anuradha Vikram, and Annie Sprinkle and Beth Stephens, among many others.
- The book is complemented by the new book *Gómez-Peña Unplugged: Texts on Live Art, Social Practice and Imaginary Activism (2008–2019)*.

Guillermo Gómez-Peña is a performance artist, writer, activist, and educator. He is the author of 12 books including *Ethno Techno* (2005) and *Dangerous Border Crossers* (2000). His classic performance pieces include *Border Brujo* (1988), *The Cruci-Fiction Project* (1994), and *Mexterminator* (1997–1999). He is founder and co-director of La Pocha Nostra.

Saúl García-López, PhD, is a performance artist, performance director, pedagogue, scholar, and co-artistic director of La Pocha Nostra. His work focuses on performance pedagogy, indigeneity, gender, decolonial theory, and border theory. His performance practice focuses on social shamanic exorcisms, conceptual cannibalism, and psychomagic actions as a passage for decolonization.

Paloma Martinez-Cruz, PhD, is an Associate Professor of Latinx Cultural and Literary Studies at The Ohio State University. Her single-authored books include *Women and Knowledge in Mesoamerica: From East L.A. to Anahuac* (2011) and *Food Fight! Millennial Mestizaje Meets the Culinary Marketplace* (2019).

"La Pocha Nostra's reputation in the performance art world precedes them. They've led rebel artist pedagogical workshops internationally under the leadership of Guillermo Gómez-Peña. Their core members have made history with their performances on the entrenched stereotypes surrounding Latino cultures. There is always an overtone of humor and drama in their spectacle. Also, there is always an opportunity for the viewer to get involved, to make a fool of themselves, to reveal their own vulnerability or to refute the performance altogether. Above all, members of La Pocha are image-makers – politicizing the well-known tropes of Latinidad for our Instagram and social media times. The gaze is paramount."

Rashayla Marie Brown, Chicago Performance

"Observations of the self as a result of the workshop:
a. My body felt stronger, with improved alignment and increased flexibility.
b. Artistically extroverted within two weeks!
c. Further developed my ability to think in images first.
d. Improved my ability to improvise and respond to others. Discovered aspects of the self and the personae that lie beneath …
e. More politically conscious.
f. Further developed my ability to analyze and reflect on what we do.
g. The gap between art and theory is closing … at last!"

Workshop participant, Tucson, Arizona, 2017

"La Pocha Nostra's work mobilizes the striking accusation that the work of an artist is the work of the anticolonial anti-authoritarian feminist revolutionary. Everyone – especially every artist – is implicated in the work of empire, racism, sexism, and homophobia. And it is the artist's work to critically examine and practice an active resistance. For LPN, it is the staging of images – images of desire, pain, spectacle, stereotype, wickedness, and rage. These images are open to be made with the audience. LPN invites us to look, act, engage, struggle. There is no way out. We are trapped in the image, and trapped into making a decision. This is the work of performance art. By extension, this is the work of LPN."

Sampada Aranke, Art History Professor and Performance Studies Theorist

"Engaging in such a revolutionary practice, the work of La Pocha Nostra and the pedagogy is to provide containment, to hold a safe, strong, conscious space of Radical Tenderness and fearless exploration and expression, in which we discover and reclaim the borderlands of our primal imagination."

Leni Hester, Participant of Santa Fe Intensive, 2017

La Pocha Nostra
A Handbook for the Rebel Artist in a Post-Democratic Society

Guillermo Gómez-Peña
and Saúl García-López

Edited by Paloma Martinez-Cruz

Routledge
Taylor & Francis Group

LONDON AND NEW YORK

First published 2021
by Routledge
2 Park Square, Milton Park, Abingdon, Oxon OX14 4RN

and by Routledge
52 Vanderbilt Avenue, New York, NY 10017

Routledge is an imprint of the Taylor & Francis Group, an informa business

British Library Cataloguing-in-Publication Data
A catalogue record for this book is available from the British Library

Library of Congress Cataloging-in-Publication Data
Names: Gómez-Peña, Guillermo, author. | Garcia-Lopez, Saul, author. |
Martinez-Cruz, Paloma, editor.
Title: La Pocha Nostra : a handbook for the rebel artist in a post-democratic
society / Guillermo Gómez-Peña and Saul Garcia-Lopez;
edited by Paloma Martinez-Cruz.
Description: Abingdon, Oxon; New York, NY: Taylor & Francis, 2021. | Includes index.
Identifiers: LCCN 2020022732 (print) | LCCN 2020022733 (ebook) |
ISBN 9780367338213 (paperback) | ISBN 9780367338206 (hardback) |
ISBN 9780429322105 (ebook)
Subjects: LCSH: Performance art–Methodology. |
Performance art–Social aspects. | Pocha Nostra.
Classification: LCC NX456.5.P38 G685 2021 (print) |
LCC NX456.5.P38 (ebook) | DDC 702.81–dc23
LC record available at https://lccn.loc.gov/2020022732
LC ebook record available at https://lccn.loc.gov/2020022733

ISBN: 978-0-367-33820-6 (hbk)
ISBN: 978-0-367-33821-3 (pbk)
ISBN: 978-0-429-32210-5 (ebk)

Typeset in Berling
by Newgen Publishing UK

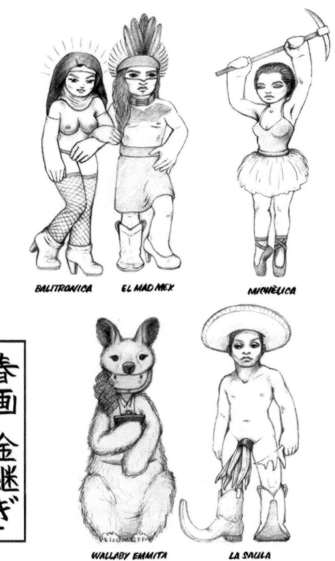

FIGURE 0.1 La Pocha Nostra
Design: Sara Pickles Taylor
San Francisco, 2019

Dedications

From Gómez-Peña …

To Balitrónica Gómez, La Chida One; my daily partner in crime, who shares with me the dangers and challenges of being alive in the Trump era. Thanks for your valor, your madness and your relentless love.

To my mother Martha, la reina de Cocoteros. I thank you with all my skin for sticking around all these years for me. Now you are merely waiting for me on the other side of the mirror. See you soon mamita.

To my loved "conceptual godfather" Felipe Ehrenberg who, after five decades of mentoring radical interdisciplinary artists, has chosen to depart from this troubled planet. His last words were: I am taking a long trip to Manchuria. See you there carnal!

To my loved compadre James Luna, who also chose to depart before me. We walked this planet together for over 30 years. See you soon carnal del alma.

From García-López …

To my family; Conchita my mother, Pedro my father, mis hermanas Mari y Lili, Fabis (RIP) thank you for giving me the wings to become the radical nomad from the shanty towns of the southwest of Mexico City.

To my extended family: Rob Scott, for his unconditional love, patience, and support in all fronts of life; and Professor Udo Schuklenk for being my intellectual resilient warrior, thank you both for not giving up on this loca! To my beloved guides Beyhan Farhadi, Sarah Johnson, Julia Antivillo, Francesca Carol Rolla, Farah Fancy, Sandra Pestana, and Karmenlara Ely.

To Gómez-Peña for being my mentor, my friend and my Mariachi madrina in Performance Art!

We would also like to dedicate this book to:

Emma Tramposch and Michèle Ceballos (core members of the current troupe), for their continued resistance, resilience, willingness, and bravery to jump into the abyss of our times with us. We need to keep strong more than ever. No hay de otra.

Contents

Special thanks

To make sure that every exercise and idea expressed here was clear and "user-friendly," we required the help of many colleagues, artists, and theorists, who patiently read version after version of the manuscript and provided us with valuable feedback.

Introducing a brand-new Latinx/border/queer voice and perspective as an integral part of the field of performance pedagogy was not the isolated effort of two vatos locas. Behind this project are dozens of intellectuals, artists, and curators who have been with us through every step of this process, on the road and online.

First and foremost we wish to thank our publisher Ben Piggott for supporting and encouraging our madness; our Chicana sister and editor extraordinaire Paloma Martinez-Cruz, our hard-core compañera Balitrónica Gómez, our managing director Emma Tramposch and our carnalita Diana Taylor, for helping us to meticulously revise every word in this book and for questioning our inconsistencies, pendejadas, and blind spots. We also wish to thank our partners in crime, Reverend Billy and Savitri D., Dragonfly, Annie Sprinkle and Beth Stephens, Micha Espinosa, Francesca Carol Rolla, VestAndPage, Praba Pilar, L. M. Bogad, Balitrónica, Juan Ibarra, Michèle Ceballos Michot, and Emma Tramposch for writing additional texts for this book.

We also thank all the performance colleagues who have generously shared exercises with us on the road throughout the years, including Esther Baker-Tartapa, Micha Espinosa, Persis Jade Maravala, and our past Pocha Nostra accomplices Violeta Luna, Roberto Sifuentes, Dani d'Emilia, James Luna (RIP), Sara Shelton Mann, and Juan Ibarra.

A very special thanks to the design team: Ricardiaco Gómez, Sarah Pickles Taylor, and Perry Vasquez.

In the trenches, against the hope-crushing machines, and from the core of our bleeding hearts, we thank you all.

La Pocha's current core company members are: Guillermo Gómez-Peña (godmother, conceptualizer, performance artist, and founder), Saúl García-López aka La Saula (co-director, theorist, and performance artist), Emma Tramposch (managing director, curator, writer, and archivist), Balitrónica Gómez (minister of

communications, writer, performer, and pedagogue), and founding member Michèle Ceballos Michot (performer, pedagogue, and spiritual avatar).

La Pocha Nostra past members include: Roberto Sifuentes, Juan Ibarra, James Luna, Ansuman Biswas, Rachel Rodgers, Violeta Luna, Emiko R. Lewis, Alex Bradley, Erica Mott, Orlando Britto-Jinorio, Dani d'Emilia, Gabriela Salgado, Lisa Wolford (RIP), Rakini Devi, Daniel B. Coleman, Maria Alejandra Estrada, Amapola Prada, Heather Haynes, Gabriela Salgado, and Nayla Altamirano.

Twenty-first-century Pocha "honorary members" include: Rene Yanez (RIP), Felipe Ehrenberg (RIP), Reverend Billy, Guillermo Galindo, Gustavo Vazquez, Annie Sprinkle, Beth Stephens (The Ecosexual power duo), Mara Bugic (City of Women), Lois Keidan (LADA London), Ron Athey, Franko B, Tim Miller, Amelia Jones, Manuel Vason, Herani Hache, R. J. Muna, Logan Phillips, Richard Schechner, Diana Taylor, Marlene Cancio Ramirez, Mariellen Sanford, Richard Gough, Leo Garcia, Suzanne Lacy, Carlos Martinez Renteria, Cesar Martinez, Marco Barrera Bassols, *"El Reynito"* Corona, Julia Antivilo, Cristina King-Miranda, Gloria Maldonado, and, of course, *la banda querida* from El "Instituto Hemisférico de Performance y Política" across the continent, The 18th Street Arts Center (Los Angeles), the "Non-Grata" cabrones, El Galpón, and Yuyachkani (Lima, Peru).

There are also over 30 current collaborators and "guest artists" spread throughout ten different countries, including Micha Espinosa, Natalie Brewster Nguyen, Marcos Najera, Esther Baker-Tarpaga, Zen Cohen, Andrea Pagnes and Verena Stenke (the pluribus VestAndPage duo), Francesca Carol Rolla, Lothar Muller, Lechedevirgen, Gerardo Juarez Jurado, Lorena Peña, Praba Pilar, L. M. Bogad, Lukas Avendaño, Maria Eugenia Chellet, Missa Blue, Princess Vuvu, Norma Flores, Fotini Kalle, Erika Bulle, Sandra Pestana, D. J. Ricardiaco, Martin Renteria, and many, MANY other incredible rebel artists, artivists, curators, and radical theorists across borders … We feel so pinche honored working in different projects with each one of the participants of this wild network of trans/ national locas y locos!

If we forgot a name, please cut us some slack.

Guillermo Gómez-Peña and Saúl García-López

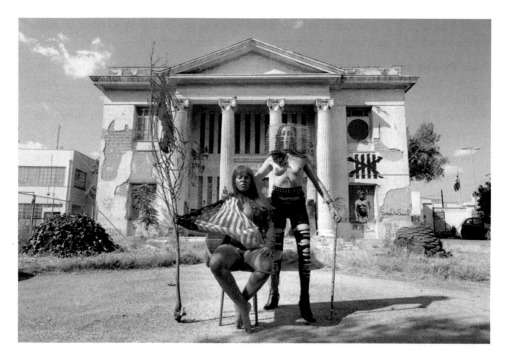

FIGURE 0.2 The Post-Democratic United Nations
Photographer: Manuel Vason
Performers: Denise Benavides and Ria Righteous
Athens, Greece, 2015.

Preface

Dear reader, workshop participant, artist colleague,

This book aims to describe, in accessible terms, our pedagogical philosophy and how La Pocha Nostra coordinates, prepares, and carries out a workshop and the preparations for a performance. We hope to inspire readers to expropriate, cannibalize, exorcize, and reinvent our method and generate their own self-styled exercises for creating oppositional performance and artist collectives in their respective communities and countries.

Ideally, we envision this book as a useful teaching tool for the university classroom and the creative practitioner as well as for community activist and artist groups. We included a revamped version of the most useful exercises from the past 20 years and added new exercises developed since the publication of our first pedagogy book: *Exercises for Rebel Artists* (Gómez-Peña and Roberto Sifuentes, 2009).

Our eclectic Pocha methodology includes performance exercises, rituals, and games that have been borrowed, cut, pasted, and excerpted from several disciplines and cultures. They range from experimental theater (Boal, Yuyachkani, the Living Theater, British devised theater, the Schechner method, etc.), dance, and contact improvisation, to ritual performance that includes shamanic practices, indigenous performance and activist practices from the Americas, the global south, and everything in between. We always occupy the "in between space." For us, the "in between" is not just a conceptual zone we inhabit as artists, but a permanent space for reinvention and creativity that we term "imaginary artivism."

Our Pocha cosmovision starts with the term "pocho," which, in the context of the US–Mexico border, refers to a person of Mexican heritage who has lost their culture to US influence – a sort of traitor to national identity. We have chosen to expropriate it, queer it, and connect it to all international deterritorialized peoples, including immigrants, refugees, asylum seekers, and victims of forced migration. In the spirit of civil rights movements that have reclaimed disparaging slurs and racist terminology and turned them into a vocabulary of pride and empowerment ("Black is beautiful," "We're here. We're queer. Get used to it," "Chicano/a power," and "Idle no more"), our artistic commitment to so-called "outsider" identities, and our use of chicanx strategies (*rascuachismo*, parody, and irreverence), culminate in a decolonizing process that privileges hybridity over tradition and nation/state. Not to mention our systemic allergic reactions to empty orthodoxies and essentialisms that force us to contest binary and vertical models whenever these arise.

As in our artwork, we cross each and every methodological border when we encounter it. In this process, new exercises specific to the ethos, aesthetics, and performance work of La Pocha Nostra have been developed and extended to new frontiers as workshop participants themselves have passed other exercises on to us and we "pochify" them.

Besides a clear description of the exercises, we include useful contextual information (i.e., how the method and pedagogical language changes when it crosses cultural borders), actual samples of the results from using these methods such as performance scripts and live images generated by participants, and a description of how the reader can create/design/stage their own performances based on our method.

We also provide a day-by-day hands-on guide of how the reader/practitioner can sample and mix these exercises in an organic and effective way, plus useful suggestions for how to intervene in the public space with efficiency and a sense of purpose ... and (we hope) not get arrested.

This book is also the product of an ongoing intellectual jam taking place both on site and online. The Pocha Nostra collaborative workshops and performances often involve at least two (if not more) troupe members, so we felt this book should replicate the same process by mirroring the polyvocal and horizontal nature of our pedagogy. Therefore, the manuscript has been prepared collaboratively. We invited our Chicana colleague Paloma Martinez-Cruz, aka *Miss Illegal Alien*, a Pocha collaborator in numerous capacities since 2000, to help us develop, edit, and organize the material. We also relied on our main partners in crime, Balitrónica Gómez, troupe core member, and Emma Tramposch, Pocha's Managing Director, to help us tighten the explanations of the exercises with their amazing literary laser rays. The names of our many other partners in crime can be found on the "special thanks" page.

Readers who worked with the first Pocha Nostra pedagogy book should be aware that our present volume is not a "revised edition," but rather a total overhaul resulting in a new approach and new subject matter based on rigorous field testing that responds to the new challenges of the times. Enhanced, dramatically reconfigured, and expanded, this volume includes excerpts from our various unpublished performance diaries. It also includes intra-Pocha dialogues about the emergent challenges and opportunities surrounding our methods, accompanied by visual material that emphasizes the radical inclusivity and centrifugal creativity we hope to inspire and practice.

This new performance pedagogy has been developed and finely tuned on the road in direct response to the political challenges of our times, the cultural specificities of the location where we have chosen to work, and the feedback provided by workshop participants and performance peers. In order to provide the new exercises in this volume, we road tested each one in multiple countries and environments over the last ten years. This has resulted in a handbook that can be taught across a broad array of university departments and many countries and used as inspiration by all kinds of artists and activist collectives.

With the departure of the original Pocha guard (Roberto Sifuentes, Violeta Luna, and Juan Ibarra) and the arrival of a new queer Pocha crew (Saúl García-López, Balitrónica Gómez, and former member Dani D'Emilia), La Pocha Nostra was inevitably reformed: not only with the enhanced queering of our identities and aesthetics, but also with the demand for a more horizontal model (refer to the new Pocha manifesto). They introduced a queer, feminist, theoretical and curatorial practice that favors brown, black,

indigenous, women- and queer-centered imaginaries over heteronormative-identified artists and aesthetics. Allow us to clarify. We are not anti-hetero essentialists, and we still welcome heterosexual artists, as long as they are queer-literate, tolerant of difference, and actively invested in the erosion of hetero bias and privilege. And we are still learning to widen our scope and queer our praxis.

This paradigm shift in La Pocha's ethos and aesthetics has also been intensified by the arrival of new far-right, ultra-macho, neo-nationalisms threatening our vulnerable communities. More than ever, our pedagogical praxis stretches out and shapes our creative work, while our performances, and even our writing (our pedagogical methods were implemented in the writing process of this book), continue to respond to the moment in a creative process inspired by both urgency and joy. We think of it as a live method for performance art practice in times of philosophical despair in a post-democratic society. Please refer to our "Candid conversation amongst La Pocha Nostra members …" on p. 201 to find out more about how we pedagogically "jam" in a time when the far-right and ultra-nationalisms are forcing us to redefine our notions of community, identity, and artistic practice.

The challenge originally posed to La Pocha by our manuscript readers ten years ago remains pertinent for this new book: "how can we translate this adaptive and ever-morphing border practice into a performance handbook for the twenty-first-century bohemian, activist, and young performance artist in the making?" As the nature of our work is permanent reinvention, and the nature of the publishing culture is changing as we speak, we are excited not only to share with readers the many updates that inform our current stage of evolution, but also to participate in its continued reinvention via the new interactive technologies that allow us to adapt and expand horizontally and internationally.

Now, with platforms such as our Pocha Nostra Facebook page, the many blogs and Instagram pages we have online, and our Twitter poetry feed, on any given day, approximately 13,000 people are connected to our work, learn about our workshops and performances, and pursue various levels of engagement with our live art and critical texts.

We're excited to extend this level of connectivity into our new publications. The book is complemented with the new book *Gómez-Peña Unplugged: Texts on Live Art, Social Practice and Imaginary Activism (2008–2019)*, also published by Routledge, a compendium of his essays, performance texts, poetry, and critical interventions from the last ten years that celebrates our multi-vocal and interdependent expressive practices. We see this pedagogy handbook as a loving invitation to participate in a broader pedagogical matrix that is adaptable and continuously expanding, challenging hierarchical models of teaching and performance practice.

Given the advantages offered to us by new technologies, the process of reinventing the Pocha method can now be transparent, interactive, and immediate. To this end, Pocha is preparing a website that will include an online component where new exercises, complementary texts, images, and videos, along with frequent reflections and updates, are offered to feed our ongoing process. This digital portal will also function as a forum for Pocha alumni to talk back to us, share your testimonies of how the exercises are working for your community, and even suggest new exercises to us.

In this sense, this brand-new reloaded pedagogical publication is the beginning of a long-term and truly dialogical, interactive process. We want you to become an active

participant in our ever-evolving performance exercises, games, and rituals. We hope you will use this book as the map to an ever-expanding, ever-becoming cartography that you are invited to co-create, and we hope that you pursue on ongoing engagement with an innovative pedagogical matrix. **Radical pedagogy for a post-democratic society** is live **pedagogy, out in the open: a blueprint for resistance drawn from the trenches of art.**

Enjoy and practice these wild exercises in your own educational institution, community center, or artist group.

Guillermo Gómez-Peña, aka El Mad Mex and
Saúl García-López, aka La Saula
Santa Fe, August 2017

"Pochology" in a post-democratic society
A book introduction

Paloma Martinez-Cruz

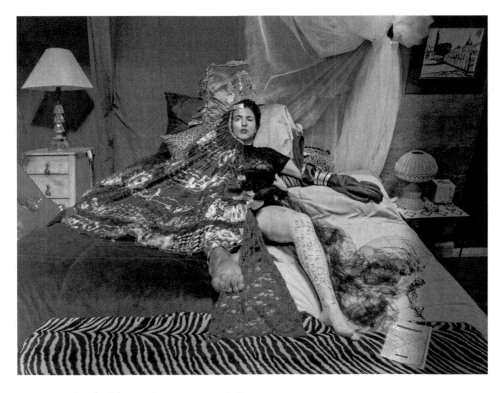

FIGURE 1.1 Border Identity Reincarnation 3.0
Photo: Herani Enríquez Hache
Image Design: Ricardiaco
Performers: Baruk Serna and Ely Rosa Zamora
Guanajuato City and Mexico City, 2016–2017

> *Working with La Pocha Nostra helped me to transcend many personal and professional borders. Working with them I felt an artistic freedom I had never experienced before. Coming from theater, where the methods are meant to limit the bodies into a specific technique and shape, performance feels very liberating in general, but Pocha Nostra's radical tenderness gives it one more twist. After attending one of their workshops, my theater work has enriched but further than that; I gained the personal confidence to start research work for a solo performance for the first time and also joined a network/family of artists with whom I kept meeting and creating collaborative work, kept crossing borders (physical and mental ones) and kept putting them all under the spot together as a collective. Thank you very much, from the heart, there has definitely been a before and after. After Pocha Nostra there was more work, more art, more friends and of a better quality.*
>
> (Jessamyn Lovell, teacher and theorist)

With the full-scale, top-down assault on democratic institutions including the free press, elections, and the obstruction of democratic participation in national and global decision making, today's need for artists and educators to foster sites of public dissent and oppositional art is fueled by do-or-die urgency. The techniques and contemplations offered in this volume provide a wide range of possibilities for harnessing public performance, social media, activism, and pedagogical actions as strategic technologies of defense against the ravages of despair and alienation. Knowing how much is at stake, this book offers tools to sharpen and enhance scholar-artivist practices and pedagogies that are at the core of any authentic democratic project.

As my following remarks will show, it's difficult for me to locate a place in these activity spheres that is NOT fundamentally infused with the magic hatched in the seed life of Guillermo Gómez-Peña and Pocha Nostra's offerings. Here, I introduce the pedagogical tools provided in this book by taking the metaphorical camera way, way out for an extremely wide shot before zooming in for an extreme close-up. I refer to these wide shots and close-ups as the Four P's: the Planet, the People, the Pedagogy, and, finally, my Participation in the pages of the text. (Don't you love alliteration? Isn't alliteration with a series of plosives the *best*?) By providing these long and near views of Pocha pedagogy, I hope to offer a varied and customizable picture of how to make Pocha your own, so you can deejay the mix from the Pocha jukebox that speaks to the political, pedagogical, ecological, and personal urgencies of our pinche "post-democratic" predicament to suit the resistance front where you stand.

PLANETARY POCHA

Performance art will save the planet. A long time ago, the text became more sacred, more exalted than the body. In performance studies, we discuss this shift as the ascendance of archival knowledge over the repertoire of embodied knowledge. Performance allows us to "do" embodied knowledge by resisting the privileging of lettered over non-lettered

societies. Why is this so important? To emphasize the body as a site of knowing resists the Western idea that the mind is supreme, and the body is little more than its throw-away Styrofoam cup. This kind of thinking results in "disposable" approaches to natural resources, because after the body dies, the soul is supernaturally transported to a superior plane in a magical off-site place beyond the clouds. The "it doesn't matter what happens to the body or planet because we leave it behind when we die" mindset has its roots in the rise of textual knowledge in Europe, where the non-physical, extra-terrestrial heaven became everyone's goal. Suppression of the body progressed alongside alphabetic literacy, and, with European colonization, the people who looked to nature and the body for knowledge flows (like the pagans and shamans) became cast out as uncivilized – even demonic – while the West insisted that intellectual authority was the exclusive realm of readers and writers.

Many excellent monographs, such as indigenous writer Leanne Betasamosake Simpson's *As We Have Always Done: Indigenous Freedom through Radical Resistance* (2017) and David Abram's *The Spell of the Sensuous* (1996), describe the philosophical journey away from the body that resulted in colonial disdain for ecological balance, but ecological metaphor does not have to figure centrally in a performance text for the work of performance to bring renewed focus to the body and its habitat. Just by turning to the principles of radical listening and radical safety as the source material for performance interventions, we resuscitate the carnal and re-inhabit the sensual territories of resistance.

By restoring the balance between mind and body, we take a first step towards reassessing the value of knowledge forms coming from non-lettered societies, and we contribute to the re-estimation of the sensual world. Pocha-based performance pedagogy has the potential to foster new kinds of stewardship of the body and the ecological environments we inhabit. It starts in your body: the perfect axis joining all the heavens and hells, the sensual solution to the destructive cycles of a disposable society. I'm not saying that a quick dose of performance art exercises will scrub the atmosphere of CO_2 emissions or magically purge the oceans of apocalyptic levels of plastic waste. Instead, I submit that the shift to awaken and honor the body's intelligence is the subtle, yet indispensable, first step in refuting the mind-over-body fallacy that the post-democratic overlords put in place in order for us to ignore the planetary destruction that paves their path to profit.

THE PEOPLE: POCHA HISTORY AS LEGACY OF DISMEMBERMENT

> *I wish to clarify: I don't aspire to find myself. I wholeheartedly accept my constant condition of loss. I embrace my multiple and incomplete identities, and celebrate all of them (or to be more precise, most of them, since there are aspects of my multiple repertoire of performance personae that I truly hate, and that sometimes frighten me).* [1]
>
> (Guillermo Gómez-Peña)

According to lexicographer Francisco J. Santamaría and eminent Chicano literary historian Luis Leal, the root of today's "pocho" was being used by the native Yaqui Californians in the nineteenth century to denote "lopped off" or "bob-tailed." From

there, it became the slur that referred to formerly Mexican Californians when Alta California was amputated from Mexico: the lost Californios who no longer belonged [2]. From these Uto-Aztecan, Yaqui roots, it grew to be a Mexican insult for speakers of anglicized Spanish, and arrives to the present day as an emblem of acerbic Chicanx self-irony.

The early 1990s witnessed a two-pronged heyday for this humor, as the blood and maize poetics of the early Chicano movement (1965–1975) shifted to embrace the inside humor of Mexican American self-deprecation. Observe the tragi-comic manifesto from the first issue of *Pocho Magazine* from 1990 created by Lalo Alcaraz and Esteban Zul: "We at *Pocho Magazine* accept Pocho as a term of empowerment for tacky, uncultured, fucked-up-Spanish-speaking Pochos everywhere and challenge both the US and the Mexican governments to a foot race down the streets of Oakland while wearing floppy red velvet sombreros and matching Anthony Quinn masks ..." [3].

Recourse to pocho identity also took hold in the 1990s as a live art project when La Pocha Nostra (LPN) was founded by Guillermo Gómez-Peña, Roberto Sifuentes, and Nola Mariano in Los Angeles, California as a way to provide a framework for Gómez-Peña's collaborations and experiments with artists of diverse backgrounds and disciplines. Since the 1990s, these reclamations of the term pocho have led to a new way to envision outsider identities and celebrate the exquisite impurities of bordered lives.

But "pochology" is not just a conglomeration of Spanglish puns and lowrider joy rides. You'll find that, within the radically diffuse projects and aesthetic impulses thriving across Pocha Nostra projects, the decolonial ethos of the Chicanx movement has combined with the queer, anti-patriarchal, and increasingly anti-vertical methods and objectives of today's LPN. In the ensuing pages you'll see that even as producers and core members endeavor to radicalize the parameters of difference and inclusion, fidelity to the specificities of border art continues to thrive at the heart of Pocha's productions, not as a set of prescribed politics or aesthetics, but as a method and discipline for creating radical spaciousness across political markers of difference. Here, you are invited to adopt the Pocha approach in your own way. While rooted in the politics of the US–Mexico border, el pueblo de la Pocha (the people of la Pocha) – a motley conglomeration of artists and activists around the world – is united in its unrelenting interrogation of *all* the borders that impinge on human mobility and self-defined determination.

PEDAGOGY

A quick snapshot of Pocha pedagogy in my life looks like this. One day, I am developing a performance curriculum for high school students on place-making and human mobility, and I facilitate the Call and Response collaborative jam session to get students to open up and explore the poetic pathways of their neighborhood and relationships (p. 134). On another occasion, I'm facilitating a diversity workshop wherein I ask members to use the Gaze (p. 88) to activate the depth of compassion and radical listening that can take place only in the silent expanse of another's eyes.

And in my teaching, for an end-of-term project in an advanced US Latinx literature class, I assign Human Altars (p. 117) based on the essay "Nuestra América" by José Martí.

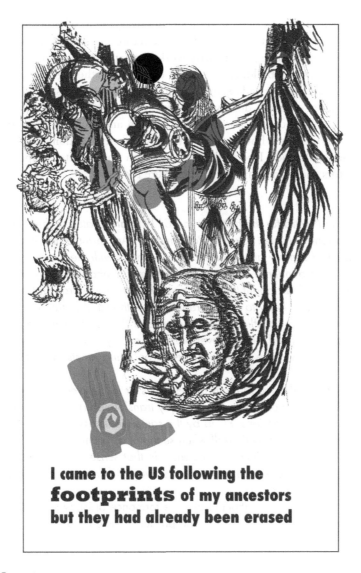

I came to the US following the
footprints of my ancestors
but they had already been erased

FIGURE 1.2 Footprints
Illustration: Perry Vasquez
California, 2019

Students are required to present photos of their collective altars, and provide a researched rationale for their aesthetic choices connecting Martí's foundational essay to their creative interpretation of Latin American identity. What's happening? I've never felt this way before! I'm not overwhelmed by the tedium of grading their final projects – I'm fascinated! How have I managed to find the cure for the monotony of grading while also handily eliminating the perils of plagiarism? With the help of Pocha Nostra pedagogy, that's how!

What I'm trying to say is that, at all levels of engagement, whether they be devised social justice theater projects, undergraduate literature classrooms, courses on gender and power and border studies, or diversity workshops, meetings, and conventions where ensemble and community building are critical to a given gathering's mission and vision, the Pocha Nostra techniques and examples (and, in some cases, existential warnings) will help you to heighten empathy, dignity, and collective empowerment across participants.

Take the plunge and cross a border. Work in open and inclusive dialogue with your community about when and how to jump into a given form or action. Be a facilitator who listens with the whole body. Deejay the exercises with immaculate compassion, meeting your collaborators and community members where they are.

I met La Pocha Nostra for the first time in 2011. I participated in their International Summer workshop hosted by the Performance Art Institute in San Francisco. I have many times in my art experienced encounters with the words international, intercultural, multi-gendered ... It was the first time I embodied them. It's one thing to travel, meet, and talk about the meaning of these trendy words and another thing to work face to face, body to body, breath to breath with the strange others. I was shocked with the inner conflicts that occurred and the outer controversies released among people. I realized we are never prepared enough, never open enough to the unknown although we love to pride ourselves on being artists, receptive and with no boundaries ...

My art was not affected in terms of aesthetics or in the creative process itself. It was my understanding on art that was deeply transformed as I envisioned it for the first time in its real dimensions. Ruled by the same weaknesses of the everyday, art can be in a constant fight with itself when seen not as a unique, lifting moment but an effort to overcome the human deficiency. In that sense a Pocha workshop is a constant reminder of our human nature that artworks often may camouflage by promoting a refined form of it.

(Fotini Kalle, performance artist, workshop participant and producer, Athens, Greece, 2013–2015)

PARTICIPATION

I was invited to work with the Pocha Nostra as this volume's editor after participating in several Pocha projects in various capacities, starting as docent in *The Mexterminator Project* (Rio de Janeiro, 2000), and eventually acting as a workshop participant and producer while maintaining a record of research publications on the subject of Pocha pedagogy and Pocha (Chicanx) identity (see the references at the end of this chapter).

At each stage in the process, the dialogue required to transform pedagogical practice into accessible prose has not only influenced how Pocha Nostra makes art, but has also evolved into a writing practice and discipline that emphasizes the group jam session

as the springboard for the development of an ever-expanding consortium of poetic voices, organizational responsibilities, and the generation of new texts. The following writings by Guillermo Gómez-Peña and Saul García-López (aka La Saula) were handed to me back and forth electronically, but also, at times, developed collectively in group conversations that included Balitrónica Gómez, Emma Tramposch, and myself. Other content was developed one-on-one as I sat knee-to-knee with La Saula or across the conference table from Guillermo. Along with the responsibility of intervening in the textual content, editing has also consisted of joining the Pocha core in a layered dialogue about the prospects of border art from the vantage point of a Xicana scholar-activist, DIY artist, and feminista más loca que tu madre. Like performance jam sessions, my textual "body" performs duets and collective conceptual actions with Pocha core members on the ensuing pages.

The challenge and excitement of helping to translate Pocha's live art laboratory to the page and update their radical pedagogy was particularly present in my writers' lab convivencias with Pocha Nostra co-artistic director Saúl, who was mapping his pedagogical performance journey on the page for the first time (unlike the Mad Mex, who is a seasoned and long-celebrated writer). During the two writing residencies in Santa Fe and Mexico City that went into this book, we often began sessions by charting our personal ethnographies of sexual trauma, colonial phantoms, and critical observations about how our respective bodies travel through space with so much transformative possibility, and so much naked fear. As artists, we search the broken places to radically humanize our own circumstances so that none of the pain thrust on our bodies goes uninspected for its liberatory potential. Challenging ourselves to write from the body's truth and inhabit the brown, queer, feminist, and abject, we disrupt the intellectual self-deportation that always threatens us and tries to convince us we don't belong in the world of letters. Just to be here, erupting onto the page in our powerfully imperfect ways, is its own kind of ritual in exorcising colonial and patriarchal demons.

Finally, the honor and privilege of getting to work with La Pocha at this exciting point on their evolutionary timeline has been deeply transformative. Writing at the moment of the inauguration of Gómez-Peña's career retrospective at the Mexican Museum of Modern Art, I am profoundly moved by the enduring power of Pocha Nostra to chart new territories of oppositional live art. My highest gratitude goes to el maestrísimo Guillermo, and to La Saula, Balitrónica, Emma, and core Pocha collaborators for having faith in my interventions. Essential support for my participation in the Pocha writing residencies was provided by the Department of Spanish and Portuguese at The Ohio State University, while generous moral support came from my loving and luminous community of family, friends, colleagues, and students. May the five dimensions of Anahuac (the Aztec terrestrial plane) guide and preserve your exploration of this book's contents, and may it ever yield good medicine for your life's work and all your relations.

C/S
PV
Paloma "Miss Illegal Alien" Martinez-Cruz
Mexico City, Mexico

REFERENCES

[1] Guillermo Gómez-Peña, *Dangerous Border Crossers: The Artist Talks Back* (New York, NY: Routledge, 2000) 9.

[2] Paloma Martinez-Cruz, "The Intimate Life of the Pocha," *The Routledge History of Latin American Culture*, ed. Carlos Salomon (New York, NY: Routledge, 2017).

[3] Lalo Alcaraz and Esteban Zul, *Pocho Magazine* no. 1, 1990.

Soundscapes for dark times: A border pedagogy for resistance
An introduction

Guillermo Gómez-Peña aka El Mad Mex

> *Working with La Pocha has changed my life – a clean, cool drink of water after traveling in a cultural desert of academia, art fairs, and museums for centuries. La Pocha is the long-lost family I have longed for for ages and now found. Like a grove of aspens, we all form a neural network connected to each other through our mind, souls, and bodies. We are fluid, we are transient, flexible. The pedagogy is inclusive and necessary to arm ourselves for the conditions of apocalypse. The workshops and exposure have led me gently to uncover my own path of forging trust in/with my own body as my weapon/tool of communication. I can be whole again and understand the truth of my/our condition.*
>
> (Ainoa Mela López, Athens, 2015)

THE GENESIS OF OUR IDEAS

Track: Nortec collective, Tijuana, 2003

For years I held on to the romantic ideal that as a "radical artist" my place was not interred within the university system or the Capital Art sphere, but out in the world. I perceived US colleges and universities, with a few exceptions, to be solipsistic and divorced from social reality. I regarded university campuses as "reservoirs for thought" and educational corporations invested in specialized training for new Darwinian intellectuals to get hired and rich, rather than laboratories for social action and artistic reinvention. I viewed tenure as the kiss of death for artists, like a Faustian pact in which we would inevitably end up softening our sharp edges and making decisions to protect our paycheck. I was prejudiced.

I was also stubbornly determined to prove that as a Mexican/Chicano performance artist I could remain independent and survive exclusively by creating my own performance work, against all odds, in a racist art world. This long struggle for autonomy and

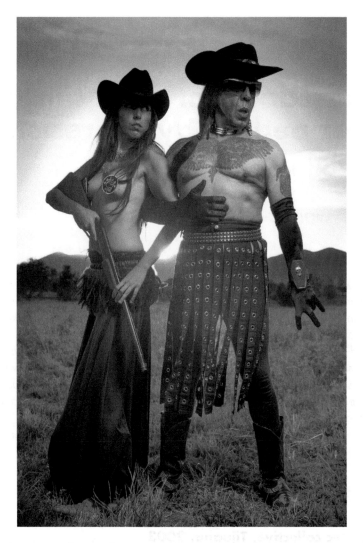

FIGURE 2.1 The Anti Border Patrol 3.0
Photographer: Herani Enríquez Hache
Performers: Nayla Altmirano and Gómez-Peña
Queretaro, 2015

self-determination spanned more than 30 years. It resulted in many great projects and 14 troublemaking books, including this one, along with permanent financial debt and a few visits to the hospital – but hell, weren't these just symptoms of living under a ruthless, Darwinian capitalist regime? Of course, all these conditions were worsened by the arrival of Trump, the alt right, and their ultra-nationalist project. But I will address these changes later on.

Throughout the early 1990s, my collaborators and I experienced serious "philosophical vertigo." First, we were faced with the collapse of "real socialism" in the ex-Soviet Union and the consequent triumph of the international Neoliberal Right. The much touted "backlash era" began in 1993 and was swiftly followed by the "culture wars" in the US. The growing popularity of new technologies and the cult of globalization forced us to rethink our notions of identity, community, nation, and borders. As if this wasn't enough, we also experienced an increasing disregard for art and the voice of the critical artist by the neoliberal technocrats ruling the global project and the new "globalized" media, what I called "the mainstream bizarre." This new media phenomenon equated our performance work with the "extreme" mindless behavior of instant celebrities. Anna Nicole-Smith and Jerry Springer inaugurated a new genre of vernacular performance art.

These drastic changes contributed to a generalized skepticism, pervasive spiritual emptiness, and political despair within the critical art world. We clearly needed to reformulate our artistic strategies.

But we were confused: race, gender, nationality, and ideology were no longer the main reasons for people gathering, collaborating, and creating. Everyone was looking for a new cultural paradigm and a new sense of belonging to a larger "we" in a time when all certainties were melting before our eyes.

It was in the midst of this stormy philosophical context that my performance troupe, La Pocha Nostra, was born (1994). We literally emerged out of the ruins and ashes of globalization. And we naively tried to offer an answer to the philosophical vertigo of the times. We promoted artistic collaboration across borders as a form of "citizen-diplomacy" and began to look for strategies to develop temporary communities of like-minded rebels across geopolitical borders.

By the mid-1990s, it became clear to us that our new artistic project had to start defining new intersections between performance, theory, community, new technologies, and activist politics. To do so, we needed to rethink our entire practice and reconfigure our poetic cartography, to invent a more inclusive map, so to speak. Eventually performance pedagogy would give us the answers we were looking for. These answers are printed in this book.

With this idea of "radical performance pedagogy" in mind, my colleagues and I began to rethink the possibilities for teaching in academia. Perhaps the classroom and/or workshop space could become an extension both of the performance space and of the social world: a kind of demilitarized zone and nerve center for progressive thought and action.

In my vision, the classroom/workshop would become a temporary space of utopian possibilities: highly politicized, anti-authoritarian, interdisciplinary, (preferably) multi-racial, poly-gendered and cross-generational. Ultimately, I envisioned a safe space for participants to really experiment, where the human body, our sweaty and marked bodies in ritual action, could act as the living metaphor for the *body politik*. With these elements, students, young artists, and artivists could push the boundaries of their fields and identities in dialogue with their elders, take necessary risks, learn how to talk back to power, and speak up for social justice in multiple contexts (the art world, academia, the media, social technologies, and, when necessary, the streets).

For performance to be a successful form of radical democracy, performance artists need to learn to listen to others and teach others to listen. Our pop-up live art laboratories and *escuelitas* (humble schools) can function only if we make mutual trust and its resulting collective intelligence a core value. We came to call this the concept of radical listening. As a key Pocha discipline and practice, radical listening means opening up to the entirety of the fellow loc@s and deeply inhabiting their truth. It is the only pathway to the radical inclusivity that our bordered bodies, our cartographically fragmented psyches, and our Pocha souls seek in order to be truly at home in the universe, a universe re-imagined by us.

At the time, I remember, we began to challenge theorists to be more performative, and artists to be more theoretical and activist-minded. If performance was to embody theory, these encounters would have to happen using the whole body in a conscious, politicized, and performative way. British theater artist Sara Jane Bailes reminded me: "The body is a way of thinking, and intellectual work can also be a creative practice."

We must add the activist potential of the human body in our performance interventions and teachings. There are plenty of institutions where students can develop artistic practices that are divorced from social conscience and historical pathologies, but La Pocha Nostra is not one of them. There is too much at stake. For us it's always now or never. As our friend and editor Paloma Martinez-Cruz put it when talking about La Pocha, "We're three weirdos away from fascism. We're two performance artists away from the trains coming for us. We're one roomful of poets away from the ovens." No shit! These ideas and urgencies began to inform our Pocha Nostra nomadic workshops.

However, one question remained. When crossing over into academia, would our perceived "extreme aesthetics and behavior" be tolerated by an increasingly puritanical and conservative university system, especially in the United States? How could we adapt our method to the institutionalized and highly supervised environment of the university classroom without compromising its core or without being expelled in the second week? Did we have to offer a "Pocha Lite" pedagogy?

I soon realized that part of our new political project within universities and colleges was to contribute to the many existing pedagogical projects that attempted to create more open and experimental teaching models. The writings of feminist performance theorist and pedagogue Joanna Frueh came to my mind: how can you bring joy, dialogue, and eros back into the classroom or the institutionalized workshop space?

My impulse to transform institutional agendas derives from several sources. My university days studying literature and linguistics at Mexico City's highly politicized UNAM in the mid- to late 1970s, and my journey through the California Institute of the Arts' "Post-Studio Arts" program in the late 1970s and early 1980s exposed me to experimental forms of education. Later on, Chicanismo taught me that art was a form of radical citizenship. My participation in the reconstruction of Mexico City after the 1985 earthquake and my involvement with Zapatismo in the mid-1990s engendered a strong sense of the social responsibilities of artists and intellectuals.

A BRIEF HISTORY OF THE POCHA METHOD

Tracks: Classic songs by The Jesus and Mary Chain, Echo & the Bunnymen, Antony and the Johnsons, and the Tiger Lillies, Los Angeles, 2005

Armed with these ideas, I began my sporadic incursions into academia. I was happily surprised by the new generation of students I encountered. They were extremely sophisticated and hyper-aware of the politics of gender and race. They had grown up with computers, global media, and interactive technologies. They were fluent in international pop culture and reality TV and therefore felt at ease with "interactivity" and role-playing, two of the main obsessions in contemporary performance art. Spoken word, sampling, pastiche, abrupt juxtapositions, and hyper-textual thinking were already *lingua franca* to them. Having been groomed by "extreme culture" and "extreme sports," they were not shocked by anything my generation might consider racy, radical, or sensitive. They were more than open to our performance pedagogy and practice.

In spite of their sophistication, they lacked commitment, consistency, and ethics. While they distrusted all governments, corporations, formalized religions, nation states, and geopolitical borders, to them, "progressive politics" was more of an existential attitude connected to the spectacle and hype of alternative pop culture and revolution as style. To them, Che Guevara, Rigoberta Menchú, Nelson Mandela, and Subcomandante Marcos were rock and roll icons, alongside Jim Morrison and the Sex Pistols – trendy images to be printed on fan T-shirts or CD covers and painted on street murals worldwide. Environmentalism, multiculturalism, anti-globalization, and anti-racist politics were more of a lifestyle than a hard-core philosophical conviction. They embraced geographical mobility and enjoyed "participating" in large-scale experiential events like the Burning Man Festival, art raves, street carnivals, and Day of the Dead parades, but they were also seduced by social media and the tech industry. When doing research, Wikipedia and YouTube were more important than actual books. This was a new generation of enlightened slackers, multicultural samplers, and designer anarchists. It was the generation of my son and nephews, and the sons and daughters of my colleagues.

Working with these students and young artists, our challenges were many and formidable. How could I talk to them about ethics and commitment without sounding like a self-righteous old fart? And they had a point. The popular ethical models, as practiced by parents and teachers, politicos and religious leaders, belonged to a bankrupt system that often led to intolerance and violence. How, then, could I shape a discussion of ethical matters that was fresh and hip? How was I to make my pedagogical praxis engaging, sexy, and highly performative while at the same time preserving its profound ethical purpose?

In response to all these issues, La Pocha developed its pedagogical methodology in stages. From the mid-1990s through 2000, Roberto Sifuentes (my main collaborator at the time) and I devised a workshop entitled "The Brown Sheep Project" directly inspired by the ideas and organizing structures of Zapatismo and by the eclectic techniques of our performance work. The basic idea was "to nurture young rebel artists and help them sharpen their artistic and activist skills." We fleshed out and tested the model in Chicano/

Latino cultural centers throughout the United States, mentoring hundreds of young performance artists.

In 1999, inspired by the summer programs of the Centre for Performance Research (CPR) located in Wales, La Pocha began a nomadic performance workshop tested over the years in many places, including London, Berlin, Barcelona, Sydney, the Canary Islands, Buenos Aires and Tucumán (Argentina), Rio de Janeiro, Bogotá, and Mexico City. Both controversial and extremely popular, these workshops became a regular fixture of the biennial "Encuentros" of the Hemispheric Institute of Performance and Politics.

Traveling across borders while leading these nomadic workshops brought up several crucial questions. How does the method change when it crosses extreme cultural borders? Which exercises survive this cultural crossover? Which ones don't make it – and why?

A parallel pedagogical experiment was created by La Pocha in direct response to the challenges of 9/11/01: "Re: group" was a San Francisco-based performance laboratory which aimed to "re-conquer the artistic freedoms being taken away by the Bush administration" and fight their pervasive panic politics with performance art jams and what we called at the time "Intox lounge culture jam events." In this conceptual space, our familiar Latino/a and Chicano/a performance communities began to compare notes with Arab-American artists regarding the new officially sanctioned racism and the frightening Western enthusiasm powering the demonization of the brown body.

Finally, in 2004 La Pocha Nostra decided to consolidate and distill all these experiences and opened a "performance summer school" in the Mexican city of Oaxaca. Artists and students came from as far away as the United States, Canada, the United Kingdom, Spain, Holland, Belgium, Germany, Australia, Brazil, and Peru to collaborate with indigenous Oaxacans working in experimental art forms. The "Pocha Summer School" became an amazing artistic and anthropological experiment. How do artists from different countries and races spanning three generations, from every imaginable artistic background, begin to negotiate a common ground? Again, performance art as radical pedagogy provided the answer, becoming the connective tissue and *lingua franca* for our "temporary community of rebel artists."

When the now famous teachers' insurrection and consequent repression by the government took place, the city became a dangerous place for outsiders. After many agonizing discussions within our group, we decided we couldn't jeopardize the safety of international students and artists who knew very little about the political complexities of Mexico. It became clear we needed a new home and safe house. In 2007, we found it in Tucson, 40 miles from the US–Mexico border.

The original idea behind our new summer and winter schools in the Southwest was "to bring together both international and local experimental artists in a temporary creative sanctuary, a safe yet unsupervised environment where, for a couple of weeks twice a year, we could engage in the ongoing exchange of radical art, new vocabularies, languages, rituals, and aesthetics." The local producers provided us with a huge warehouse equipped with lights, sound, and costumes where we held daily ten-hour sessions. We marked the end of the process, as we often do, by presenting an open salon and jam session to the local arts and activist community.

This extended laboratory gave participants the freedom to experiment with new material and share their practice on a deeper level with others. Along the way some artists developed genuine and long-lasting friendships across international borders. These links helped form new performance projects and artist communities in several countries. By 2000, La Pocha Nostra had mentored radical performance collectives in several countries, including Mexico, Spain, Brazil, the United States, Canada, and the United Kingdom.

Later on, similar summer and winter schools took place in Athens (Greece), Évora (Portugal), Barcelona (Spain), Rio de Janeiro and São Paolo (Brazil), Guanajuato, Tijuana, and Mérida (Mexico), San José/Heredia (Costa Rica), Montreal and Toronto (Canada), Lima (Peru), and many other places. During these years, we amended and expanded the exercises of our original "Pedagogy for Rebel Artists" and created a more advanced site- and theme-specific pedagogy. Today, La Pocha's nomadic pedagogical project continues to nurture multinational communities of rebel artists through our summer and winter schools and the shorter workshops that take place in various countries every year. This book is the distilled result of the successful road-testing of our performance pedagogy in all these multiple cultural contexts during the past nine years.

La Pocha Nostra is at once wild but also intelligent. They galvanize participants to respond to the difficult questions, not through words so much as through image, action, and incantation. La Pocha generates a naked series of tasks, in a warehouse of archeological findings, a pilgrimage of seemingly disparate artists, who start quietly but build into a fierce battle – against the status quo, but also against their own preconceived assumptions about one another. Gómez-Peña creates space for that dialogue. He is a radical Mexicanoloco, and also a radical listener in groups of people. So, while there may be bondage onstage, the real bondage is in the relationships we built, and continue to build, together. Radical community, that is the future.

(Denise Uyehara, performance artist, writer, and director)

Since 2004, La Pocha Nostra has conducted an average of 40 workshops per year in the most unlikely places, from feral abandoned buildings to chic academic contexts, museums, galleries, and everywhere in between. La Pocha has mentored over 15,000 artists from more than 30 countries. Participants have come from diverse ethnic backgrounds, gender complexities, and multiple generations. Sometimes our workshops are hosted with production support from cultural institutions or funding sources. But, more often than not, we self-produce our own pedagogical projects, including securing the venue, resources, and participants.

Each workshop is distinct in terms of site, context, and participant blend, making every pedagogical adventure a truly experimental live-art laboratory. Just to think about it is exhausting, but it is also an ongoing source of political hope for us. The great paradox is that after all these years of touring an average of 75% of the year, we remain poor, have no medical insurance, and can barely pay our monthly rent. But, hell, we love it.

FIGURE 2.2 US/Mexico relations in the Trump era
Photographer: Heather Sparrow
Performers: Jessamyn Lovel, Nikesha Breeze, and Alessandra Ogren
Santa Fe, New Mexico, 2018

THE POST-DEMOCRATIC ERA

Tracks: A mix of Mexican hip-hop bands, AKWID, Cartel de Santa and Gran Silencio, any border town, 2011–2017

I excerpt and quote from my unpublished performance diaries:

> *As orphans of two nation states, we get invited to the Mercosur Biennale in Brazil, to the Centro Cultural La Recoleta in Argentina, and to the Teatro Nacional in Santiago de Chile. We get invited to represent a conceptual nation called "the Border," located in the poetic map of our ImagiNation. It all feels like a Bolivarian dream …*
>
> *I howl from the rooftop of my studio …*
>
> *Tonight I am literally standing on the ruins of globalization, drinking mescal and smoking mota with my friends. We are slowly re-entering the world. We are quiet witnesses to the recent meltdown of Wall Street and consequently, the global economy; respectful witnesses to the emergence of myriad citizen movements against authoritarian regimes worldwide.*

I cry for a vision ...

I can see the political streets of planet Earth from the balcony of my recent memory enhanced by mescal: mostly youth across class and nationality, rebelling against a world without jobs, housing, quality education, and medical services; a fucked-up world without gender or race equality, social justice, respect for human and civil rights, and certainly without any kind of hopeful future.

Organized primarily through texting and social media, the Spanish indignados are quietly filling up La Puerta del Sol in Madrid as the valiant Arab youth are defying autocracies from Cairo to Tripoli. The joyful performative camps of the Occupy Movement across the world are capturing our imagination. Topless women in the Ukraine and their FEMEN followers worldwide are embarrassing corrupt politicians and the church. The anarcho-queers and their trans-feminist artivist peers are camping around bonfires in abandoned buildings throughout the planet. We visit with all these new urban tribes and share performance strategies to cause trouble in the streets ... Many Pocha Nostra alumni, young friends, and peers are part of these movements. I am so proud of them. My source of hope is located in their vision and performative actions. My philosophical hope is located in their tender gaze and brave bodies covered with tattoos, piercings, and messages of political resistance.

I continue crying for a vision ...

Wikileaks (and later Snowden) released "classified documents" that reveal the corrupt intentions of governments and corporations worldwide. The silent marches against violence led by a scruffy Mexican poet named Javier Sicilia often number half a million people, including relatives and friends of those who have been killed by organized crime and their Mexican military and police collaborators.

"Black Lives Matter" takes the world by surprise. A new generation of young, Afro-American activists and their multi-racial peers hit the streets of America, putting their bodies in the line of fire, demanding basic justice for the 900 plus black and brown young men killed by racist cops every year in the violent streets of America; demanding the resignation of racist police chiefs protecting their cronies and the local politicians in cahoots with them.

Everywhere I turn, I see imaginative and brave citizen actions. These movements have no recognizable leadership. It's a new form of decentered anarcho-performance-artivism. They utilize many performance art techniques, some even borrowed from our Pocha method. I feel humble, excited, high, and hopeful, very hopeful ... well, temporarily hopeful ... Wait – I need more mescal ...

(...)

In 2012, after a six-month tour in Europe, I experience a total health collapse *and become temporarily "paraplegic." It takes me six months to get a grip and begin to move my limbs and recapture my memory. The affection and daily care of my closest friends and relatives, and my self-styled "psychomagic performance actions," (one ritual performance a day, one part of my body a day), help me to slowly recover my body movement and mental clarity. In the process, I meet Balitrónica, the love of my life, and we choose to share the next chapter of our lives as a macabre power duo in the arts and*

*on the road. La Pocha Nostra welcomes her with joy. "You just saved Gómez-Peña's life,"
they tell her. It's love against physical illness and cultural entropy; love against metaphys-
ical loneliness and globalization-gone-wrong; love against ultra-nationalism; love across
borders … It's a great time for La Pocha Nostra …*

(…)

*Unfortunately, time passes, four, six months, a few years, and everything begins to
turn sour:*

*The Occupy movement moves to page 12 of the NY Times, and then disappears
altogether. Harder Muslim autocrats replace civilian autocrats in North Africa. The
Spanish right wing wins the presidential election; and fringe ultra-separatist "National
Front"-type parties throughout Europe begin to gain momentum and slowly become
"mainstream" … What the pinche fuck?! I'm glitching … As if this weren't enough, Julian
Assange is in hiding at the Ecuadorian embassy in London while Edward Snowden is
being protected by the Russians. Both have pending charges for treason in the United
States; both are hiding from professional assassins. It reads like an Ian Fleming novel
or like a "Fantomas" comic book. The legendary Subcomandante Marcos who ignited
our political imagination in the mid-1990s is allegedly dying of lung cancer (is this true
or just a tactical performance by Marcos? I don't know anymore), and the Mexican
PRI party which dominated Mexican politics for 70 years is back in power. To add
insult to injury, white cops in the United States begin their ridiculous "Blue lives matter"
campaign.*

*What next? We happily vote with nostalgia for authoritarian regimes, police states,
and rampant corruption? Is mankind doomed? Nowadays it seems like "hope" can
only last for a few months, half a year maximum. Is ephemeral hope, then, our new
condition?*

***Inevitably, the new zeitgeist gets internalized by our own progressive communi-
ties:** Our performance and activist peers begin to fight amongst themselves. They fight for
oxygen, funding, apartments, academic jobs, recognition, and attention on the net or the
political streets.*

*In 2015, the anarcho/queers and pornoterroristas in Spain and Mexico, become
hard-core separatists and start organizing art events and festivals that exclude the
entrance of anyone who is not a member of the "inner circle" or a current lover. Even
some of my own performance disciples tell me: "No Gómez-Peña, you are not welcome
tonight. You've got a penis. We question your queerness … Besides, you are a bit too
old for this!" Ouch!*

I am now crying and drinking out of despair and sadness …

***La Pocha Nostra, our troupe, is also suffering internally from all these bitter
changes and new ethical predicaments.** Four members drop out within a span of
two years. Tired of the road and the financial uncertainty, two Pochas succumb to
the seductive academic paycheck; and two others, to extreme political correctness and
essentialism.*

*Most everyone in the US, Canadian, and European progressive communities is
afflicted with self-righteousness, hyper-cultural sensitivity, and instant "trigger warnings"*

broadcast daily by academia and the mainstream media. If you look at someone the wrong way, you may be accused of sexual harassment or soft racism. You can lose a friend or a collaborator forever over the wrong phrase or display of affection. Sex is criminalized and so is the joy of making art or being a bohemian. It's the new authoritarian puritanism paired with a new bizarre phenomenon: the victimization Olympics in the sluggish "consumer democracy" of a broken president Obama.

Our progressive communities are divided. Like many other performance colleagues, the members of LPN are exhausted from crossing so many daily borders in search of alliances and healing. What is clearly missing in America is a sense of compassion and radical tenderness within and in between our multiple communities of difference. We are doing the job for the far right. And the far right is silently organizing and infiltrating academia, the military, ICE, and other law enforcement agencies, corporate and religious America, and the tech industry.

The larger picture is even more scary. This culture of hyper-sensitivity regarding matters of race, gender, religion, and nationality is taking place precisely at a time when the United States and its phony "Western allies" begin to bomb new countries in the Middle East and Africa, causing an international refugee crisis. Clearly, the nation-state as we know it is dated and dysfunctional. As a reaction, right-wing parties continue to gain momentum and win elections throughout the Americas and Europe ...

Meantime in Teeveelandia, a sleazy popular Reality TV show called "The Apprentice" reaches the lowest levels ever of humiliation towards candid celebrity wannabes with dreams of instant power.

A humongous orange balloon with the written words "Trump Enterprises and Casino" flies in the distant cloudy horizon. It's now 2014, 15, 16, and Obama can barely keep his "cool" democracy alive. We have not the least idea of the storm ahead. There's a new sheriff in town. Like Yosemite Sam, his name sounds like a bad joke: "Donald Trump," an ex-casino owner, greedy landlord, and reality TV actor is now in power, and every day feels like a new episode of a 24-hour post-apocalyptic reality TV show titled "The President of Chaos."

Determined to destroy the culture and legacy of the civil rights movement, he promotes anti-constitutional fascistic laws on a daily basis. It's hard for us little artist-citizens to process the changes. And that is precisely Trump's main strategy; to keep us confused and wear us out.

The much touted ex-"silent majority" (remember?) is now an army of exalted racists, xenophobes, and homophobes. These new American jihadists are ready to kick our ass. They believe that the right to bear and use arms is more important than the 1st amendment in defining "our democracy," a word they utilize as a war chant. And they are everywhere, even in universities, art openings, and dive bars. We simply can't escape them, and they want to fight.

Even Alonso Pepito "Orlak," our Pocha teacup Chihuahua, along with the stars in the San Francisco night sky, are sad. We are all trying to keep our style and our dignity intact, but it's $%#^& hard. It's time for us once again to reinvent our performance and pedagogic strategies ...

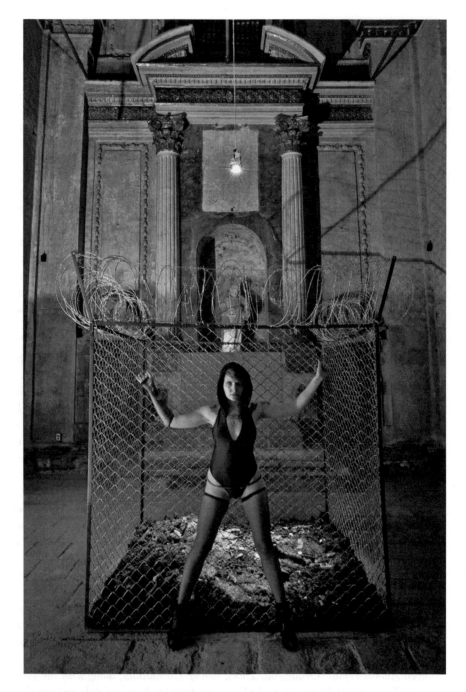

FIGURE 2.3 Church Invasion: La Pocha Nostra crashes the X-Teresa Temple
Photographer: Herani Enríquez Hache
Performer: Balitronica
Mexico City, 2014

WHAT IS THE NEW POCHA PLAYLIST?

Tracks: Scratch and mix from classical European composers and Native American drumming to Chicano hip hop, noise, death metal, and electronica, the borderless Americas, 2018

Conceiving of La Pocha Nostra as an ongoing practice of radical pedagogy, and not just as a set of finished art projects, has made us rethink our entire performance praxis. It is true that the performance itself carries a transformative seed, a seed that nests in the psyche of the audience and slowly grows in the weeks and months following the performance. However, the actual methodological process of developing original material (as outlined in this book) might be the most transformative and hopeful aspect of our current work. In other words, whether it results in a public performance or not, the methodological process itself is now the ultimate political project.

Taking students and artists (both young and established) on this exciting and dangerous creative journey constantly raises new issues and dilemmas. These not only include troubling and surprising artistic and spiritual discoveries, but also profound cultural mis-encounters alongside instant border-blurring and a constant shifting of lines that can and cannot be crossed, day by day, as we task diverse individuals to develop the discipline of radical listening and radical tenderness. As a border performance artist, how could you ask for more stimulation when you constantly see others making even the smallest of aesthetic discoveries – or, as often happens, you yourself are challenged by younger artists and need to readdress your own set of beliefs and ideals? During this process the border between instructor and student becomes meaningless. We are all on the same side of the border; we are all implicated. We are all deejaying. We are all dealing with our personal and social demons. We are all dreaming collectively.

During this process, the workshop becomes a metaphor for the larger social world and the politicized human body becomes a site for creation, reinvention, and activism. Both instructors and participants collectively realize that we can negotiate political, racial, gender, aesthetic, and spiritual differences. We cross so many borders in the workshop that are or seem to be out of reach on a daily basis that we are inevitably inspired to cross them outside the limits of the workshop. This discovery is highly empowering and spills into people's personal and professional lives. So, in a sense, our ultimate goal is to help participants (and ourselves) become better border-crossers in multiple territories, not just in the terrain of art making. We hope we can all become more integral and civic-minded individuals, responsible citizens, peers, neighbors, friends, lovers, and revolutionaries, in the best senses of these terms.

Witnessing this discovery is a moving experience: one of the most radical and hopeful aspects of performance pedagogy is precisely its profound transformational dimension. Participants can discover the political, poetic, sensual, and spiritual possibilities of performance as well as its intricate connection both to their everyday lives and to the civic realm.

We are hoping to persuade the reader of this statement. We truly hope you join us in this shared project by becoming a practitioner and re-conceptualizer of the ideas, suggestions, and wild methodologies articulated in this manuscript. And, in the spirit of La Pocha: after reading this book, we ask you to go find an interesting space in your hometown, get a bunch of weird props and costumes, and do it now – "*de ya!*" Don't wait. Try these trippy exercises with your fellow locos and locas tonight! Enjoy!

Gómez-Peña, 2017, Santa Fe, New Mexico

**DURING THE WORKSHOPS, ESPECIALLY FIVE- TO TEN-DAY
INTENSIVES, WE OFTEN OBSERVE THE FOLLOWING:**

- **Gender and race militant essentialists become increasingly more
 open** and compassionate towards the other "others."
- **Participants (including Pocha members) have time and space to
 confront our own prejudices and open up to dialogue** with the very
 racial or gender "other" we fear or distrust.
- **Shy and self-involved participants become artistically extroverted.**
- **Art dilettantes and skeptics discover the passion and commitment
 necessary to embrace their** *métier.*
- **Mono-disciplinary artists discover other possibilities of creation** and
 distribution of ideas and imagery.
- **Paramount to the Pocha universe: life-giving, long-term friendships
 and collaborations across multiple borders begin.** In a time like ours,
 when paranoid nationalism and fear of "otherness" are the master discourse, to
 encourage people to cross borders becomes a crucial political project.

The 2019 Pocha Nostra Manifesto for a "Post-Democratic Era"

"What is La Pocha Nostra? A bunch of ethno-cyborgs, sacred monsters, deviant ballerinas & trans/shamans. How do we survive? En chino y al reves?"

"Pocha Nostra T-shirt: BULLETPROOF: Latin@Queer/Immigrant ... y que?"

"Precisely because we are a border troupe, all Pocha Nostra truths are half-truths. O sea, we are an exception to a non-existing rule."

Motto for the twenty-first-century artist/warrior: "Permanently outraged but always tender."

A note from La Pocha headquarters: *This document has been extracted from various Pocha Nostra "manifestos" and "anti-manifestos" from the last 23 years. Due to the spooky "Trump Effect," it has been distilled to its minimum/maximum. Still in permanent progress, we hope it will give, to our beloved collaborators, followers, producers, and curators currently working with us, a strong sense of who we are and how we work. If you wish to reprint it, simply ask us for permission.*

Please use it in any way you wish and most importantly enjoy it! If we don't love what we do, why pinche bother?

Bear in mind it is a living, ever-changing "open literary system." Therefore, it is still full of typos and awkward syntax. We are currently looking for a writer with amazing editing skills who can proofread the text for publication.

We are also interested in foreign curators and intellectuals attempting a feral translation into other languages. Just double check the "neologisms" and pochismos with us.

Here's a version, in progress, like life, like live performance ... like the way our deviant minds, bodies, and multiple communities work.

La Pocha Nostra is an ever-morphing trans-disciplinary arts organization. Based in San Francisco with factions in other cities and countries, our original mission statement (2003) read: *"We provide a center and forum for a loose network of international rebel artists from various disciplines, generations, gender persuasions, and ethnic backgrounds."*

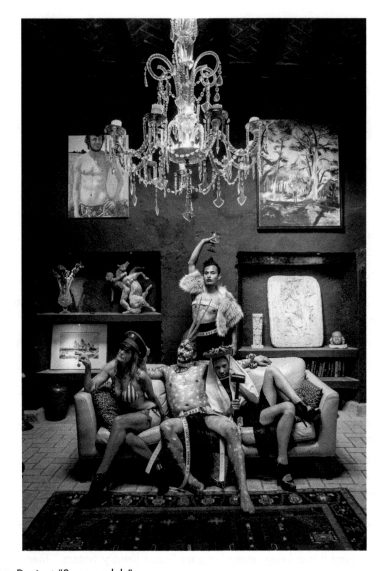

FIGURE 3.1 Deviant "Supermodels"
Photographer: Herani Enríquez Hache
Performers: Lilia Garcelon, Baruk Serna, Raúl Gámez, and Linnea Rufo
Photo Performance Karaoke in San Miguel de Allende, Guanajuato, 2016

For 23 years, La Pocha Nostra has been fully engaged in the field of performance and live art through myriad collaborations, lectures, writings, pedagogy, artivism, and digital art. We have reinvented ourselves constantly in order to remain current, sexy, and edgy. We have operated at the intersecting points of new and old (political, cultural, geographical, and conceptual) borders. Inevitably, our language, performance strategies, aesthetics, membership, and location have changed with the times. We invite you to jam with some of our ever-morphing strategies and core ideas.

Here are some of our ongoing strategies and core ideas.

Who is La Pocha Nostra? Are we, as we've been perceived by journalists, a bunch of "neo-indian cyborgs, sacred monsters, deviant ballerinas, border dandies, trans-shamans, inter-cultural chameleons and identity thieves?"

In a sense, we are ... but we are many other things:

A spoken-word poem: *"... an intercultural poltergeist, a migrant dream that suddenly becomes a nightmare, a pagan religion located in the body, a bunch of malfunctioning cyborgs who rebel against the scientist or the curator, an urban tribe of mythological monsters, a deterritorialized desire, a border epiphany, a woman pierced with corporate flags, a mariachi crucified by the border patrol, a queer phantom mariachi fighting eviction and deportation, a shooting gallery of broken stereotypes, a clumsy but efficient form of radical democracy ... a deeply committed crew of artist peers and friends ...*

With radical tenderness and compassion, La Pocha Nostra has been fighting colonial inner demons and postcolonial re/oppression at the intersection of race, gender, and class since 1993, fighting la migra, the PRI (the Institutional Revolutionary Party in Mexico), the formalist art critics, and the capital "Art World"; fighting our own fetishistic and kinky desires for 20 years, at least; and of course, fighting terror with all our indigenous brothers and sisters since 1492.

We are a unique community of deviant, radical artists still trying to make sense of the post-Zapatista, post-"occupy," post-Arab-Spring global culture gone wrong; trying to make sense of the sudden arrival of the Trump/ocalypse, the Mexican crime cartels, and the pervasive anti-immigrant rhetoric in favor of the (fictional) construction of walls, or rather the staging of a parallel reality constructed by "alternative facts" and political reality TV ... but we are also trying to pay the bills and avoid eviction!

We claim a border/less America in the largest sense of the term. We live in the South of the North, and in the North of the South.

We claim an extremely unpopular position in post 9/11 USA: No homeland, no fear, no borders, no patriotism, no nation-state, no censorship. In the Trump era, we stand strong under these same principles: We are matriots not patriots, "Americans" in the Hemispheric sense of the term, with a devotion to land and people and not to the leaders of governments and corporations. Now more than ever La Pocha needs to rein-vent and re-energize itself under these principles in order to remain relevant and present in our troubled contemporary times.

We are committed to presenting a poly-cultural and pluriversal "America" from an inter-nationalist, radical humanist, and progressive perspective. Our America is still an open society with porous borders and transnational communities; our America is neither "Red" nor "Blue": it is brown, black, yellow, pink, green, and transparent. It always has been ... "here", in the third world within the first world and vice versa; "here" in the United States, Europe, Latin America, and the Global South in the Regional North!

La Pocha Nostra is a virtual *maquiladora*, a conceptual assembly line that produces body-based brand-new metaphors and symbols, and that recycles, retouches, and rebrands old ones. We create/re-create new images and words to articulate the complexities of our times. Through *sui generis* combinations of artistic languages, media, and syncretic

performance formats, we explore the interface of migration, hybrid identities, border culture, globalization-gone-wrong, de/colonization, and new technologies.

La Pocha collaborates across national borders, race, gender, language, class, generational lines, political beliefs, and assorted theories: Postcolonial, Queer, Trans-Feminist, neo-Chicano, neo-indigenous, Quantum, Shamanic, *et al*. Our collaborative model functions both as an act of "citizen border diplomacy" and as a means to create ephemeral communities of like-minded people like you.

We are also a "live art laboratory," an international "loose association of rebel artists" thinking together, exchanging ideas, aspirations, music scores, playlists, and props and creating on-site projects. The basic premise of these collaborations is founded on an ideal: if we learn to cross borders on stage, in our bodies, in the gallery or museum, we may learn how to do so in larger social spheres and transgress what keeps us apart. We hope others will be challenged to do the same. This is our ultimate radical act.

La Pocha Nostra has died and has been resurrected dozens of times. Throughout the years, 23 this year, LPN has been a garage performance troupe, an experimental sideshow, an interactive living museum and curiosity cabinet, an inter-cultural orgy, an ecosexual parade in the streets of San Francisco, a wild night club in Berlin, a deviant traveling party, a politicized x-treme fashion show, a conceptual surgical theater with transgressed bodies laid on top of each other, scenarios of the unconsciousness, a bus full of radical nuns driven by a sex worker … or vice versa.

Pocha has also acted as a performance clinic, a nomadic performance school, a lab of misfit identities, a weird town meeting, an intellectual rave, and a virtual resource center. Pocha can also be a Trojan horse (with or without condom? sin condón!) by finding the way to involve other artists in the creative process. La Pocha is this and that and everything in between, always with fluctuating borders and ALWAYS flaunting our "otherness." We are bold, and always occupy the space in-between.

La Pocha challenges traditional art world mythologies. We do NOT accept the role of the artist as a suffering bohemian and misunderstood genius drowning in the angst born of their existential suffering and personal traumas. La Pocha artists are first and foremost social critics and chroniclers, intercultural diplomats, re-interpreters and mis-translators, radical pedagogues, informal ombudsmen, media pirates, information architects, reverse anthropologists, experimental linguists, border semioticians with P/T jobs as "high/low-tech exotic intercultural fetishes for rent during weekends." We even bartend at times.

To us, the artist is, above all, an active citizen, a public citizen immersed in the great debates of our times. Our place is located not only in the "Art World" but in the world at large, in the patterns and corners of everyday life. The so-called "Art World" is just a safe place to gather, an irreplaceable rehearsal space where alternative cultural models are developed and later on tested in other realms including community, activism, politics, radical pedagogy, new technologies, and media. For us the capital "Art World" is merely a space to learn new experimental languages to talk back to power and decolonize ourselves. It is a training field for resistance, reinvention, and "imaginary activism."

At different times and for different reasons, we have been called: "decadent," "sado-masochists," "not Chicano enough," "too Chicano," "reverse racists," "hipster racists,"

"anti-American," "anti-Mexican," "anti-Catholic," "gratuitously violent," "Chicano art on steroids," "unnecessarily shocking," "controversial," "too queer," "faux queer," "too bizarre," "elitist and artsy," "too populist," "too theoretical," "politically incorrect," "too triggering," "always nude," "perpetrators of stereotypes," "too theatrical," and "not really theater." We are easy targets of orthodoxy, normativity, and mono-culture. It's called "performance art."

Our favorite term was when Indian theorist Rustham Barucha called us "the dead-end of multiculturalism." But our very VERY favorite name is "Essentialists of hybridity," a beautiful contradiction in terms. It's like being called "Spanglish purists" or "puritan sexworkers."

At the same time, we have also been labeled "the most influential Pan-Latino performance troupe of the past ten years." We blush.

La Pocha is an ever-changing community. Pocha can be two people or 50 people in physical or virtual presence. Inspired again by the early Zapatistas, we create "regenerative and sustainable sources of artistic labor built from temporary concentric and overlapping circles." Sounds corny but it's pinche true! And this open structure truly works. We've been around for a while. Here's the basic blueprint:

The inner sphere comprises the "core members of the troupe" (artists/artivists/pedagogues) whose membership is determined by their degree of commitment and time.

The subsequent middle circle embraces performance artists, activists, curators, musicians, filmmakers, and designers working part time on several Pocha projects. It's our incredible net of Pocha collaborators, guest artists, and akin organizations in various countries.

The last outer and overlapping circle includes artist collaborators, students, workshop participants, theorists, and producers throughout the world who may work with us in a specific project if/when the time and place are right.

We believe that there is enough room in the conceptual/performance jacuzzi for everyone (well, almost everyone).

Our constant change of membership inevitably alters the nature of the work and contributes to the permanent process of reinvention. This continuous shifting multi-dimensionality can hinder sustainability. True. But maybe we hold on to this unconsciously as our antidote to the risk of institutionalization and corporatization!

We sadly see so many performance troupes behaving like mainstream institutions and traditional theater collectives. They love grants! They spend all their time working on grants. They also love big festivals and water down their material to make themselves "festival-friendly"! They lose touch with the world. It breaks our heart. We call it "Blue Men Syndrome."

How do we survive? We have an online "Conceptual Credit Union" to fundraise against the corporatization of culture, the hipsterization of the barrio, and the dismissal of conceptual border art by the mainstream art world.

We adopt the Medusa model: multiple production bases and overlapping circles (physical and virtual) with troupe members across the world assuming their roles as "Pocha ambassadors" and leading the local forces under the imperative of a clear and transparent communication with the San Francisco Headquarters. We learned this model from the Zapatistas.

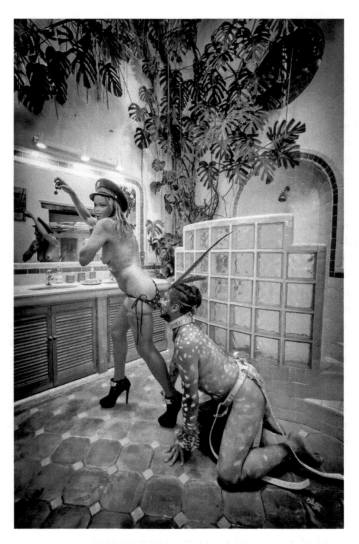

FIGURE 3.2 The Coppertone Gringa in Tijuana
Photographer: Herani Enríquez Hache
Courtesy of Hache Herani and Pocha Nostra archives
San Miguel de Allende, Guanajuato, 2016

We remain anti-essentialist and anti-nationalist by nature. This permeates every level of our practice. "Pocha" is hybridity, lives in the permanent border, and embraces "impurities" as a tool against any kind of essentialism. Hybridity is the only condition of our Imagi/nation state from which we can talk back, empower our bodies, and free ourselves.

We **continue to embrace diversity and complexity regarding inclusion** for workshop participants, pedagogues, collaborators, and Pocha "guest artists." La Pocha is and will always be about diversity in gender, race, age, ethnic background, nationality, and everything in between.

The Spanglish neologism "Pocha Nostra" translates as either "our impurities" or "the cartel of cultural bastards or traitors." We love this poetic ambiguity. It reveals an attitude towards art and society: cross-racial, cross-trans- or post-national, poly-gendered, post-ultra-retro-experimental, neo-indio, or a remix of the same or none, ¿y qué? ¿Cuál es el pedo? After all, nation states are dysfunctional and dated.

La Pocha practices radical tenderness and radical compassion as a daily existential and professional ethos. We treat others the way we wish to be treated (on a case by case basis, of course), from janitors, cooks, and security guards to museum curators and festival directors. We are only formidable enemies of those abusing positions of exaggerated power.

Our common denominator is our desire to challenge, inhabit, cross, and erase dangerous borders between art and politics, practice and theory; between artist and spectator, mentor and apprentice, the human body and our cultural nightmares and twisted subjectivity.

We strive to eradicate myths of purity and dissolve the borders surrounding culture, ethnicity, gender, language, power, and métier. In the act of crossing and erasing borders, we don't deny that we might create new ones that keep challenging us. Sadly, at this point in time, 23 years since we began, these are still considered "radical acts." Chingao!

La Pocha operates from a horizontal model of continual, clumsy, and chaotic democratic negotiation, radical tenderness, listening, patience, heroic sustainability, and love. We are far from perfect, and perfection is very far from our desire. But one thing we have learned is that a star-driven vertical model does not work for us. We strive for humble and egalitarian participation from our core troupe members and to honor the hard and committed work of our many affiliates throughout the globe. For some of us this is a utopia, a distant marker in the horizon; for others, the younger ones, a mere daily anarchist practice.

La Pocha functions through an open belief system: performance is theory and practice. We strongly believe in embodied theory and embodied artivism. We strongly trust the idea that consciousness is stimulated through non-traditional presentational formats stressing the role of the "intelligent body," and the concept of "embodied poetics and ideas." Therefore, we view each performance project as an effective catalyst for thought, action, and debate.

La Pocha encourages public dialogue. By embodying theory and art, we challenge theorists and activists to be more performative and artists to explore intellectual avenues and write. Our hope is that our performance and ritual formats are less authoritarian and static than those we see in academia, religion, pop culture, high art, and politics.

La Pocha encourages internal dialogue. Our rehearsals and workshops, virtual weekly staff meetings, quarterly board meetings (just kiddin'), and open web documents and Google jam sessions involve intense discussions of current issues. At these "gatherings" we explore new ways of thinking about art and community, and new audience development. We highlight the theoretical and methodological possibilities of performance as a way of addressing the changing role of the artist in society. We are also discovering how to better work together from different geographies.

La Pocha's performance pedagogy performs a major role in our political praxis. Our pedagogy is also becoming more and more part of our artistic praxis. The interaction of these two universes is an ongoing process; the process itself becomes "the ultimate project."

Our pedagogy encourages autonomy. It challenges authoritarian hierarchies by horizontally spreading responsibility and participation. It also challenges specialized knowledge by creating temporary utopian spaces where interdisciplinary dialogue and artistic imagination can flourish.

These temporary "utopian zones" are loosely framed by, but not contained within, a pentagon-shape of radical ideas and actions whose vertices are community, education, activist politics, new technologies, and experimental aesthetics. Every project we undertake is loosely framed by these parameters. "Radical tenderness" and ongoing "trans-cultural trans-disciplinary border crossings," concepts developed by La Pocha 15 year ago, are the framing devices for this "utopian/dystopian pedagogical space."

La Pocha workshops serve as an anthropological and artistic experiment where multiple communities of difference can find common ground in performance. It is our connective tissue and *lingua franca.*

La Pocha seeks a unique aesthetic. Functioning as a kind of "crossover live culture jam," our "robo-baroque" and "ethno-techno-cannibal aesthetic" samples and devours everything we encounter, including global pop culture, TV, film, rock and roll, hip-hop, comics, journalism, anthropology, pornography, religious imagery, theory, and, of course, the history of the visual and performing arts.

We cross-reference this information, embody it, and then re-interpret it for a live audience "thereby refracting fetishized constructs of otherness." We become the "shocking" spectacle of our staged hybrid identities by using our highly decorated and accessorized bodies. In this sense we are always physically, culturally, and technologically hybrid beings, what Sandy Stone once called "cultural cyborgs" and what Mexican writer Roger Bartra refers to as "artificial savages" resisting projected stereotypes and exorcising the body from colonial projections perpetuated over time.

This aesthetic praxis works most of the time. However, every now and then we engender a true monster, bad art, cheesy live art … and that's also fine.

La Pocha's aesthetic praxis involves ethnic and gender bending, cultural transvestism and power inversions. Many of our images show women, queers, transgender people, and "people of color" in positions of power. In this inverted universe, cultural borders have moved to center stage while the alleged mainstream is pushed to the margins and treated as exotic and unfamiliar. We often place the audience member/viewer/reader in the position of a "foreigner" or a "minority" living in the suburbs of our temporary performance city.

La Pocha crosses dangerous aesthetic borders. We often cede our will and the stage to our audience. We invite them to co-create the piece and to participate in our extreme performance games and rituals riddled with postcolonial implications. We transform audience members into instant performance artists. These games are integral aspects of our work. It sometimes works, but sometimes it backfires. But we try to work with the accident. It's is part of the game. If we fall, we trust that someone will catch us in mid-air.

La Pocha is an ever-growing "living archive." Our personal collection comprises thousands of original photographs, raw videos, books, magazines, soundtracks, performance documents, props, artist-made objects, books, and weird, one-of-a-kind costumes. Two-thirds of our archives are located in San Francisco and the other third in Mexico City. But our *arte-factos* and archive keep growing in every place where a Poch@ lives.

In order to really "walk the talk" outlined in this manifesto, La Pocha Nostra is in a process of shifting from a star-driven vertical model to a more horizontal one in which ALL members involved in a specific project share equal responsibilities, perks, rights, and payment. This implementation of a neo-anarchist model responds to the claims of the younger members, along with a weak economy in the arts, and the scary resurgence of old geopolitical and ideological borders in the world.

Nos aventamos, ¿que no? Untranslatable! Why?

Precisely because we are a border troupe, all Pocha Nostra truths are half-truths. O sea, we are an exception to all non-existing rules.

La Pocha is, above all, a utopian idea. Our ideal setting is a marker in the political distance, a philosophical direction, a quantum dream, a horizon of possibilities, a fucked up anti-poema co-written by Anne Sexton and Nicanor Parra.

Sometimes our frail egos and financial hardships cause us to fall into personal voids, experience compassion fatigue, and temporarily lose our path and compass … In these times of X-treme crisis in all fronts, to recapture our strength, place, clarity, voice, and dignity, we count on our international community.

Truly yours,
The LPN core members
on fire, during the post-democratic era of good ole' USA

What to expect from a Pocha workshop

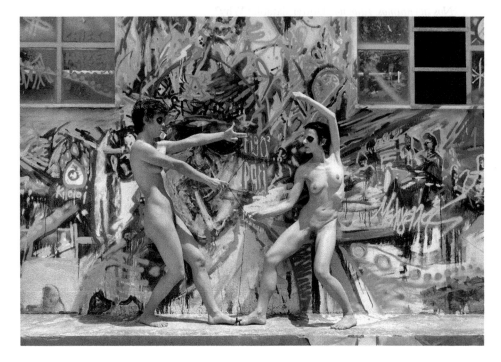

FIGURE 4.1 Human graffiti
Photographer: Manuel Vason
Performers: Laura Corcuera and Litsa Kiousi
International Summer School, Athens, Greece, 2015

Pocha Disclaimer 001: This document functions as a mini-pedagogical manifesto. We send it to the participants in advance so they have a sense of the basic ideas behind the workshop. It can also be used to craft a convocatory (a call for participants) and/ or a press release.

La Pocha Nostra practices a vertical (in terms of class) and horizontal (geographical) mobility that most "famous" performance troupes don't. One day we are at the Tate or MACBA, next day we are performing for a workers' union in South America, producing performance projects with a low budget, but with a relevant political stance in a place outside the art epicenter.

What follows is a simple guide for Pocha Nostra workshops. Our hope is to dispel potential misunderstandings, so when participants arrive they have a sense of what to expect. Of course, there is always the possibility for surprise, accident, discovery, deviance, and change. At the end this is precisely the core of live art.

What to expect:

- **Physical and mental endurance exercises and sometimes fatigue.** The work is very intense, but fun and exhilarating. Don't forget to pay attention to your energy highs and lows throughout the day by taking care of your body and spirit. Bring whatever will help you to boost your energy. Try to avoid magic mushrooms or psychotropic drugs!
- **A strange and sometimes wonderfully disorientating sense of community and group collaboration.** Solo creativity is out of place … but we will try to find a place for everyone, even for the occasional loners and *enfants terribles*.
- **A cross-generational, poly-gendered, and poly-ethnic group of rebel artists, activists, and theorists.**
- **A cross-disciplinary group.** It makes for a more varied and interesting community of rebel artists.
- **The beginning of many strong transnational friendships** with like-minded artists from other countries.
- **A poly-lingual pedagogy** including Spanglish, gringoñol and portuñol. We welcome bad English and Spanish accents! We celebrate linguistic hybridity! Performance becomes the lingua franca.
- **Lots of social interaction and unexpected border crossings,** ritual games, and jam sessions.
- **Over-caffeinated instructors with compassion and a sense of humor.**
- **A multi-vocal instructional model** that resembles a performance jam session. It is pedagogy out in the open. Instructors adjust the pedagogical plan of the day in situ as the process unfolds.
- **A routine of intense social and cultural experiences** that extend beyond workshop hours.
- **An anarchic queer/eco-sexual/trans-feminist/multi-ethnic/trans-border collective** in which everyone partakes in all decisions, and works towards horizontality within the troupe and the workshop.
- **Chances to bring in sound bites of work:** we welcome getting some sessions started off with textual interventions or political provocations that can help get the group going or start to build bridges across radical differences.
- **An environment of respect, tolerance, and the ongoing negotiation of boundaries.**
- **A place to test spontaneous and new ideas.** We are not afraid to say that we love raw pedagogical and creative intercourse and conceptual promiscuity.

What not to expect:

- **A vertically driven performance troupe** or hierarchical models of teaching.
- **Conventional patterns for eating, exercising, and sleeping.** Our apologies.
- **A serious attitude, since we don't take ourselves too seriously.** We love jokes and irreverence that help us see behind the masks and mirrors.
- **Linear logic at all times.** We welcome contradictions as part of the pedagogical process and as an important part of performance making. We are a contradictory bunch of locas y locos.
- **Heavy intellectual or theoretical discussions during the workshop.** But during our late-night gatherings at funky local bars and bohemian restaurants, there is space for this kind of discussion y más.
- **A perfect flow of the planned activities during the workshop.** We are adaptive to the city, venue, and particular group dynamics. Remember, we practice clumsy, radical, democratic models of collaboration.
- **Social or psychological realism,** community theater practice, "positive" depictions of community members, and "feel-good" empowerment art.
- **A bottle of tequila and a sombrero as welcome gifts.** We don't give workshop bags or *morralitos* with pens, flyers, promotions, or notebooks either. But, if we have got our s#!t together, you might be able to buy some books, videos, or T-shirts from us.
- **Counseling and an environment for "healing."** We simply don't have the training or credentials for this. We expect each individual to deal with his/her/their own personal demons that may come out during the process with live art images, not confessional language. However, there will be plenty of radical tenderness to help us take risks together.
- **Mainstream modes of prohibition and censorship.** But, whenever there is a spurt of racist, sexist, xenophobic, classist, nationalist, or otherwise hateful behavior or speech towards or between any of the participants or facilitators, we try to understand its source, and use performance strategies to elicit dialogue and search for a creative resolution. And if someone gets irrationally violent (it rarely happens), we will need to expel them for the good of the group.

Our conscious goals are:

- To build transnational communities of rebel artists.
- To develop alternative modes of collaborating as acts of radical citizen diplomacy.
- To contest any form of authority (aesthetic, religious, political, sexual, etc.).
- To vindicate the human right of having fun while making serious art.
- To set you free with tools you can use for your own work and lives.
- To redirect our attention to our bodies as the main source of creation and activism.
- To become more aware of our condition as humans and become better citizens. Is the imagiNATION out there?

SUGGESTIONS TO CONSIDER IF YOU DECIDE TO USE NUDITY, INCLUDING IN A PUBLIC PERFORMANCE INTERVENTION

La Pocha uses highly politicized nudity; however, nudity in live art and in our workshops is optional. It is never encouraged or mandatory, but if you wish to get nude, please help yourselves. The nude body is a territory for reinvention of identity, imaginary activism, and the creation of new poetic cartographies, especially when marked, accessorized, and presented with the tactical intervention of objects. This is especially the case for the outcast exploring the decolonized body. Our skin and blood are the only materials we are left with after centuries of repression. Our body is the only artifact we can directly reclaim and empower to talk back. Here are some humble suggestions to protect yourselves when using nudity in the public sphere:

1. **Learn the nudity and public decency regulations of your city** so you are ready for the one–two punch of conservatives and cops.
2. **And also figure out the regulations for a chosen site,** because a university campus, a public plaza, a mall, or a populated street will all have different standards, particularly when young children are present.
3. **Get a letter from a local art institution in case you get stopped.** Sometimes a reference letter about your artistic practice from a local institution can be useful to present to the authorities. If you cannot obtain a letter, substitute it with a forged letter that justifies your intervention as a "theater exercise sponsored by ..."
4. **Identify the target of your action** (institution, corporation, government entity, etc.) and analyze the different ways they might interpret your performance in order to create dialogue rather than mere spectacle.
5. **Identify your local allies** and alert them to the particular aims of your performance and the vulnerabilities your process entails.
6. **Know when (day and time) your intervention will have the most impact,** taking into account the logistics, complexities, and regulations of the site.
7. **Invite a collaborator who will serve as your "conceptual bodyguard"** for the duration of the performance and can provide you with fast backup in case of any aggression from the public or the authorities. You can have colleagues at both ends of your street with cell phones ready to call you if the cops arrive so you can dismantle your installation, disappear within a few minutes, and blend in with the citizenry.
8. **If the intervention isn't being covered by any official media,** ask a friend to dress up as a journalist (a T-shirt that reads MEDIA should suffice) and create a faux video or photo shoot. Invite friends to come to record you with their cell phones and broadcast the action live online. This can serve as a way to protect yourself.

9. **Brand your intervention with a sign.** Have a printed sign ready that reads "instant performance" or "instant theater" to frame your action, just in case. Also, by adding a title to your intervention you will provide clarity to your performance and your involuntary street audiences will be more open to your art.
10. **If you are in a foreign country or in a community that you aren't familiar with,** don't forget to carefully investigate the cultural specificities and border semiotics of your performance action. You don't want your intervention to be misinterpreted and backfire.
11. **Have a plan for how to exit the site** in case things get out of hand and there's imminent danger.
12. **Form a group of, say, ten colleagues who come out with you** all wearing the same color skirt. Cover their eyes with transparent gauze, but make sure they can see their surroundings. This will signal to the authorities: "Art event; don't worry."

And if you want to use nudity in a public intervention, consider the following:

1. **Don't go out to the public if your performance actions are not conceptually, aesthetically, and politically clear.** Don't do stuff just to be provocative or macho/a.
2. **Avoid the use of nudity in a public space if your objective is merely to be outrageous** or for the sake of creating controversy without a clear purpose.
3. **Avoid engaging in a nude public intervention alone.**
4. **If you wish to appear nude in public,** do it preferably with legal consultation from a progressive lawyer so that you avoid arrest.
5. **Adjust your level of risk in accordance with the local regulations,** and consider performing half-nude, or use a specific cover for a particular "intimate" part that can potentially be in line with the regulation but override it at the same time. When the time comes you can become a flasher for ten seconds, get a photo, and cover yourself again.
6. **You may paint your full body.** Body paint can be perceived as costume. Or wear a full costume and take it off at a specific time.
7. **It better be powerful cabronx!**

We humbly suggest not using nudity in public...

8. If you ignored our indications above and did not bother to research the site and its social and political significance.
9. If it creates major problems for your sponsoring institution.
10. If the city where you are performing is a majority right-wing and highly policed one.

11. If it could spark violence that threatens you and your peers.
12. In a religious setting that you don't understand.
13. If you are in another country ... and you don't understand the local complexities of the intervention and the history of the site!
14. If you are not ready emotionally or artistically to get nude.

To play in this way with iconography, symbolism, and metaphor on so many different levels: artistically, culturally, politically, and socially was astounding to me. There is something here about a postcolonial healing, a need to uncover and recover the past, and, as performance artists, to do this through the body.
(Christine de León, Hebel am Ufer, Berlin, June 2008)

Important notes to producers and workshop facilitators

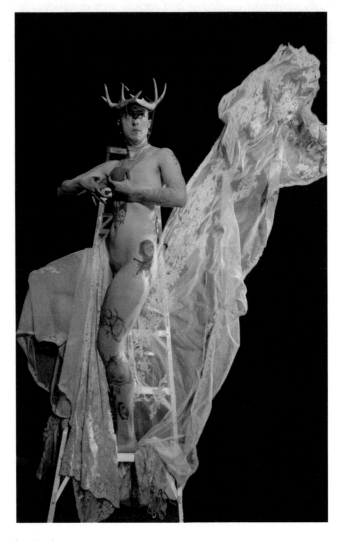

FIGURE 5.1 Border Madonna
Photographer: Monica Vega
Performer: Enok Ripley
Workshop Photo Karaoke MAI, Montreal, Canada, 2017

Pocha Disclaimer 002: *Dear presenter, curator, or teacher, if you wish to organize your own workshop inspired by this book, this crucial chapter describes in detail how to prepare for a Pocha Nostra-inspired performance workshop. We suggest that you excerpt this text and share it with your team, including production assistants, technicians, and public relations personnel.*

THE CALL FOR PARTICIPANTS AND THE SELECTION PROCESS

Our popular cross-disciplinary, cross-racial, and cross-generational workshops often involve students from various university departments, as well as professional-level performance artists, actors, dancers, martial artists with artistic tendencies, and spoken-word poets. Videographers, musicians, visual artists, political activists, and theorists interested in the use of the human body as part of their work are also welcome. The workshop venue can be located in a museum, gallery, theater, university, community center, or any other interesting space.

In the call for participants it's important to outline what participants should expect. The following paragraph is a good simple way to express the expectations of the workshop. "We share our eclectic performance techniques and exercises, challenging you to develop hybrid personas, images, and ritual structures based on your own complex identities, personal aesthetics, and political concerns. The process is highly intense, rigorous, and also a lot of fun. The artists jam together, play wild performance games, and engage in critical discussions about the pertinence of performance art. The workshop may culminate in a full-scale performance open to the public or an open performance salon for invited guests or audiences (this only if the workshop is from five to eight days long). If there is a 'jam session' open to the public in the final day of the workshop, Pocha members may join in and perform alongside our new colleagues. But it is important that you understand that the pedagogical process of working together is the primary objective. We don't want the pressure of a public presentation to overshadow the workshop. We definitely don't want the pedagogical process to turn into a rehearsal."

If the workshop takes place at a university, exclusively for that community, we aim to integrate students from the departments of Art, New Media, Theater, Dance, Anthropology, Chicano/Latino, Cultural, American, and Performance Studies as well as English and Spanish Literature and Cultural Studies. Professors and journalists are welcome as long as they are willing to partake in the exercises.

If the workshop involves local artists and/or activists, the host institution will preselect them in dialogue with us. In many cities and countries, we already know artists who put us in touch with possible participants. If the workshop is open to both local and international artists, as often happens in our summer and winter schools, then the host institution will curate the local group and La Pocha will curate the international guests.

It is very important to us that the "call for participants" is circulated throughout the most diverse communities. The goal is to gather the most interesting, interdisciplinary, and culturally eclectic group possible. We never really conduct "auditions" in the traditional theater sense. Candidates are asked to submit a statement of purpose and a sample of their work.

We do not necessarily choose the most technically trained candidates or the most popular individuals, but rather those with the most interesting ideas and multifaceted training and personalities. We are particularly interested in rebel artists and theorists, with complex identities, excited to engage in experimental performance strategies. Ages can range from 18 to 80+!

It is preferable, but not mandatory, that participants already have some physical training and performance art experience. It also helps if they are familiar with our work and with the performance art field at large. If some are not, we encourage them to research the work of La Pocha and other performance artists before the workshop begins. Our document "User-Friendly Guide to La Pocha Online 2019" (available on our website) is a fantastic resource for this. There we can refer to books, videos, and journal articles we've written as well as to our website and photo blogs. Ideally, for our summer or winter schools and large residencies aimed at large groups of artists, we prefer that participants know our work and have an existing "body-based" practice. However, for short residencies based in universities or colleges, the level of performance experience can vary more greatly. In these cases, often the objective is to get the participants interested in the possibility of including body-based performance art in their practice. We also believe that a group with diverse training and diverse levels of expertise can open up interesting territories of creativity.

If only one Pocha Nostra instructor is present, the number of participants can range from six to ten people. Since most of the preparatory exercises are conducted in pairs, it is important that there is an even number of participants. When two instructors are present, the ideal number of participants is between 16 and 20 people. Sometimes, when three or four instructors are present, we can afford to include up to 22 participants, which often happens in Pocha Nostra summer and winter schools.

Workshops can last from one day to eight days and for the duration of an entire school term, but this will depend on the budget of the overall project, the availability of the participants and the space, and the coordinating capabilities of the producer or institution. We can work on consecutive days for the duration of the project or, in a university context, for a few days a week over the course of a semester. An ideal work session is six to eight hours long. Sessions usually start around 2:00 PM, but in university contexts we often need to adapt to the students' complex schedules and tailor the schedule to meet the needs of the majority of participants. While on tour we never start before 2:00 PM, as the mornings are reserved for our own physical practice and the planning of the day's session. This also benefits the out-of-town participants, so they can attend to their own existential and personal predicaments, explore the city together in the company of locals, and process the notes given at the end of the previous day's work.

When the final list of participants has been decided (a few weeks before the beginning of the workshop), we usually send a welcoming letter outlining the requirements. These

include wearing comfortable rehearsal clothes, and bringing a list of costumes, props, and artifacts that they may want to select from their "personal prop archeological bank." If the workshop is at least a week long, we also encourage them to bring samples of their own work so they can share it with other participants during the breaks over the course of the residency.

This is a typical Pocha convocatory statement for your reference, feel free to adapt it.

~ CALL FOR PARTICIPANTS ~
La Pocha Nostra presents five-day performance art intensive in Santa Fe, New Mexico
August 27–August 31, 2017 (Deadline to apply July 15)

After the extreme success of our first ever workshop in Santa Fe last year, La Pocha Nostra is proud to announce that we will be hosting a second summer workshop intensive in magical **Santa Fe, New Mexico**! *This live art laboratory is open to experimental performance artists, actors, dancers, theorists, activists, and students from all over the world. We are expecting participants spanning four generations and coming from ten different countries. Please send in your application ASAP to ensure your participation!*

This year, **La Pocha Nostra (Guillermo Gómez-Peña, Saul García-López aka La Saula, and Balitrónica Gómez)** will hold one of their legendary international performance workshops in **Santa Fe, New Mexico.** We consider our workshops to be La Pocha's **most important pedagogical adventures** of the year. *Aviéntense locos y locas! Please join us!*

This workshop intensive will take place at **the Santa Fe Art Institute with additional outings and exercises throughout the city at the Institute of American Indian Arts.**

About the Pocha workshop
The summer school involves **five total days** immersed in performance art with a focus on **the human body as a site for creation, reinvention, memory, and activism.** We will also place emphasis on the relationship between the **human body and environment** and have multiple sites to play with. This amazing **cross-cultural, cross-disciplinary, and cross-generational laboratory** will host up to 20 participants.

The "Pocha workshop" is internationally recognized as an amazing and rigorous artistic and anthropological experiment in which carefully selected artists from several countries and every imaginable artistic, ethnic, cultural, and gender persuasion begin to negotiate common ground. Performance becomes the connective tissue and *lingua franca* for our temporary community of rebel artists.

As always, space will be limited and is expected to fill quickly. Responding to the economic challenges of our times, notifications of acceptance will be given

within two weeks of having submitted your application, this will help you to plan in advance. La Pocha Nostra will help you with official letters if you need them. We encourage all interested applicants to **submit your application as soon as possible**. Application guidelines included below.

What will be taught?

The exciting six-hour-per-day workshop will offer **two parallel processes:** Participants are exposed to La Pocha Nostra's most recent performance method-ologies, an eclectic combination of exercises borrowed from multiple traditions including performance art, experimental theater and dance, the Suzuki method, ritual shamanism, performance games, and live jam sessions. Parallel to this hands-on process, the group will analyze the creative process, the issues addressed by the work, and its aesthetic currency, cultural impact, and political pertinence. The Saturday after the workshop, there will be a public performance in Santa Fe by the following La Pocha Nostra members: Guillermo Gómez-Peña, Saúl García López, and Balitrónica Gómez.

Who should attend?

Performance artists, experimental actors, dancers, theorists, activists, and students interested in the topics addressed by La Pocha Nostra. Ages can range from 18 to 80+ years old. Applicants must have some performance experience, and must be familiar with La Pocha Nostra's work. The workshop is extremely fun but both phys-ically and intellectually rigorous.

What is the application process?

International participants will be carefully chosen by a selection committee com-prised of Pocha Nostra members and other international artists. Please fill in the application form online and answer the corresponding questions. Responding to the economic challenges of our times, notifications of acceptance will be given within two weeks of having submitted your application, giving you time to plan accord-ingly. We will be accepting participants on a rolling basis, so we encourage submit-ting your application in advance of the deadline.

KròniK: About the production and other demons: La Pocha Nostra en Lima, Perú, 2016: As independent cultural managers that love this artistic genre that no one understands (nor will -ha-), and that has little or no place in a place like South America in the state or private cultural support funds, we join ancient traditions of collaboration and communal management of resources, what in Peru is **called "the Ayni,"** a "circle of people" who join to share food, lodgings, desires, work, and affection. A circle of love and hard work. As an alternative and autonomous cul-tural space, over the years, we have formed a network of friends and colleagues who are very much interested in the development and pedagogies of Performance

Art, but who do not have the economic resources or a space to learn and develop a practice. So, when we invited Pocha Nostra to come to do their Intensive Workshop in Lima, we already knew that it would be difficult to get the funds to cover their expenses, and that is why we turned to our own network of friends and allies, as a strategy of production. If you are worried about the space where the troupe will stay, don´t, because we got it sorted through a family house of one of the core members of elgalpon.espacio; her family opened the doors of a small three-bedroom apartment, originally reserved for the use of Airbnb, and collaborated with us by leaving us the lodging at 20% of its real cost. In the event that you have many friends on your network and they cannot pay the total tuition of the international workshop, we invite you to let them participate by barter: we organized a task calendar, a list of things that you could give us a hand with, and thus they began to get involved in the organization, from the cleaning of the space, the pickup of the teachers, the friend who had the car to help with some purchases, those who could be hosts and take the teachers to do some local tourism in Lima City Centre, those who had many props kept in their houses or trunks, etc. ... everything counts.

A close friend, who is the director of an important university cultural center, gave a fellowship to two national participants. Through the Mexican embassy entry visas were obtained for the troupe. The whole production process of the POCHA workshop in Lima lasted one year, from February 2015 to February 2016. We want POCHA to return, NOW! You always can, when you want.

el.galpon.espacio (Lima, Perú). Co-directors:
Jorge KOKI Baldeón, Diana DAF Collazos,
and Lorena LO Peña

IDENTIFYING AND PREPARING THE SPACE IN ADVANCE

The working conditions are vital to the process, and every effort must be made to ensure that the following recommendations are taken into account. Space, lighting, sound, props and costumes to play with, and hospitality are all extremely important elements of the workshop.

We must do everything we can to treat each other as professionals in the field, and treat aspiring performance artists with dignity and tenderness, providing them with the most exciting learning conditions. Here's a blueprint for how to attain this goal.

The choice of space

The size of the space is greatly determined by the size of the group. The exercises can be performed by groups as small as eight people or as large as 26. Whatever the number is, it is important that there is enough room for them to do physical work and not to feel like they are constantly running into colleagues.

Ideally, the room should be at least ten meters square, with wooden floors, large mirrors that can be covered, and the option of soft, controllable lighting. But if we are working in historical buildings, as La Pocha often does, or spaces with precarious facilities, it is OK to have stone or brick walls and floors. We can certainly adapt as long as the room is spacious and has some character and architectural beauty.

If there are windows, they must have curtains or blinds to control the level of daylight, otherwise black cardboard or paper can be used to cover the windows. Medium-to-large black box theaters and empty gallery spaces can also work well as long as we have continuous access and some privacy. A secure room or a nearby office for the group to store props, costumes, and equipment is also important.

In short, this is what you need regarding the space:

- The workshop requires a lot of movement and should be spacious enough to comfortably accommodate all participants and instructors.
- The space should be as clear and free from extra objects as possible prior to the workshop start time.
- Be aware of the cultural and political context of the site. Is it a historic building, a university room, a gallery, a museum, a community center, or an independent arts venue?
- To be sure of the conditions of the space, get floor plans and photos of the space far in advance.
- Please ensure that the workshop space is 100% private and free from any visitors or observers. This is extremely important for creating a safe space for artistic experimentation.

Lighting

We can't stress the importance of lighting enough as a means to deinstitutionalize a space. It is key to creating an intimate "performative" atmosphere during the exercises and definitely needs to be well thought out. Ideally, the space should have multiple dimmable lighting fixtures that can be directly operated from the floor of the space by the workshop leader or a technician at hand. If theater lights are being used, the lighting board should be located in the workshop space and not in a separate lighting booth, as changing the lighting looks and playing with colored gels should happen quickly and easily. Gallery track lights are also fine as long as they aren't all "white." Fluorescent overhead lighting, as found in many institutions, is unworkable. This kind of lighting kills any atmosphere and magic, drains the energy from the room, and is not at all versatile. On occasions when this is the only lighting in the space, we have solved this predicament by bringing in clip lights and freestanding lamps and even using household dimmers. These portable sources can be manipulated by the participants themselves and repositioned to create the desired effect.

Ideally, for the first day of the workshop, we suggest a general lighting wash that covers the whole space and some "specials" for dramatic effect. The lighting instruments will be refocused or moved around by group members on a daily basis. To have a technician available is always desirable.

FIGURE 5.2 Illegal Border-Crosser Guards at the Southern Border
Photographer: Herani Enríquez Hache
Performers: Micha Espinosa and Norma Flores
Mérida, Yucatán, Mexico, 2016

In short, this is what you need as lighting requirements:

- Ideally, the space should have multiple dimmable lighting fixtures operated from the floor. Keep in mind that lighting is key to creating a "performative" atmosphere.
- If theater lights are being used, the lighting board should be located in the workshop space.
- Include some colored gels to play with texture and color.

- Fluorescent overhead lighting, as found in many institutions, is unworkable and is not versatile. When this is the only lighting in the space, we can solve it by bringing in at least ten clip lights and four freestanding lamps connected to household dimmers.
- If there is a lot of natural light in the space, blackout drapes are ideal to control the natural light levels. Also, you can cover the windows with paper or cardboard.

Sound equipment and live music

The space needs a good-quality sound system with a mixer that connects to your computer or music/playlist device. It is essential that playback and volume can be controlled from the workshop floor. At least two good-quality speakers should be available. A microphone (to allow individuals to experiment with voice) is also important.

With the exception of certain exercises that demand complete silence, there will always be music playing during the workshop. Music performs multiple functions in this context. Besides creating interesting mindscapes and "charging" performance imagery with culturally specific content, music can also help to enhance or alter the moods and sentiments of the creative process.

The music that we have found particularly effective is an eclectic fusion of drum and bass from different cultures, electronica, period rock and roll, rock en-español, hip-hop, neo-cabaret and classical, Latin lounge, and others. We invite you to create and play with your own playlists. Just make sure to check that your music choice will enhance the objectives of each exercise. In Pocha, sometimes we stick with one genre for a whole day; other times we mix it up to create abrupt mood and content changes. Participants are encouraged to bring their favorite mixes and playlists to feed this combination of styles.

Occasionally, we've had electronic composers, deejays, laptop rockers, or classical musicians create a live musical soundscape for us. If a few musicians are on board, we can also use live music during certain exercises, especially during the jamming. Throughout the years we have invited local musicians with accordions, saxophones, percussion instruments, electric guitars, pianos, and/or cellos to accompany certain exercises and jam sessions.

In short, this is what you need as sound requirements:

- A good-quality sound system (two good-quality speakers and an amplifier) with a connection for music devices. Remember that sound/music is an important element of the workshop.
- It is essential that playback and volume can be controlled from the workshop floor.
- A microphone (to allow individuals to experiment with voice).

THE PROP AND COSTUME "POP ARCHEOLOGICAL" STATION

A week before the workshop participants are given a checklist asking them to bring artifacts and costumes that have specific cultural, political, or spiritual meaning to them, items that are strongly connected to their ideas, aesthetics, and complex identities. These

objects tend to belong to their "personal archeology" as they evoke important chapters or moments in their lives.

Some examples would be figurines, talismans, fetish items, masks, wigs, hats, shoes, stilettos, makeup, and pieces of ethnic clothing or fabric. Military, fetish, sports, and iconic ethnic wear from multiple cultures can also be fun to play with. We ask the locals and producers to help us locate construction and gardening tools (pickaxes, shovels, wheelbarrows, hammers, rope, duct tape, caution tape, chains, etc.), which are useful props to incorporate into live image-making exercises.

Items should not be too delicate or precious, and the participants must be willing to share these objects with others during the exercises. When identifying objects and costumes, themes to consider include ethnicity, sexuality, religion, war, pop culture, urban subcultures, tourism, and gender/ethnic bending. These props will become part of the group's "pop archeological bank" and potentially an entire installation for a jam exercise.

If participants don't own that many interesting objects, we suggest that they borrow some from fellow artists or that they go to the usual "performance art supply stores"; these include thrift shops, second-hand stores, souvenir shops in the local ethnic neighborhoods, fetish shops, and hardware stores. This aspect of our requirements for the workshop has been considerably challenged by precarious economies among local artists and the airlines' high fees for extra suitcases for international artists. That is why we try to solve this by asking the entire group to donate some money and buy props and/or tour the site's surrounding areas and collect objects. It is possible to get a unique collection of borrowed, collected, and/or purchased performance props and costumes by applying all these options.

Often the local producer, curator, or teacher coordinating the workshop, along with those artists who live in the area, will have access to larger set pieces or interesting furniture in advance (a dentist's chair, a surgical bed, a coffin, etc.). They can also help us in advance by locating "dangerous-looking props" that out-of-town artists can't travel with, such as replicas of weapons, medical instruments, and prosthetics. The more serious "toys" we have to play with the better.

An area for laying out props and costumes becomes vital. This "station" can be created with three worktables and two clothes racks with hangers, essential for laying out props and costumes. If there are no mirrors on the walls, we will need a full-body portable mirror in this area.

It is essential, when we set up the prop and costume station, that we organize these objects by categories (i.e., all the wigs and hats together, all the shoes, all the weapons, all the sex toys, etc.). Think of an old native Mexican marketplace and how they taxonomize their produce. Think of the prop and costume station as our arsenal of metaphors and symbols to accessorize our performance personas for creative exercises and public interventions.

In short, this is what you need for the prop and costume station:

- All participants are asked to bring props and costumes for the exercises.
- This "station" is essential for laying out props and costumes that participants bring to the sessions. It can be easily created with two or three large worktables.
- Two large worktables for laying out props and costumes.

- At least two clothes racks.
- If there are no mirrors on the walls, we will need two full-body portable mirrors.

PROPS CHECKLIST FOR PARTICIPANTS

All participants must receive this in advance of the workshop.

- Participants should wear black, loose, and/or stretchy clothing that allows freedom of movement.
- Notebook/journal for thoughts, impressions, drawings, and general assignment notes.
- Personal archeology: prior to our arrival participants are encouraged to gather a handful of objects related to their personal mythologies and iconography, including interesting-looking objects, figurines, or ritual artifacts, which are important to your symbolic universe and aesthetics.
- Costumes: ethnic, military, fetish, artist-made, wearable art, fabrics, etc.
- Accessories: wigs, hats, masks, interesting jewelry, shoes, makeup, etc.
- Supplies useful for exercises: rope, tape, etc.
- NOTE: Please do not bring any item that would cause stress to its owner if it were in any way harmed or damaged.

THE HOSPITALITY AND REST STATION

In the Pocha method, it is crucial that we treat our work and our bodies with respect and attention. From the first day onward, as the group will be spending long stretches of time in the same space, there needs to be a "rest" area located somewhere in the workshop space, with a couple of sofas and an adjacent table complete with water, tea, good coffee, and sodas, along with a basic supply of munchies (nuts, power bars, fruit, local snacks, etc.) provided by the producer, the participants, or both. Nothing fancy, but the work is very intense, and this basic courtesy allows the group to work for long periods without leaving the space. This supply should be replenished by the producer with the help of participants each morning before the workshop. Sometimes, certain participants, of their own volition, volunteer to prepare some food for the group. If it falls within the budget or means of local producers and residents, any chance to share home-cooked meals together enhances the sense of community that is vital to our work, and we call it "radical hospitality."

In short, this is what you need for the hospitality station:

- A table, ideally located outside of the room, where tea, coffee, and water are available along with a basic supply of light snacks (fruit, nuts, baked goods, etc.) provided by the producer, by the participants in partial scholarships, or organized by the entire group as a potluck.

- This supply should be replenished with the help of participants each morning before the workshop.

THE DILEMMAS OF HAVING OCCASIONAL VISITORS

Visitors are welcome but their visits must be planned. When researchers studying our method wish to attend, we encourage them to take part in the entire workshop in order to gain a more integral understanding of our pedagogy.

If theorists, journalists, filmmakers, or other performance colleagues wish to pay us a one-day visit, this is fine, but only after the group has established itself, and become comfortable with one another and the material. This often happens after the third day.

We try to have open spaces in the workshop where invited guests and visitors may be present. Why? Constantly shifting the gaze between action, contemplation, and reflection is an intrinsic part of La Pocha's methodology. The occasional presence of outsiders in the space can have a positive impact. The foreign energy of an occasional visitor forces participants to expect critical responses and to avoid thinking of our temporary community as a precious or privileged "secret society." If the workshop lasts for five or eight days or more, we encourage a creative session open to the local arts communities and friends of the participants at the end of the process.

Unannounced visits are a different subject. Because of the nature of the work, we never allow people to show up unannounced to observe for a few hours, regardless of their artistic or celebrity status. This is not beneficial to either the visitor or the group and can be disruptive to all involved.

In short, this is what you need to deal with visitors:

- Privacy is extremely important for creating a safe space for artistic experimentation.
- Please ensure that the workshop space is 100% private and free from any visitors or observers.
- You can allow visits in the third day, and during the last two hours of the session, but make sure that the visitors have previously been introduced to the group.
- Seek group consensus when inviting visitors.
- Never allow people to show up unannounced to observe.
- You can organize a creative session open to the local arts communities and friends of the participants at the end of the workshop.

Notes to workshop participants

FIGURE 6.1 Workshop participants of the Pocha Nostra Winter Intensive School, 2018
Photographer: Herani Enríquez Hache. Courtesy of Pocha Nostra archives
Museo de Arte Contemporáneo, Mexico City, 2018

Pocha Disclaimer 003: We usually provide some notes to the participants during the first session of the first day, after we have all been introduced. The following notes are examples of the ones we have found to be most useful. When starting your own Pocha-inspired workshop, you may wish to give the participants your self-styled version of some of these notes and repeat them as necessary throughout the workshop. They will help participants to remain focused and not get lost in the everything-goes universe of performance.

- **Pocha workshops attract people from multiple communities and nationalities.**

Often the group will be extremely eclectic. It is important to emphasize to the group the challenge of the workshop as a great anthropological experiment. How *do* we find a common ground for up to 26 people, who speak several languages, come from different countries and generations, with various gender identifications and artistic backgrounds? How do we cross these borders with caution, sensitivity, and valor?

- **Pocha workshops are wonderfully intense and bizarre.**

Although we assume that most people are familiar with the work, every now and then a participant can be a bit shocked by the explicit nature of images generated during the workshop. Although we never demand that the live images generated in a workshop be extreme, nude, or violent, participants often make these choices on their own volition, and we are not there to censor but rather to help them evolve in these choices. Please refer to our "Suggestions to consider if you decide to use nudity, including in a public performance intervention" on p. 35.

Any discomfort regarding the images that emerge organically out of the workshop exercises must be discussed straight away with one of the instructors and if appropriate with the group as a whole. Certain vulnerabilities will inevitably surface at some point during the workshop. The participants should push themselves to confront these limitations – but remember that you always have the ability to opt out of an exercise without judgment if you think it is not your time to cross that border. Perhaps the following day you might feel stronger to do so. We see that, as the level of trust in the group increases, participants become willing to take risks.

- **Pocha workshops foster punctuality and commitment.**

We encourage participants to commit to arriving consistently and on time to all sessions. Unfortunately, some people still see performance art as a recreational activity (some time off "real work" and a space where they can "go wild") and don't see anything wrong with showing up late, leaving one or two hours early, or not showing up at all for the day. We are extremely polite and accessible, but we cannot tolerate this kind of dilettantism during our process. The field of performance art is already characterized by the theater and dance worlds as a territory that welcomes all slackers, dilettantes, "bad actors," and differently-bodied dancers, and we are sad when workshop participants demonstrate that they might have a point. Resolve not to be that person.

Often, artists who are eager to be part of the workshop have other commitments that require them to miss entire sessions or significant portions of the day. What they don't realize is that this is detrimental to the process and destroys the community spirit and trust we are all trying to build. Fostering punctuality and commitment helps develop a strong sense of group responsibility and trust. There is nothing potentially more dangerous than to go on a performance adventure with a group of people one does not trust. Anyone not able to commit fully should rethink their ability to participate.

• **Pocha workshops stress the importance of egalitarianism and autonomy.**

Division of labor in performance (as opposed to theater or dance) can be addressed on the first day. Please refer to "Cities of the Apocalypse" on p. 217. We seek egalitarian and multi-tasking models of production as opposed to hierarchical production processes. Pocha can provide participants with some conceptual parameters and useful strategies, but we are not here to "direct" them. Rather, we allow participants to assume responsibility for themselves and find their own place within the world we are all creating together. The way this responsibility expresses itself in the quotidian realm is by making sure we all participate in the daily ritual preparation of the space, the careful maintenance of props and costumes, and the cleaning of the space at the end of the workday. And, as the workshop progresses, we often ask certain seasoned members to take over the leadership role for an hour or so and share performance and literary exercises of their own that they find pertinent to this process. We all learn from one another. The ultimate objective in this territory is that each participant develops their own methodology.

• **Pocha workshops combine humor and discipline.**

Participants need to understand that, although the workshop is an enjoyable experience and humor is a vital element in our work, they must also take the work and the process seriously. We walk a fine line between irreverence and discipline. We laugh a lot, but are extremely focused.

• **Pocha workshops are neither therapy nor a form of alternative healing.**

Although we understand that participants have personal problems outside of the performance space, we ask that complete focus be given to the issues and exercises at hand. Our exercises allow individuals to confront certain artistic, cultural, ethical, or political issues, but sensitive personal problems should be left outside the room. If a participant has a serious personal problem (i.e., a sudden illness or death in the family, or a recent painful breakup, or a philosophical meltdown) that occurs prior to the workshop, we strongly suggest that the person prioritize self-care, and take the Pocha workshop on a different occasion. Pocha is here to help people cross new borders and fully embrace their practice, but we have a commitment to the integrity of the group and all of its members, and are not staffed or trained to accommodate one person whose emotionality puts the integrity and cohesion of the rest of the workshop at risk.

If a participant discovers in the middle of the workshop that their emotional well-being is at risk, we encourage them to stay and simply be present without having to partake in the exercises, and/or help us in other important territories (deejaying music, caretaking of props and costumes, photographing certain images, resetting the prop and costume station, etc.).

• **Pocha workshops are physically strenuous.**

The Pocha methodology involves a physical practice. We encourage participants with various physical abilities to participate, but it is important to know that the workshop

will challenge the participant's body in ways to which they are not accustomed. Because of this, participants have the responsibility to inform their partners or the group as a whole of any relevant physical condition that is not visibly obvious (e.g., a knee, neck, or shoulder injury). Participants should push themselves, but not to a point that is beyond their physical ability. Saying "no" is *always* an option.

Inevitably, after the third day, members of the group may begin to get tired. The instructors must remind them of certain tips to help them regain energy: staying well hydrated by drinking water, and practicing deep breathing helps a great deal. Try to sleep at least seven hours a day. A more hard-core tip consists of taking a long, cold shower – if the space has a shower available, take a cold shower during a break. If the physical practice becomes overwhelming on a given day, participants can still be present and perform other roles in the workshop, e.g., the role of deejay or documenter for a day, caretaker of the prop and costume station, or they can take a break and observe for a while and write notes in their diaries, or provide a meal for the community. What we try to avoid is people disappearing for hours and not informing us. This takes a toll on the community cohesion: radical trust breeds radical trust!

- **Pocha workshops are live performance sketchbooks.**

We stress the significance of participants keeping a diary of their thoughts, notes outlining useful exercises that might be integrated into their own practice, and, most importantly, a record of the most interesting images and ritual actions they discover during the process. They should find a way to clearly record or "score" some of the surprising material that emerges during the sessions. This documentation can be in note form and/or through drawings. It is very likely that versions of some of these images and actions will find their way into a final performance or into their own future projects. Later on in the workshop we will introduce the use of cameras, iPhones, and audio recorders as scoring devices.

- **Pocha workshops foster collaborative creations and shared authorship.**

The Pocha workshop is not a product-based workshop for artists to create individual work. All of the exercises and images generated during the workshop are group collaborations. There is no individual "ownership" of material developed during the workshop. All of the images generated within the workshop, whether live, photographed, or on video, are equally owned by everyone involved and may be borrowed, shared, exchanged, and reshaped during the process. All developed material is available to all participants to incorporate into their own work after the workshop.

- **Pocha workshops engage actively in the politics of documentation.**

A discussion about the importance of and risks accompanying photographic and video documentation should be introduced during the workshop, especially in a time in which every citizen with a cellphone has become a paparazzo of ordinary life.

This open discussion usually takes place on the third day of the process, and, if everyone agrees, we will introduce documentation devices on day four. Normally the consensus of the group dictates that no image should circulate without the authorization of the performers involved in the image, especially when it involves nudity or delicate political themes. Let's remember that every participant faces different vulnerabilities outside the workshop space, for example one participant might not have any issue with being documented in hard-core images, but he or she might want not to post those images in social media because they might be fired from work or because this would create serious issues with their families or partners. We all have to be very sensitive about all this. Remember, this is a live art workshop and focus on documentation should not overtake this aim.

Crucial questions to discuss are:

- What does it mean to bring a digital camera into the process?
- How should we incorporate documentation into the process in such a way that it does not affect people's concentration?
- Should everything we do be documented, or only the visual results of the image-building exercises?
- What are we going to do with this documentation – merely revise it as a visual diary when developing images for a final jam or perhaps create a mini-documentary of the entire process?
- If people wish to use some of the photos on their own social media networks and apps, should they do it with the consent of those involved in the photos?
- Who is going to be responsible of collecting the images? How?
- Who does not want to be photographed at all?

Each group has their own level of interest about documentation; some don't care and others care too much. Pocha generally puts forward a simple but effective system. The first recommendation is not to take a photo without asking for consent; the second is not to post in social media without asking for permission from the people who appear in the image. Consider not taking photos of those who do not want to be documented at all. Ask for a volunteer to gather all the photos in a hard drive, on a computer, or in a private and closed group online for all participants to check the images. In this process, each participant has the right to delete any images from the archive. Sometimes, it is tough to see powerful images disappear, but we need to respect the motivations of each person to allow, or not allow, an image to be distributed. After this process, we strongly recommend not uploading images without giving them a thematic, place, and activity reference. If possible, give to the images a title that creates a contextual relationship with the viewer. This is a very effective way of politicizing an image and avoiding trouble with comments from viewers who don't understand the workshop process.

LPN asks their audience to think about our desires. What is it about the erotics of pleasure, the mechanics of power, the technologies of control that are so arousing? How do our desires for racial and sexual fetishization manifest into the perverse

> *logics of conning stereotypes and hegemonic force? How can we slow down that process to ask: what if we can sculpt our desires towards more liberating rather than oppressive actions? What is the function of desire? There is no question that, for LPN, the line between laughter and weeping, whispers and shouts is very thin. The performance event is meant to suspend the time between the act of looking and the act of responding, in order for those of us looking to think about how we will react and why.*
> (Sampada Aranke, art history professor and performance studies theorist)

- **Pocha workshops often extend into the social life of the group.**

It is important for participants to "connect" in a more informal way. We encourage participants to take advantage of the privilege of spending a period of quality time with like-minded rebels and peers. We encourage them to have meals together, take long walks together and explore the host city, engage in lively discussions about art and politics, and party together. We encourage the group to hang out with us after hours at an exciting local bar. Some of the most interesting ideas and reflections on the work emerge from these informal gatherings, and the juiciest political, artistic, and personal discussions tend to take place at the bar or in an old-school café. That's when people really open up and engage in sensitive discussions regarding personal borders. The café/bar dialogues in this way become a continuation of the workshop.

If the workshop is long enough, we try to organize a couple of parties and pachangas at the homes of local artists or curators so we can all go crazy and dance until we drop! Sometimes, these Pocha social gatherings become exciting performance salons where participants are able to create impromptu performances or to informally share their work with one another and the local artistic community.

- **Pocha workshops involve a critical component.**

We try to set aside time, at the end of some working sessions, to theoretically analyze the creative process. This may happen some days at the space and other days at a bar or café. It is during these reflective sessions that we can openly discuss the project's aesthetic currency, its cultural impact, and the political pertinence of the live images generated by the workshop.

It is also important that both participants and instructors are given space to voice their thoughts and concerns about the sensitive nature of the material developed during certain exercises. Issues of political, racial, or gender tension and possible solutions will differ from group to group, and open dialogue is essential. These discussions should be brief and light, otherwise the workshop runs the risk of becoming an AA (Artists Anonymous) meeting or a heavy theoretical discussion. In the Pocha universe, tensions and crisis often get resolved by making live art and not in panel discussions.

- **A note regarding mind-altering substances.**

We are extremely respectful of people's personal vices and secret rituals. But we encourage participants to refrain from using drugs or hard-core alcohol during the actual exercises, especially during daytime. If they choose to do so, we try to be tolerant, but it puts the entire community at risk. If they are simply too stoned or drunk to partake in the exercises, we will discreetly get them a cab and send them home to rest. The workshop itself provides a natural high, and there will be plenty of post-workshop playtime. There is no reason our time together should be derailed by individual disruption.

Radical pedagogy for a post-democratic society
A pedagogical introduction

Saúl García-López aka La Saula

FROM THE BORDERS OF MY IDENTITY TO THE COMMUNITY OF REBEL ARTISTS ...

Music in the background ... *Britney Spears* ... *Baby One More Time (electro-mariachi version, of course).*

Here begins the live streaming of the one they call ... Saúl García-López, Soul, Sol, Sal, LA SAULA ...

In Mexico City, I was a "chacal," a pejorative word for urban working-class indigenous guys from the ghetto.

Intellectual work? ... ¡no mames guey!

Bullied for seven long years at school because of my hazy gender orientation: not man, not woman. Sexually abused and surviving, I am standing and standing strong.

In Australia, I was the Aztec prince! the hyper exxx-hot-isized Mexican.

In 2012 SAULA becomes core member of La Pocha Nostra. In 2015 GARCÍA-LÓPEZ becomes Artistic Co-Director of La Pocha Nostra.

Queer and three-spirited post-NAFTA chupacabras against the Trumpocalypse and the nightmares of globalization.

From the territories of the sex industry trapped in colonial exotic desires to a decolonial performance sexworker, positive sex advocate, and proud ecosexual land mine.

La práctica de la locura simbólica (performance) nos lleva a la sabiduría y a entender las contradicciones sociales extremas.

I speak Aussie-Joburg-Glaswegian-Torontonian-Chilango-Chicano Spanglish and the slang of la locura.

In post-apartheid South Africa marked by a black and white binary, the Mestizo Latino became the odd and unrecognizable object.

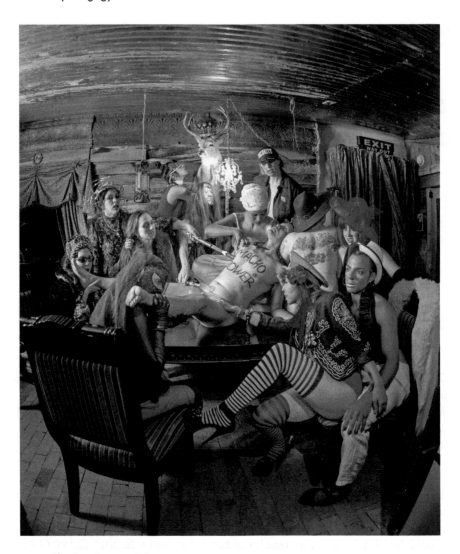

FIGURE 7.1 The Last Supper 2.0
Photographer: Heather Sparrow
Performers: La Saula, Balitrónica, Emilie Arroyo, Leni Hester, Jessamyn Lovel, LROD, Freyr Marie, Shana Robbins, Lola Amar, Heather Gray, Clare O'Brien, Nikesha Breeze, Salman Hanuman
Pocha Nostra Photo Performance, Santa Fe, New Mexico, 2018

El "mariachi-zombie de Culiacán," nude con una penca de maguey en el pito y un gran sombrero de mariachi against the organized crime in Mexico.

Auto-exiled from Mexico, lonely immigrant, post-national-post-Mexican and reverse wet-back activist coming from the far north.

In Canada, I was the Latino/a exotica ingredient of the multicultural soup. Canadian-Mexican-Canadian-Latino-Canadian-Spanish, Filipino, Indian (from India) and for some even British WTF!!!?????

I practice sexo performático anónimo, role-playing with unknown people in unthinkable places … like hip galleries and governmental museums.

In the UK, I was the Mexican wearing the wrong skin color … I was not the white, rich Mexican shopping in Gay Soho or having afternoon tea and cucumber sandwiches with Chipotle Mayo at the Ritz hotel.

A Vato Loco that decompresses with margarita in hand in mental institutions. Bipolar crises 1.0 Mexico, 2.0 South Africa, 3.0 SA, 4.0 SA longest stay in a psychiatric hospital, 5.0 Scotland, 6.1 Canada, 6.1.2 USA-SF, 6.1.3 and 6.1.4 Canada and counting …

ChiCA-Nadian, Chica-no, Chica-si, Mexquimo, OxfordVato, polite-Mexican, Polite-Chicano.

When I go back to Mexico City, I am Colombian, Puerto Rican, Cuban, Chicano, or Peruvian, but not Mexican anymore!

Listen … Cambio … I climb into performance as a vehicle to cross my borders and test new fronteras, performance as a seductive and sensual power, as colonial exorcism, as symbolic cannibalism for identity reincarnation.

My identity, just as yours, continues to be a work in progress. I have been an object for the enjoyment of the "white" cultural consumerism of the Latino/a. My cultural DNA – mestizaje – has sometimes rendered me invisible. I have had fake identities, I have been welcomed with a "high and mighty" postcolonial apologetic undertone that overrode the specificities of my origins and made me part of "the postcolonial universal human." I was able to be cast as a Scottish Man as product of the "benefits" of "blind casting," deleting my own identity. In the Americas and specifically in Canada, I became … kind of Mexican, kind of Latino, kind of many other cultures, and by visiting so many international bohemian pubs, I stopped drinking only Tequila and learned to drink good Scotch! Ajua!

Just like many of our alumni, my artistic work was radically transformed after taking my first Pocha Nostra workshop in 2010. I had the unique opportunity to be a workshop participant in two summer intensives, then three workshops as a pedagogical coyote, activating exercises as a workshop participant propelling key pedagogical aims (mentored by the incredible Michèle Ceballos). I became a core member of Pocha in 2013, when I started to apply the pedagogy. Thanks to these experiences, I have been able to establish a connective axis that brings new alignment to my complex identity, ambiguous accent, gender fluidity, and the historical, physical, and imaginary markers of my body. I gathered powerful tools to dislocate stereotypes and to conceive and forge my personal, ongoing process of decolonization. The catalyst that brought all this to the forefront of my consciousness was performance art, and the radical pedagogy of La Pocha Nostra.

Now, I am here paving my way back to the South, and my journey has been multidirectional, coming and going from west to east, south to north, the Americas to Australia, Africa to Europe, Europe to Canada, and the USA to Mexico. I have been infused by the colonial forces of the Americas and the Commonwealth. I head south to the USA, to the land of ongoing resistance. The Chicanx community has welcomed me with open arms, this unconventional CHICAnx, sometimes eccentric and at other times too shy.

My generation, the generation that is reflected in my work with Pocha, is one of crisis and collapse. Fighting fears of becoming the detritus of the baby boomers, I am sandwiched between the false political hopes of the late 1990s, the end of the belief that politicians will save us, the collapse of old political structures that mark the beginning of

the end of democracy, and the rise of corporate totalitarianism. I am the last front line of the X Generation and the oldest Millennial. I grew up between the hope of the tech revolution and its monopolization by corporations. I turned clumsy in face-to-face negotiations in public places for a date or a sexual partner or client, and had to learn to use my virtual body in date sites and hook-up apps. From my vantage point in the west, I am a witness to the social chirurgical procedure of the demonization of the east and south. But, in this post-democratic time, where political figures are products of a reality show, I hold the hope that this book may serve as a guide that opens alternative paths and territories of resistance.

Thanks to the Mad Mex (Gómez-Peña), La Pocha Nostra's pedagogical and creative world was presented to me. I have been exploring this bizarre, intense, and loco planet for the last nine years. With Gómez-Peña's mentorship, I have had the opportunity to continue Pocha's pedagogical jams, and to experiment, analyze, test, and create new exercises and expand old ones. I feel so humble to have done this with the help, wisdom and support of my beloved colleagues Balitrónica, Michèle Ceballos Michot, Emma Tramposch, and other founders and former Pocha members.

During recent years, Pocha has crossed new borders, opened new possibilities for transformation, and changed shape to constitute a new Pocha identity. It's my hope that, in our present handbook, the Pocha radical pedagogy may liberate centrifugal/horizontal/queer visions, and turn hard borders into open fronteras, into flexible and fluid spaces that contest the centripetal/hierarchical/patriarchal punishments that limit the body's potential as a powerful, ancestral, and authentic technology for transformation.

A CHICANO QUANTICAL JOURNEY OF CROSSING AND QUEERING BORDERS AND ENVISIONING NEW FRONTIERS – RADICAL PEDAGOGY EPISODE 2011–2019

During the last years we have witnessed public places usurped by generalized violence and experienced exceptionally participative audiences that are outraged by the routine of environmental disaster, catastrophic trauma, far-right politics, and the social shortcomings of globalization. Our pedagogy and ARTivism re-emerges out of a purposeful clash between various influences, aesthetics, cultures, iconographies, attitudes, and social media that are specific to the post-globalization era we live in.

The radical pedagogy of La Pocha Nostra emerged locally in the Mexico–US borders, but, during the last ten years, Pocha has developed and nurtured several artistic, collaborative networks. In the text "Soundscapes for dark times …" (Chapter 2 in this book) Gómez-Peña talks about this process and how the troupe core started to expand. The new Pocha core members (including me) challenged the pedagogy, expanding it to new territories, and politicized it further by queering the border.

As a consequence, our pedagogy more than ever stands against traditional models of performance training that follow pyramidal models of teaching. Pocha offers a teaching model that is dialogical, and the role of the famous instructor who holds special knowledge is constantly contested. How do we negotiate the intersections between Guillermo Gómez-Peña as a "celebrity" figure, Pocha as a troupe, core members with specific pedagogical

approaches, and the creative experience of each one of the workshop participants? We advocate for both sides, the pedagogue and the participant, to meet at ground level. The participant must talk back and speak up every time something is not clear, or every time a delicate issue emerges: the pedagogue and participant are co-conspirators in situ within the pedagogical adventure.

The Occupy movement, the *indignados*, the Arab Spring, Athens on fire, the movement against violence in Mexico, #MeToo, Black Lives Matter, and indigenous movements like Idle No More and those that resist the construction of oil pipelines – all these citizen initiatives challenged our notions of performance and the new relationships between our bodies, environment, our pedagogy, the politics of gender, and arts activism. We noticed that our varied pool of exercises shaped up differently each year in order to dance along with the needs of each group, the institutions involved, and the macabre relationship between different modern art institutions and university spaces, and also to respond to what is happening just outside the door of our workshop space or across a more distant, yet equally present border. The intimate borders people choose to cross or the aesthetic and political slant they imprint on the work became the crux of our time together. This hybrid re-assemblage has become our eloquent state that influences our pedagogy and artistic practice.

We engaged in a multilevel, poly-linguistic type of pedagogy in which we were constantly shifting and sampling roles, languages, and leadership and mixing exercises in ever-evolving ways. Sometimes we collapsed vertical, hierarchical models of teaching into what felt like pedagogical jam sessions. We learned to be more precise than ever in our instructions. While our beginnings represented a total loco clash of teaching influences and a struggle to stay attentive to each participant's vulnerability, ego, and aesthetics (like a very bad rave party in the middle of Copacabana beach), we eventually learned to fine-tune the pulse and needle skip.

We learned that, when pedagogical instructions are given in three languages, the number one rule of a translation in situ is that it has to be shorter than the actual command. We understood that not translating pedagogical instructions was sometimes okay because it forced the students to be more vigilant about sparking their performance intelligence. Instructions or observations needed to be carefully translated in order to be understood by all. Here is a concrete example: Balitrónica would give the practical exercise directions, I would focus on the outcomes of the exercise by sharing my experience, Michèle Ceballos would join the exercise and activate it from within as a pedagogical coyote, and Gómez-Peña would give the historical context and objectives. All would be watching the tempo of the group, which informs the score of exercises that should be played next, just like a pedagogical deejay. Pure rock and roll and electronic cumbia!

We often used simple exercises borrowed from different training traditions, but, by cutting and pasting different ones, subverting and bastardizing them in various ways, and redirecting the exercises' aims to our bodies and social context, we created conceptual shifts and reached complexities beyond performance training. We became more acute in *pochifying* exercises, resulting in new expansions such as Lowrider Chicano Biomechanics.

We realized we needed to keep innovating and adapting exercises to incorporate text in a non-parliamentary fashion, avoiding illustrative dialogue in a theatrical sense as much as possible. We had to openly experiment with text as environment, meta-fiction, and prop – with text embodied in the live image and directly written, or drawn

on the skin. We had to think of the body as a canvas, as a mural wall or an open book, and *The Illustrated Body*, our quintessential Pocha exercise from the 2000s, reached new dimensions as a result.

In our political ethos of building transnational communities of rebel artists in our workshops, we always try to include ten "nationals" with a partial or full scholarship, and ten "internationals" from the so-called First World, who pay a comprehensive tuition fee. But during the last six years, due to the sinking global economy, the international participants came from countries like Colombia, Chile, Brazil, and other struggling economies. Most of the "nationals" could only cover the fee in *tequio* – in exchange for favors. We are constantly devising new ways of inclusion and production. Financial sustainability: one of our biggest challenges! Please refer to the text "Cities of the 'apocalypse'" on p. 217 to learn more about this topic and how Pocha produces self-sustainable workshops.

We also placed more emphasis on public interventions in autonomous zones, in places struggling with the government, or in buildings with conflicted political and labor histories. The actual workshop site had evolved into a headquarters for us to plot our public interventions that hope to renegotiate the meaning of many highly charged buildings and public spaces.

The desire of the workshop participants to test the pedagogy in public places stressed the political implications of the exercises, enhancing the performance actions and courage of the students. These interventions also emphasized the transformational process of individual and group aesthetic choices and the relationship of the human body to the architecture – the actual space – and the public.

The wish to use performance to intervene and exchange with the local community also triggered some very interesting conversations within the troupe, especially due to the various sociopolitical backgrounds of the participants. At one point, in discussing the possibility of making work in public spaces, a crucial issue came up: performance actions have very different impact and consequences in different cultural and social contexts. Clashes with local authorities can also produce very different consequences for the individuals involved, because of the specific social markers that carry ethnicity and nationality. The consequences for Mexican artists of doing demonstrations in the streets of Oaxaca or San Francisco are different from those of American or European artists. While some might end up in jail or deported, others might not suffer serious legal consequences. Refer to "Making the most of your beautiful arrest," p. 223, "The unnoticed city: Urban radical interventions against invisible bodies," p. 225 , and "Metaphysical musings and empirical explorations: Turning the body visible in the city," p. 227.

Very recently, due to our challenging political times, we have encountered communities in deep despair, and workshop participants looking for creative and spiritual refuge. We encounter trauma at the individual and collective levels. This is posing new challenges in our pedagogy, and we are learning how to creatively canalize trauma in our exercises and pedagogical work. A new territory where collective and individual rituals, shamanism, psicomagia, and radical spirituality serve as creative catalyzers to exorcise trauma is rapidly unfolding. I particularly have been influenced by this, as trauma serves as an important reference point to talk about my experience of learning and teaching the pedagogy. Please refer to our "Candid conversation amongst La Pocha Nostra members ..." on page 201 to

learn more about this topic, and how we deal with some of the most critical challenges that the troupe faces in current times.

Borders are material expressions of imposed limits. They are real, dangerous, change place over time, and seem to disappear when the collective desire for freedom overpowers them. This is the place that this pedagogy inhabits. This is why our pedagogy endures over time, because we acknowledge the trauma borders impose, and work fiercely to liberate the imagination needed to allow us to dismantle them. By queering repressive and imposed limits, we embrace the possibility of imagining a new territory, a new frontier beyond all fixed, problematic, and dangerous borders.

I imagine a Pocha world that expands and becomes the planetary system called Pocha (refer to the text by Paloma Martinez-Cruz "'Pochology' in a post-democratic society," Chapter 1 in this book). This dream can happen only alongside all those who live in the galaxy, with the help of our allies and our beloved and well-respected community of rebel artists around the world. Performance art is our intergalactic live technology.

In sum, this is a quantic anthropological pedagogy, in which polynomial social circumstances embedded in always-evolving social conditions and site-specific variables inform every workshop we teach. It is in this territory of the challenge, this anti-binary, queer, and ongoing re-negotiation of the self that we uncover our clumsy democracy. This live matrix of radical intimacy lets us reach beyond our geopolitical and self-induced borders.

> *As a border crosser and pedagogical coyote, I have a certain body of performance experience that I share in the role of facilitator, but there is also so much I need to learn. From each participant I grow and evolve, which can happen only when we encourage participants to feel comfortable talking back and questioning how they can make what we offer their own. I experience the role of the coyote as a way to facilitate crossing a border: a border they themselves have chosen to cross, such as using their body kinetically when they usually aren't physical. If I join in the exercise, this can help them relax and feel more empowered. They also loosen up and are more creative risk takers when they don't have a traditional teacher–student dynamic. We don't supply a formula that they then have to memorize and recite back to us. They are equal players in the Pocha world.*
>
> *(Michèle Ceballos Michot)*

THE FORMAT OF OUR PEDAGOGICAL EXERCISES

Each exercise is presented in the following format: title, pedagogical range, length of time, level, and practical considerations. We then explain the "CONTEXT AND OBJECTIVES" of the exercise. In the "FACILITATION" section, we focus on specific considerations for the pedagogue or pedagogical DJ (deejay). In the section "PROCESS," you will find the steps and instructions to implement the exercise. Finally, in "EXPANSION," we offer exercise variations for further development.

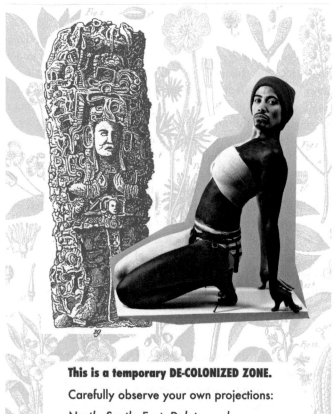

This is a temporary **DE-COLONIZED ZONE.**

Carefully observe your own projections:

North, South, East, Delete, en loop...

This is a temporary DE-COLONIZED ZONE. Carefully observe

your own projections: *North, South, East, Delete, en loop...*

FIGURE 7.2 De-colonized Zone
Illustration: Perry Vasquez
California, 2019

As a fellow workshop alum, my first-person voice joins you on the page in the "CONTEXT AND OBJECTIVES" section ("La Saula") to provide notes from the field from my own life of Pocha risk taking and exploration. I hope that my interventions stir up ideas of your own, because I believe that something new can emerge through the meeting of our stories, which is the goal of our aesthetics and politics of multi-vocality at La Pocha.

The exercises are presented with some images[1] that indicate their "pedagogical range":

 Coyote. Ice-breaker style exercises accompanied by this symbol indicate that they are easily adapted by non-performers to build trust in a given community and activate the basic building blocks of radical listening. The coyote is a border crosser and a trickster who overturns conventions and erases all kinds of geopolitical, cultural, spiritual, gendered, and racial borders and hierarchical structures.

 Infinite Alien. A range of physical engagement with the other inhabitants and architectures of the space–time continuum, appropriate for practitioners familiar with a formalized body practice such as dance, theater, martial arts, and live art. Infinite Alien begins to reconnect with the body's infinite possibilities and is powered by voracious curiosity tempered by awareness of individual aptitudes and abilities.

 Cucaracha. Higher-risk style exercises accompanied by this symbol indicate that we reserve these for hard-core performers and activists who are comfortable with a range of physical engagements and spatial vulnerabilities and are accomplished interdisciplinary border crossers. The cockroach is excited by experiments in radical positionality that use the body as a living metaphor. The name cockroach was inspired by the iconic Chicano novel *The Revolt of the Cockroach People* by Oscar Zeta Acosta.

I strongly suggest reading the manuscripts from Chapter 9 to complement our exercises with further pedagogical advice and insights by Pocha Nostra and our invited collaborators. In Chapter 10 you will find examples of pedagogical, multi-vocal writing jams inspired by the Pocha method. The texts in those two sections are clear examples of the engineering that inspired the creation of this book.

OUR TEACHING APPROACH

The Pocha exercises are useful not only for performance artists but also for theater artists, dancers, spoken-word poets, installation artists, photographers, filmmakers, activists, and educators. Anyone willing to confront the borders of their identity and interested in incorporating the human body as an integral part of their artwork can benefit from this practice.

Pocha's methodology is eclectic. The sessions include different forms of dance techniques, hard-core aerobic sequences combined with Mex-ercises, and simple breathing exercises borrowed from dance, theater, yoga, martial arts traditions, Butoh, aerobics, shamanism, tensegrity (Carlos Castaneda's Magical Passes), and induced laughter.

Basic warm-up and stretching exercises serve the purpose of "preparing" the body for the rigorous physical workshop ahead, and our perceptual exercises are intended to help workshop participants to re-engage with their bodies and develop a strong sense of community, collaboration, and site awareness.

As part of the preparations, we ask participants to bring personal objects, costumes, and unique artifacts. Objects are a crucial part of the process, and the participants should anticipate the care with which they should relate to them. These shamanic artifacts carry personal and collective memory; they serve as secret passwords to gain admission to a border territory, a psychomagic realm where our identity is continuously reinvented.

Discussion and reflection are an important part of any collaborative or pedagogical practice. Throughout the exercises outlined in this book we encourage you to incorporate physical breathing spaces so that participants can write their reflections in journals, and exchange impressions and moments of discovery with their partners. We encourage you to keep these moments of reflection somewhat brief to avoid the kind of intellectualizing that disrupts embodied knowledge. Silence during the exercises is also a good ally that helps us to redirect our attention to the body, avoiding having to make decisions only with our mind; at the same time, it forces us to look around at others to learn and get inspired by what other participants do.

Group discussions also require caution. If they aren't brokered carefully, they can paralyze a process, sapping the energy from creative work in favor of purely intellectual discourse. They can also destroy the magic of an exercise and make people unnecessarily cautious in future exercises. The urge to have long discussions sometimes masks the foreseeable fear of entering the unfamiliar territory of physical and intuitive creation.

Tensions are bound to occur, especially those connected to race, culture, gender, age, and ideology. We encourage people to accept them as inevitable, to find surprising responses, and to create artwork inspired by these issues instead of suppressing them or pretending they don't exist. But sometimes it's not enough and a good discussion is necessary.

We have incorporated the exercises and strategies that we have found useful for dealing with delicate issues in a non-confrontational manner, and bringing these issues into the flow of the methodology. We also try to take the discussion to the less formal (and often more revealing) context of a bar or café. The ritual of eating and drinking together enriches both the discussions and the overall rapport of the group.

The facilitator/s of the exercises should feel free to *pochify* (adapt) our descriptive pedagogical language to their own voice and teaching style. We wish to blur the lines between instructor and participant as much as possible, but the more complex exercises require an outside eye and therefore someone must take on the role of the pedagogical DJ or facilitator. This could be any member of the group, as long as they have read the background information and understand the purpose of the exercise. Remember that teaching is also performing. As pedagogical deejay, we have to be fully aware about how much we can give of our own energy, and each deejay will have their own personal rituals to decompress.

Pocha Nostra is fiercely committed to the celebration of the complexities of race, class, gender, physical ability, age, linguistic inclusion, body training, and other circumstances impacting the embodied production of meaning. As such, there is no normative body for which the following exercises are intended. We encourage any and all modifications of our instructions in the service of radical inclusivity of all bodies and

abilities, and to further the practices of radical tenderness and uncompromising safety in all ways possible.

Workshops can range in duration from a one-day master class or a three-day intensive, to a split process divided into several weeks or an entire semester. A Pocha workshop "intensive" is an immersive process that lasts for five to ten days. We normally divide the day into two work sessions, each lasting approximately three hours. The first session includes a combination of the physical, perceptual, poetic, and conceptual exercises (from Sections 1 and 2). Then we have a one-hour break for people to have lunch, freshen up, and make journal entries. The second session normally involves creative exercises to develop material (Sections 3, 4, and 5).

Although the "creative exercises" and the "jam sessions" with a pedagogical range "Cucaracha" are often the most fun and most useful when developing new material, we suggest that you concentrate on the more foundational and intermediate exercises outlined in Sections 1 and 2 with a pedagogical range "Coyote" and "Infinite Alien" for at least three days. Through these fundamental exercises, the group develops a collective performance vocabulary, sharpening radical listening and tenderness, and gaining an understanding of each other's skills and energies, elements necessary to enter into the "Cucaracha" pedagogical range. This base is crucial for an effective creative session and essential for keeping the exercises and overall workshop flowing.

In this book, you will find eight pedagogical sections that appear to be separate. However, during an actual workshop they are intertwined in an organic manner, constituting a live pedagogical matrix. Remember that this is pedagogy in the open, being constantly adapted in situ. In this pedagogical jam, the exercises follow a natural line of progression from one to the other. Some are repeated daily with variations; others occur only a few times during the entire workshop, and all represent a constant fluxus between the environment, space, artifacts, and the specific make-up of the group of participants.

In 2011 I began working with La Pocha Nostra. The pedagogy gave me tools that were essential in developing my process as an educator, interdisciplinary artist, facilitator, and collaborator. I have integrated Pocha pedagogy into my teaching of choreography, interdisciplinary collaboration, and improvisation at numerous University dance programs as well as internationally in various collaborative contexts. I fondly remember when Guillermo Gómez-Peña dubbed me a "radical choreographer," a blessing for which I am thankful. To be "radically tender" in a daily artistic practice and in collaboration with others creates spaces of respect for each other and is empowering in building self-trust and group trust. La Pocha Nostra creates spaces of liberation, healing, provocation, and transformation. The language of the pedagogy is honed and crafted over time and the exercises and language create a space of inclusivity and radical experimentation. I learned ways of facilitating and practicing radical tenderness, ways of empowering individual voices in a group process, how to encourage students to take risks and push their growing edge in process and performance, how to honor and respect multiple ways

of being in the world, how to support individual voices and the community as a whole, that it is important to question and disrupt hierarchy, never censor anyone but ask questions. Maybe a possible bumper sticker for me could read: #PochaHel pedMeSurviveTheTrumpEra.

(Esther Baker Tarpaga, performance artist, radical choreographer and dancer, pedagogue and theorist)

THE EXERCISES

We're excited to welcome you to the heart of the book: our collection of live art exercises that we have divided into eight sections. The exercises in Section 1 are mostly explained from the point of view of the participant. In Sections 2 to 8, instructions are given mostly as if to a pedagogical deejay or facilitator.

Section 1 "'Hands-on' physical and perceptual exercises" contains physical and/or perceptual exercises to help you:

* reconnect with your bodies
* operate in performance mode
* explore various strategies for collaboration
* sharpen your performance senses
* control and direct your gaze while in performance mode
* develop a collective performance vocabulary

To be clear, performance mode denotes a heightened awareness of present time paired with a sense of total body performativity. These exercises should be undertaken with the same intensity as an actual performance. When we talk about exercises/explorations/interactions being performative, we wish to show that pedestrian movements played out in performance mode take on another level of complexity for both performer and audience.

Even in the few cases where you may be standing still for long periods or moving very minimally, it is important that you learn to gather and control the degree of energy needed to communicate with an audience while essentially "doing nothing." During the course of the workshop, it will become clear when appropriate "active rest" periods can be taken during exercises. You will see as you progress through the methodology that these exercises are, in fact, performances.

Section 2 "Exercises to generate performance material and living images" includes "creative exercises" that help participants develop original performance material and strategies for collaboration.

Section 3 "Conceptual and poetic exercises, opening spaces of inquiry" includes conceptual and poetic exercises to help you hone your analytical and rhetorical skills, and map out new territories of inquiry in a non-academic way. It also contains formats for non-confrontational discussion that we have found useful in dealing with cultural and

institutional divides and tensions that emerge out of racial, gender, social, or generational difference.

Section 4 "The infamous Pocha Nostra 'jam sessions'" describes the Pocha performance sessions that will become the bulk of the creative sessions and put all the previous exercises into practice.

Section 5 "Refining your performance personas" includes exercises to "stylize," refine, "sharp out," activate, embody and develop performance actions for specific personas developed during the workshop.

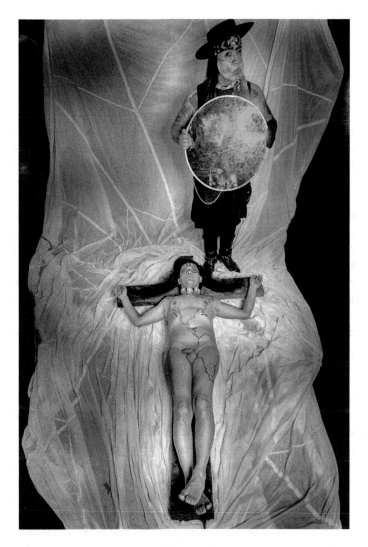

FIGURE 7.3 Las Americas
Photographer: Donatella Parisini
Performers: La Saula and Guillermo Gómez-Peña
Byron Bay, Australia, 2018

Sections 6 "Devising a pedagogical public performance" **and 7** "Producing and 'rehearsing' the final performance" include various methods (devising, producing, and "rehearsing") for bringing the practice to the public in open pedagogical performances and larger-scale presentations.

Section 8 "La Pocha Nostra pedagogical matrix for workshops" includes a day-by-day guide suggesting ways of combining and sampling the exercises to obtain the best possible results from our pedagogical workshops.

I end this introduction with two texts Pocha shares with the workshop participants in the first day of the workshop. They contextualize the pedagogical universe the participants are about to experience.

PRIORITIES AND PRINCIPLES OF THE POCHA NOSTRA WORKSHOP

- **To re-center performance as a survival kit.** We use it every day. All the ways we present ourselves in the world are performance art, and we can shift across invisible, visible, and hyper-visible identities to cross borders. Performance art skills are useful for navigating our individual and community dilemmas and social struggles.
- **To create temporary communities of rebel artists** from different disciplines, physical abilities, ages, ethnic backgrounds, gender persuasions, and nationalities, in which **difference and experimentation are not only accepted but encouraged**.
- **To develop new models for relationships between artists and communities, mentor and apprentice, that are neither colonial nor condescending**.
- **To find new modes of relating to the "exotic other"** in a less-mediated way, bypassing the myriad borders imposed by our professional institutions, our religious and political beliefs, and pop-cultural affiliations. To experience this, even if only for the duration of the workshop, can have a profound impact in the participant's future practice.
- **To discover new ways of relating to our own bodies.** By **decolonizing and re-politicizing our bodies,** they become sites for activism and embodied theory; for memory and reinvention; for pleasure and reconciliation.
- **To raise crucial questions.** Why do we do what we do? Which borders do we wish to cross and why? Which are the hardest borders to cross, both in the workshop and in our personal lives? How do we define our multiple communities, and why do we belong to them? What is the relationship between performance, activism, pedagogy, and our everyday lives? What about the relationship between the physical body and the social body?
- **To make performance art pertinent to** a new generation of potential artivists.

- **To convene people from multiple communities and nationalities.** Often the group will be extremely eclectic. It is important to emphasize to the group the challenge of the workshop as a great anthropological experiment. **How do we find a common ground for up to 20 or so participants,** who speak several languages, come from different countries and generations, with various gender identifications and artistic backgrounds? **How do we cross these borders with both sensitivity and boldness?**
- To explore and foster the practice of **radical tenderness.**
- **To delve into our own wonderfully intense and bizarre imaginaries.** Although we assume that most people are familiar with the Pocha work, every now and then a participant can be a bit shocked by the "explicit" nature of images generated during the workshop. Any discomfort must be discussed straight away with one of the instructors and, if appropriate, with the group as a whole.
- **To meet vulnerabilities as they surface during the workshop.** The participants should push themselves to confront these limitations but remember that they always have the ability to choose to skip the exercise without any judgment.
- **To explore radical autonomy and self-determination as a performance goal.** We seek egalitarian and multi-task models of production as opposed to hierarchical production processes.
- **To combine humor and discipline.** We work between irreverence and order. We laugh a lot, but are extremely focused. **There is nothing potentially more dangerous than to go on a performance adventure with a group of people that one does not trust.** Thus, our playfulness is there to serve the safety of participants, and the integrity of our pedagogical, political, and aesthetic objectives.

Final Recommendations

- **Pocha workshops are physically strenuous.** Take care of your own body. This workshop is mainly conducted through partner work. Please let your partners know if you have a physical injury before the exercise begins, or at any point throughout the activity.
- **Pocha will do most of the speaking during this workshop, so we invite you to take notes in your sketchbooks.** Feel free to join us after the workshops to discuss any philosophical or methodological concerns, issues, or theoretical applications (if you *must*).
- **Politics of documentation:** no photos or voice recordings are allowed, for the comfort of your instructors.
- **Props:** participants will take turns overseeing the creation of installations with the group's personal objects.
- **Dress in black or neutral dark tones**, and wear clothes that allow full physical participation. Plain, black clothing makes for a better live art canvas. No words or logos, please.

- **Take care of your mental and emotional health.** Please let one of us know if you're going through something that you need to talk about. We are here for you!
- **All the exercises are optional,** but we encourage you to challenge your comfort zone.
- **Feel free to adapt the exercises** according to the needs and abilities of the participants.

LA POCHA NOSTRA WORKSHOP WELCOMING

Guillermo Gómez-Peña, Michèle Ceballos Michot, Saúl García-López, and Norma Ambrosini, Lima, Peru, 2016

Welcome carnales y carnalitas, we invite you to:

- stay open to this experience.
- undress … from your social, political, and aesthetic conventions
- reconnect with your inner monsters.
- welcome forgotten and remote sensations. In this pedagogical journey, you won't face a linear or conventional narrative discourse.
- confront what has been forgotten, ignored, or forcibly normalized, such as the cultures of real and mediated violence and social injustice.
- not try to understand the exercises, but rather to experience them, to live them.
- inhabit a world conceived for dissidents, radicals, and visionaries interrogating gender, discipline, and race through the intelligence of the body.

We humbly suggest that you:

- free yourself to transit from your internal and external space and vice versa, fully activating both spaces at the same time.
- create your own spiritual and aesthetic journey.
- take risks; here nothing is good or bad, or too sacred, or too profane, although it could be in a pagan sense.
- allow yourself to get provoked by an image; it is normal to perceive ambiguous or contradictory sensations.
- not draw conclusions about something through the intellectual process, but remain open to the absorption of phenomena as a whole: thoughts are tasted, sights are tactile, just as in a dream or a collective nightmare.
- be alert to all our ignited and hallucinated bodies. Our bodies are a product of the present crisis. Can we make room to allow what awakens naturally in our bodies during this experience?
- treat the props with the utmost care, as if they were shamanic objects.

- never succumb to peer pressure, collaborate without harming someone emotionally or physically, and without touching them non-consensually. If other participants invite you, or you invite someone to participate and collaborate in your performance locura, feel free to do it, but always in consensus.

WORDS TO AVOID WHEN CONDUCTING A POCHA WORKSHOP

Academia
Autobiographical
Correct/incorrect
Chinga tu madre
Clicas
Competition
Derrida
Developing or emerging artist
Erection
Essentialism
Freud
Guacamole
Healing/cathartic/therapeutic
Hipster Lumber Sexual
Holding Space
Horny
"I am triggered by your smoking"
I don't like it
Illegal Alien
Inner (anything, with the exception of demons)
Interesting
Inter-textuality
Intolerant
Latin
Liminal
Magic mushrooms
MOCCA
Ontological
Oriental
Subjectivity

NOTE

[1] Credit for the Coyote, Infinite Alien and Cucaracha illustrations: Sara Pickles Taylor, San Francisco, 2019.

Performance exercises, rituals, and games to cross borders

FIGURE 8.1 Decolonizing the Body at the Athens School of Arts
Photographer: Manuel Vason
Courtesy of Manuel Vason and Pocha Nostra archives
International Summer School, Athens, Greece, 2015

SECTION 1: "HANDS-ON" PHYSICAL AND PERCEPTUAL EXERCISES

Pocha Disclaimer 004: If anyone objects to aesthetic irreverence, politically and sexually charged work, or physical proximity with colleagues from other races,

social classes, generations, or gender persuasions ... believe me, you are in the wrong workshop.

Pocha Disclaimer 005: *We've heard rumors that "nudity and stylized violence are mandatory in a Pocha Nostra workshop." We must clarify: nothing, with the exception of tuition (when it applies), wearing neutral colors, bringing your props and costumes, and punctuality, is mandatory. We are radical pedagogues, not cult leaders ...*

PHYSICAL WARM-UPS, STRETCHING AND BREATHING EXERCISES

The monkey-breathing dance

Pedagogical range:
Length of time: 15 minutes
Level: Foundational
Practical considerations: We recommend the use of high-energy electronic music.

CONTEXT AND OBJECTIVES
One of our favorite breathing and physical endurance exercises is the "monkey-breathing dance" taught to us by Mexican performance poet Araceli Romero. Versions of this breathing dance exercise can be found in practically every culture around the globe, as it goes back to the early times when pre-hominids would emulate the movement and behavior of other animals as a way to understand our relationship with nature.

This exercise helps to increase focus within the group and continues to build energy. We find it useful to break the ice and build a more relaxing creative atmosphere during the workshop. By applying different variations and levels of complexity, this exercise can open the door to a creative process in which breath and body movement guide our imagination.

La Saula: Through demands of physical endurance, I cross the border of exhaustion and let my body adapt and express its own intelligence. I observe how participants leave behind the "seriousness" of the Eurocentric creative process that diminishes fun as part of artistic training. Laughing at ourselves is one of the greatest joys and privileges of Pocha creation.

FACILITATION
We use this exercise at the end of the warm-up or after a break. We usually include ten minutes of kinetic breathing exercises to high-energy music. In our workshops we have different bodies with different levels of training, skills, and physical resistance. We emphasize this by allowing people to adapt the exercise on the basis of their lung capacity and/ or physical injuries or restrictions. However, all participants must commit to the exercise for its entire duration.

Having the opportunity to work with and learn from such a radical group of artistas, my body has truly become a vessel that allows me as an artist to be free to create thought-provoking work that is fueled by wisdom based on the ritualistic and spiritual nature of creative practice. In the moments I spent working with LPN I was filled with an overwhelming sense of freedom to develop and work with my many personas, exercising an ability to live "in-between" spaces of identity, sexuality, and gender normativity. It was in these moments that I experienced clarity and efficiency, which brings me to my current state as a creative being.

(Jason Eric Gonzales Martinez, San Antonio, Texas)

PROCESS

Begin by forming a circle. Imagine you have hydraulics in your knee joints and pelvis. With this image in mind, slowly bounce up and down with the rhythm of the music without moving your feet from the floor, as if mimicking a monkey. At the same time, you should work with a breathing pattern that harmonizes with your own lung capacity. With short deliberate breaths, breathe in two, three, four, then out two, three, four, and repeat.

Once you've got your initial breathing pattern connected to your bouncing, you can begin disconnecting the movement of your arms and hands from the rest of your body, as if mimicking an excited chimp, so that each arm moves independently from your torso or legs. Increase your energy level and make the movements larger until your jumping and breathing pattern becomes more intense and you slowly cross over into free-form dance patterns. Do this without losing the basic monkey motion or bounce. It's definitely an energizing and fun way to jumpstart a session.

EXPANSION

These extended variations, borrowed from the simple children's game "musical statues," increase the need to engage with a split focus: the body, the sound, fellow dancers, and the interconnectivity between the three. This can function as an entry point to a creative process.

After doing this exercise a few times and having developed a little bit more resistance, we introduce some variations. You can experiment with different rhythms and levels. You can ask participants to move at 25%, 50%, or 100% the amount of energy, and the participants adjust their breathing accordingly. You can ask them to experiment with levels by moving as close to the ground as possible, or as high up as they can.

Once your group has reached the dancing stage, participants can break from the circle and dance around the space, moving on their own or in duets or larger groups. The person managing the sound system then stops and starts the music abruptly. When the music stops, everyone freezes in whatever position they are caught. When the music continues, they go on dancing. These sudden interruptions should be as surprising and unexpected as possible. Furthermore, you can introduce a different soundscape, and let the movement evolve with it. Encourage participants to keep dancing in duets or subgroups. This variation could be the beginning of a creative process for movement composition and choreography.

The things that I think were special, unique, and very beneficial were the creation of a safe, common, non-judgmental space in which different aesthetics, perspectives, realities and sexual, political, racial, and economic background could coexist. A collectivity was created in relation to the fantastic variety of all of the participants. We explored our fears and desires as a group and as individuals. We explored issues such as how to feel empowered and empower others, how to communicate effectively with our bodies, and ways and possibilities to create bridges between different communities.

(Dorcas Roman, choreographer, dancer, Puerto Rico)

The glitch dance

Pedagogical range:
Length of time: 10 minutes
Level: Foundational
Practical considerations: A room big enough to allow participants to have enough personal space for movement experimentation; a sound track with cybernetic effects and ongoing interruptions.

CONTEXT AND OBJECTIVES

The glitch is a series of unexpected malfunctions in a system. It interrupts functionality, it's sudden and it doesn't have a traceable origin. This dance is inspired by the late-1930s visual experimentations of Len Lye, the reports of the engineers behind the space odysseys of the 1960s, our ongoing experience with technology, and the text by Gómez-Peña called "Glitching."

This exercise opens up the possibility to relate to our bodies in unexpected ways. It helps to increase body awareness, to create a pattern of movement, and then to break it into smaller fragments by interrupting its fluidity. The ongoing interruptions or failures build energy and an original form of movement, creating a total body meta-language.

La Saula: In 2013, during the rehearsal of the performance *Dancing with Fear* in San Francisco, Gómez-Peña challenged both me and radical dancer and choreographer Esther Baker Tarpaga to embody a series of glitches. For Pocha, glitching is not just an unanticipated failure of the ordinary functionality of the body, it is failure as a path for intervention. It is an action that interrupts and disrupts the expected perceptions of our body; a tool that can open possibilities to reinvent our identity.

FACILITATION

This exercise does not need a technique or specific body training. It has the potential to be practiced by anyone. Allow enough time for the body to understand the glitch and generate an ongoing sequence that later can be interrupted. It is important to use a soundtrack that glitches to facilitate this task. This exercise can be used as part of a warm-up, after a

break and to generate unique actions and movement sequences. Warning: glitching could be addictive!

PROCESS

Begin by forming a circle and starting a simple exercise of stretching and breathing to warm up the body. Focus on expanding your body and start moving in your own terms. Start with small movements at a low speed. Find a quality of movement or an action that is fluid. Once you have a series of movements, close your eyes and focus on interrupting the sequence. The interruptions must be short and sudden. Take your time to develop your glitching pattern. Use the glitching soundscape as inspiration.

When you feel that you have understood the dynamic and your body feels comfortable glitching, open your eyes, and continue glitching. Allow yourself to travel in the space and experiment with levels, distances and speeds, duets, and spontaneous glitch dance troupes.

The skeleton dance

Pedagogical range:
Length of time: 10 minutes
Level: Foundational
Practical considerations: A space big enough for participants to move around freely; a high-energy music score.

CONTEXT AND OBJECTIVES

Through human history we've learned that many cultures around the world have practiced dances that intend to free the body from the mind. Some hold religious connotations, others are part of shamanic healing practices, and yet others have implications for physical therapy. From a Eurocentric standpoint, these dances have generally been exoticized or demonized: mind must never lose control over body!

La Saula: Inspired by the combination of indigenous dances and exercises learned from teachers of the contemporary postmodern dance scene of the late 1990s in Mexico City, I introduced this exercise to Pocha when I became a core member. This is a Pocha-shamanic body practice borrowed and reworked from exercises of Release and Butoh dance techniques. The task is to shift the power relations of control that we impose to our bodies. This has been an essential building block that leads up to performance jam sessions. The principle of this dance is to allow the skeleton, the joints, the organs, the breath, gravity, and impulse to be the generators and organizers of the movement. It is intended to free us from our mind, disciplined dance techniques, and the strength of our muscles. By focusing on the capabilities of the skeleton and internal organs to create movement, we learn to trust in our body. The goal is to let that body make the decisions during a creative process such as a performance jam.

FACILITATION

It is important to warm up joints, stretch muscles, and do some breathing exercises focused on muscle relaxation to prepare the body for this dance. It's a productive exercise at any point in the workshop, as long as focused warm-up has taken place. Allow participants to enter the exercise from their own understanding of their body and allow enough time for them to develop their own movement.

PROCESS

After the warm-up, stand still and close your eyes. Try to visualize your body and your skeleton, just as if you were seeing an X-ray picture of your own body. Start focusing on visualizing your cranium and the joins that sustain it, including the ones that are part of your face. Slowly start moving those joins. Once you have allowed enough time to explore the possibilities of this part of the body, move on to the next part of the skeleton, such as the shoulder blades, the ribs, the spine, the arms, fingers, waist, knees, ankles, feet, and toes. In this way, we reach a total activation of the skeleton. Once you have activated a part of the skeleton, keep moving: it's an accumulative process. Don't forget to breathe during the entire exercise at your own pace. Think about breathing not as an igniting force to generate movement, but to promote the relaxation of the muscles and the body in general.

Keep focusing on moving your bones and follow their impulse, allowing the muscles and other parts of the body to react to this. Once you have gained enough trust in the process, allow yourself to open your eyes, start experimenting with different rhythms, and explore walking. The soundscape should facilitate this process. Allow the exercise to end up in an entire collective dance of random skeletons.

EXPANSION

By extending the time of this exercise, you can reach levels of shamanic trance and open up opportunities to increase the level of risk taken with the body, which can lead to a movement jam session or a score for a choreography.

Collective choreography

Pedagogical range:
Length of time: 15 to 30 minutes
Level: Foundational
Practical considerations: A space big enough for participants to move around freely; an assortment of popular rhythms. Pocha loves atmospheric Latino lounge music for this exercise.

CONTEXT AND OBJECTIVES

Pocha proposes a fun dance format that allows vernacular dances to be shared. Inspired by social and collective events such as dance parties, raves, and different styles of street dance in urban areas such as breakdancing, this exercise allows freestyle movement, improvisation, and social interaction. Co-creation is democratized by the opportunity offered to each

participant of the group to propose a movement from their own personal dance archive. This might be inspired by popular dances or a specific body technique, or can be totally improvisational and wacko. The intention is to increase community collaboration and allow that different techniques and levels of body training and expertise come together.

La Saula: I enjoy this exercise so much because it breaks the ice and allows me to honor the flow of my own body. Leadership rotates among group members, promoting a horizontal pedagogical experience. The community becomes the teacher. Different popular cultures and geographies fill the room in an experiment in the collective un-bordering of the body. I personally like to share some of the steps I learned in the queer bars of Castro (San Francisco) and Garibaldi (Mexico City). Hips don't lie!

FACILITATION
This exercise can be introduced at absolutely any time in the process, but is usually most energetic when a sense of community trust has emerged.

PROCESS
In round one, form a circle with all the participants. Each participant proposes a warm-up exercise. The participant takes leadership in the proposed exercise for one minute

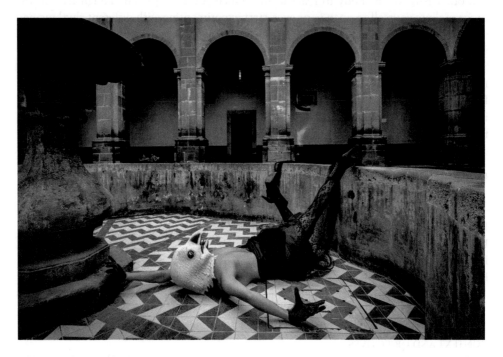

FIGURE 8.2 Winged Migration
Photographer: Herani Enríquez Hache
Performer: Jesica Bastidas
Querétaro City, Mexico, 2018

and the rest of the group follows. Then the next person follows until all the participants have proposed an exercise. Some participants might propose a dynamic, complex move, while others might propose a very slow or simple one. All kinds of movements are welcome!

In round two, we repeat the sequence, but this time each person proposes a dance or a sequence of movements inspired by their culture or ethnic background, their artistic training, or a totally freestyle form. The group follows each participant in turn.

In round three, each participant goes to the center of the circle and creates their very own dance by cutting and pasting from all the movements proposed by everyone during the last two rounds. Each participant might take a minute to present their own fusion.

EXPANSION

You can do the entire three rounds of this exercise or just the first round as a collective warm-up. We propose one to two minutes for each participant to develop their proposed movement, but feel free to extend the time if your schedule allows.

Following the tradition of street dances that evolved outside of the dance studio, feel free to take the exercise to open spaces such as squares and plazas. Another alternative is to use this exercise as a collective ritual to fine-tune the participants' energy for the work ahead and/or decompress at the end of the session.

PERCEPTUAL EXERCISES

Working in the dark

Pedagogical range:
Duration: 15 to 20 minutes
Level: Foundational
Practical considerations: Clear the space of personal bags and potentially dangerous obstructions. If people are barefoot, make sure the floor is free from dangerous objects and the surface is smooth. At least two instructors should oversee the exercise to watch out for the safety of the others. Practice the exercise in total silence.

CONTEXT AND OBJECTIVES

This trademark Pocha exercise emerged during the first Pocha workshops back in the mid-2000s during the post-9/11 era. It was a creative response to the extreme public surveillance and the taking away of spaces for creative experimentation. Pocha believes that places can be transformed with the conscious use of the body, and new cartographies of radical safety are waiting to emerge.

Generally, we are accustomed to using our eyes to assess space and situation, to assist with balance and identification. But this exercise forces you to listen, feel, smell, and touch. It is a challenge to develop these other senses so that they become as important as sight and be able to rely on them to navigate the space.

Your aim is to learn to negotiate between caution and risk, fear and trust; to be adventurous but careful; to be hyper-aware of your surroundings in the room. This objective is extremely important in performance because it can initiate the reconfiguration process or remapping of the meaning or use of the space, opening up possibilities of performance interventions.

La Saula: By practicing this exercise several times, I discover that the body is an extension of the performance site, the spinal cord and generator of actions that transform it. I realize that performance intelligence is not consciousness driven by the mind, but consciousness driven by the senses connecting to the vastness of space.

FACILITATION
Working in the dark is an effective way to become familiar with your new peers and with a new space. It is a very powerful way to break the ice when you begin to work with a new community. Another vital goal of this exercise is to "conquer" a new space by making it totally familiar through multi-sensorial and corporeal exploration.

We'll start this exercise after warm-ups as early as day one. For this exercise, the instructors or people performing the role of leaders need to look out for potential crashes that could lead to injury and do their best to stop them happening.

For pedagogical clarity, we have separated the exercise into two parts. In practice, these two parts are organically integrated:

1. Walk in the dark
2. Forming communities in the darkness

Part 1: Walk in the dark

PROCESS
To begin, this exercise should be performed without music. To start, walk in a circle, counter-clockwise, keeping the same distance between the people in front and behind you. Try to keep the circle as perfect as possible. As you walk, look only at the feet of the person in front of you and try to keep to the same pace as theirs, strengthening your peripheral vision and awareness of the group as a whole. Once you are moving in unison, slowly increase the speed of your walk, building the momentum until you reach a trot. Then, begin to slow down until you are all walking at a very slow pace.

Now that you are walking very slowly, break the circle and start exploring the space. People make their own journey by walking randomly in the space. Imagine that the site is an installation and that each detail has a purpose. Exercise radical curiosity by allowing yourself to explore each detail with all your senses. Smell, touch, look, hear, feel the different temperatures and perceive the different light intensities in the room. Engage with every architectural feature of the place. Be adventurous and try different levels and speeds of exploration.

Once you have spent some time in this exploration, close your eyes and continue walking and exploring in darkness. Please proceed with caution, as the space will probably

be new to the majority of your group. Be mindful of potential dangers such as chairs, tables, steps, columns, and walls. When you do bump into one another (and you will!) keep your eyes closed and don't overreact. Be graceful during the crash, responding as though you had hydraulics in all your joints or airbags around your body. We suggest you use the sound of the footsteps of those around you and the impact of the light sources on your skin as tools to guide you around the space. You can use your arms and legs as antennae and your entire bodies as spatial scanners. It is important that you keep your eyes closed throughout the entire exercise. Having your eyes closed will allow you to move and dance without self-consciousness, and become more aware of the use and importance of your other senses to perform the exploration.

As you and your group become comfortable with the walk in the dark, we encourage you all to be increasingly more adventurous and original in the way you negotiate and navigate the space with your eyes closed.

Once you feel comfortable with your blind explorations, try to use your entire bodies to move around the space (some of you may choose to crawl, roll, or slide). You may find that you respond more creatively to the objects and textures of the space as well as to other bodies if you experiment with altering your levels, rhythms, and modes of locomotion.

However, as you begin to get more daring in your movement, you will also need to be more cautious so that you don't injure yourself or other participants. This exercise involves a constant negotiation between caution and risk.

EXPANSION

The instructor can begin the exercise by asking the group to follow the sound of their voice as they move surreptitiously around the room. In this variation, the constantly moving voice of the instructor becomes a disorienting navigating signal.

Part 2: Forming communities in the darkness

Pedagogical range:
Duration: 15 minutes
Level: Foundational
Practical considerations: No music or soundscape.

FACILITATION

The extended aspect of the previous part of the exercise is vital for forming a sense of trust and group awareness. Partnering with closed eyes frees individuals from their usual inhibitions, and the movement they develop becomes much more eclectic, risky, and wild. This is true for the experienced movers as well as the non-movers in the group who might be inclined to feel self-conscious.

Though the exercise is done under dim light with eyes closed, after repeating this exercise several times, people begin to recognize each other corporeally, and strong connections occur. This can often be a sign of a strong performative relationship amongst

kindred artistic spirits with whom ideas will be shared later on during the workshop process.

Keep in mind that some people like to take too many risks too soon. The instructor must keep reminding people to take it slowly.

PROCESS

As an organic continuation of "Walk in the dark," continue to move through the space with your eyes closed until you locate a partner. First, travel through the room together holding your partner's arm or hand for a while. The journey you take together should happen organically without a leader or a follower. In your own time, you may part with this person and find a new partner in a completely different location. As the exercise continues with closed eyes, we invite you to play, dance, and/or navigate the space in creative ways with your temporary unknown partner. After a few minutes of working in pairs, you can begin to form temporary communities of three and engage in similar performative explorations.

After about three or four minutes, you can increase the number of your temporary communities of players to four, and then five, people – each time joining up for a while, then breaking free to form new, larger groupings. (The leader of this exercise can keep time and remind people to progress and form larger communities.) Eventually, the group forms one single large community of anonymous bodies negotiating the space together. It becomes a beautiful metaphor for an accidental community of difference and sameness.

After you have formed one single community of bodies, begin "compressing the community" slowly into one compact entity. Please make sure you don't squash those in the center of the group or at the bottom of the pile! The goal is to end up with a human conglomerate in which each participant's body is interconnected in some way with the others. It is important you don't stop moving until you find your place within the conglomerate of anonymous bodies surrounding you.

When you sense you have found your true place in this accidental community of bodies, freeze. Feel the vibration and temperature of the bodies around you. Listen to the breath of others. The feelings you experience may vary from profound tenderness and a strong sense of belonging for some, to a sense of loneliness or even slight fear. This whole range of responses is welcome.

Before you open your eyes, the group should engage in an exercise of "radical imagination":

- First visualize where you think you are located in relation to the overall group. Who are you standing beside? Who are you touching? Whose head or arm are you holding? Engage your senses of smell, touch, and hearing, as well as your intuition.
- Now try to imagine the overall shape of the group.
- Finally, try to guess where exactly the conglomerate of bodies is located in relation to the room.

The process of comparing your imagination with reality should happen in stages. First, open your eyes and look at what is in front of you. Then, after a few seconds, begin to move your head left and right to discover your neighbors. Finally, step out of the image.

This process of discovery is often quite surprising, as your imagination can dramatically betray you.

Spend some time exchanging impressions about the exercise with your new colleagues and then take a five-minute break to freshen up and have some water.

EXPANSION

1. **Making mischief.** By the third day, you can begin to complicate things in interesting ways. Instructors can play mischievous tricks on the participants. They can grab a person by the hand and have them run around the space. They can provide surprising sensations to inspire new movement qualities, using objects and fabrics to touch participants. Instructors can signal for the entire group to suddenly freeze and open their eyes for a few seconds to see what is in front of them. This will provide the group with a moment of spatial reflection to reconsider whether they wish to shift the course of their journey. Occasionally, the instructor can ask a participant to step out of the exercise and become a witness of this laboratory of zombie aesthetics.

2. **Adding soundscapes.** Another variation: after compressing the total community of bodies, you can add a sound exercise. With eyes still closed, we ask the group to hum together. Beginning at the same pitch and tone, let out a hum at low volume and slowly raise the volume until the sound fills the room and the vibration can be physically felt. The next time you practice this exercise, you may want to deviate from this single humming track, and experiment with variations of tonal patterns, structures, and volumes until you lose yourselves in a trance-like experience. Once you feel totally comfortable with this form of sound experimentation, we encourage you to be really creative with your sound patterns – to add words or phrases in different languages, or animal sounds, or to speak in tongues. The impromptu vocal collaborations become intimate shamanic operas. After about five minutes of immersion in this physical mass and sound environment, slowly begin to lower the volume until you reach total silence. After this intense period of humming and lexicological chant poetry, the return to silence can be overwhelming if it is not controlled carefully.

3. **Following the sound** (inspired by an exercise facilitated by musician and sound artist Aldo Aliprandi, co-curator with Marianna Andrigo at C32 performing art workspace during the Educational Learning Program of the Venice International Performance Art Week, 2017). Here is the version that I have adapted for La Pocha. The instructor/s ask the group to follow a strange music or soundscape coming from a portable speaker. The instructor moves around the space to find a place and stay for a moment to allow the participants (with their eyes closed) to get closer to the sound. Once they are close to the sound, the instructor moves to another place. The instructor can explore different levels and speeds, becoming a disorienting navigating signal and forcing the community to stay close. At the end, the instructor leaves the portable speaker somewhere and lets the community gather around the sound. Once they have gathered around, the speaker asks them to "compress the community" and find their true place in the community. You can apply then the exercise of "radical imagination," explained above in "Forming communities in the darkness."

4. **Working in the dark with a primary look.** This is probably the most advanced version of this exercise, given that it implies an entire creative process. Around day five of a workshop, ask participants to create a primary look (a performance persona), and carry out the entire exercise with all the previous variations of their choosing. Aim to integrate their performance personas. Their props and costumes become instruments for exploring the space, the architecture, and the community. Once you find yourself comfortable in your exploration, add a creative awareness to the experience. This version is an effective way to find actions for personas and generate interesting live art images and performance possibilities of collaboration among partners and within small groups. It could be the initiation of a performance jam or Open Salon.

Running blind

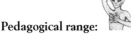

Pedagogical range:
Length of time: 15 minutes each version (depending on number of participants)
Level: Foundational
Practical considerations: A space long enough for participants to move from point A to point B in a direct line. The distance needed for this exercise should be at least 35 feet (about 10 meters) long. If the workshop space is not long enough, you may want to find a larger nearby space (indoors or outdoors). We suggest you practice the exercise in silence.

CONTEXT AND OBJECTIVES
This is an ancient exercise of trust and valor inspired by warrior practices from various tribal societies. Though it still resembles warrior training, we want to remove the competitiveness and turn it into an exercise of performative and idiosyncratic modes of running. In simple terms, it is about running as performance.

For Pocha, this exercise is also a metaphor for human solidarity, as it exemplifies what happens when you have a community to look after you and watch your back while you engage in what is perceived to be a dangerous task.

Simply running with your eyes closed in a new space and in front of a new community of peers can be quite revealing. It can tell us a lot about our personality, our fears, and even our memories. Initially it's quite scary, but eventually, after the first round, it is lots of fun and definitely a great icebreaker.

La Saula: Running blind is one of the most organic ways to enter and experience what we call performance mode. It is action that emerges when our body confronts the known in real time. The reactions that unfold become our raw material; it is not representational art. Every time I practice "Running blind," I confront personal borders and engage emotional and physical balance. On my run, I have two options: to stop, or to keep running; to jump into the "abyss," or play it safe. I decide to keep running, to commit to the action, to fall and keep falling. In the fear, I build my courage, my trust. My body is wise, responds quickly, always seeks the way to save me, it is sustained by the compassionate web of the community's care.

FACILITATION

It is crucial for participants to understand that there is no right or wrong way to run with closed eyes. When confronted with this challenge, everyone runs in surprising ways, some like children or cartoon characters, others like elegant animals or strange mimes. Their facial expressions and hand gestures, especially in the last few meters of the journey, become extremely bizarre and sometimes hilarious. Witnessing these beautifully idiosyncratic ways of running is one of the objectives of the exercise, it is raw performance mode. Remember: it's not about speed or valor, but rather about the performativity of running.

For this exercise one needs to commit to running non-stop until we hear the word stop. This is the only way we can experience the purpose of this exercise.

PROCESS

The group forms a single line along the side wall with the beginning of the line located at the farthest point away from the instructor. This could be against a back wall if the space is long enough, or the run could go from corner to corner. The objective is to use the longest cross-section of the room as a conceptual "running corridor." Two people leading this exercise should position themselves, one usually just over midway down the running corridor, and the other one at the very opposite end of the room, as "safety nets." One of these two facilitators will call out the instructions.

The instructor may ask the group, before they embark on this uncertain challenge, to imagine an important journey in their lives (i.e., crossing the border into a new country, escaping the past, confronting their destiny, committing to a new art project, etc.).

One at a time, each person comes to the front of the line for a turn. First, look to the end of the room where one of the instructors is located, visualize your path by drawing a straight line with your mind and then close your eyes. On the count of three (one, two, three, go!), run as fast as possible with your eyes closed towards the other end of the room.

When you are about to reach the end of the room or one of the side walls (if you deviate from the straight line), the facilitator will clap their hands and yell "STOP." As soon as you hear this, open your eyes and stop.

If the participant runs too fast and has built up a lot of momentum, the facilitators are there to physically stop them before they reach the wall. You should also ask the other participants to safeguard their colleagues if they run off at an angle!

EXPANSION

Once all have taken a turn, you can try several variations, spread over several days, with a different variation each day:

1. **One at a time running backwards with eyes closed** … scary!
2. **Running in pairs while holding hands** (preferably with someone about the same height and weight), both forwards and backwards. Before you try it, running in pairs may seem much more difficult, but soon you will realize that it is in fact easier! Why? Trusting in one another and sharing the risk usually spurs the runners on. It is a version about negotiating skills that focuses on solidarity.

3. **Running blind while everyone else is trying to stop you.** Stop the runner and don't let him/her reach the end. For this the runner must fully commit and run, run, and run despite any obstacle. We run against the impossibility of running.

4. **Creative running blind.** Although this freestyle way of running blind is a variation, it crosses over into the realm of image making and creative moment, and therefore deserves a more elaborate description. "Creative running blind" is at once very challenging and extremely freeing. Trust has built over several days, so individuals will tend to take greater risks. The group divides in half and forms a corridor by standing on both sides of the room to protect and "guide" the blind runner as he/she makes his/her journey. One at a time, each of you standing at the front of the two lines is invited to move across the space in any way you choose. You can be as crazy, conceptual, or funny as you wish. The only objective is to eventually arrive at the other end of the room while keeping your eyes closed. People may move across the space dancing, spinning, performing cartwheels, and/or utilizing any other forms of spontaneous creative movement and locomotion. You may also incorporate sound into your journey. While waiting in line for your turn, try to avoid developing a mental script. Instead, be an alert witness and be prepared to help your colleagues when they deviate from the straight line. As you inevitably bump into your colleagues on either side of the corridor, they will gently guide you back to your path with a soft push. Stay committed to your action. Your peers/spectators will, without a doubt, crack up at your original movement – that's part of the fun, and all participants have a chance to watch and be entertained! This creative version of running blind is definitely the first formal group performance of the workshop. You can repeat the creative version after few days, as this is an effective option to assess (individually and collectively) what has changed from the first time the exercise was done.

5. **Creative running with primary look.** Embody a primary look or persona, one that has emerged from the workshop, and run blind. You can try all the variations here, from running forward and back and with the creative version. This is another way to find potential actions and images and come up with a script for your persona. You also have the option to perform this version as part of an open salon.

The gaze

Pedagogical range:
Length of time: 10 minutes each level
Level: Foundational
Practical considerations: A room with dim light large enough to allow participants to move freely. You can either introduce a soothing soundscape or practice the exercise in silence. Some verbal cues and instructions are provided during the implementation of this exercise.

CONTEXT AND OBJECTIVES
This exercise is one of the oldest shamanic exercises we know. It is very likely that you may have tried it out informally without realizing its implications. Kids, lovers, witches,

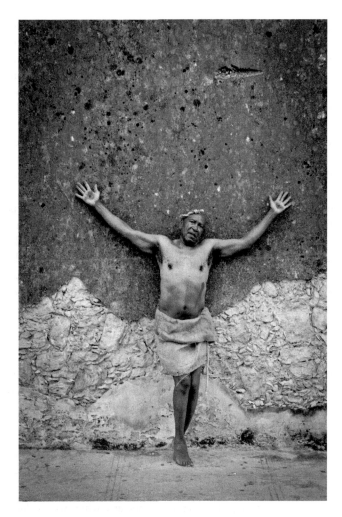

FIGURE 8.3 Caribbean Cruci-fiction
Photographer: Herani Enríquez Hache
Performer: Richard McClarkin
Courtesy of Hache Herani and Pocha Nostra archives
La Rendija, Mérida, Yucatán, Mexico, 2016

brujos, and madmen do it all the time, and in certain cultures it is used to diagnose diseases.

Pocha contextualizes this action as a way to re-enact the primary form in which humans recognize each other, just like the first time that Neanderthals traveled north and met other tribes, or when Cristóbal Colón met the Arawak in the so-called first encounter between Europeans and Amerindians: gazing as a tool to fully recognize our physical similarities and differences and enter into a deeper state of awareness.

When gazing for an extended period, people enter the realm of ritual time, an enhanced present in which past and future appear to be inconsequential. We also become much more in tune with our senses. In a parallel process, by contrasting our bodies with others, we gain much more awareness of the particularities of our body and its meaning for us and others. These notions and hyper-awareness will become very important later in the process because they become the materia prima for developing actions and ritual structures for performance personas.

Looking into each other's eyes for extended periods of time seems quite innocent, but in our globalized society where most social interactions are brief and impersonal or mediated by technology, or cultural sensitivity, this ritualized action can be extremely radical.

La Saula: I remember I felt so uncomfortable the first time I did this exercise. As a queer, urban "indio" from Mexico City favelas, the hyper-exoticized Mexican in Australia, the invisible mixed-race person in South Africa, or the unexpected non-white Mexicano in Scotland, I always felt that I was the "other." Why should I put myself through this exercise? By allowing myself to be othered, the visible characteristics of my body become an invitation to reverse the gaze. Mi casa es tu casa. My own discomfort becomes temporal and I grant myself the power to change my position at any time. Thus empowered, I am less anxious about stepping into the raw encounter of self and other.

FACILITATION

Gazing helps people open up to the members of a new community, so it is a fantastic way to humanize a process, a meeting, a social gathering, or even a political debate! It also helps to develop a strong sense of *presence* – of being in the here and now, as we are, which is the time, space, and cosmogony of live art.

As facilitators, we need to be sensitive to the fact that certain cultures are more inclined to look into the eyes than others. There are many reasons for this, so we often encourage participants to treat the workshop as a space for experimentation – a temporary space to cross borders and gain experiences that might later inform their practice.

It is important to stress during the exercise, especially when we explain the terms to choose a partner, that our perceptions of "affinity" and "difference" are subjective rather than fixed or static: they change over time and with experience.

PROCESS

Begin walking randomly around the space, shifting direction and avoiding collision with others. Keep your eyes open, and make eye contact as an act of acknowledgment as you pass one another. Continue to walk and think of someone you would like to get to know better. Ideally, this should be someone you don't know very well and, if possible, someone who is as "different" as possible in obvious ways (race, gender, age, body type, subcultural affiliation, etc.). Gravitate towards that person and intuitively assess whether your desire for this partner is reciprocated. If not, don't take it personally, and continue walking around until you find someone else.

Once the group has split into pairs, each pair should find their own space in the room and stand two feet apart facing each other. If one person is considerably shorter, they should get a small step or chair and stand on it to level the gaze. Why? The objective is

to maintain eye contact without straining your necks. Now, look into each other's eyes without blinking. It is very important that you make an effort to release yourself from initial nervous impulses – giggling, coughing, or blinking. Try not to stage any emotions with your facial features or "act" them out by exaggerating your features, using obvious illustrative facial expressions, and, of course, try not to convey complex telepathic messages – that is a different workshop. The goal is very simple: to be present and open, to express a basic existential message with your gaze that goes something like, "We happen to be here today, to coincide on this strange planet and it's OK. We are here together sharing a moment in life and art. It's a pleasure to be here with you."

After a few minutes of intense staring, the features of your partner may begin to shift or move around, and strange visual phenomena may occur. First, you may see changing colors and auras around your partner's face. You may then see the faces of children, elderly people, people from different races or historical periods. Participants often report that they saw animal features or mythological beings. Once they break through this optical poltergeist, a deeper mutual connection is established in a highly personal and non-verbal manner. The eyes of your partner can also become mirrors, and through them you might establish a dialogue with your own inner selves, which can be extremely powerful and memorable.

After about five to seven minutes of gazing, close your eyes for a moment to reflect on the experience. Once you open your eyes again, spend a couple of minutes sharing with your partner what you saw and felt; your physical and perceptual sensations and emotional reactions.

EXPANSION
Each day, start with the most basic version outlined above and then try one of the following variations with different pairings.

1. **Two points of contact.** After five minutes of gazing into each other's eyes, hold hands with your partner, first with only one hand and then with both hands. Your hands should be connected at the palms to create better energy transmission.

2. **Distances and levels.** After five minutes of gazing into each other's eyes, begin to experiment by shifting distances and/or levels between you and your partner. (By levels we mean looking from above or below or one person seated or lying on the ground and the other standing.) Play with the elasticity and compression of the "gaze." In other words, move farther apart or get extremely close. These shifts must occur slowly during the exercise, without ever breaking eye contact. When you reach a new position, freeze for a while until one of you initiates a change.

3. **Creative gazing.** Finally, you may combine shifting distances, levels, body positions, and points of physical connection while still maintaining eye contact. Begin to experiment with movement and body shapes. Each pair determines the nature of their own poetic/performative dialogue. But please, don't let the choreography take over. No matter how inventive your gazing becomes, you must always remember that the exercise is primarily about eye contact and not about movement, and remember to freeze every time you find a powerful or tender moment. Hold this moment for a short time to imprint

it in your body memory. These forms of creative gazing can actually help you to begin constructing powerful diptychs and unusual tableaux vivants. At the conclusion of a creative gazing exercise, we often ask you "to find a physical image that emerges organically out of this performative exploration; a tableau vivant that encapsulates the nature of your dialogue. Once you feel you have found it, just freeze." The archetypal beauty and simplicity of the images created will more often than not reference history of art and religious imagery that the participants are familiar with.

4. **Speed gaze.** A simple way to connect with your collaborators and technicians before opening the door/going on stage or to kickstart a creative process. Walk in the space, gravitate towards someone; if you are reciprocated, stop and do gazing for a minute. Close the eyes for a moment, open the eyes, and walk around and look for someone else. Repeat as many times as possible.

Creative Indian wrestling

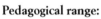

Pedagogical range:
Length of time: 10 minutes each part
Level: Foundational
Practical considerations: A room big enough to allow participants to move freely. Parts 1 and 2 can be practiced in silence. For part 3, we recommend an inspirational soundtrack such as ritual music or electronica.

CONTEXT AND OBJECTIVES
This exercise is inspired by a traditional form of wrestling practiced by indigenous communities throughout the Americas. Besides training the body to get stronger, it is a practice about power and dominance over someone else. In the original version of this wrestling match, the objective is to make your opponent lose their balance. However, Pocha is not interested in reproducing traditional power relations, so we have extracted the competitiveness from the original exercise and turned it into a unique form of collaboration, contact improvisation, and live image-making technique.

Participants learn how to move with another person while maintaining physical contact, and how to take care of their partner and themselves by carefully balancing the combined weight. This knowledge will help them construct powerful images in motion. Through the body, this exercise helps to unpack traditional power relations and ways to override these by sharing power more evenly and horizontally.

La Saula: I struggle in any scenario that implies competition. I never enjoyed playing football, despite my father's wish that I become the rising star of the barrio soccer team. I dissented; my focus was always on collective work. The first time I practiced Indian wrestling I felt again I was on the soccer field. Thankfully, it was only a stage (not the dusty field of my childhood), and the deeper I went, the more the vertical power was replaced

by mutual negotiation of control. I found strength in unexpected ways. Nowadays, I tell my father, "Hey, Dad, I did not become the next soccer star, but I am an Indian wrestling contender in live art!" He smiles at this and says, "Estás bien loco!"

FACILITATION

The Indian wrestling exercise allows people with varied physical performance experience to explore basic partnering skills and weight sharing. It helps to use physical strength in ways other than confrontation, and encourages new forms of cooperation. It also increases trust among the workshop participants.

For the facilitator, it is important to recognize different physical capabilities and let each person adapt the exercise accordingly. Allow enough time for the students to understand the mechanics of the exercise and then give them enough time for exploration. During the cooperative and creative parts, remind the students to freeze when they have arrived at an interesting position or image.

PROCESS

Find a partner who is close to your equal in weight and height. Facing your partner, bring your right foot forward, widening your stance to about three feet. Place the outside edge of your right foot against the outside edge of the right foot of your partner. Your weight should be centered between your legs, keeping your stance wide enough so that you can almost squat to the floor. Keep your knees in the same direction as your feet; avoid twisting the ankles or knees. Now hold your partner's right hand as if you were diplomats shaking hands. The three-part exercise begins in this position.

Part 1: Basic Indian wrestling (10 minutes)

The objective is to pull, push, release tension, and shift one's weight without losing balance, breaking your grip, or moving your feet to keep from falling. The objective is to make your partner lose his/her balance and to play with the balance that emerges from the two of you. This should be a gentle testing of your balance and strength. After several minutes, you and your partner should switch to the left side and continue.

Part 2: Defying gravity with Indian wrestling (10 minutes)

Here, we remove all the competitive aspects of the exercise and get more audacious in the way we relate to our partners, work together to reach the limit of our balance, and help each other to regain it. If at any moment you no longer wish to keep your rear foot planted on the ground, you may move it. Now, your main shared points of contact are your right or left hands and the front of your feet. When you both feel you have arrived at an interesting amount of tension or image, freeze for a while. Listen to your body with all your senses. Breathe and extend awareness throughout the entire inner and outer space, then reanimate your partnership until you find the next powerful moment. Continue to engage in your particular form of stylized "wrestling." Switch between left and right feet at your own discretion.

Part 3: Creative Indian wrestling (10 minutes)

You now have total creative freedom in your movement. Your partnering becomes more like a vigorous contact jam duet. Your point of contact can be your hands, backs, hips, shoulders, legs – whatever you and your partner discover. This is an entry into freestyle jamming.

A variation is to do this version with a primary look or persona. It is a very effective way to look for compelling images and actions, and to create a mutual performance universe or score with others.

The Aikido/chess game

Pedagogical range:
Length of time: 30 minutes or more
Level: Foundational
Practical considerations: A room to allow participants to move freely. You can practice the exercise in silence or add your soundtrack of choice.

CONTEXT AND OBJECTIVES
This exercise was developed during a five-week residency at Dartmouth College in the UK. Pocha Nostra puts a lot of emphasis on finding ways to develop a language entirely with the body with the purpose of developing our performance skills. How do you find a communication system that works for two colleagues who haven't met before?

In these circumstances, we like to propose a combination of the physical dynamics of Aikido and the strategy of chess. You will learn to use your opponent's energy and actions to your benefit in a similar way as you would in an Aikido match by accepting and deflecting energy. At the same time, you can put complex strategies and "moves" into practice as in a chess game.

La Saula: This happens to be one of my favorite exercises for the initial development of my personas. Sometimes, I find myself alone in a studio agonizing and trying to make sense of the bizarre firmament I have constructed on my body. When I want to understand my persona's cosmos, I invite a colleague and play Aikido. I'll confess: I've never played chess before or understood the rules. I thought chess was the exclusive territory of pretentious men, but the following exercise proves this wrong!

FACILITATION
This game is not necessarily about "winning," performing symbolic aggressive gestures, or displaying physical strength, but rather about exercising our performance intelligence, our body intuition, and "responding" poetically to specific challenges and moves. It is here where the participants have to practice radical listening to be able to connect, understand, communicate with your own body and with that of your partner. This exercise could also

be very useful for participants whose training allows them to be more confident about creating moving images but less confident about creating tableaux vivants.

Before focusing on creating images, allow participants to take the time to find their common territory for communication, fine-tune their bodies, and then develop their own, shared language.

PROCESS

Break the group into pairs. Once in pairs, each duo finds two chairs and positions them facing one another around five feet apart. The chairs should be distributed evenly around the room, leaving plenty of space for movement around them.

Participants start the exercise seated, and then establish the gaze for two minutes to establish a strong connection. When one of you feels the impulse, that person makes a simple gesture or movement and freezes; the other partner then responds with another gesture or action. Each couple continues in this way, using deliberate, symbolic actions, gestures, or moves in a physical dialogue with their partner.

You may choose to stay in contact with your chairs or leave them altogether. The energy of the actions should follow the pattern of a rising crescendo from subtle and minimalist gestures to complex and high energy with larger gestures and movement. This should build slowly over 15 minutes. You may make contact with your partner, exploring weight and tension, push and pull, or you may choose to remain separate. Remember that by this exploration you are creating a unique form of communicating with the other. Remember to listen to the movement of your partner, let it finish, and then respond by offering the next move. Every time you find an interesting, powerful, or poetic moment, you should freeze and hold that position so that it becomes imprinted in your physical memory. Reflect on this moment in relationship with your journey, the space, your body, and the relationship with your partner, and then continue.

After 15 minutes, find a final moment, pose, or image that encapsulates the nature of the dialogue, and freeze. This image is not purposely sought after, but unfolds organically from the process. When the facilitator signals the end of the exercise, you can briefly thank your partner and discuss some of the images and actions you discovered mutually.

After this period of reflection, it is important to repeat the same exercise with a new partner. You will find that there will be very different results, as the energy from each new pairing is entirely different.

EXPANSION

1. **Without chairs.** Each pair can decide how to begin: both standing, one standing and one seated, both on the floor, etc.

2. **With props.** Each person chooses one prop at the start, and then sits in the chair facing their partner and the exercise begins. Try not to utilize your prop in a literal manner.

3. **Spontaneous props.** You might choose to start without props, and the instructor surprises each pair by handing them one prop in the middle of the exercise. The partners then have to incorporate this new element into the symbolic language they are developing. This object can have any function they wish, but not a literal one.

4. **Swapping partners.** The instructor can discreetly swap partners in the middle of the exercise.

5. **Aikido with primary look. This is an advanced level that we use after teaching image composition and primary looks creation.** It is useful to find and score a list of actions to find and expand the meaning and universe of your personas. Instead of trying to find the meaning of a primary look that has emerged from the intuitive work of the workshop, we offer an alternative route by applying this exercise. The sequence for this variation is as follows:

 a. Create a primary look or embody a new/old persona (15 minutes).
 b. Find someone else and become each other's stylist by helping to enhance their look. Reverse the role (15 minutes).
 c. Spend some time playing and internalizing your persona by observing yourself and how your body feels in in that look.
 d. Start the Aikido exercise with a partner. You can use a soundscape if you want.
 e. Interrupt and/or recombine partners; introduce any of the previous variations.
 f. Feel out and determine the combinations that are most productive for the group.
 g. The exercise could be extended for more than an hour.

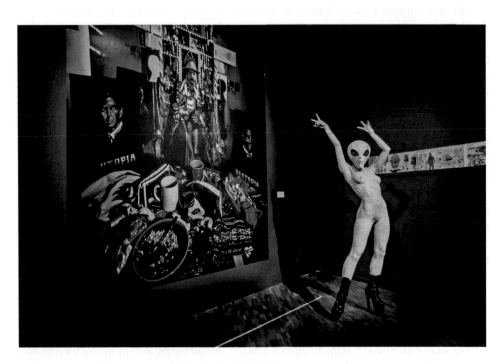

FIGURE 8.4 Museum intervention by Pocha Illegal Alien
Photographer: Herani Enríquez Hache
Performers: Muza Luz and Guillermo Gómez-Peña
Museo de Arte Contemporáneo, Mexico City, Mexico, 2018

Note: If you choose to utilize this technique to develop original material for performance, dance, theater, or duets, make sure to have a third person scoring or documenting the most interesting tableaux and interactions that emerge during the exercise so you can restage them later.

Poetic ethnography

Pedagogical range:
Length of time: 40 minutes
Level: Foundational
Practical considerations: A room spacious enough for participants to feel comfortable. The last thing we want is for this exercise to be cramped and spatially stifled. We suggest total silence among the participants during the exercise, or a relaxing sonic atmosphere that promotes concentration and introspection.

CONTEXT AND OBJECTIVES

Pocha Nostra developed this poetic ethnographic approach to performance training during rehearsal in the mid-1990s, and has continued to hone it over time so that it now stands as one of our signature exercises. It took more than six years to refine it. The goal was to find an effective method for multi-sensorial exploration and careful manipulation of the human body to discover the imprint of our ancestral, personal, and collective memory and unlock its potential for reinvention. The location of these borders becomes a collaborative effort, as the question of who is in control (the subject or the object) becomes an eloquent blur. The exercise is helpful for developing compassion, practicing radical tenderness, and awakening to the totality of our bodies as a biographical map and a cultural and aesthetic artifact.

La Saula: That lonely child who was always accused of "wasting" time living in a fantasy world was invited to come out to play. This exercise stayed with me for several days, stirring in my dreams and emotions, making me smile unexpectedly. Through it, my body entered a process of identity reconfiguration, and a path was revealed to engage with what my body symbolized for others. I learned to breathe, to relax, to accept that I have multiple meanings. I still keep imagining a fantasy world that I, alone, inhabit, but now I also walk in the space of incredible possibility when I connect this world to those of others.

FACILITATION

Once participants begin to feel comfortable with one another (perhaps on the second day), it's time to take on this major Pocha adventure. The exercise helps us negotiate the delicate borders between risk and consent, caution and adventure, self and other, and artist and audience member. For pedagogical clarity we have separated the exercise into three phases. In practice, these three parts are organically integrated.

1. Forming partners and clarifying instructions
2. Multi-sensorial exploration of the human body
3. Handling and manipulating another human body while in performance mode

Part 1: Forming partners and clarifying instructions

PROCESS

Begin by walking around the space and find a partner, preferably someone with whom you are not too familiar, and who is "different" from you in obvious ways (race, gender, age, body type). Gravitate towards that person and intuitively discover whether your desire to partner is reciprocated. If not, don't take it personally, and continue walking around until you find someone else.

Partners should stand facing each other two to three feet apart. Decide with your partner your initial roles within the experiment. One of you will be the *ethnographer* and the other the *specimen*. Specimen and ethnographer are metaphors that describe your role in the exercise – the person in the role of ethnographer does not "perform" a scientist in the theatrical sense. Rather you are both your actual selves in this time and place, exploring each other as "human artifact." This verbal negotiation should be kept as brief as possible. (You will reverse roles upon completing the exercise.)

Once the roles have been established, certain basic guidelines should be articulated: ethnographers should try to be compassionate, sensitive, and truly open in their exploration of their specimen. In this process of negotiation of the borders of intimacy, it is important to be adventurous, but always respectful. Ethnographers should not examine areas that may be considered invasive (i.e., breasts, genitals). If ethnographers examine areas that might still feel awkward or uncomfortable to the specimen (e.g., the feet, the inside of the mouth, the back of the ears, nostrils, knees, etc.), the specimen can simply give a hand signal for them to stop. The ethnographer will understand that the specimen is not consenting, and they shouldn't "go there." Although they seem to have a more passive role, the specimen should always be present and aware during the exercise.

Once these guidelines have been carefully explained, the second part of the exercise can begin.

Part 2: Multi-sensorial exploration of the human body

FACILITATION

During this delicate exercise, it is important that the instructors walk around and work with each pair, making sure directions are clear and that people are truly careful and radically tender in their exploration. If there are two or three pedagogical deejays, it is a perfect time to decentralize the voice and practice polyvocality. If the instructors sense any discomfort from a participant, they should encourage them to take a break. If the instructors sense that someone is not proceeding with respect, they should stop them, take them to one side and reiterate the importance of respect and consent. It rarely happens, but it's important to stay aware of this possibility.

PROCESS

Specimens close their eyes for the duration of the exercise. The ethnographers begin to examine their specimen in stages, adding sense by sense, layering each sense onto the next until all of their senses are engaged in the exploration simultaneously. (The instructor leading the exercise will call out each sense, signaling when to add a new sensorial layer to the exploration. Theirs will be the only voice that is heard during this exercise.)

- **Sight:** First use just sight. The ethnographer should try to find out as much as possible by examining the specimen from different perspectives, angles, and distances, strictly using their eyes. The idea is to find out as much cultural and social information as possible about the body of the specimen.
- **Smell:** After five minutes, you can begin to include smell. The ethnographer should (respectfully) smell the specimen's hair, face, hands, clothes, perfume, etc.
- **Sound:** The ethnographer can now add a third sense and begin to "listen to their partner's body." You should try to "hear" the breathing, heartbeat, digestion, and other sounds emanating from the body of your partner.
- **Touch:** A few minutes later you can begin to use touch. Try to experience the texture of the other person's clothes, skin, muscles, bone structure, and hair. Feel the temperature in different zones of their body. Engage your sense of touch, without abandoning the other senses.
- **Taste:** For obvious reasons, we will do without taste!

Once these four senses are at work, the ethnographers should continue exploring interesting marks and idiosyncratic features (scars, pores, veins, tattoos, jewelry, clothing, dyed hair, makeup, perfume, nail polish, etc.), discovering signs and symbols of specificity or difference. Think of your partner's body as an ever-morphing living metaphor. Think of the body as a map, a landscape, a machine, a musical instrument, a living sculpture, an open book.

After about 15 minutes of exploration, the ethnographer returns the specimen to a neutral standing pose, and the specimen may open their eyes. The ethnographers should thank their specimens for ceding their will.

Partners now change roles and reverse the gaze. It's best to make this change with no verbal discussion between partners. After the gaze has been reversed, you may include a short period where partners can share what they have "discovered" about each other.

When this exchange is over, thank your partner and walk around the space in search of someone new. Again, you should assess whether your curiosity is reciprocated. The exercise is repeated once new partners have been chosen. This time you should try to take your exploration just a little further whilst respecting the same basic rules.

Part 3: Handling and manipulating another human body while in performance mode

PROCESS

As an organic continuation of the multi-sensorial exploration of a human body, you can now begin to learn how to handle someone else's body in the following manner.

After incorporating sight, smell, hearing, and touch, we ask you (the ethnographer) to begin comparing your limbs, height, skin color, hair texture, scars, clothing, and the shape of your hands and feet with those of your partner. A few minutes later you can begin to examine the bone and muscular structure of your specimen.

You are now ready to "activate" the other person's body and see how his/her joints work. In doing so, your roles will slowly morph from "ethnographer" to "artist" and from "specimen" to "raw material."

We now encourage you to think of your partner as an anatomical figure and begin to deal with matters of weight and the effect of gravity on your partner's limbs and body. Try to carefully feel the weight of the limbs of your partner. Find out their center of gravity and shift that center. Be aware that if you are physically moving the other person, you must be able to support their weight at all times. If you don't feel confident you can support your partner, you should not radically shift their weight and put them in dangerous positions.

Now you can begin to explore the movement possibilities of your partner's body, including:

- How do their shoulders, head, and pelvis rotate?
- How does the torso move from side to side, twist, and bend?
- What happens when you move their arms in different directions?

Try to carefully bring your partner to the ground. Use your own body as counterweight and support to help them down to the ground. Be careful not to put too much stress on their body or your own. Once they are on the ground, you can explore the movement of their legs, feet, and body in a different way. You can roll your partner, carefully shifting the position of their arms and head so that they are not crushed or twisted as they move.

The raw material always plays an active role, allowing their body to be shifted and maneuvered into unexpected and interesting positions. They are, in a sense, collaborating with their partner, holding positions as their partner steps back, reflects, and then re-enters the exploration.

When this intimate role-play comes to an end (usually after about 10 to 15 minutes) we ask you (the artist) to find a powerful image or shape for your raw material that emerges organically out of your exploration. Once you have found it, you can either insert yourself into the image and freeze in a duet, or step away from your partner and walk around, observing what others have created.

After viewing the other images, return to your partner and gently bring him/her back to their original neutral standing position with the same care you used when moving them down to the floor. If your partner's clothing, hair, and jewelry have been altered or removed, also help to return these elements to their original state. As always, treat your partner with the utmost care and respect. The raw material may open their eyes. You may now swap roles.

Human puppets and dancing doppelgangers

Pedagogical range:
Length of time: 20 minutes
Level: Foundational
Practical considerations: Enough room to allow participants to move freely. You can practice the exercise in silence or add the soundtrack of your choice.

CONTEXT AND OBJECTIVES

Middle Eastern performance artist Persis Jade Maravala originally introduced us to this Grotowski-inspired exercise in 2008. We borrowed and modified it to suit the objectives of our methodology. The objective is for participants to experiment further with the creative manipulation of the body, which is introduced by our "Poetic ethnography" exercise. It's also a unique way to choreograph surprising movements onto a partner and witness the results right away.

La Saula: Just like many other participants, I can be deeply triggered by some of the Pocha exercises, as beautiful or painful memories echo through my body. We radical artists, queers, sex workers, activists, and rainbow spectrum of deviant humans have our stories to tell. As a survivor of sexual abuse that took place during my school years, my body carries intimate knowledge of being used, abused, and discarded. For me, surrendering my body to others is a huge border to cross. By allowing myself to be a human puppet, I gather the broken aspects of my body's memory as a vehicle to self-acceptance and transformation.

FACILITATION

This exercise requires a true commitment to radical tenderness. At a sensorial and conceptual level, it challenges the control we might have over our performance material and personas. It actively encourages a higher level of collaboration by awakening the awareness of our bodies and physical strength.

You can create pairs randomly or by pairing couples by affinity or difference. As this exercise may test physical resistance, we recommend you begin with a five- minute warmup beforehand. You'll want to allow enough time for pairs to develop material and enter into an atmosphere of total concentration throughout the group.

PROCESS

Try to partner with someone who is about your height. Begin with the exploration of your partner's body as described in the poetic ethnography. At a certain point, after manipulating their body for a few minutes, return your partner (with his/her eyes closed) to a standing neutral position. Now, stand behind him/her and carefully press your torso and legs against the back and legs of your partner, with your arms under his/her arms so that the palms of your partner's hands are resting on the tops of your hands.

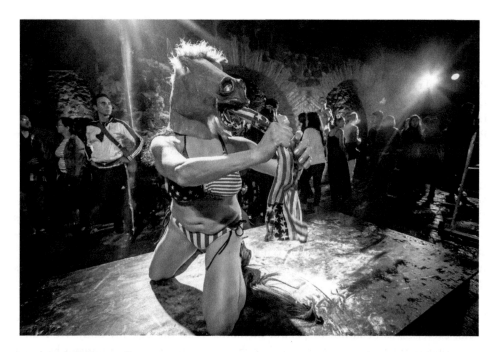

FIGURE 8.5 Pledging Allegiance
Photographer: Herani Enríquez Hache
Performer: Michèle Ceballos Michot
Festival Cervantino Guanajuato, Mexico, 2016

Slowly begin to transfer the energy and impulses of your movement to your partner's body. In turn he/she should collaborate by facilitating this transference of movement, becoming an active participant in the creation of an unusual choreography. Your movements initiate the movements of your partner. In a sense he/she is dancing for you and responding to the movement phrases you are imprinting onto his/her body. He/she is your dancing doppelganger.

The "human puppeteers" can eventually engage the entire body of their partner. You can move the torso, head, shoulders, and hips using your own hands to direct your partner. Make sure to engage their arms, legs, hips, and shoulders or, for smaller movements, the hands, fingers, or feet. Use your whole body to direct your partner. Occasionally you can check out other duets for inspiration. The "puppet" is an active participant and should never stop moving, continually re-interpreting and stylizing the movements and impulses given by their partner.

Eventually, when you have imprinted at least four movement phrases onto your partner, we ask you to step away and move to the front of your human puppet and observe the movements you have created. Now you can think about how you might want to develop or change this movement.

At this point you might:

- change their rhythm;
- expand or compress the movements (make movements larger or smaller);
- refine or add complexity to a simple movement;
- insert small idiosyncratic and strange transitional movements in between the larger dance phrases.

This action of stepping in and out for reflection and alteration of movement can be repeated a few times.

After ten minutes, when all human puppets are performing their unusual dances, the puppeteers can begin to walk around the room and slightly "intervene" in the movements of the others' puppets. Be careful not to leave your puppet alone, moving wildly near other puppets, as they might crash into one another. If you see that one of the dancing puppets is about to crash, gracefully redirect them to a safer position in the laboratory of collective movement. After five minutes, you can return to your original partners and discover how others have transformed their movement. Then, reinsert yourself into their body and slow down their movements until both their body and yours reach total stillness.

EXPANSION

Doppelgangers in a persona or primary look is one of the most advanced exercises of La Pocha. We "surrender" our persona to the interpretation and creativity of our colleague, reversing the way traditional artists look for meaning and challenging authorship at the same time.

This is an effective way of using the body to find actions for a persona and have a better sense of its meaning, which is productive once you have practiced few times and when the group has a grasp on how to create primary looks and personas.

1. Create a primary look or embody a new/old persona. Take 15 minutes.
2. Find someone else and become each other's stylist by helping to enhance your partner's look. Reverse the role. Take 15 minutes.
3. Spend some time playing and internalizing your persona by observing yourself and becoming fully aware of how your body feels in that persona. If you have already explored this persona in other exercises, please incorporate those actions that you think already work.
4. Create partners and practice "Poetic ethnography" for five minutes.
5. Start the Doppelganger exercise with your partner. You can use music to accompany the exercise.

Note: If you choose to utilize this technique to develop original material, we suggest you have someone scoring or documenting the most interesting actions and interactions that emerge during the exercise. You can revisit them, cut and paste, and create your own performance score based on your notes.

> *Maybe I am just a truly private person, but I find it hard to stare into a stranger's eyes, I find it hard to stare into anyone's eyes but my husband's. Looking someone in the eyes is much different than gazing into their eyes. I try to convince myself that this is not a competition; we are not trying to see who can hold their breath the longest. I do not need to feel guarded. We are instructed to holds hands – just one hand. All of a sudden that human touch transfers the energy and I feel a great release of tension. What power the human touch holds!*
>
> (Workshop participant in Austria, 2012)

SECTION 2: EXERCISES TO GENERATE PERFORMANCE MATERIAL AND LIVING IMAGES

> *The poetic ethnography opened my eyes to the sculptural possibilities of the human body, and in seeing others I was able to see myself more clearly.*
>
> (Workshop participant, Pittsburgh, Pennsylvania, 2010)

Activating the "prop archaeology bank"

Pedagogical range:
Length of time: 30 minutes
Level: Creative
Practical considerations: In our workshops, people are asked in advance to bring a selection of artifacts, props, and costumes from their own personal collection for the first day of the workshop. Many of our exercises rely on the existence of this prop bank (see the letter at the end of this exercise with a clear example of the kind of props we ask participants to bring). Two to three worktables, two mirrors, and one costume rack will be needed.

CONTEXT AND OBJECTIVES
Ritualizing the use of objects and costumes in performance is an ancient practice which can be found in most forms of indigenous rituals and in the history of performance throughout the world.

This exercise helps participants to understand that taking good care of and developing our prop installation is of great importance for the understanding between object, body,

and environment. We also realize the difference between anthropological objects of our personal history and theatrical props. These artifacts are live prosthetic extensions of our body and turn into shamanic objects that help us to expand and transform our identity. The exercise also helps us to learn to negotiate the use of props and costumes with other collaborators without having to fight for them.

This exercise is an ongoing parallel process that begins on day one and continues until the last day of the workshop. The prop archeological bank should be augmented, edited, and refurbished on an ongoing basis, especially during longer workshops after participants feel they've exhausted the possibilities of some objects.

La Saula: I learn to appreciate the symbolic dimension of objects in performance – to think of them as extensions of our body, as artworks, and to learn how to relate to them in a non-theatrical manner. A humble suggestion: don't put your passport on the prop table. I have seen them ripped apart during a performance jam while the stunned participant looked on, wondering how s/he was going to get back home. Even worse, avoid putting the ashes of your grandmother on the table. They might end up being used as a smoke effect for an incredible, super queer Miami-style radical image!

FACILITATION

This exercise is ideal at the beginning of the day or during the lunch break. It is important that participants understand that all objects must be handled carefully and with respect, that all the props on the table are up for grasp by everyone, and that every now and then something does get damaged.

If the number of props is low, encourage the students to bring more. The best method is to see what connections local artists have around town and look for people who can help with lending interesting props.

Also, you can plan an activity of 15 minutes scouting the indoors and outdoors surroundings of the space to collect more props. Also, you can encourage participants to bringing a new object every day. The infusion of just a few new things a day can re-enliven the other props.

At the same time, try to discourage participants from contributing extremely precious materials that have personal intimate value, such as their birth certificates, credit cards, or the precious teddy bear made in Tijuana from their childhood!

PROCESS

On the first day, before beginning the "creative session," the instructors should arrange for two to three worktables to be set up against one wall of the main space, and ask everyone to carefully lay out the props and costumes they brought. Objects should be arranged in a way that is both aesthetically compelling and practical, using simple categories (all the wigs and headpieces in one section, all the "weapons" in another, etc.). The costumes and fabrics can be placed on a clothes rack. The makeup and body paint can be laid out on a separate, smaller table.

The basic rule for the use of the prop table during the workshop is as follows. Every time an object is removed from the prop and costume installation to be used in an exercise, the

object should be returned and placed in a new and surprising manner once the exercise is finished. In this way the ritual installation is continuously changing.

We usually ask a small group of three to five participants to arrive at the space an hour before the workshop begins so they can construct the installation of the day. Ideally, this group should be different every day, though at times a handful of participants take ownership of this ongoing project. It varies from workshop to workshop.

"Editing" is an important aspect of this process. Both instructors and participants should use a critical eye and continually edit out objects that do not contribute to the exercises. We are talking about objects that are too small, too theatrical, or simply crappy-looking (no commedia dell'arte masks please!), although rubber masks of current politicians and animals are welcome These "edited" items should be discreetly returned to their owners.

The group's "pop archeology bank" should continue to expand and morph during the days as both participants and producers find new artifacts and set pieces. If there is a performance at the end of the workshop, this ritual installation provides objects and costumes that have already been tested.

EXPANSION
By day three or four, you can create a full performance installation with the props bank. This installation could be placed in an interesting part of the workshop space and work as a performative backdrop to start an advance Composition of Triptychs or a Performance Jam session. The installation gets activated and transformed by the performance jam.

List to be sent to participants a few days before the beginning of the workshop:

IMPORTANT CHECKLIST FOR PROPS:

- Personal archeology: Prior to our arrival participants are encouraged to gather a handful of objects related to their personal mythologies and iconography. These may include, but are not limited to:
 - Props: Interesting-looking objects, figurines, ritual artifacts, which are important to your symbolic universe and aesthetics.
 - Costumes: Ethnic, military, fetish, artist-made, wearable art, fabrics, etc.
 - Accessories: Wigs, hats, masks, interesting jewelry, shoes, makeup, etc.
 - Supplies useful for exercises: rope, tape, tools, etc.

NOTE: Again, please do not bring any item that would cause stress to its owner if it were in any way harmed or damaged.

Creating tableaux vivants

Pedagogical range:
Length of time: 30 minutes for series 1 and 2, 40 minutes for series 3
Level: Creative
Practical considerations: Practice the exercise in silence, or you can choose a soothing musical landscape that facilitates concentration and an introspective mood. For this exercise make sure that the room is big enough to allow plenty of space for exploration around each couple. The space needs to feel safe and intimate; it has to be properly secured from the outside view.

CONTEXT AND OBJECTIVES

This is one of the original Pocha Nostra exercises. Pocha piloted early versions during rehearsals in the mid- to late 1990s to develop original live images for *The Mexterminator* project and the Museum of Fetishized Identities.

This particularly useful exercise is the basis for the development of most of La Pocha Nostra's imagery. It functions as a kind of sketchbook or laboratory for the creation of live images. The objective is to discover and come up with original performance imagery and living metaphors that articulate the complexities of our times, our psyches, and our social environment.

The versions presented in this book have been fine-tuned and road-tested over the years. This exercise helps us to get creatively and with full respect closer to our bodies, and the bodies of others, and to discover their multiple meanings and metaphorical possibilities to create live art images.

La Saula: This exercise transformed my entire practice; it made me realize how my body is read by others. This introspective journey, ignited by someone else's touch, meant the "subjugation of the body" for me. It wasn't an easy feeling to deal with. As the exercises evolved, I came to realize that I have power, I can talk back, I can negotiate and re-interpret the suggestions and manipulations suggested by my colleague. Thus, the exercise turned into a subversion against the systemic forces of domination. The ability to constantly be able to re-negotiate the terms of the relationship was key for my body to understand this. The most important element that helped me to cross the border of any dominant and colonial power relation was the use of radical tenderness. The exercise became an embodied process of decolonization.

FACILITATION

We suggest implementing this exercise during the creative session of the day. This is an exercise in three parts, and each part can be taught one after the another in a long session, or in individual modules practiced on different days.

The instructor should provide the following notes to the participants:

1. **There should be NO SPEAKING.** Do not verbally "direct" your partner. His/her role is precisely to cede their will to you and tacitly collaborate by facilitating movement

and position shifting. But if you place your temporarily blind partner in a dangerous situation, say at the edge of a staircase or holding a huge kitchen knife, please do let them know.

2. **Participants should try to avoid the obvious and the simplistic,** including major clichés, stereotypes, and literal meanings. Everything else is allowed.

3. **Consent is a must during the exercise.** Every person has their own personal limits, fears, and phobias. Always let your partner/s know in advance about your forbidden zones.

4. **Please make sure that no clothing is removed without the consent of your partners.** You may verbally ask your partner about their limits either prior to or during the exercise. We encourage you to ask and to speak out as an exercise of negotiating boundaries; don't let your own assumptions from either side stop you creating.

5. **Is nudity a requirement in a Pocha workshop?** Answer: We have never imposed it, but it is true that a lot of participants choose nudity of their own volition because they are given a safe arena in which to try out new behaviors and identities. Remember, this is a laboratory to take risks and cross borders, so you can make choices in your own practice on bases of experience and the degree you allow yourself for experimentation. Please refer to our text called "Suggestions to consider if you decide to use nudity, including in a public performance intervention" for some recommendations. You will find this text on p. 35 in Chapter 4.

Series 1: One-on-one: Constructing a live image on someone else

PROCESS

Begin by walking randomly around the space in search of a partner as you did in earlier exercises such as "The gaze." Partners should stand three feet apart facing one another. Unlike the "Poetic ethnography," here your roles are of a different nature. One person is "the performance artist" and the other one is the "raw material" or "human artifact." After deciding who will perform these temporary roles, the human artifacts close their eyes and become compliant to the performance artists. Remember: the eyes of the "raw material" remain closed throughout the exercise.

First follow the procedure outlined in the "Poetical ethnography" exercise to become familiar with your raw material. This time it will be a much shorter exploration process. It shouldn't last more than five minutes. Recapitulating:

1. **First, engage in a brief multi-sensorial exploration of your partner.** Remember: incorporate sight, smell, hearing, and touch with sensitivity and care. Begin investigating the shape, limbs, height, skin color, hair texture, scars, tattoos, jewelry, and clothing of your partner. Discovering all these details will provide you with important information for the process of constructing your first live image.

2. **Examine your partner as an anatomical (and symbolic) figure.** Examine their bone and muscular structure and then "activate" their body to see how his/her joints, pelvis, head, and torso rotate, move, and bend.

3. **Step back occasionally and notice the interesting iconic images** that emerge as you manipulate his/her body into various positions and shapes.

After five minutes, begin carefully to construct an image with your raw material, by shifting the position of their body and working their individual parts (head, arms, legs, etc.) into interesting and dynamic shapes. You should avoid verbal direction. Manipulate their body until they understand the position you want them to assume.

You should make use of your collaborator's whole body, as well as his/her clothes and accessories, to create an "original still image" based on your own aesthetics. Don't worry yet about subject matter. It is a formalist exercise at this point.

It is important to begin to push the physical limits of the body you are working with and at the same time to be sensitive to its limits, specificities, and possibilities. It may be physically demanding for the raw material to remain frozen in certain positions for a long period of time. That's OK, as long as the position is not actually hurting them!

When the "performance artists" feel that their live image is complete (no more than ten minutes in total after the exploration), you may walk around and observe the creations of your colleagues. After a few minutes, you may "intervene" and make minor alterations to the other creations (e.g., slight changes to the position of the head, an expression on the face, the twist and tension of the body, adding or subtracting a prop, etc.). Why? It is important to begin contesting the sacred notion of authorship/ownership of an image and to establish collaborative and multi-centric relationships with your new partners in crime.

When all the creations have been viewed from different angles and distances, the "performance artists" can return to their original partners and carefully bring them back to their neutral standing position and state of dress. Again, it is important that this is done with a lot of tenderness and care. Since some people may have been holding awkward positions for some time, you may wish to offer to massage their back or shoulders. Thank them for ceding their bodies to you.

Now, the raw material has their chance for a sweet revenge! Switch roles and repeat the procedure.

When you try this exercise with your next partner you can begin to use a simple and broad theme (e.g., try to create "an image you've never seen before," "an image you would like to see in the world," or "a dream image"). Using such open parameters challenges participants to think beyond social or psychological realism, access the metaphorical and symbolic realms, and trust their imagination.

EXPANSION
The following variations can be added by instructors incrementally throughout the workshop. Take your time. Instructors should explain to the more seasoned performers that it is necessary to go step by step.

1. **Suggest more complex and racy themes:** Dealing with themes or conceptual parameters that are part of the current media-scape helps people feel more connected to the material as opposed to suggesting highly intellectual themes utilizing words such as "deconstruction" or "agency." These notions are actually embedded in the exercises and can be discussed or noted after the exercises. But they should not be part of the explanation.

Instructors can give participants two conceptual parameters to work with: fashion and religion, war and drag, crime and sex, the sacred and the profane, etc. After a few days you can begin to introduce themes centered around the body. You can find some examples in the text called "Suggested themes for Pocha exercises" at the end of Section 3, p. 153, of this chapter.

2. **Incorporate props and costumes:** Provide a theme for the exercise. After exploring and handling the body of your partner for a few minutes, go to the pop archeological/artifact installation and take one prop or costume item and incorporate it into the live image. Make sure the relationship between object and image is not a literal one. In subsequent pairings you may work incrementally with two, three, four, and finally as many props and costume items as you feel necessary. It should be a gradual process. Don't add so much stuff that your partner ends up looking like a human Christmas tree in a Tijuana storefront!

3. **Add simple movement:** After practicing this exercise a few times, you can give your creation a small, repetitive, obsessive, enigmatic, or contradictory action to add layers of meaning. Try to avoid complex choreographies and literal or theatrical connections between action and image. Remember to avoid verbal directions. Manipulate their body carefully until they understand the action you want them to carry out. They will tacitly collaborate with you by making it easier for you to manipulate their bodies.

4. **Think of the body as a blank canvas or text:** You can begin to use makeup, art supplies, and body paint. You can "mark," "decorate," "draw," "tag," and write on the body of your "raw material." Use eyeliner pencils, lipstick, water-based markers, and body paint. Use emblematic words, short poetic phrases, or simple drawings, designs, or symbols. This is a great method for complicating, narrowing, or altering the meaning of an image.

5. **Incorporate yourself into the image:** Whenever you feel that the image you have created requires your own participation, you can insert yourself into it, turning it into a diptych.

6. **Explore the syntax and connection between images:** As the group gets more advanced, you will inevitably begin to discover syntactic and conceptual relationships between images that are created independently. If appropriate, you may link your live image with another image in the room in some way. How? In discreet dialogue with the creator of the other image you find akin to yours, you might move the images closer together, place them in a particular spatial relationship with each other, or connect them physically in some way, perhaps with a long rope, fabric, or tape. Please note that syntax usually refers to language, we have transposed the meaning to refer to the physical language of performance and to the movement and conceptual phrases that connect two or more live images. In this sense, we are asking you to "read" an image and look for similar readings in the other images created by the group.

7. **Experiment with existing light sources:** You can begin to experiment with the existing ceiling lights, portable light fixtures, or natural light (peeking in through a curtain or doorway). You can begin to think of light as an important sculpting and performative element, which can actually heighten the aesthetic level of your image.

8. **Experiment with the relationship between your image and the architecture of the room:** Once people are creating complex living images, connecting them in interesting

ways, and lighting them, it's time to suggest that the group utilize the architectural features of the space – to think of the room not as a neutral (white or black) space in which to locate floating images, but as a total site with its integral specificities that can enhance images. You may choose an interesting location within the space to position your image, incorporating the surrounding walls, door frames, stairs, windows, furniture, and/or lighting fixtures. We are now entering the territory of performance/ installation.

9. **Experiment with the semantic power of labeling (or titling) an image:** By branding an image with a title, one can alter, expand, or pinpoint the meaning of the piece. Different titles can transform the same image into a comical piece, or a highly dramatic one. Titles can politicize or historicize an image. Once all performance artists have finished their images, engage in a simple semantic experiment: the creators can travel as a group from image to image and people volunteer possible titles for the individual pieces. The power of language can literally transform the meaning of the live images in front of your eyes. This simple realization can blow people's minds.

10. **Applying the exercise to oneself:** By creating a primary look and image.

Don't forget to experiment with humility: Props, costumes, paint, movement, architecture, and lighting are all an integral part of performance, but remember that the body of your partner is still the most important element. Don't bury the body in all the crap you can find, hoping that a good image will emerge. If the much-awaited "killer" image does not emerge, don't get frustrated. Your colleagues will eventually come to your rescue and help you find it.

Series 2: Collaborative tableaux vivants

FACILITATION

This exercise is a logical extension of the previous exercise. Collaborating with one or several peers without making verbal (and therefore more intellectual) decisions allows further development of the participants' performance intelligence. Decisions are made not just with the mind but with the entire body in action and with the imagination embedded within that body.

In this collaborative exercise, it is vital that the instructors make an important point clear to participants. When the two collaborating "performance artists" are manipulating their raw material, they must be sensitive to each other's aesthetic decisions. The collaborative decision-making process needs to happen without verbal negotiation but instead on a more instinctive level. Again – NO SPEAKING.

Divide the workshop into groups of four and repeat the instructions of the previous "one-on-one" exercise. This time two people create an image using the other two as raw material. Since, by now, everyone is familiar with the system, participants can go through the steps more organically and at their own pace. Make sure each group has enough space to work around them.

For the next two stages the criteria to divide the group can be determined by chance or can purposely intensify the already-existing divisions in the group: men/women; gay/

straight; local/foreigner, performance/visual artist, etc. Depending on the context and the specific composition of the group, the division can be made according to nationality, race, métier, or age. It's up to the instructors to experiment with this binary criterion. The work should somehow dissipate the apparent binary differences.

In a nutshell, this is how it goes:

PROCESS

1. **Introduce a subject matter.** The theme can be similar to those suggested in the previous exercise or related to binaries and pairs (e.g., "create a superhero and a super-villain for the new century," "create a pagan Saint and a border Madonna for the new century"). Please refer to our additional text called "Suggested themes for Pocha exercises" for some recommendations. You will find this text at the end of Section 3, p. 153, of this chapter.

2. **Within a group of four, each of the two collaborating "artists" chooses to work with one of the two "raw materials."**

3. **The "artists" examine and manipulate the body of their "raw material"** and, in silent dialogue with them, create a dynamic living image related to the image of their collaborating artist. Together the two bodies must function as a diptych. This semantic relationship should not be literal.

4. **Use all the material available, including the raw materials' own clothing and the "pop archeological bank"** of objects and costumes, including the makeup and assorted art supplies.

5. **In silent dialogue with your collaborator,** utilize the whole space and its unique architecture to position your almost-finished diptychs in an interesting location.

6. **When the performance "diptych" is completed, the creators should walk around and check out the other diptychs.** They may intervene and make small changes, additions, or edits.

7. **The roles within the groups are reversed** and the exercise begins again with the same theme.

EXPANSION

Increasing the numbers in the collaborating teams teaches participants to better negotiate aesthetic and conceptual decisions with larger numbers of collaborators. In other words, this exercise can go a long way in terms of teaching people how to collaborate in an efficient yet compassionate manner with a new group they are just getting to know. It is great practice for developing non-verbal communication/collaboration while operating in performance mode.

After trying out the diptychs a few times, the exercise can be repeated, progressively augmenting the number of participants in the collaborating team first to six (three and three), then to eight (four and four), and so on until the entire group is divided into two collaborating teams.

Series 3: Group creations: Instant "living museums"

FACILITATION

This advanced exercise is the culmination of the series. It helps participants consolidate this process and put into practice everything they have learned up until now, including how to cede their will to a collaborator, how to create living images, how to negotiate the use of props, costumes, and space with others, how to relate to the given architecture of the workshop room, how to light the images, and how to collaborate with the total group, being sensitive while intervening in other people's creations.

This fast-paced group exercise opens up exponentially the imagination of participants, providing them with an instant sense of the possibilities of working collaboratively with a large group. You may say that it is a community art project. It provides them with a strong sense of being in a collective laboratory where sketches of live performances are being created all around them. At this stage you can change the music to reflect the new theme and add a more upbeat tempo.

Facilitators need to explain the following to the group: one half of the group will construct live images using the other half of the group, collectively creating a complex performance/installation – a total artwork incorporating everything we have learned up until now. The carefully designed human bodies are strategically placed in unique spatial positions generating multi-dimensional relationships between all of them while utilizing the lighting and the architecture in the space. The result will be a coherent performance system and aesthetic universe that contains all images. Let's get to work:

PROCESS

1. **Divide the workshop into two groups,** half "performance artists" and half "raw materials." The two groups should stand facing each other.

2. **Offer the theme of the "living museum."**

3. **The raw materials close their eyes (they remain closed throughout the exercise).** Each performance artist chooses a raw material and brings them to a temporary space in the room, not too far away from the other raw materials and preferably near the prop and costume installation.

4. **Work for a few minutes examining and carefully handling your raw material.**

5. **Spend ten minutes dressing your live image,** using props, costumes, and makeup, and, if necessary, writing on the body.

6. **Once all artists are finished with a draft of their individual images, people can walk around the room** and work on other images, adding or subtracting costumes and props. The goal is to make sure all images are strong and aesthetically related. Be sure to tell the group it is important not to dramatically alter other people's creations, but simply help them be sharper.

7. **Once the group is satisfied with all the drafts, begin to place your living image in an interesting space in the room.** Again, carefully consider the overall architecture of the room. Look for niches, doorways, and interesting areas accessible to existing light fixtures or to the daylight entering through windows, etc. Use platforms or chairs to alter the level of your image. Most importantly, look for possible syntactic relationships

with the other images in progress. Remember: in this process you are working in the realm of "installation art," which means you can use the whole space and resist the the-atrical impulse to stage a "frontal experience."

8. **Now that you have found a location for your image, complete your tableau vivant** by adding a few last-minute visual elements, simple movements, or even the strategic use of language as a "prop."

9. **Once the group has completed a first draft of the "living museum," step back from your individual artworks and witness the total museum** from different perspectives, distances, and levels. This reflective moment will give you new ideas. Then you can re-enter the process and make final changes to the total installation or any individual image.

10. **When the museum is completed, the whole group exits the room and then re-enters to experience the living museum devoid of humans as if for the first time.** After a couple of minutes viewing the exhibit, the exercise is over.

11. **Return to your original image and help them shake off the image and recover,** return props and costumes to the station, and take a refreshing two-minute break. The group is now ready to swap roles and use a different theme.

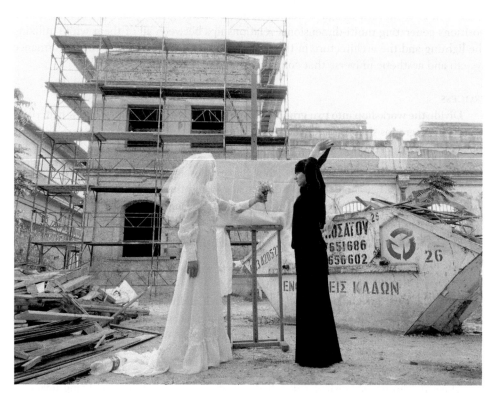

FIGURE 8.6 Tender Encounter at the Border
Photographer: Manuel Vason
Performers: Rae Uddin and Marina Barsy Janer
Athens, Greece, 2015

Staging your conceptual funeral and rebirth

Pedagogical range:
Length of time: One hour
Level: Creative
Practical considerations: The workshop space, or a visually compelling site indoors or out-
doors. Have the prop bank handy and ready. Make a sound system and light effects
available. We recommend silence and/or ritual music.

CONTEXT AND OBJECTIVES

The universe of shamanism and psychomagic actions have been part of contemporary per-
formance art since the 1960s with the work of Jodorowsky, Castaneda, and other thinkers
and artists. Franko B, an acclaimed artist and Pocha alum, reinterpreted our conceptual
altars and made this version. Years later, Franco's exercise inspired La Pocha to create a
pochified version that incorporates a rebirth altar.

This is an exercise of identity reinvention, involving neo-shamanic principles and indig-
enous traditions of funeral and altar rituals from around the world. It is also an important
opportunity for participants to work on their own with the principles they have learned
so far during the workshop.

La Saula: We have the potential to reinvent ourselves anytime. To embrace the symbolic
universe offered by funeral and altar traditions of different cultures like the Mexican Día
de los Muertos or to carnivalize funeral rites is to totally pochify the notions of social
death and rebirth.

FACILITATION

The "Pagan funeral" is an exercise we reserve for the end of the workshop. Meant to be
an individual, silent process, it involves the construction of an installation and the use of
a body as centerpiece.

PROCESS

Staging your conceptual funeral. Start by asking the participants how you would like to
be remembered, and imagine that we have the opportunity to stage your own funeral.
Then choose a partner. One becomes the "raw material," the body; the other, the "artist."
The artist stages or creates an installation representing their own funeral. Choose an
indoor or outdoor space incorporating the architecture, if you wish. After constructing the
installation, the artist works on their raw material, and then the body is incorporated into
the installation. Take time to gather the group to create a procession and appreciate each
installation. Repeat the exercise by now inverting the roles.

EXPANSION

Staging your conceptual rebirth. You can repeat this exercise on the following day of the
workshop. You can change the subject matter to create an installation for the reincarnation

or rebirth of participants, or as an exercise for total and radical identity reinvention. Each installation can be taken to the next level and visually fine-tuned to become a collective installation open to the local community.

Creating and inhabiting your post-apocalyptic home and barrio

Pedagogical range:

Length of time: 30 minutes to scout for materials, 30 minutes to create the home, and 30 minutes to prepare to inhabit the home. Give five minutes (per home) to witness the actions developed inside each home.

Level: Creative

Practical considerations: The barrio can be built in the workshop space, or feel free to expand outdoors and indoors. Have the "prop archeological" bank handy. We need a sound system and, if possible, some lights available. We recommend the use of a playlist with different genres of music to bring varied emotional energies into play.

CONTEXT AND OBJECTIVES

We learned the original version of this exercise from the performance duo VestAndPage (Verena Stenke and Andrea Pagnes) during the Educational Learning Program of the Venice International Performance Week in 2017 produced by Francesca Carol Rolla. Our Pocha version is an exercise on trash aesthetics and Chicano art to spark social imagination and reinvention.

For Pocha this is an exercise of social activism, the creation of this conceptual barrio that exists somewhere in our social imagination. It is a sociomagic act for social transformation, the path to our ImagiNATION.

La Saula: I always dream about living on another planet, a social reality in which I am Mex-Alice in Wonderland using high-tech technology made from the trash generated in government and corporate buildings. Of course, we cannot forget glitter, lots of glitter, spaceships, and glamorous, over-the-top pirate costumes from the French Avant-Garde made by far-right politicians working in a maquiladora … *long time ago in a Pocha galaxy far, far away …*

It is a surreal experience to witness the transformation of the space into a conceptual neighborhood, into a performance barrio, a clear example of imagination as activism. Trash art and Chicano aesthetics at its best.

FACILITATION

We usually do this exercise during the second half of the day during the creative session on day four or five. As the workshop advances, the boundaries between creative and foundational sessions blur themselves, so you can also do this exercise after a warm-up.

If you can, expand the limits of this performance neighborhood beyond the workshop space to include the outdoor environment. Just make sure that the houses don't end up too separated from each other.

Stress the idea that, collectively, we are a new, post-apocalyptic barrio. We are creating individually a conceptual home, but we are being conscious of what the community is creating around us.

PROCESS
Gather the participants and ask them to imagine that the world, as we know it, it is coming to an end. The only way that we will survive is by radically reinventing the way we live, and by creating a new home, a new barrio or neighborhood, with the material available around us, the "waste" of our contemporary civilization.

Ask the group to scout for unused material in the building and, if possible, the neighborhood, including trash bins. Give them 30 minutes. Once they have gathered all the materials, give them 30 minutes to build their homes. After this time, you can gather everyone and visit each home and post-apocalyptic barrio. Mi casa es tu casa!

EXPANSION
Inhabiting your own home. Give 30 minutes for the participants to create a primary look or persona. Ask them to think about how they can activate their homes using some performance actions. They can mix and match ideas from their own work or use what they have created or discovered so far. They are welcome to use the prop table for this.

After they have created their primary look, ask participants to prepare a mini-performance of five minutes only. We advise five minutes because we want to give time and focus to each participant. Once the participants are ready, create a collective visit to witness each mini-performance.

You can also divide this exercise into two parts and perform it during two different days. You can implement the exercise at the end of the session and then leave the homes overnight and the following day start with the inhabiting part of the exercise after a warm-up.

You can even go further and use this post-apocalyptic barrio as a performative template of an open salon and create an entire performative experience for a potential audience.

Human collective altars

Pedagogical range:
Length of time: One hour
Level: Creative
Practical considerations: In the past, we have used religious music from different cultural traditions. The exercise can take place in the workshop space or an alternative place indoors or outdoors. Just remember that privacy is a must.

CONTEXT AND OBJECTIVES

This living and/or dying dioramas exercise is another postmodern, and postcolonial, interpretation of an ancient ritual performance practice in which the human body becomes the centerpiece for a collective altar-making project. Throughout the world, from India to indigenous America, humans have constructed elaborate altar pieces around the corpses of deceased community members. La Pocha has turned this practice into an experimental and highly politicized community arts project.

The main objectives are to continue learning to negotiate aesthetic decisions within a large group and to introduce the notion of the sacred in performance. This might be the most challenging collaborative exercise in this section of the book, since it involves a large group making decisions regarding one single artwork and one single body.

La Saula: I was the body, I turned into a blank canvas, I was text, and I was a collective artifact. I discovered my migrant body, I was a radical advertisement against violence. I felt the respect and radical tenderness of the group. I became a living hypertext and the positive or negative messages on my body did not affect me. My body can be written and rewritten as many times I want. I return to my collective identity and soul.

FACILITATION

We suggest implementing this exercise after a break. It is also a good exercise to close a session. It is important to choose a subject matter for the altar beforehand. When introducing this exercise for the first time, Pocha Nostra usually proposes one altar for a "fallen pop star" and another for a "fallen immigrant". Please refer to our additional text called "Suggested themes for Pocha exercises" for more recommendations. You will find this text at the end of Section 3, p. 153 of this chapter. Practice the exercise in silence, and allow the group to make the decisions. Avoid canceling each other's suggestions. Practice Aikido, work with the suggestions from your peer, and reinterpret them instead of rejecting them.

Ask for a volunteer who is willing to offer their body as the centerpiece (raw material) of each altar. As in prior exercises, the person performing this role must close their eyes as if he/she was the "raw material" or "body artifact."

If your group is larger than 16 people you should divide the group into two and create two human altars with different themes simultaneously. Pocha generally proposes an altar for the "fallen immigrant" and another for the "fallen pop or porn star" to give a complex spectrum of topics and moods.

PROCESS

The following instructions are for creating a single altar.

1. **Now each group of creators should in turn divide into two teams** (negotiated between themselves): "body stylists" and "altar designers." One team will be responsible for decorating and dressing (styling) the body. The other group will decide where in the room to locate the "altar," and will design the ritual installation or backdrop that will contain (or frame) the human body. Both of these simultaneous activities should take around

20 minutes. During this time, while one group is decorating the body, the other group is constructing the sacred environment that will eventually host the body with objects, set pieces, and fabrics, and beginning to light the environment. All these collaborative processes should take place without any verbal negotiation.

2. **When both of the two independent projects are close to being ready, the body/corpse is carefully inserted into the ritual installation.** The body can be lying either on the floor or on a table, standing inside a niche, or seated on a chair. At this point the "altar designers" and "body stylists" will complete the total altar together (another ten minutes) by treating the joint images as one single artwork. It is crucial to pay careful attention to the choice, placement, and syntax of the individual objects in relation to the body, and everything in relation to the total installation.

3. **When the image is nearly finished, the participants finalize the lighting of the human altar**, still negotiating without speaking.

4. **Once the altar is completed, the creators can spend a few minutes reflecting on** the image, and editing out any unnecessary objects.

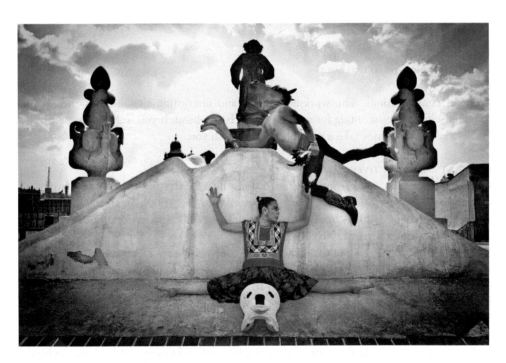

FIGURE 8.7 Urban Guerrilla Intervention
Photographer: Herani Enríquez Hache
Performers: Alexandra Zamudio and Gerardo Juarez
Mexico City, 2014

5. **At this point, the instructor can take the opportunity to engage in a critical pedagogical moment with them:**

 a. Ask the group to offer possible titles for the image.

 b. Ask whether any participant would like to incorporate themselves into the human altar as a diptych.

 c. Ask the participants "to activate the altar with a simple ritual performance action."

 d. If you are working with two altars you can then invite one group at a time to witness the other human altar and engage in the critical moment for both groups.

EXPANSION

After trying this exercise a few times with a large group, you can ask for two volunteers, create an altar/diptych, and use the images as a performance installation for a jam session by inviting the rest of the group to insert themselves into the image and slowly activate the altar.

Guerilla interventions into multiple spaces (indoors/outdoors)

Pedagogical range:
Length of time: One to two hours
Level: Creative
Practical considerations: The workshop space, and interesting sites indoors and/or outdoors. It requires scouting for suitable places beforehand. If you want to have a playlist available at all times, take a portable speaker with you.

CONTEXT AND OBJECTIVES

Guerilla performance interventions have a long history, starting in the early twentieth century with certain Dadaist and surrealist pranks. In the 1960s Brazilian theater artist Augusto Boal suggested hundreds of ways to think of public spaces as potential worksites, and site-specific performance became a genre.

After a week of working in the same space for hours at a time, it is important to break up the routine and challenge the participants' sense of the familiar by working in different spaces. By doing so, the participants learn to work with architecture and site-specificity, both formalistically and conceptually. Because these are "quick and dirty" performances, built in five minutes and viewed for only a few minutes, participants learn to make instant decisions based on compositional elements (place, pose, direction, depth, levels, movement, and rhythm) practiced in the composition of triptychs, and to commit to those decisions.

La Saula: I used to freak out when I needed to improvise in a creative process. I was one of those who thought too much, and that paralyzed my creativity – it never was fun. With this exercise, I learned to accept that is totally OK to fail; that some creative interventions are sometimes good and others not. When my body understood performance as an ongoing, unfolding journey, the chances of falling were as not as important as

the broader journey. I saw that images are active particles that emerge, disappear, and re-emerge in different forms. As soon as I arrive at an image, a departure from it unfolds. The body is the vehicle for it. The liberating moment, discovered with this process, is to know that if you arrive at a "bad image" or a "problematic image," you can find your way out. The key is to trust in your body intelligence. It is not about finding the right images, stabilizing them, and reproducing them successfully over time. Let's leave that to the performing arts. WARNING: if you find this reflection too pataphysical, let's blame the influence of watching *Blade Runner* while writing this text. At the end, it's a creative blast to infiltrate charged sites and institutions with a band of radical artists willing to do anything.

FACILITATION
We recommend doing this exercise as part of the creative session after the break. Take into account that it is a long exercise, and make sure that you have introduced "Compositional triptychs" before doing this exercise.

To choose your sites, start exploring other spaces in the building or surroundings where you are working. Once you have exhausted these possibilities, you can begin to explore other interesting buildings and public spaces in the city.

In the space or building where you are already working, you can definitely locate additional sites for creation, including interesting adjacent rooms, a large closet, a courtyard, a stairwell, a long hallway, the windows of the building façade or a large balcony, perhaps even the roof of the building.

When choosing a site away from the working space, we suggest that you call ahead if possible, so that the chosen institution (victim!) or the authority overseeing the site knows you are coming in persona with costume and props. If you don't entirely disclose the nature of the intervention, most spaces will get a kick out of a bunch of performance artists activating their environment for a couple of hours. Just make sure that nothing is damaged and you don't break (too many) decency laws!

The instructors in dialogue with the producer of the workshop and the local participating artists can do some research in advance for possible sites. For example:

• Indoors: the studio of an artist friend, an abandoned building, a mall, a library, an unusual local museum.
• Outdoors: the courtyard or patio of a local museum, an interesting yard or garden at the home of a workshop participant or patron, a site in the desert or woods, a public plaza, etc.

The question of nudity and sexualized imagery in public spaces is a site-specific matter and should be addressed by the whole group before the session begins. In Evora, Portugal, La Pocha had private access to the gorgeous courtyard of a medieval church/castle in a small town. We were doing precisely this exercise, and suddenly a French performance artist stripped naked and climbed to the top of the highest spire and straddled the crucifix. His flowing blond hair and bare butt was visible to the whole town that gathered in the square. This strange apparition is now part of local folklore. Be aware that city "public" sites in many countries are often actually private and highly surveilled. As this exercise might involve a "run-in" with authority (or two!), it should be optional. Please refer to

our text called "Suggestions to consider if you decide to use nudity, including in a public performance intervention" for some recommendations. You will find this text on p. 35 in Chapter 4.

PROCESS

On the day of the guerilla interventions, ask the participants to assemble at the workshop space (if the exercise takes place in the building) or at the chosen location. Then you can list the potential "performance" sites and the overall ethical, conceptual, and political parameters of the location.

The group then divides into two or three smaller groups of five to seven people. The groups should be as eclectic as possible in terms of race, nationality, and gender, and each group should have a deejay/timekeeper.

The first exercise is performed without any props or costumes, just to get familiar with the system.

The first group chooses one of the suggested sites for their "intervention." Once they have agreed on a site, the clock is started. They have five minutes maximum to explore the chosen space and create an instant living installation. They are allowed to use anything they are wearing, anything they find in the space, and most importantly the architecture of the space itself. They may create a series of solo images and/or duets, trios, or a group image. Ideally, each image must make sense both by itself and in relation to the total world they are creating.

After five minutes, the timekeeper brings the audience (the participants of the other groups) to the site. He/she will also tell those "inside" when the "audience" is about to enter. The audience finally enters and "discovers" the performance/installation. They should take a few minutes to check out every image from different angles and perspectives. Once they have all seen it, they can offer their applause.

Then, the members of group 1 disassemble their images as those in group 2 now go to their chosen site and begin to construct their living installation. After five minutes have elapsed, the others (groups 1 and 3) join them in the space and view the performance/installation of group 2. Once this has been completed, the members of group 3 go to their space to begin to work while those in group 1 brainstorm about their next performance site. The performances continue in this rotational format until all possible sites have been exhausted. Participants waiting to experience an installation should do so in another room or somewhere where they cannot see those about to perform. When performing outdoors, your chosen sites are more likely to be different areas of the outdoor space, rather than separate rooms.

After a few rounds of creating living installations without props, you can now invite each participant to bring a few props and costume items from the station. These items can be shared with the other members of the smaller group. If you go outside, take a bag with the most exciting props and costumes to be shared.

EXPANSION

1. **Guerrilla interventions allocating group categories.** You invite the participants to join the following group categories focusing on different aesthetic interests. We create these

categories in order to give space to experiment with different styles, approaches, and learning concerns.

* Nudity (optional)
* Conceptual minimalist
* Political actions and activism
* Ritual
* Poetic – spoken word

Each group is not restricted from incorporating any of the other categories. As an instructor, feel free to create new categories together with the group to address their particular interests.

2. **Guerrilla interventions in a museum.** An advanced variation can involve an interesting local museum of oddities, a natural history museum, or other vernacular museum displaying flamboyant dioramas. Ask your producer to help you obtain a permit for the group to spend a day at the museum in costume using the existing dioramas as backdrops for impromptu solos, duets, and group pieces. Weird museums are often empty, and their directors might not mind hosting you. If you are careful, you may choose to go without permission; but be aware that you may be denied entry or be asked to leave if they find your presence disruptive or scary. Be strategic!

3. **Guerrilla interventions in a public plaza.** Another variation involves mapping out a large public plaza on a busy day. You begin at noon in the workshop space. Each participant spends an hour putting on costume and makeup. If the plaza is nearby, you walk in a processional line to the site and convene at the center, forming a circle in silence. If the plaza is farther away, it might be more practical to cover up and travel to the site in a more convenient manner. If this is the case, try to enter the space in a processional ritualized manner as described above. After a couple of minutes the mapping begins: one at a time, each person leaves the circle and walks in a straight line until they reach the edge of the plaza or another obstacle. Once you reach the end of your individual path, freeze for a minute and then walk another straight line in a different direction. Continue this process. If you encounter other colleagues on the way, you may find unusual ways to interact with them for a few minutes, then proceed in another direction. During this process, you can also create tableaux by inserting yourselves into architectural structures, sitting on the edge of a fountain or at an outdoor café, and interacting with the public. If your personas are interesting-looking or maybe slightly humorous, people will play with you. After a predetermined period of time, everyone reconvenes at the center of the plaza in a circle and precesses back to the space or to the next intervention site.

Note: To understand the complexities of public performance interventions, please refer to our additional text called "Suggestions to consider if you decide to use nudity, including in a public performance intervention" (on p. 35 in Chapter 4) and "Making the most of your beautiful arrests" by L. M. Bogad, "The unnoticed city: Urban radical interventions

against invisible bodies" by Reverend Billy and Savitri D., and "Metaphysical musings and empirical explorations: Turning the body visible in the city" by Dragonfly (p. 225 in Chapter 9).

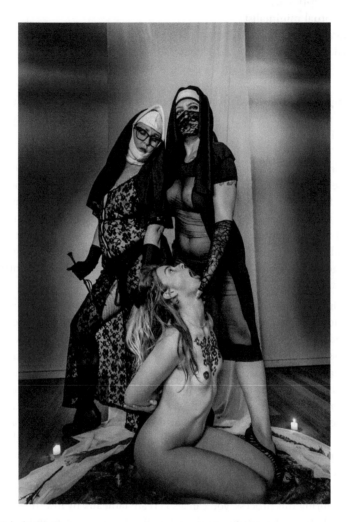

FIGURE 8.8 Unholy Trinity
Performers: Balitrónica, Holly Walker, and Cyd Crossman
Photographer: Donatella Parisini
Courtesy of Donatella Parisini and Pocha Nostra archives
Byron Bay, Australia, 2018

Compositional triptychs

Pedagogical range:
Length of time: One to two hours
Level: Creative
Practical considerations: The workshop space, subsequently you can take this exercise to interesting sites indoors or outdoors have the "prop archeological" bank handy. We need a sound system and, if possible, some lights available. We recommend the use of a playlist with different genres of music to bring varied emotional energies into play when introducing variations.

CONTEXT AND OBJECTIVES

This exercise for three artists was introduced to us by performance artist Allison Wyper. It was immediately adopted and pochified. In time, it became an important exercise in our pedagogy to practice movement, location, and composition. We found it especially useful as a point of departure for guerilla interventions into multiple spaces and for our "Pocha jam sessions."

The "Compositional triptychs" begin as a purely formalistic exercise that does not involve the "prop archeological" bank of props or costumes, and there is no particular subject matter. The objective is for you to put into practice your "performance intelligence," making compositional decisions in situ within a live art context that includes your relationship with space, body, and other participants. Deciding when to enter an image and where exactly to place yourself is an important lesson for image composition; in this sense the exercise echoes the way in which a visual artist works. The exercise gets much more complicated with the introduction of props and costumes and with an incremental increase in number of participants.

La Saula: I never experienced a fluid creative process until I became comfortable with this exercise. I felt constricted trying to be creative under the forms and parameters that traditional art expects creation to be. When I did this exercise with Pocha, there were two concepts from the instructions that caught my attention: the "performance zone" and the "civilian zone." It immediately sparked my imagination because they opened up the possibility to unsettle the rigid borders of creation, allowing identity, social, and space permeability in my creative process. In this pedagogy, the border between our civilian experience and creation is porous and necessary. It is like dancing a minimalist norteño dance with pointy red boots and leopard underwear in the Museum of Ethnology in Vienna.

FACILITATION

We recommend implementing this exercise after the break.

During the break, light the space, creating an area approximately 16 feet long by six feet deep (about five by two meters), either in front of a wall or in an interesting corner of the space incorporating the architecture. This space should ideally be opposite the prop and costume station. The rest of the workshop/rehearsal space should remain fairly dim.

Create an imaginary fluid borderline (or make an actual line with tape) dividing the "performance zone" from the rest of the space, which we will call the "civilian zone."

The facilitator must highlight, as the exercise unfolds, the effective interventions that make an interesting image. Comments related to compositional elements such as place, pose, direction, depth, levels, movement, and rhythm are vital to understand the skills we want to sharpen with this exercise. It is important to notice how each compositional element interacts with the others, preventing one element from becoming too influential over the others. This is an important element that separates performance art from theater or dance and puts it closer to the skills needed in visual art. Participants are often amazed how the images produced in this exercise are so synchronized and aesthetically related.

If an image does not work, it is important for the instructors to try to explain why, and then get the exercise going again.

Potential problems that may require the verbal intervention of the instructor include:

* All three artists are clumped in one area and not considering the entire space.
* The live images are totally disconnected.
* All three artists are on the same level, i.e., standing or lying on the floor.
* After you add movement, all movements are happening at the same rhythm.
* Someone is pantomiming a literal action.

To facilitate a dynamic rhythm, encourage participants not to think too much but to let their bodies take a decision. We should not agonize by thinking too much about the creation of a good image. Instead, highlight that some interventions might be good and others not, and that this is OK.

PROCESS

The group stands in the "civilian zone" facing the lit area or "performance zone." When the music starts, the exercise begins. One person enters the performance zone, creates an interesting symbolic image with his/her body, and freezes. After a few moments of assessing this establishing image and the changed space, another person enters the performance zone, finds a place, creates a second image, and freezes. This new image should somehow counterbalance the first one in terms of composition (location, depth, and levels). Once these two images have settled (after only a few seconds), a third person goes in and completes the triptych.

When the group is satisfied with the composition, thank the performers: they can now return to the civilian zone. As soon as they cross the imaginary border between the two zones, the next person should immediately enter the "performance zone" and create the "establishing image" for the next triptych. The exercise continues in this way, with each "completed" image comprising three bodies.

What becomes immediately apparent to the whole group is that the compositions created in this exercise are the result of all the prior exercises. Participants are often amazed how the images produced in this exercise are so synchronized and aesthetically related.

During the first ten triptychs, the instructors should continue to provide verbal instructions and instant critiques guiding the compositions just as explained in the FACILITATION section. Once the system is working, participants can continue alone

without verbal comments from the instructor, but don't forget to call attention to a good moment or image.

EXPANSION

As the workshop progresses, practice some variations of the triptychs. Each new variation increases the complexity of the exercise. Build from one to the next. Eventually you may wish to sample from all of them:

1. **Add set pieces and furniture:** You may add a chair, small platform theater cubes, or even a ladder to increase the possibilities for levels within the performance zone. Participants should be able to freely move them around or take them out of the space whenever they feel like it. Make sure not to crowd the performance zone with too many items.

2. **Add movement:** One of the people in the triptych (the first or the last) can create a moving image. The movement can be a repetitive gesture or action, or a traveling image that moves, walks, or dances across the space at varied speeds. The movement should not be literal or representational. Pantomime is outlawed! Orthodox pantomime is strictly prohibited by Pocha decree!

3. **Begin adding props or costumes:** Every time a performer enters the "zone" they can bring one object or piece of costume and incorporate it into their image. When they step out of the performance zone, they should return to the props and costume table and replace the used prop or costume. The idea is for the performers to grab something new to use the next time they enter the performance zone.

4. **Retain a central or "primal" image for several triptychs:** If one person creates a particularly striking image with a lot of "performance gravitas," tell them to remain as the central image and see how wildly different scenes can be created around that image by two other participants who continue with the exercise, changing places as before. If the image is strenuous, this turns the action into an unintended endurance piece. After the central performer has remained inside for three or four rounds, it can get even more interesting.

5. **Increase the number of participants:** After a few days playing with "architectural triptychs" and when participants least expect it, ask them to add one more person to the experiment. After experimenting with four participants, increase the number to five, and so on until half of the group is inside the performance zone. As you increase the number of participants, you are venturing into the territory of a "jam session" and the performance zone is constantly active.

6. **Taking the exercise to other indoor and outdoor sites.** Choose interesting places such as parks, monuments, streets, galleries, museums, rooms, or a building with an interesting architecture. For instance, one of our favorite places to use is a tiered theater seating; the entire exercise happens not on the stage but in the seats, and the participants become an audience in total "crisis." With this specific version, we love to reverse the gaze of the spectator, turn the tables on the audience, and destabilize 500 years of the fourth wall. You can add props and use this version to do a performance jam session. To understand the complexities of public performance interventions, please refer to our additional text called "Suggestions to consider if you decide to use nudity, including in a

public performance intervention" (on p. 35 in Chapter 4) and to "Making the most of your beautiful arrests" by L. M. Bogad, "The unnoticed city: Urban radical interventions against invisible bodies" by Reverend Billy & Savitri D., and "Metaphysical musings and empirical explorations: Turning the body visible in the city" by Dragonfly (on pp. 223 and 225 in Chapter 9).

Lowrider Chicanx biomechanics

Pedagogical range:
Length of time: 20 minutes
Level: Creative
Practical considerations: For this exercise, make sure that the room is big enough to allow plenty of space for movement between the participants. You will need some pedestals or platforms big enough for participants to move and dance on them. If not, you can mark the space with a tape.

CONTEXT AND OBJECTIVES
Inspired by Meyerhold's body training technique, Pocha presents its very own take with the "Chicano biomechanics" exercise that we've divided into two parts. This exercise combines previous Pocha exercises such as "Doppelgangers," "Poetic ethnography," and Aikido together with some Chicano cyborgian imaginary. It involves multiple negotiations between the body (raw material), the participants (the artists), and the multiple and simultaneous images and movements imprinted on the body.

La Saula: This exercise was inspired when I performed *The Corn Man-Xochipilli* (the god/goddess of corn) at the Museum of Contemporary Art in Mexico City in 2016, and was fine-tuned later on in a Pocha workshop at the Center for National Arts in Mexico City. At that time, I started to experiment with edible performance inspired by the work of performance artist César Martínez in Mexico City. As a pedagogue, I was obsessed with developing a way in which the performer's body can serve as a canvas for the projection of actions and images from the audience and embodying them in situ. In *The Corn Man-Xochipilli*, my body is completely covered with edible corn, and people are invited to eat directly from my body in a cannibalistic, decolonial act against historical violence. At the Museum, many audience members felt compelled to directly manipulate my body all at the same time. It felt almost as if I was part of an Aztec human sacrifice. Peeling the corn from my skin, they vocalized with me and directed me, suggesting poses, images, and even voiced interventions, all at once. All my boundaries were tested to the limit; however, the audience were careful with my body.

FACILITATION
We recommend implementing this exercise after doing "Doppelgangers," "Poetic ethnography," and Aikido, during the creative part of the workshop.

Emphasize the idea that this is a collective creation that uses the principles of Aikido. You can start in silence and then, once there is an understanding of the dynamics of the exercise, incorporate some music that inspires the body to move.

Please, make clear that the exercise is inspired by the idea of a Chicanx cyborg, but this does not mean that they need to act literally as one. It's not a casting call for *Terminator Returns*. This exercise is about copying and pasting and negotiating simultaneous suggestions between the "raw material/cyborg" and the "artists/audience."

PROCESS

Divide the group into two. The facilitator chooses one person (we recommend starting with a good mover) for each group. We put our human cyborgs on a pedestal on the center of the space.

Part 1: Collective sculpture

Ask each group to create a sculpture on the human cyborg. Each group member manipulates the body and suggests a body position or gesture based on the history of art. This is a process that can last between five and ten minutes. To get to understand the system, don't allow many simultaneous interventions at the same time and allow enough time for the cyborg to embody the collective image suggestions. The aim is to create a series of poses and images, inspired by classical images from the history of art in the West. Each gesture must be syntactically related to the previous one.

Part 2: Teaching the cyborg how to move like a human

We teach our cyborg to move like a human by using the archetypal gestures of the first part as a starting point. This time, try to give fluidity of movement to the cyborgs. Here we can apply the principles of the "Doppelganger" exercise by carefully inserting oneself into the sculpture and suggesting a sequence of movement; alternatively you can do the same facing the cyborg and using your hands. Everyone should collectively intervene while the cyborgs are in full motion. At the same time, the Chicanx cyborg samples, copies, and pastes all the suggested moves until it gains autonomy and frees itself and prepares to fight against the Far-Right post-apocalyptic monsters!

EXPANSION

If you have a very advanced group of movers or dancers, you can have four cyborgs at the same time, and the entire group can walk around and intervene with each cyborg randomly. Alternatively, you can repeat the exercise until all participants have had the experience of becoming a Chicanx cyborg.

The Pocha catwalk

Pedagogical range:
Length of time: 30 minutes for series 1 and 2, 40 minutes for series 3
Level: Creative
Practical considerations: You can choose a high-energy, rock and roll musical landscape. Choose a space in the room to construct a catwalk, either with some platforms or by marking the floor with tape.

CONTEXT AND OBJECTIVES
Pocha have used different identity catwalks and instant photo karaoke during the last 15 years. In the Ex Teresa Arte Actual in Mexico City, 2012, Pocha produced the biggest performance catwalk called *El Cuerpo Diferente*, a performance catwalk in fashion-show style with more than 20 artists with "different" bodies. It was an incredible locura.

La Saula: I had the opportunity to co-produce and co-direct this epic event together with Gómez-Peña. At that time, Gómez-Peña felt seriously ill, and I had to take over the direction of the overall event: my graduation ceremony as a performance director and deejay! The main objective was to know our bodies, and to celebrate them with both humor and respect. We had the fat body, the queer body, the super-skinny body, the trans body, the body with physical and mental "disabilities," the indigenous body, and more.

FACILITATION
This is an exercise that includes three catwalks, and each of them can be introduced one after the other in a long session, or as individual exercises practiced on different days.

Catwalk 1: The different body catwalk

PROCESS
One by one, each participant presents themselves in a pedestrian mode, walks to the end of the platform, creates an image, walks back, strikes a pose/image, and exits.

For a second time, one by one, each participant presents themselves in a pedestrian mode, but this time they remove as many clothes as they want (ending up topless, in underwear, panties, you decide).

For the second part, you will create partners and give them humorous and problematic titles that expose the stereotype. It is a way to push the stereotype to the limit, until it is rendered absurd by its own weight. Please don't take the labels given to you seriously. Exploring hyper-types (stereotypes on steroids!) is an important part of the Pocha Nostra process of exposing political absurdity through funhouse mirrors. Here are some examples:

- Typical arrogant Argentine intellectuals
- Ethnic Adam and Eve. The Original Sin

- Are they really Latin Americans?
- The exotic señoritas
- Angry deterritorialized Chicanx from the north (note: they don't speak Spanish properly)
- Machos or Machas?
- The over-sexed Latinx body
- Typical global hipsters
- The normative couple or the abnormative couple?
- Typical respectable teachers or academics

Catwalk 2: Creative catwalk with primary look

PROCESS

In this series, we focus on looking for interesting actions and poses for instant primary looks and personas. It is an effective way to embody and give movement to an image that later might be part of the performance playlist.

Using the objects and costumes from the prop archaeological bank, ask the participants to pick their favorite subculture onto which they can embody cultural projections and fantasies. Allow 15 minutes for them to do this individually. Once the time is up, ask each of the participants to find a partner and stand in front of them, then each partner in each couple helps the other to refine their persona by functioning as a stylist in two ten-minute turns. Ask participants to look for three poses that emerge from the interaction between their body, the costume, and the props. This is done individually in the space of 15 minutes.

Next, ask participants to gather in a line beside the catwalk as if they were a group of supermodels of radical differences. Each participant follows the next pattern, with model A occupying the catwalk and striking one of the three poses and freezing, then model B joins and strikes exactly the same pose. A and B freeze for a second, and A walks to the front of the catwalk while B stays frozen. A strikes two or three poses, walks back towards B, and exits. C enters the space and strikes a pose with B, they sustain the image for few seconds and B walks to the front of the catwalk, strikes two or three poses, and walks back and exits. Then D joins C and we repeat the system for the rest of the participants. Rehearse this system a few times so the participants get familiar with it. To close the catwalk, invite everyone to walk on the catwalk, creating a typical fashion parade grand finale, just like in the fashion capitals of the world Paris, Milan, Salt Lake City, and Tijuana. You can extend this exercise as a way to kickstart a performance jam or as a format for an open salon.

Catwalk 3: Catwalk with *Photo Karaoke*

PROCESS

For this variation you invite a local photographer who is familiar with the art of performance. It is an exercise of instant image creation for the camera in total collaboration with the photographer. The students learn the difference between live performance and photo performance. It is a rock and roll, non-stop experience.

1. Ideally the photographer has been invited to see the catwalk exercise or has been around witnessing the process.
2. **You follow the same process as for the catwalk exercise,** the difference is that at the front of the catwalk the participant sustains the image for longer for the photographer and the camera. The photographer and the instructor can help the participant to find the right pose for the camera. You can create instant duets, small groups, and perhaps at the end a collective image.
3. **You can invite two photographers to have two photoshoot stations, and rotate the participants between these two stations** in an ongoing system of image creation for the camera. You can create mini-installations with the props available to create a background for the image. This is a collective process in which the entire group helps with props, costumes, lights, and makeup.

Note: This expansion it is also a way to close a short workshop that does not involve a performance presentation. The photos taken become a collective archive, and the best photos are shared with the participants for their portfolios.

> Often during the workshop, after an image has been created, the Pocha pedagogue will address the group and ask us rhetorically, "What the hell was that? Was it a sculpture, a performance, a painting, a poem, an installation, an assemblage?" I am only interested in art that has an identity crisis about itself. As you organize your images, remember to make your decisions with your heart and your body. Avoid talking. Avoid the brain. Thanks to the paradoxical and contradictory nature of truth, you will be able to create images that communicate beyond your limited conceptions.
>
> (Perry Vasquez, artist/writer)

SECTION 3: CONCEPTUAL AND POETIC EXERCISES, OPENING SPACES OF INQUIRY

> Gómez-Peña, Balitrónica, and García-López adopt necessary "survival aesthetics" where poly-lingual, transcultural, and international performance artists thrive like merolicos del Zocalo vendiendo todo en la gran Tenochtitlán and inventively employing strategies from a borderless open space to imagine and forge the birth of an imaginary troupe, La Pocha Nostra cons afos y otros compatriots beyond any imposed nationalism that is divisively set to control our most precious weapon: the decolonized body ...
>
> (José Torres-Tama, performance artist/poet)

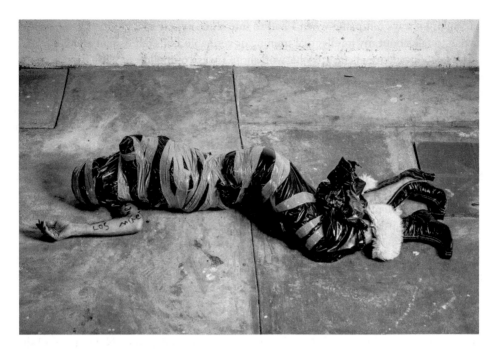

FIGURE 8.9 Forgotten body at the border
Photographer: Jalil Olmedo and Irwin Azair Cruz
Performer: Bruno Varela
Oaxaca City, Mexico, 2019

Poetic introductions

Pedagogical range:
Length of time: 15–20 minutes
Level: Conceptual
Practical considerations: Make sure that there is a comfortable setting, with everyone either seated or standing in a circle. Try to manage time efficiently so no one takes too long to introduce themselves. The ideal rhythm should be quick and spontaneous.

CONTEXT AND OBJECTIVES
Introductions can sometimes feel very formal, academic, and even competitive. We want to avoid that by offering a poetic way of introducing ourselves that avoids conventions and formalities. Instead of a long dissertation about the work you are currently doing and/or your training experience, the exercise encourages you to present yourselves in a brief and creative way. The aim is to build trust on the basis of our human condition; we want to people to relax and talk about their identities.

La Saula: I always felt panic when I had to introduce myself to a group of strangers, and having to talk about my intellectual training or verifiable skills felt distant and cold. When I first introduced myself in a Pocha workshop, I was compelled to shift from a typical, ego-driven presentation to confront my own identity, and notice the complexities of the group. For once, the idea "mind over matter" that infuses "classical" creative training and is translated in the typical phrase "*leave yourself outside the rehearsal room to enter the world of creativity*" was challenged by this very simple exercise. I'm including some of the Pocha intros so you get the idea:

Saula García-López: MX/South Africa/Glasgow/Canada: I am a neo indio Mariachi living somewhere between my motherland, and my adoptive ones. I embrace my three-spirit-multi-gendered identity and defy my global designer ID through performance, a glass of Tequila, and a music score that starts with *Ur so Gay* by Katy Perry.

Michèle Ceballos Michot: Phx, Az, NYC, Bogotá, Lafayette, Michèle + transforming patterns of thought, beliefs, moving whole body, spirit diving into soul, surrendering mountain pose, grounded, floating.

PROCESS

On the first day of the workshop, before or after providing the "Notes to workshop participants" (Chapter 6), provide poetic introductions of yourselves one by one to the rest of the group by first gathering in a circle.

We then start by explaining that this introduction compares to a poetic tweet: short, direct, and honest. After saying your name and the city and country you come from, provide a short, poetic, conceptual, performative, or humorous definition of yourself. People come up with extremely original ways of presenting themselves that often say more about their work than a mini-CV.

You can follow this very simple formula with the intro "Tweet": name/city + discipline + poetic description of how you feel today/why you are here.

Poetic exquisite corpse

Pedagogical range:
Length of time: 15 minutes
Level: Conceptual
Practical considerations: Make sure that there is a standing forming a circle. One of the instructors performs the role of a "poetic DJ." An audio device is useful if you want to record the session.

CONTEXT AND OBJECTIVES

This quintessential Pocha exercise was inspired by the surrealist game of the exquisite corpse of the early twentieth century, in which someone starts a drawing and passes

it around for other people to continue. This game was pochified by blending it with word games that hip-hop crews from the 1980s and 1990s utilized to develop poetic material.

This game re-vindicates the importance of poetic gnosis as a tool to chart new territories of performance. Given that our workshop communities are formed by a very diverse set of disciplines, ages, genders, and ethnicities, this exercise helps enter a space of radical listening in a new community, and also results in a potent laundry list of issues, giving voice to what is most urgent to a given community.

La Saula: I admire the power of many spoken-word artists such as my carnalito Guillermo Gómez-Peña, Micha Espinosa, our Pocha collaborator, and Paloma Martinez-Cruz, my writer midwife, among many others. As a body-based performance artist, one of my biggest challenges has been to give sound and voice to my inner body. I constantly feel that something is about to come out, but it gets stuck. With this exercise, I found an effective entry point to let my voice out of the closet! It was throughout a communal unison voice that I found my path into the spoken word.

When I am the Indio metrosexual, asexual, bisexual, transsexual or very sexual, I felt my body pumping, soy muy caliente, I am a skeptical MexiCANadiense, Mexican't, Euro-Méxicano, Chicano, Chica-No, Chica-YES artist. I am a reverse "wetback" coming from North to South. This is the post-occupation movement, the revolution that Trump occupied. I occupy no comfort zones in my body and in my ancestral motherland.

FACILITATION

This exercise is a great way to open up the scope and possibilities of the performance field and discover how the group inhabits personal and political territories together. After this exercise, you can warm up as usual and start the day, or you can use it to kick start the session after your lunch break.

In this game you or one of the instructors performs the role of a "poetic DJ." Your role as DJ is to make sure that "the word" circulates constantly and evenly and that everyone participates in the making of a polyvocal chant poem, even those who are less talkative.

It is useful to set a few simple guidelines:

* Participants should be clear and somewhat loud when speaking.
* If two or three people speak at the same time, make sure they repeat their phrases at different times for clarity's sake.

PROCESS

You start by making a simple, open-ended rhetorical statement. One by one, in no particular order, people begin to complete the "trigger" statement with brief poetic words or phrases. As people engage in this creative form of call and response, you may snap your fingers at the end of each phrase in order to add continuity and a dynamic rhythm to the poetic exercise.

Let's say that the trigger statement we use is: "I do what I do, because if I didn't …" Then someone answers, "… I would go mad." Then, as the instructor, you repeat the trigger phrase and someone else yells out, "I couldn't face myself in the mirror," and so on. After a few rounds, people get increasingly freer and more creative, until the experience becomes a collective chant or spoken-word "exquisite corpse."

If people choose to close their eyes and concentrate on the meaning, musicality, and rhythm of the language, it can be an even more powerful experience.

EXPANSION

In every poetic mapping session, one person can volunteer to record the session with an audio device or act as a scribe and write the collective poem as it happens. These performance poems are then transcribed and shared with the group, sometimes posted in the performance space or uploaded to a workshop blog. The transcripts of these poetic sessions read as amazing performance scripts! (examples of texts generated by this exercise can be found on page 232 in Chapter 10).

Here are some triggering phrases that have worked for us. If the trigger statements play with positive and negative open endings (samples 1 to 5), start with the positive phase for a few minutes and then switch to the negative when the participants least expect it.

1. "Performance (or live art) is …"/"Performance is not …"
2. "My community is …"/"My community is not …"
3. "My identity is …"/"My identity is not …"
4. "I make art because …"/"I make art because if I didn't …"
5. "If I could transform the world I live in with my imagination, in my world there would be …"

Note: You can find some examples of poetic work generated during our workshops in Chapter 10. If you are looking for exercises on how to work with voice, please refer to "How to use voice in the Pocha Nostra method" by Micha Espinosa in Chapter 9, p. 228.

Daily questions on performance art and group discussions

Pedagogical range:
Length of time: 15–30 minutes
Level: Conceptual
Practical considerations: A comfortable space for gathering the entire group, with everyone either seated or standing in a circle to heighten radical listening.

CONTEXT AND OBJECTIVES
Although Pocha Nostra does not run away from important philosophical conversations, we find we need to remind ourselves (and our participants) that the workshop is to

develop our body performance intelligence, not our rhetorical abilities. We try to avoid long sessions of debriefing and discussion after or before an exercise so that the pedagogical process does not become a discursive exercise.

This is not to say that language can't provide generative moments in our workshops. Facilitators will ask participants questions in order to trigger their imagination and transport them to a critical mental landscape for the day. These questions are posed briefly and poetically, towards the goal of creating a lingering conceptual backdrop against which the body can explore.

We recognize that sometimes it is necessary to allocate time to air pedagogical, political, and creative concerns during the process, especially when a generalized concern arises that somehow obstructs the pedagogical process. After many years of experimentation on the road, I developed a model inspired by old Zapatista meetings, indigenous protocols for community talk, and some techniques borrowed from mental health support groups. The intention is to open a space where everyone with a particular concern can be heard and collectively offer thoughts that might help us to find an answer (refer to the EXPANSION section below).

La Saula: One of my favorite times are the social gatherings after the workshop. There important discussions unfold as part of the process, not as something that we need to teach or discuss. We engage in hard-core academic, philosophical, pedagogical, and even silly conversations in a more relaxing atmosphere. I learn a lot from the participants during these times, and their feedback creates the ideal laboratory of new ideas to try during the workshop. Pochas love to seek out bohemian dike-queer-friendly local bars that serve virgin (and not so virgin) margaritas!

FACILITATION
This exercise is ideal to jumpstart the first session of the day, right before the warm-up, or after the lunch break or to be inserted during any foundational exercise.

Remember that our main intention is to post our pedagogical, political, and philosophical concerns or dilemmas in the social sphere, trusting that some answers or clues will be discovered during the entire pedagogical process.

PROCESS
Option 1
You can open the session by posing a particular question and allocating five minutes of quick, random answers. The aim is to create a collective conceptual map around a specific topic. Ask participants to be brief and answer in the form of a conceptual, spoken "tweet." Their answers can be in any form, including poetic interventions. As a deejay of the exercise, it is important to be aware of time, and not let the exercise become an intellectual conversation.

Option 2
Another way is that during the "Walk in the dark" or a gazing exercise, or another exercise, the pedagogue poses a different question each day. This question can be repeated in different forms during the entire day. No answer is needed; the question stays as a conceptual

framing for the day. If you notice that the group needs to express their thoughts or you want to give closure, you can allocate some time at the end of the session and implement option 1 to gather some answers.

Remember we are looking to create a conceptual backdrop for the day. Feel free to create questions that are pertinent for each group.

Some questions we have found useful include:

1. Which border do you wish to cross today?
2. What issues have been obsessing you lately?
3. What living, embodied metaphor would you use today to describe your place in the world?
4. When you hear the word "community," who do you think of?
5. Do you perceive your identity as fixed or mobile?
6. What are the sources of your performance material?
7. Is there an image or a persona you always wanted to create but have so far been unable to?
8. What is your recent performance alter ego or avatar?
9. Can the human body be decolonized?
10. What is the role of performance in a time of intensive global crisis and censorship?

As the workshop progresses, you can pose the following questions that have been suggested by participants over the years:

1. Can we be radical and talk back to power from within the structures of the institution?
2. How can we continue to be strategic insiders and outsiders in multiple communities and institutions at the same time?
3. What are the new roles of the performance artist? Gender Brujas, media pirates, reverse anthropologists, diplomats of extreme difference, ethnic drag queens, religious iconoclasts, walking billboards of utopian poetry, vernacular philosophers?
4. Is it possible to create spaces where binary thought and narratives are eradicated?
5. What are the political and ethical limits of art?
6. Where is the conceptual home/place of the radical artist in contemporary society located?
7. How is art valued? How do we align ourselves in relation to the art economy?
8. Where do we belong when our alliances are not with a nation-state or a particular institution or community?
9. Can our creative practice be a space for philosophical hope, radical tenderness, and permanent reinvention of our personal identities?

10. When/where do the boundaries of the individual blur with the boundaries of the collective?

11. Can the specific racial, gender, political, and artistic borders we cross in the workshop bleed into the social sphere?

12. Is activism of the imagination just an imaginary activism?

13. How do we continuously reinvent strategies for inclusion in the face of a society that promotes intolerance for otherness?

14. How can we be sharply theoretical when we secretly (and not so secretly) detest disembodied theory?

15. How to produce work functioning under the principles of a clumsy but efficient form of radical democracy?

EXPANSION

Group discussions
When there are pedagogical and theoretical issues that need to be discussed, we suggest accommodating around 30 minutes for listening and group discussion. In order to avoid over-intellectualizing or the exercise becoming a group therapy, we need to carefully structure the time. The instructor must be an effective deejay and timekeeper.

In a circle (standing or seated) explain the purpose of the exercise.

* Each person has up to two minutes to explain their concern. Request that the person address the entire circle, not just the pedagogue. It is an act of sharing to the community. When the two minutes have expired, the deejay/timekeeper must politely stop the participant.
* The deejay invites anyone from the community to express their thoughts in connection with the concern posted to the group.
* Give around one minute to each intervention; we suggest that three or four interventions are more than enough.
* Before moving to the next person, the instructors can contribute with their experience. Remember we are not looking for specific answers, and all opinions have room to co-exist.
* Repeat the process until everyone has expressed their concerns.

This is an effective way to democratize a discussion and give equal time to everyone who needs to be heard and express themselves. The process makes us equally vulnerable by sharing what bothers us about the process with the community, and can empower us when we offer a thought that might help the other person.

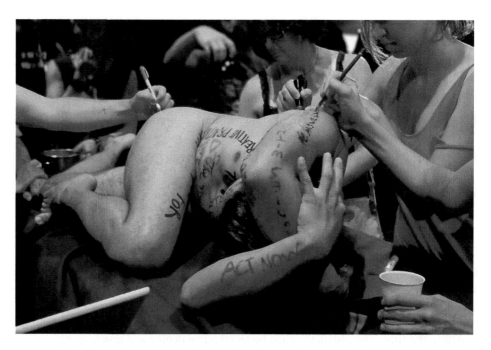

FIGURE 8.10 Public intervention: The Illustrated Body
Photographer: Herani Enríquez Hache
Performer: La Saula
Mexico City, 2014

The illustrated body

Pedagogical range:
Length of time: 40 minutes
Level: Conceptual
Practical considerations: Provide a good number of washable markers, especially in black, red, and dark blue color. It is important to find a warm area in the room and a comfortable place where two bodies can lie down, such as work tables with blankets and pillows. A musical environment that facilitates a meditative and ritualistic atmosphere is welcome. Use a set of lights to create an intimate warm atmosphere – avoid harsh overhead lights and cold, institutional lighting.

CONTEXT AND OBJECTIVES
Using the body as a canvas has taken place in almost all parts of the globe across the millennia, including the ancient cultures of Egypt, Greece, the Arabian Peninsula, China, and pre-Columbian civilizations. The purpose of marking our bodies varies from place to place, and tattoo art in Western societies has even become part of popular culture.

This exercise is a great opportunity to explore the politics of body, gender, and race representations according to the particular perception of each workshop participant. It is a powerful ritual of contemplation and exposes the power of branding and rebranding the body by inscribing, re-inscribing, or scraping off stereotypes and stigmas by covering the body with words, poetry, political slogans, and drawings. The power of our skin is exposed as a tool for creation and intervention. For those writing on the body this exercise confronts with our very own resistances and historical assumptions projected onto the human body.

La Saula: This exercise started as a bonus exercise with little explanation in our previous pedagogical book. I had the incredible opportunity to perform "The illustrated body" during the Pocha Nostra workshop at York University in 2010. It was one of the most powerful performance experiences that I have ever had. By offering my body as a human canvas, and being the recipient of incredible drawings, broken words, poetry, and even "destructive" and "offensive" words, I was able to break down my own assumptions about my identity, and this made me realize the power of my skin in performance space. It might sound corny and pretentious, but this exercise gave me the ability to understand centuries of colonization inscribed in my skin and illuminated a path to detangle and empower myself through such means in my everyday life and in my artwork. I understood by the body a way towards decolonizing myself. Since then, this action has been used in different contexts, in performances, artists' gatherings, conferences, community activism, and artists' talks; it has become a powerful exercise in our pedagogy.

FACILITATION

We suggest implementing this exercise after the fourth or fifth day of the workshop, as it requires a solid sense of community, respect, and trust.

Representations and politics work differently for each gender, so we suggest two bodies which are biologically female and male. We encourage the participation of bodies that have been historically racialized and radicalized by the mainstream society and dominant culture, and who demonstrate a complex gender identity.

We need to remember that the bodies must be nude, so we need to carefully ensure that the participants feel comfortable serving as the canvas. If not, someone who feels comfortable with it should take their place. The volunteers need to know that they are going to be raw material, and are going to be touched and manipulated by each member of the group in order to reach a particular part of the body.

The instructor needs to stress to the group that they should focus on covering the entire body with drawings, poetry, slogans, and political and personal statements. Different languages, unfinished lines and all kind of writing styles are permitted. Drawing is allowed as mentioned above, but don't let that the drawing take precedence over the text. The participants are creating a total art work. This is a perfect action to practice radical tenderness.

PROCESS

After explaining the exercise, ask the nude volunteers to lie down on the tables. They should close their eyes for the duration of the exercise.

Set the atmosphere, using the sound landscape, and ask the rest of the group to start to write with the markers on the bodies. You can start by asking them to write about what that particular body represents for them.

After finishing writing the text on the body, ask the volunteers to stand up (with their eyes closed) and help them to come to a standing position. Help move the bodies to a comfortable standing position in front of each other. The human canvases keep their eyes closed. You can direct warm lights onto the bodies in order to be able to appreciate the finished artwork. The rest of the group takes time to explore closely each of the bodies and read the text written on them.

After some time of appreciation, make sure that the two bodies are facing each other, then the instructor will request that the volunteers open their eyes and slowly start to read each line on their own bodies. They must take their time and do this action without any rush. Once they have finished reading their own body, they start reading the other person's body simultaneously. If necessary, the instructor mentions that they can touch or hold a part of the other person's body in order to read the text. The illustrated bodies should read each line on every inch and part of their bodies. In my opinion, some of the beauty that could evolve from the final part of this exercise is the beauty of reading and the natural movement that happens while doing so.

Once the exercise has ended, don't leave the volunteers alone. Tenderly help them to dress and clean their bodies, if they wish.

EXPANSION

This exercise could be a template for an entire performance. Over the years, we have been inspired by our workshop participants, inviting them to be part of our performance interventions. We have seen incredible text and drawing designs to powerful juxtapositions of body types and gender complexity.

Forty performance actions pulled out of a hat

Pedagogical range:
Length of time: 15 minutes for preparation; three minutes per performance action.
Level: Conceptual
Practical considerations: Obviously, a hat …

CONTEXT AND OBJECTIVES

Inspired by assorted contemporary and 1960s Fluxus exercises and by the mini-scripts of Yoko Ono, we pochify this approach by adding a pedagogical dimension for performance training.

This exercise encourages the group to think about interpretation and subjectivity and focus on an action without thinking too much about its meaning. The action becomes a space open for intervention between the participant and the viewer. It is a way we introduce the idea that performance, as Pocha understands it, is not just about a finished product but about the process of creating.

La Saula: In my early years as an actor in Mexico City and during my training as a theater director at the VCA in Melbourne University, I internalized that art should have a clear meaning and that success was measured by effectively achieving this. I became the worst judge of my own creations; at one point it was not fun and I had panic attacks during the openings of my performances … I worked (and agonized as an artist) under a pyramidal Darwinian assumption embedded in our Western and capitalist approach to art training and consumption. Over the years, and crossing the borders between theater, dance, and performance, with my experimental and radical carnalitos from theater, performance, and dance, I understood that agonizing about achieving a piece of art with a clear message for people to understand is pretentious, patriarchal, and condescending towards the audience. Exercises like this one have helped me to recognize the importance of the creative process as part of the overall artistic work, and helped me to be more humble and honest at the time of presenting my work to the audience. This exercise has the potential to spark incredible ideas and interpretations, ranging from the odd, kooky, and obvious to the total failure of the action! All are welcome and inspiring.

FACILITATION

This is also a good exercise to promote free creativity and get physical when the group shows some kind of exhaustion, generally by day four or five.

Write each one of the actions provided in the list below on small pieces of paper, and place them inside the hat.

The instructor should keep time with a stopwatch so as to signal to the performer when his/her time has expired. Extremely short pieces should be performed at a slower pace or repeated with different rhythms and intentionality until the three minutes are up.

If the instructions involve other people, the performer should discreetly inform his/her chosen colleagues of their participation. Of course, if any of the written tasks are objectionable, people have the option to interpret them more loosely or to skip certain actions.

Remind the participants not to agonize about showing off their dramatic or comedic skills. They just need to be present and truthful to their gut instincts. Be in "performance mode," remain committed to the action for the entire three minutes, and be open to what happens.

PROCESS

Form a circle and sit on the floor. One at a time, in any order, stand up and go to the center of the circle, pick a piece of paper from inside the hat, spend 30 seconds reading the text

to yourself, and then carry out your "performance instructions." Performances must last three minutes, no longer. The facilitator will tell you when to stop. The following list provides samples of instructions to be handwritten on small pieces of paper and placed inside the hat. The instructions are not in any particular order.

1. Find someone in the circle with animated body language, sit in front of them, and mimic them as perfectly as you can for one minute. Then find a second person and do the same.

2. Break one rule you have always wished to break.

3. Reveal the part of your body you like the most.

4. Dance the strangest dance you can.

5. Play your body as if it were a musical instrument.

6. Sing passionately a made-up punk opera without melody.

7. Ritually exchange your clothes, one at the time, with different members of the group, until everything you are wearing is not your own.

8. Embody and channel your ancestors, whoever they are, historical family, mystical, or none.

9. Take a marker and ask the others, one at a time, to write a fear or desire on your body.

10. Embody your "inner animal" without being literal or representational.

11. Create a live self-portrait using movement, gestures, and sounds.

12. Without speaking, gather the group close together, close your eyes, and ask them to carry you around the room as if you were flying.

13. Show us your favorite scar (real or metaphorical).

14. Walk like a supermodel for one minute, and then slowly decompose into animal behavior; a monkey, a snake, a lizard, a bird, etc.

15. Become a stereotype of a performance artist. Do it as seriously as possible.

16. Tell a story about a time when you bled.

17. Tell us the most racist, sexist, or homophobic joke you know, without saying sorry at the end.

18. Confess five secrets to five members of the workshop. Speak softly and clearly into their ears.

19. Do your best Gómez-Peña, García-López, or Balitrónica impersonation.

20. Curse in a language other than your mother tongue for two minutes.

21. Sing into the mouth of a colleague.

22. Tell us about the most significant time you broke the law.

23. Become an amoeba.

24. Become an extraterrestrial.

25. Become a melancholic spider and crawl on the body of one of the participants you choose.

26. Tell us a story, just with your eyes; or your feet; or your left leg.

27. Scream at the top of your lungs: "Mother, I love you! Come and rescue me from this performance workshop! I'd rather be a ballet dancer or a Hollywood actor/actress!!"

28. Take one person outside of the room. Perform a "sensual" action for him/her. Have that person re-enact your performance in the center of the circle in any way they like.

29. Get drunk with imaginary alcohol. Avoid being literal.

30. Dance as if you have a leaky body.

31. Become the demonized or fetishized body people project on you.

32. Turn into the worst stereotype you can think of about your racial or gender identity.

33. Become a weird "ethnographic specimen" for one minute and then taxonomize yourself verbally for another minute, i.e., "I am …, my habitat is …, my survival utensils are …, my language sounds like …," etc.

34. Ask for forgiveness. You choose the reason.

35. Close your eyes, internalize one of the plagues of our times, and embody it in front of everyone.

36. Repeat the instructions of this exercise as an answering machine message.

37. Enact a useless skill you've had since you were a child.

38. Re-enact the first performance you ever did.

39. Re-enact a recent dream you remember.

40. Grab two people and tell them to cede their will to you. Your objective is to construct an instant triptych (an image made up of three people) with them.

EXPANSION

For this version, instead of relying on the list of actions we suggest, the instructor can ask the participants to take five minutes on their own to write a set of written instructions for a short performance. These simple instructions will function as a mini-script to be interpreted and carried out by someone else in the group. The instructions must be very clear and extremely brief (not more than five actions), and should be anonymous.

When everyone has completed their scripts, the participants sit in a circle and place their written instructions in a hat.

One at a time, each participant chooses a piece of paper out of the hat and reads it to him/herself. Then, without thinking too much about it or rehearsing, they perform the script for the others. Each performance should last a maximum of three minutes only, and the same rules apply as from the previous version.

You can do two versions on different days. We never know, one of these actions can become an entire performance. In this sense, this exercise could become a laundry list of performance actions to be develop.

Radical psychomagic acts for personal change

Pedagogical range:
Length of time: Depending of the action
Level: Conceptual
Practical considerations: These exercises ARE NOT for the workshop time, but for each
 participant's personal life, and may last for as long as the person practicing finds it
 necessary.

CONTEXT AND OBJECTIVES
This list of psychomagic acts for personal change was directly influenced by the teachings
of the mystic N. Grace, the literature of the anthropologist Carlos Castaneda, the phi-
losophy and humor of Anton Lavey, and the radical spirituality of artist and filmmaker
Alejandro Jodorowsky.
 "Pochified" by Balitrónica Gómez, these exercises can be used in times of personal crisis
to shift your mental and esoteric paradigms and stimulate positive changes in your per-
sonal life and performance practice.

La Saula: During my times of mental, creative, physical, or economical despair, I have
found that practicing psychomagic actions helps me to reconfigure the energy flow of my
everyday life. Creatively, I have applied these actions in a rehearsal space as a way to enter
into a creative process and develop material.
 These actions open a cosmogonic connection to my inner shamanic energies, they
lift my energy, and they're a great way to manage my anxiety. Inviting performance into
your everyday life can have incredible effects. As Gómez-Peña has said "performance has
saved me from mental institutions," and the same applies to me. Warning: sometimes your
partners, family, and colleagues may mistake a psychomagic action for the irreversible
social "impairment" of becoming a conceptual coyote, hard-core performance artist, and
unapologetic illegal identity. Enjoy!

FACILITATION
This is an autodidact exercise and it is not mean to be part of the workshop curriculum.
These actions are meant to be performed by the participants on their own, as an exten-
sion of the process of workshop invention and self-discovery. However, many of these
psychomagic actions might ignite powerful ideas for a performance action, so feel free to
use these ideas during the workshop as part of a self-care regimen, and incorporate them
into your own creative work.

PROCESS
1. **Brush your teeth with your non-dominant hand for a week.** (Optional, use chili-flavored
 toothpaste if you can find it or make it.)
2. **Take a different route to work or school** (even if it's longer or inconvenient). Try to use
 public transportation if you don't normally.

3. **Go through your closet and eliminate all of the clothing items that don't make you feel absolutely amazing** when you put them on.

4. **Once a month, change a $20 bill into 20 $1 bills and hand one out to every homeless person you encounter during the day.** Make sure you smile and look them in the eyes when you hand it to them, and, if possible, engage in a meaningful conversation.

5. **When trying to make a hard decision between two or three options, commit to spending one entire day as if you had made one of the choices.** Then for one week, live your life fully as if you have made the decision one way or the other. Repeat for the other options. Once you have done this exercise, you'll have a better idea of which is the best choice. This also applies to a performance art project.

6. **Sleep outdoors for three days.** If you have a garden or patio, bring your bed outdoors. If you live in a cold place, build a tent or an igloo. Look at the sky during the night. It will give you humility.

7. **Sleep upside down in your bed**, placing your head where your feet would normally be.

8. **At night before going to bed write down one of your fears** that you're going to let go of during your dreams and place the piece of paper under your pillow. Next morning, throw that page down the toilet, or burn it. Do this for at least an entire week.

9. **Set an alarm for any time in the middle of the night without looking**. When the alarm goes off, wake up and write down or draw in a notebook what you were dreaming about or your thoughts upon waking. Do this for a month.

10. **Choose a day of the week, and for an entire month engage in cyber-dieting during that day,** which means, don't use any technological device in your home (iPod, iPad, iPhone, computer, etc.)

11. **Walk backwards** for an entire day.

12. **When you are in the middle of a personal crisis, look for a quiet place in your home,** turn off all computers and digital devices and stay seated naked on a comfortable chair or sofa for one hour with your eyes closed and doing deep breathing. The answers you are looking for will come to you.

13. **Write a love letter to your parents (even if they are dead)** and let them know that regardless of what your childhood was like, you know that they did the best they could, given the circumstances. If they are still alive, this action will be helpful for them when they are transitioning from this existence to the other side. You can also do this exercise with past lovers with unresolved business.

14. **Destroy or burn all of your pillows once a year and buy new ones.** You'll be destroying old states of mind and starting anew. Especially if you have shared your bed with others, whether lovers, relatives, or friends.

15. **Clean your entire house using either distilled water or your own favorite alcoholic beverage** (rum, tequila, mescal, or whisky work very well) as holy water and a new towel. Imagine that with every movement of your hand the towel is removing all of the negativity/bad energy of the space. Do this once a month.

16. **If you feel lonely in your house, get a pet.** Even if it's a small pet, like a fish or a poisonous toad. Care for it with utter tenderness. It will make you a less selfish person.

17. **Write your will and last wishes.** Make sure to update it every year, if you are lucky enough to continue living.

18. **Anthropomorphize your own death as a beautiful female partner.** Imagine she is always following you like a shadow over your left shoulder. Use her as an advisor to remain humble and grateful.

19. **Return to the vacation spot that you used to go to with your family when you were a kid, but go there alone.** Spend some time there writing your favorite memories in a journal. When you're having a bad day, open the journal and read your memories. You'll feel better.

20. **Talk to your neighbors for a few minutes every time you encounter them.** You belong to the same neighborhood and therefore you share similar social concerns.

21. **If you have never left your home country, leave your country for the summer and become an international citizen.** Do this every year in a different country.

22. **Travel south to Latin America or Africa.** Confront your fears.

23. **If you suffer from social anxiety, practice "shoplifting" once a week,** or try to engage in a conversation with someone you don't know every day.

24. **Identify the loneliest person at your workplace or school.** Send them flowers anonymously for their birthday.

25. **Give yourself one day a month (or one day a week, if you can) where you indulge in "radical self-care."** Get a pedicure, drink delicious tea and honey, read the book you've been meaning to read, get a massage, go swimming in the ocean or a public swimming pool, go for a hike, attend a sweat lodge, or do whatever clears your head.

26. **Contact the first person you fell in love with** and thank them for that experience.

27. **Make a list of all of the people who influenced you** when you were growing up. Send them thankyou cards or emails and let them know.

28. **Next time you take a long hot shower, eat an orange or tangerine.** You can throw the peels on the shower floor to create your own orange steam room.

29. **Leave your favorite composer or musician on the stereo whenever you leave** the house so he/she can infuse the house with emotional sound.

30. **When you break up with a partner, burn all of the lingerie or underwear that they've seen you in and buy new ones.** Also, collect all the items they gave you, and save them, or, if they were mean to you, throw them away.

31. **Leave a pad of post-it notes and a sharpie in your purse or bag.** Whenever you use a public restroom, leave a poetic note of encouragement on the back of the door for the next person who uses the stall, something like "Leave behind all your troubles."

32. **Remember what your favorite childhood books were** and read a line or so of them every night before bed or while taking a shit.

33. **Buy your mother or grandmother/father/grandfather concert tickets** to see their favorite artist. Take them to see the concert if you can. If you have no relatives in your hometown, you can invite a lonely neighbor.

34. **Make an extra pie, pizza, burrito, or casserole during the holidays.** Give it to the first homeless person you come across on your way to work or school.

35. **Let your partner pick out a new perfume or cologne for you.** It needs to be one that they like, regardless of whether you like it or not, for you are, in fact, wearing it for them and not yourself. If you don't have a partner, ask your closest friend.

36. **Eat for breakfast whatever meal your parents would never let you eat** for breakfast when you were a child. Do this for a week.

37. **Go into a high-end department store and convince them to let you try on the most expensive suit or dress in the store.** Walk out of the store without buying anything or with your new suit or dress on without paying. If you choose to shoplift, it's at your own risk, but it can be an important anti-capitalist exercise every now and again!

38. **Write your own psychomagic acts** for personal change.

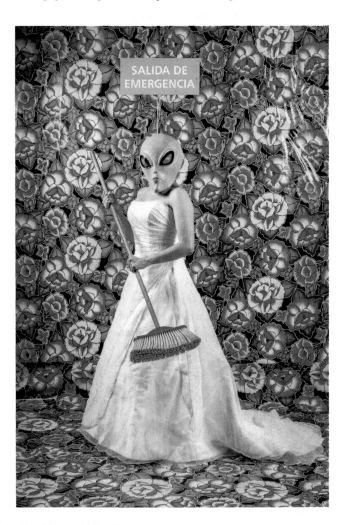

FIGURE 8.11 The US–Mexico Wars II
Photographer: Jalil Olmedo and Irwin Azair Cruz
Performer: Alisa Gomez
Oaxaca City, Mexico, 2019

Our planet as human body

Pedagogical range:
Length of time: 10 minutes
Level: Conceptual
Practical considerations: There are no specific spatial considerations other than just a group
of workshop participants or an engaged audience. Paper and pens for people to write.

CONTEXT AND OBJECTIVES
The aim is to reflect on the philosophy of the body and how our physical body anchors
political and material reality that we easily take for granted. It is an effective way to engage
the body with the politics of representation and identity.

La Saula: Gómez-Peña has used this poetic intervention as part of his solo performances.
I have had the opportunity to tour intensively with him, helping in the production of
his performances and witnessing the profound impact of his piece. In our quest for new
exercises, Guillermo suggested I turn this participatory spoken-word exercise into a con-
ceptual exercise. Here, we present you with the pedagogical version of this participa-
tory spoken-word exercise about embodied cartographies. This exercise has helped me to
reflect on all the inscribed messages on my body, and turn my body into a walking bill-
board resisting control and convention.

FACILITATION
This poetic piece can be used as part of a workshop, but also as part of a live performance
or during a class visit. This new version incorporates the most recurrent answers Gómez-
Peña has received from audience members and workshop participants.

As a facilitator you will read the piece to the audience with a calm and measured
delivery. It's important to practice with the language on your own to get familiar with the
piece. You will find some rhetorical questions as part of the spoken-word exercise, so allow
for some short pauses for the audience to find their answers. Feel free to adapt the text.

PROCESS
Dear class/audience …

Let's all close our eyes, breathe deeply and for a moment imagine our bodies as territo-
ries and our planet as a human body …

Please keep your eyes closed during the whole exercise, and listen carefully to my voice:

> If the world was in fact a human body,
> where would the brain be located?
> In Paris or London perhaps?
> No, that's a colonial stereotype
> Why not Paraguay or Madagascar? OK, I'm just making a point
> And the memory? *Short Pause* …
> In Egypt, China or Mesopotamia

Allegedly the oldest civilizations …
At the four corners of the Anazasi …
Hard to tell, there are so many different memories
and where would the heart be located?
In Mexico!
No, that's more like the liver.
And the lungs?
In the Amazon!
Nah, that's a terrible cliché
Besides, if they were truly located in the Amazon,
They would have TB or emphysema
What about the arms?
They would probably be … the industrious USA
Nah, I think the USA would be more like the stomach,
the ultimate organ of consumption, digestion,
And the legs? Where would the legs be located?
I need some help here …
Brazil? Not to stereotype them, but
those Brazilians are great dancers
And the feet? Patagonia? Too literal!
The nalgas? ¿El culo del mundo?
Australia or Antarctica?
Nah, that's a literal geographical transference
No, more likely Washington DC
Or … where are the headquarters of the IMF?
Switzerland or Belgium?
There are no headquarters
The IMF is everywhere; in every part of our colonized bodies
Now, the location of the genitalia would be quite contested que no?
Let's debate it. Any ideas?
Should we do it by gender?
OK, what about the vulva?
I'd say either the Mediterranean or the Caribbean?
Good guess. And the penis and testicles?
Africa? See that's racist.
What about the Himalayas? Too PC!
Any other parts of the human body
that you can connect to geography or culture?

(People continue responding)
Now, with these images in mind, let's write an improvisational poem in five minutes
maximum.
"If the world was a human body …" Run with it! Be as wild as you can!
When the time is up, we will read some of them out loud.

EXPANSION
You can implement the "Exquisite corpse" exercise to create a collective spoken word piece after this exercise using the triggering phrase "If the world was a human body …"

Magical chess

Pedagogical range:
Length of time: The game lasts for as long as the participants wish.
Level: Conceptual
Practical considerations: A space big enough to move freely. One square table in the center of the space that is easy to walk around. We suggest practicing the exercise in silence. The ideal number of participants is from six to eight.

CONTEXT AND OBJECTIVES
This performance game was developed by Gómez-Peña while teaching in art schools in California to experiment with different pedagogical approaches beyond the restrictions of the educational institution.

In this conceptual exercise, every game is unique and unrepeatable. The logic is poetic, quantic, and performative – not rational. Thus, the game is to exercise our metaphorical and performative "intelligence."

This exercise is about an exercise of identity reinvention, it offers an opportunity to see ourselves from different standing points, and reflect about the fluidity of our identities. But also it is a practical exercise that implies the need to negotiate leadership and ideas.

La Saula: As a performance artist, I have noticed that there are skills that cannot be learned from others. As a pedagogue, in this particular situation, I hope to lay out a universe or environment with certain rules to open a space to practice and sharpen our performance tools. With this exercise, I learned to trust and develop my intuitive perception on making bridges between what is similar in actions that are dissimilar. With rational eyes, this would seem illogical, but a big component of performance art is precisely that, a metaphorical intelligence that involves an act of resemblance, in other words is about crossing borders.

FACILITATION
This exercise can be shared with workshop participants after hours or in a traditional classroom. In our specific workshops, this exercise works best if done on an evening after the formal workshop day has concluded.

As part of the planning you need to ask each participant to bring their own game board or any other game they like, as well as five personal figurines, talismans, or small props of their choice.

Everyone needs to understand that there are no fixed rules. In fact, the rules are created by all the participants as they play, allowing negotiation of ideas and leadership.

PROCESS
We begin by constructing an architecture with the various boards on top of a large table and organizing our figurines. It is like an art installation.

1. **The board is like a small performance stage.** There are no winners or losers.
2. **Each player determines the nature, tone, and length of his/her move.** The moves can be conceptual, enigmatic, realistic, outrageous, or humorous, or a combination of the above.
3. **One move per person going clockwise;** unless someone decides to rebel.
4. Do not engage in unrelated conversation. Only speak or use language when it is part of the game.
5. **You can produce sounds or use words or phrases as moves combined** with the moving of actual pieces
6. **Players are allowed to "pass" if they decide.** If two players decide to take a break, we can all take a break.
7. **If you decide not to follow any of these rules it's also fine.** These suggestions are only meant to jump start "the system."

SUGGESTED THEMES FOR POCHA EXERCISES

When we develop live art images, we never expect workshop participants to limit themselves to Pocha aesthetics or subject matter. Instead, we encourage them to draw from their own inventory of aesthetics and ideas.

Certain exercises will be followed by a list of themes to play with. These themes have been suggested both by La Pocha and by workshop participants in the past ten years. They can be helpful for instructors to propose subject matter for specific exercises that deal with the cultural and spiritual predicaments of our times.

SUGGESTED THEMES FOR CREATIVE RUNNING BLIND

- Run as if the border patrol were chasing you.
- Run while getting rid of your clothes.
- Run while the rest of the group is trying to stop you from getting to the end.
- Run while asking for help from your community. This help can be in the form of songs, animal sounds, specific noises, or spoken-word one-liners, or even in the form of actions to carry out collectively.

SUGGESTED THEMES FOR ONE-ON-ONE CONSTRUCTIONS OF LIVE ART IMAGES

Create an image onto your partner by using the following commands:

- Images from dreams and nightmares (subconscious images).
- The disjointed, mutilated, fragmented, and/or tortured body.
- The anonymous body; the body without identity, or with its identity cropped by the media.
- The demonized body; the imaginary evil "other" created by racist politicians or media outlets.
- The mythological body. Draw from sources around the world, i.e., Medusa, Coatlicue, Sisyphus, Kali, etc.
- The body for sale; the media/tized body. Inspire yourself by TV or magazine ads that utilize "alternative" identities to sell a product.
- The (culturally or sexually) fetishized or exoticized body.
- The queer body. Inspired by gender complexity and blurred binaries.
- The militant/activist body, without reproducing the stereotypes of resistance and empowerment culture.
- The cultural cyborg. A body composed by bits and pieces from different cultures and machinery.
- Fashion and violence on the body. Corporeal style zones from military to criminal.
- Neo-indigenist urban warriors or robo-punk proletarian warriors against globalization.
- Ethnic/gender bending, embodying cultural and gender difference to achieve a double hybrid.

SUGGESTED THEMES FOR TABLEAUX VIVANTS TWO-ON-TWO

- Impossible lovers; vis-à-vis religion, gender or class, e.g., an Amish and a China Poblana; or a lesbian couple in Charlottesville.
- East meets West.
- The body for sale.
- The outcast/exiled body.
- Telenovelas on acid.
- Hollywood gone wrong.
- Identity freaks and artificial savages.
- Saints and Madonnas of our own religions.
- Artificial savages constructed in the Pocha garage.
- Freaks of globalization vs. normative identities.
- Hetero vs. LGBTQ.
- Utópicos vs. Apocalípticos.

- Adam and Eve (the original mestizaje).
- Adam and Eve in times of war).

THEMES FOR "LIVING MUSEUMS" AND COLLECTIVE PERFORMANCE INSTALLATIONS

The above one-on-one and two-on-two themes can be used to create total "living museums" and collective live art installations. Additional suggestions for subject matter include:

- Performance artists in a mental institution trying to stave off boredom by creating performance images and games.
- Saints and madonnas for social or political causes, sacred or profane, e.g., The Holy Madonna of Border Crossings, or the Patron Saint of the Homeless.
- "It's a Small World" multi-culti brunch date gone wrong.
- The primitive others rebel against the curator.
- The end of Western civilization.
- A freaky cartoon of a totalitarian and neo-nationalist state.
- The museum of dissidence (sexual, political, cultural, religious).
- Postcards from the tower of Babel.
- Outtakes from the British Museum or the Smithsonian.
- A government office on acid.
- Businessmen, politicians, and their favorite sex workers.
- The bordello of extreme identities.
- Anarchist theme park.
- Narco crime scene with gore aesthetic.
- A world dominated by women.
- Grooming tips for insurrection.
- The dementia of Western thought.
- The torture chamber heritage park.
- Squatting in this building of various urban tribes; choose five objects for survival.
- Post-apocalyptic religious sects.
- The exotic señoritas y señoritos.
- Angry deterritorialized immigrants and refugees from the South rebel against the host country.
- Freaky cartoon of "typical global hipsters" engaging with their technological gadgets.

SUGGESTED THEMES FOR JAM SESSIONS AND OCCUPATIONS OF ABANDONED PUBLIC BUILDINGS AND WASTE LANDS

- The last supper of apocalyptic politicians and their escorts
- The insanity of reason: Mexcaping from a mental institution

- Religious S&M.
- Post-apocalyptic cabaret.
- Sci-Fi automatons and replicants. Region 4.
- Chicano ci-fi. Post-apocalyptic Warriors against a new conservative totalitarian regime: they are poly-gendered, multi-ethnic, self-styled fashionistas, with fashion created out the detritus and debris of the Western civilization.

I think of our poetry jams ... "Home is ... a place outside the map. It is not my passport. It is on fire. Home is something my mother talks about. It is for sale. Home is not a police station." "Home is where I share my ideas. While I was in Tucson during this workshop, I further developed a concept called 'Firefly Insight.' This is the idea that metaphor is the missing link in the translation of ideas. It is the aesthetic interpreter to the heart."

(Tavia La Follette, artist, activist, curator, Pittsburgh, Pennsylvania)

SECTION 4: THE INFAMOUS POCHA NOSTRA "JAM SESSIONS"

We are instructed to move and jam with the other people in the room, to interact and explore them as much as the space. Even though I tend to dislike touchy-feely experiences, this one is oddly freeing. Although, it is apparent to me, and even more apparent to those with their eyes open, that the cold New Englander in me prefers the bruised shins to the strange body parts.

(Workshop participant, Athens, 2015)

At this point in the pedagogical matrix, the learning experience is redefined in situ by the performers themselves, and it is time for the pedagogical DJ to slowly fade away. The purpose of the jams is to put in practice everything we have learned. We aim to find new territories of collective creation where negotiation, tolerance, creativity, and radical tenderness are the lingua franca. In the jam sessions, we act on strategies to cross all kind of borders, shift from one territory to another, and embody many identities at once. We aim to reclaim and redefine an anti-binary and queer space, and look for a creative and autonomous process. This is the ultimate anthropological quantic journey called the planetary system of La Pocha Nostra. The performers call for total autonomy, and, in the name of live art, it's best to let them have their way!

La Saula: I see myself from above composed by many tiny bodies. I found others and we gather as if we were a planetary system in which the cohesive power emerges from the awareness of my body and its creative autonomy. My spacesuit is made of my reconfigured

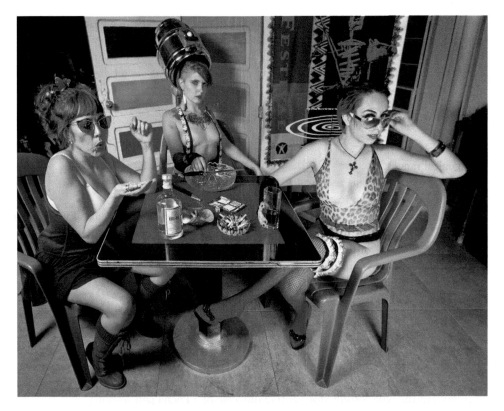

FIGURE 8.12 Pocha Nostra Beauty Parlor
Photographer: Herani Enríquez Hache
Performer: Balitronica, Anuk Guerrero, Lorena Méndez
Mexico City, 2014

and expanded "bare" body, my oxygen is composed by the pedagogical experiences I have learned, my intergalactic artifacts serve my aesthetic purpose, and my personal politics are my supernumerary devices to expand consciousness. I become many shamanic creatures at once, a **Coyote** – a border crosser physically engaged in building trust in the community by using radical listening, an **Infinite Alien** – a being interconnected with the inhabitants of the planetary system testing infinite creative possibilities tempered by radical tenderness, a **Cucaracha** – a strange creature taking the highest risk at the compositional and image-making level. Coming in and out from all directions, testing hard-core physical engagements, and spatial vulnerabilities. All together ignite bizarre identities and experiments to talk back. The body, in the infamous Pocha performance jams, becomes a living metaphor of our times, for penance or joy …

This section describes some of the strategies La Pocha utilizes to "jam." These jam sessions grow to be the bulk of the creative sessions after a few days of intense foundational and creative exercises. It is highly advisable that you practice "Compositional triptychs" before embarking on a jam session and understand the process of how to create

primary looks or personas. We also recommend that at least one Pocha member or pedagogical deejay take part in the exercise. This increases the confidence level of the group and can help to break down any atmosphere of authority. If there are several instructors in the group, you should alternate leading and participating in the exercises.

Basic jam session

Pedagogical range:
Length of time: One hour
Level: Creative and conceptual
Practical considerations: Prepare the performance space during a break much as you did for the "Compositional triptychs" exercise in Section 2 (p. 125) of this chapter. A platform, a few chairs and theater cubes, and/or a ladder can be useful. Light the performance zone with a few warm lights. Apart from the "performance zone" and the props and costumes station, the rest of the room should be fairly dark. Music may vary depending on the overall subject matter.

CONTEXT AND OBJECTIVES
Devised by La Pocha in the mid-1990s and developed over the last 15 years, this is perhaps the most popular and exciting Pocha exercise as it involves aspects of all prior exercises. By going through the exercises outlined in the first three sections, participants will be ready to jump into the wonderfully disorienting universe of a Pocha jam session.

The objective is to "jam" with your new community of performance peers, much in the same way as musicians jam. It's a serious game. Incredible live images and performance actions emerge organically out of these jamming sessions. At the practical, pedagogical level, this unplanned performance material is the result of multiple factors: the individual aesthetic decisions of those involved in the jam, the accidental juxtapositions of the individual images, and the interventions and edits made by those outside of the performance zone, including the instructor.

FACILITATION
The aim of the pedagogical DJ is to sustain interesting visual and conceptual negotiations within the jam session and make sure that the total composition is always working. The role of the instructor/s is not to direct but rather to coordinate. Someone in the group should act as the music deejay for this exercise.

Collectively, the group will create a dynamic symbolic universe in permanent process of transformation. This realization is at the core of the Pocha performance methodology. The jam sessions can last for as long as they are working, but they do need time to develop. When the instructors notice people are getting tired and more than half of the group is sitting down, it's probably time to stop.

PROCESS
The themes proposed for a basic jam session should not be too specific. We suggest you use a theme wide enough for all participants to project their own ideas and find an entry

point, a theme that functions as a subconscious backdrop for the experiment. Some useful examples include "dreams and nightmares," "an apocalyptic cabaret," "a pagan church of ethnic and gender-bending saints and madonnas," and "the end of Western civilization." Please refer to our additional text called "Suggested themes for Pocha exercises" for more ideas. You will find this text at the end of Section 3 (p. 153) in this chapter.

Step 1: Five minutes
Participants begin by spending about five minutes silently checking out the props and costumes and reflecting on which ones they might want to use during the exercise. Select only one or two to begin, and bring them to the front of the performance zone.

Step 2: Ten minutes
When everyone has their props or costumes on or at hand, we ask them to stand facing the "performance zone," and begin the exercise with a typical advanced session of "Compositional triptychs" just to get the basic system working. The only rule for this initial session is that every time anyone steps out of the performance zone, s/he has to go back to the prop station and replace one of his/her objects, props, or costume items.

Step 3: Ten minutes
The first person steps into the "performance zone," places his/her own body in a symbolic position or individual tableau, then freezes. The next person has two options: they can slightly alter the position of the first image and/or position themselves somewhere in relation to this image. The next person might slightly alter one or both of the existing images and/or position him/herself in relation to the total composition. Once the triptych has been completed, thank the performers; they can take a break as the next person jumps in and starts this process again.

Step 4: Ten minutes
Continue with the exercise, but now, if a participant outside the performance zone senses that one of the images is not working, they can enter the performance zone during the exercise and "fix" it. They should make only small changes that do not totally interrupt the action, or that don't need to be explained at length to the person they are shifting. Ideas for possible changes include shifting the body position of the performer, turning the performer to face another image or the audience, or moving them to a different space and/or changing one of their props. This now means that people outside the performance zone are no longer just preparing to jump in, but are performing the dual role of co-creators and editors of the overall composition in motion. This new function of the outsiders can remain for the duration of all jam sessions. Carry on with the exercise and don't stop. Once the basic system is understood by the participants, follow the steps below.

EXPANSION
Once the system is understood, you can extend the time of the images during the jam. By adding the following strategies, you can advance towards an ongoing and autonomous jam process. We recommend using the strategies in the order provided below. Once the jam

reaches an autonomous level, you can use the strategies randomly to keep the jam pedagogically exciting or when the jam seems to get stuck or collapse.

Strategy 1

When one image within a triptych is very strong, tell that person to remain in the performance zone while the other two are replaced. You are now experimenting with the length of time some people remain inside the performance zone.

Strategy 2

Invite a fourth person in, and, if you sense the time is right, perhaps two of the strongest images can remain for a longer period of time. Now add a fifth person and two or three can remain while the others rotate. This should continue until there are at least seven people inside the "performance zone." *Now* we are jamming!

Strategy 3

A participant may choose to enter, perform a quick action, and exit. Then s/he returns a while later and repeats the same action. The same action can be performed several times over the course of two hours.

Strategy 4

Once this new system is working efficiently, the instructor's role fades and the performers are pretty much on their own. Individuals can now decide when to enter the performance zone and how long to remain inside, and while on the outside can choose to "fix" any of the live images in progress.

Strategy 5

As an instructor, look for a final image that is particularly strong so that you can end this session on a high note. Ask your participants to take a 15-minute break, then come back to the room and discuss what you have experienced.

"Stop-and-go" jam session

Pedagogical range:
Length of time: One hour
Level: Creative
Practical considerations: Just like the previous exercise, prepare the performance space during a break much as you did for the "Compositional triptychs" exercise in Section 2 (p. 125). Choose a new exciting site for the jam. A platform, a few chairs and theater cubes, and/or a ladder can be useful. Light the performance zone with a few warm lights. Apart from the "performance zone" and the props and costumes station, the rest of the room should be fairly dark. Music may vary depending on the overall subject matter.

CONTEXT AND OBJECTIVES

Developed in the mid-1990s by La Pocha with the objective of working out our own primary looks, developing performance personas, and finding the outer limits of these creatures, this has eventually become an integral aspect of our pedagogical aim to practice radical listening from within the image and develop what we call performance intelligence.

This classic Pocha exercise is a great way to begin "deconstructing" the images and actions generated by a typical jam session. We attain this by freezing an image and utilizing those freezing moments to engage in a critical pedagogical moment and provide instructions. With this strategy, participants become hyper-aware of their position within the overall composition and are forced to make decisions and changes from within an image. These decisions are often made with their entire bodies. Intuitive "performance intelligence" takes over from their rational mind. These living murals or moving tableaux are extremely exciting both for the participants (who must think, imagine, feel, and act on their feet) and for those watching the creation of bizarre and extremely original imagery.

FACILITATION

This jam version is heavily moderated by the instructor and is very different from a more open jam session. The instructor calls out changes, freezes, and other instructions, and is constantly challenging the performers to discover new imagery.

PROCESS

Start with a basic jam. When you (the pedagogical deejay) see a particularly strong performance composition or image "on stage," the instructor turns down the music. You can ask participants inside the performance zone to freeze. Call out, "One, two three, freeze!"

- **During the freeze ask them to change their positions while looking for "internal tensions,"** slight variations, and new ways of connecting to their surrounding images. You then tell them to "Go!"
- **When you see a new powerful image emerging, on the count of three, you call "freeze!"** The performers hold the image for a few moments. Then you ask them to look for a new position, again emphasizing internal tensions – then you yell out "Go!"
- **Once you sense they have found a strong new image, you call "freeze" again, and so on!**
- **Every ten minutes you can pause the action for a moment to allow some people in the performance zone to be replaced by others.** This will inevitably transform the internal dynamics and the multiple meanings of the composition in motion and the iconography.
- **If you sense that people are creating repetitive images, you can ask them to take a break.** Ask them to find a new primary look, and then restart the exercise with a new framing device.
- **If people are getting too heavy, the same emotional landscape gets repetitive, it gets dramatic or too representational, you can tell them, from now on, we are going to experiment with humor,** and poor and trash aesthetics.

You'll be amazed by the results of this stop-and-go process. The participants inside the composition will be making surprisingly sharp and original aesthetic decisions from within and the results will be gorgeous to watch. It's like a living ever-morphing mural or a stop-motion animation.

EXPANSION
When the new system is rolling, you can begin to experiment with conceptual variations that will deconstruct the process of living murals even further and add layers of complexity.

Some suggestions follow:

- **You can begin to syncopate the mural in steps:** "At the count of three, everyone freeze with the exception of [name of one participant who is particularly strong]." They can continue doing what they are doing with a new sense of awareness, or "Everyone freezes with the exception of [two or more participants]."
- **When they are frozen, we might give them more complex theoretical instructions such as:** "Reverse the gender and racial power relations in your images," or "Add more violence and sexuality to the composition," or "Add more humor and political irony to your images."
- **You can suggest dramatic changes of subject matter:** "Let's shift the theme of the mural and send a live postcard to the White House (or to the Pope)," or "Let's create an apocalyptic rave." To open up their imagination, your suggested themes can be very enigmatic and exuberant, and you can create your own self-styled themes related to the concerns of the group you are working with or to the city where you are working. You can make reference to all the poetic/performance texts generated by the participants during the workshop as well.
- **Mischievously change the genre of the music** and ask participants to allow the new music to influence the imagery they are creating.
- **Take the opportunity to comment on the nature of the overall image.** As the group out-side the performance zone witnesses these surprising variations, you, as an instructor, will have many pedagogical opportunities during freezes.

As an instructor you can also have some serious fun by participating actively in a more performative manner. Here are some suggestions for different ways to "direct," or rather deejay, a living jam and mural:

- **Give commands with a mic or megaphone,** then pass it around and ask others to deliver their own impromptu instructions.
- **Like a Chicano Leonard Bernstein, "conduct" the mural with a music baton** as if the participants were members of a chamber orchestra. Clearly, for this version, everyone needs to be looking at you.
- **Ask one of the participants to swap roles with you.** You can jump into the mural while the volunteer instructor tests his/her pedagogical smarts.

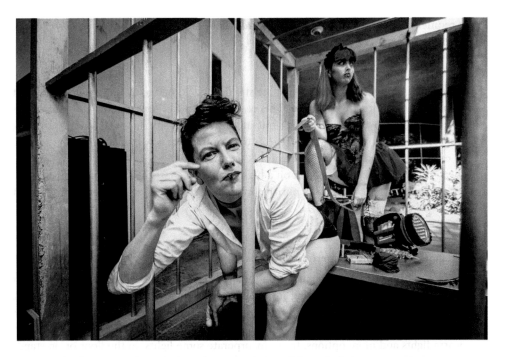

FIGURE 8.13 Restaging the couple in the cage during Gómez-Peña's retrospective
Photographer: Hache Hirani
Performers: Sara Johnson and Rebeca Soto
Museo de Arte Contemporáneo, Mexico City, Mexico, 2018

Advanced jam session

Pedagogical range:
Length of time: Two hours
Level: Creative
Practical considerations: Choose an interesting site for the jam; this time the preparation of the space will be done by the group, it will be part of the exercise. Have some platforms, chairs and theater cubes, and/or a ladder ready for the group. To have some lights for the performance zone is important. Apart from the "performance zone" and the props and costumes station, the rest of the room should be fairly dark. Don't forget an exciting playlist for the jam.

CONTEXT AND OBJECTIVES
During longer workshops these advanced jam sessions eventually become the bulk of the creative session in the second half of the day. An advanced jam session is physically and creatively demanding. There will be very high-energy creative periods and moments when the energy is low and it feels like the exercise has died. It is important to push through

these moments of uncertainty. This is the time when some of the most interesting creative breakthroughs occur.

FACILITATION

The instructor will perform the role of artistic deejay. Someone in the group should act as the music deejay for this exercise. This responsibility can now rotate. This exercise is heavily moderated by the instructors, but at the end the instructor almost disappears, allowing full autonomy. At this stage, the entire community is responsible for the success of the exercise and the universe that unfolds.

Always try to end the jam session on a high note with a large group working inside the performance zone. This will have a positive impact on the mood of the group for the next session.

PROCESS

1. **Preparing/designing the performance space (30 minutes).**

 Choose an area in the space that is architecturally complex and varied, perhaps different from the one you've been using in prior jam sessions. You can use platforms, levels, scaffolding, and other elements to break up the space and add architectural complexity. Set up your prop and costume area near this space. Light the performance zone with warm lights and more options; try to incorporate some lights on the floor or on stands with wheels so that you can change the lighting at will during the session. A few portable lights can be very useful. Add a microphone to the sound system and place it on a stand near the performance zone. The design of the space can change with every advanced jam session.

2. **Creating a primary performance persona (30 minutes).**

 Take some time to make up and costume yourself with an initial persona based on the chosen subject matter and your own ideas. The image can be one that you've discovered in prior exercises and would like to develop further, or it can be something entirely new. It's up to you. After you have created an initial draft on yourself, choose someone who has finished his/her draft, a partner who will act as your "mirror" and "experimental stylist." Get together with your partner and help each other to clarify and edit the final details of your "looks." This whole procedure should not take longer than half an hour. Refer to "The Pocha catwalk" (p. 130) and "Creating tableaux vivants" (p. 107) in Section 2 of this chapter.

3. **The jam (up to two hours).**

 All the costumed performers gather facing the performance zone. The music begins and the exercise commences. Begin by following the steps of a basic, stop-and-go jam session. Once the jam session is autonomous and there are at least five people performing, you can begin to add new complexities and variations.

Suggestions for livening up the jam session

1. **Get creative with the lights:** If a lighting technician is available, you can suggest to them to really jam and play with the lights. You can also incorporate some lights on rolling stands or floor mounts. Participants operating in performance mode can move

the lighting around to highlight an area or a particular action. If you are outside, you could also pan a light around the space, catching special moments as you pass them by.

2. **Use the microphone (or a megaphone) for vocal interventions:** The mic should be placed near the front of and facing the performance area. Occasional microphone interventions from participants may include a song, a poem, a spoken-word text in English or other languages, instructions to their peers, a theoretical text, and/or samplings from the performance scripts developed with the exercises in Section 3 of this chapter. Also consider the text "How to use voice in the Pocha Nostra method" by Micha Espinosa in Chapter 9, p. 228. These verbal interventions can last from a few seconds up to five minutes, depending on their efficacy and power. Brief interventions can be repeated every now and then, like a live sample. Vocal interventions are intended to create an ever-changing conceptual landscape, and not to operate as a script. In this sense, performers should try to avoid interpreting them in a literal manner. The deejay needs to be aware of the people using the mic so they can alter the sound level so that performers can be heard.

3. **Invite local musicians to jam with the group:** You may wish to invite a local professional deejay, electronic composer, or laptop rocker to create live music for a session. You may add musical instruments. Occasionally a musician may bring some instruments and add them to the bank of props for anyone to use. A performer may choose to incorporate an instrument into their persona and play it in character during the jam session.

4. **Try working in silence:** Stop both the music and the verbal interventions and see how operating in total silence affects a jam session in progress.

5. **Add projections:** We have had the privilege of working with some incredible video artists and VJs in our workshops, who have brought their own video projectors to process images live during a jam session and/or to project material from their own video archives. This optional but highly seductive technology is great to transform the blank walls of a potentially bland rehearsal room into exciting visual environments.

EXPANSION
Try the capoeira-style performance "circle": Mark a large circle (ten feet in diameter) on the ground with tape and light it. Participants apply an initial look as in previous jam sessions and gather around the edges of the circle. Then one person at a time begins to enter the circle and construct an image. A second person will follow, and so on. There should never be more than six people inside the circle. Those outside the circle must be constantly shifting positions, viewing the tableau from different places, and looking for surprising entry points.

The ultimate jam session

Pedagogical range:
Length of time: From two to three hours
Level: Creative

Practical considerations: To complicate matters, the instructors may create two or more performance zones in different parts of the space. Have the participants spend some time creating interesting architectures in each of the chosen performance zones. They can utilize all the available multiple-sized platforms, theater cubes and pedestals, scaffolding, and ladders. Don't forget an exciting playlist for the jam.

FACILITATION

Define two or more "performance zones." For example, one against a wall involving a platform and a few cubes; another, a circle in the center of the room "capoeira style." A third could be located within or next to an interesting architectural feature, perhaps framed by a large window or door, or a staircase.

The criteria to divide the zones can be chosen in various ways. Aesthetic groupings, or zones separated according to pace and/or intentionality of movement, make sense. For example, the largest zone can be allocated for more baroque ever-changing tableaux and living murals, and the smallest space for individual performers only. The circle can be for "quick and dirty" images, and the architectural zone can be for long-lasting minimalist interventions without elaborate props or costumes.

As a performance deejay, your role is equivalent to the one in the advanced jam. Work towards making the participants aware that they must continually practice "multiple focus points" in order to keep the exercise alive.

PROCESS

In the process of an advanced jam, try to reach full participant autonomy as soon as possible. It should not take long if the participants have practiced the previous jams. All spaces must be active at all times. Each space operates independently from the other. The largest frontal zone can accommodate more performers (about six); the "circle" can contain up to four; and the third, architectural zone can be for solos and duets only. During the three-hour jam, performers can move between the three spaces, until a performer has found a strong durational image he/she can choose to remain in in one zone for an extended period of time.

The participants should keep an eye on all performance spaces, making sure they are never left empty. At the same time, they should be preparing a new look and assessing when exactly to enter. The emphasis here is on making quick but sophisticated performance decisions.

SOME GENERAL GUIDELINES TO CONSIDER WHEN LEADING AND PARTICIPATING IN ANY AND ALL JAM SESSIONS

- **The basic rule regarding props and costumes remains** take care of them, treat them with respect, and, if you consider that you have exhausted the performance possibilities of a prop or your primary look or image, step out of the jam, return at least one prop and/or costume to the station, and get new ones.
- **At any moment if you feel your own image is no longer necessary or has lost energy, meaning, or presence, you can edit yourself out** and become an active audience member once again and/or help your

colleagues inside the jam (refer to the following advice of this list). Trust in your body; you will sense when to enter to the jam again.

- **At least half of the group should always be outside the perform-ance zone.** Their role is to be the outside eye, both as editors and as active audience members. If the composition loses clarity or energy, those temporarily on the outside should intervene immediately.

- **If you are outside, try to stay on your feet as an active audience member.** If you begin to sit and watch, you will be less "ready" to jump in when the moment strikes.

- **If anyone feels like changing the place of a set piece or redirecting a light source during the jam session, go for it!** These kinds of changes are as important as those inside the image.

- **There is no judgement, if you don't feel like performing at some point of the jam or on a particular day.** Sometimes the jam can be over-whelming at an emotional, physical, and aesthetic level, and it is important to take care of ourselves. We recommend, however, that you find another useful role within the jam session – make editing changes, keep the prop and costume station organized and clean, shift the light sources, deejay the music – but don't just sit idly or withdraw from the community. Remember we are all equally respon-sible for the maintenance of our complex performance system.

- **You can invite a member of the group who can deejay** to mix live during a jam session.

- **Before a new jam session, revisit (for a few minutes) the group discussion about documentation.** Unless the surprising images generated by a jam session are recorded, it can be very hard to retrieve or recall these improvisational exercises. In this regard, the instructor might choose to assign someone to photograph the jam. Or maybe it's better that they remain ephemeral and unrepeatable. After all, this is the very nature of performance art. Trust your group intelligence to decide.

The space feels like a gallery of human cuckoo clocks all going off at the same time. One tableau emits a looping laugh track as the members take turns slapping each other Three Stooges style. They each look like a different ethnic stereotype. Elsewhere other images are equally outrageous. In the background, melodramatic Mexican soap opera music plays on the stereo. Other irrational images pervade my field of vision. The entire scene reaches sensory overload and I suddenly lose it. I find myself rolling on the floor laughing hysterically. I've crashed into the wall. Everyone is rushing around. No one seems to notice me, making me laugh even harder. It feels like I've been dropped at the threshold of another border and on the other side is lunacy.

(Perry Vasquez, artist/writer)

SECTION 5: REFINING YOUR PERFORMANCE PERSONAS

FIGURE 8.14 Illegal Superheroes
Photographer: Ami Mathur
Performer: Esther Baker-Tarpaga
San Francisco, California, USA, 2014

Mitotilistli: from "actor" to Neo-Shaman Vulture: I'm from the Ixtacalco borough of Mexico City, and have served as a steward of the Virgen de Guadalupe Chinampera. Being of the First Peoples, I live in search of that which is transcendent, the ritualistic, the priestly, the shamanic, the performative – that which is imbued with the strength of Ehécatl to make the psychomagic visible. In a country and world in which being Indigenous implies inequality, I renounced the vertical structure of theatre schools and set out to create performance. I became an autodidact and, without realizing it, I came to embody exactly what the art world stigmatizes and rejects: an Indigenous performance artist. La Pocha Nostra incited me to inhabit the borders between the myth of the credible and the incredible, the traditions of our past and the Indigenous present; to stand within the transmission of knowledge that only performance can achieve: the Mitotilistli, the rite of Mayahuel, collective authorship, extraterrestrial miracles, the pathways of radical tenderness, the fissures of the body, corporeal decolonization, the critique of savage capitalism, the politics of the body and the poetics of political action.

(Gerardo Juarez)

The objective here is to fully develop our unique hybrid personas from the repertoire of multiple identities generated during the workshop. The aim is to refine their political and/or aesthetic aspects and prepare them to be presented as part of a performance.

For this section, we strongly suggest that each participant select one of their most powerful personas, actions, and images generated during the workshop. With the following exercises, we will navigate deeper in the images and stylize, activate, embody, and create a performance playlist of actions for a persona and a performance.

This pedagogical section is a very good opportunity to keep developing what we call **performance mode;** a heightened awareness of present time paired with a sense of total body performativity (refer to the pedagogical introduction by García-López, Chapter 7).

La Saula: If you are not planning a performance salon, you can still use the following exercises as part of the final day of a long workshop of seven to ten days. This process is a great way to go deeper into the development of personas and consider their political and aesthetic relevance. After doing the exercises, you can devise a final advance jam to put in practice the material developed in this section to close the pedagogical process. If you are planning a pedagogical performance refer to Sections 6 and 7.

In the following text, you will find some important and humble suggestions to refine your personas. It is a manuscript inspired by the different challenges many participants have faced while preparing personas for a performance event. This text was developed in collaboration with my beloved Pocha colleagues, Balitrónica Gómez, Michèle Ceballos and Guillermo Gómez-Peña.

USEFUL SUGGESTIONS TO DEVELOP YOUR PERFORMANCE PERSONA FOR A PERFORMANCE

- **Use all the knowledge and experience you've acquired** from the workshop exercises, including the brainstorming sessions and discussions.
- **Preferably try to rely on performance personas you have already discovered and explored in the workshop.** Don't jump into the abyss with a brand-new performance persona. It's simply too risky!
- **These personas should not be mere "impersonations" or theatrical "representations" of popular or stereotypical characters, but rather live art composites of your own political, religious, social, and sexual contradictions and concerns.** These concerns should intersect with your peers' concerns. The final performance must have a consensual nature, where all of the images somehow belong to the same universe.
- **Avoid naturalism and social or psychological realism at all costs.** Ideally, the resulting personas should function as "living metaphors," "human artifacts," and "cultural cyborgs."
- **Look for surprising cultural, political, religious, and sexual juxtapositions.** Embrace ethnic and gender bending. Surprise yourself and your peers!
- **Roughly, these composite personas are manufactured with the following formula in mind:** one-quarter stereotype; one-quarter audience projection; one-quarter aesthetic artifact; and one-quarter unpredictable personal/social monster!
- **The specifics of individual performances will emerge from a combination of sources,** including charged moments discovered (and noted) during the exercises, relationships amongst the group participants and/or their personas, the political and aesthetic concerns of group members, the location of the workshop, and the pressing issues of the times.
- **Document (pics, writing, audio, and video) the most interesting actions and images** that emerge during your "rehearsing" process. Select the best and most powerful ones – they will become your final playlist of performance actions.

"Stylizing" your performance persona

Pedagogical range:
Length of time: One hour
Level: Creative
Practical considerations: Practice the exercise in silence. A few large mirrors placed in the prop and costume station will help performers tremendously to develop their look. If you are planning a final performance, use the space where this will happen.

CONTEXT AND OBJECTIVES

We propose a series of creative tasks characterized by the **"holistic" inclusion of everything we learned during the workshop.** The exercises are presented as an interconnected ongoing process, as an exchangeable matrix explicable only in terms of embodied knowledge and all the aspects of the pedagogy learned in the previous parts of the workshop. As mentioned before, the focus is on refining and sharpening the chosen images, primary looks, and personas for a performance or final performance event.

FACILITATION

Silence is important. By not talking, your aesthetic choices will be much more focused. To develop your "total image," and to think of your performance persona in visual and conceptual (non-theatrical) terms.

 If the space is a new site we recommend starting with the exercise "Working in the dark" before implementing the exercise.

PROCESS

Gather people around the prop and costume table in silence.

1. **Performance persona primary look** (15 minutes)
 Ask the participants to begin the design of their chosen performance persona using the existing artifacts, costumes, and makeup. If more than one persona requires the same prop or costume element, they will need to negotiate which of the two needs that particular item more. If two or more people need an extremely unique object equally, they should plan how they can share it during the performance.

2. **Stylist nurses** (15 minutes)
 After all participants have designed and embodied a draft of their persona, they should partner up with a colleague and act as a stylist/mirror or nurse for one another, adding any finishing touches to each other's costume, makeup, and body text. This practice of mirroring is a more detailed version of what we did when creating a primary persona for an advanced jam session.

3. **The modeling circle** (15–30 minutes)
 Both participants and instructors form a standing circle. One at a time, participants move to the center and model their personas to the rest of the group. This provides yet another extremely important pedagogical opportunity: instructors and participants should offer a brief, polite, but tough critique of the total look of each participant and a few suggestions to improve it. The objective of this critique is to tighten and "fine-tune" the images and what they represent. Inevitably during this critique, some props or pieces of costume will be removed, added, or simply shifted around. This part of the exercise functions as a bizarre impromptu fashion show where the semiotic connections between live images and themes become crystal clear. When everyone is satisfied with their "draft" it's time to activate the personas.

EXPANSION

With this new refined primary look, you can repeat one of the different versions of the exercise "The Pocha catwalk" (p. 130) in Section 2 of this chapter.

Activating your performance persona

Pedagogical range:
Length of time: One hour
Level: Creative
Practical considerations: Practice the exercise in silence, or you can choose a soothing musical landscape that facilitates concentration and an introspective mood. If you are preparing a final performance, you can implement this exercise in the performance environment (or set), if it is ready. If there is a dramaturgical crew, make sure they take notes of the most powerful images and actions so the performers can recall them easily and write their individual performance playlist (please, refer to "Determining the final roles of the workshop participants" (p. 179) in Section 6 of this chapter).

CONTEXT AND OBJECTIVES

The ultimate objective of this exercise is to consolidate a series of iconic actions and tableaux that you can retrieve and sample during a performance, and to develop a ritual structure capable of containing the flesh and bones and actions of the emerging personas (remember, all based on what was discovered during the workshop). This material is what will constitute the final personal and group performance playlist. Remember, at this stage we don't recommend trying new, untested performance actions or personas that were not part of the work generated during the workshop.

FACILITATION

Advise the participants to have their diary handy to record the most powerful images and performance actions they discover during the activation of the persona. Remember, just like the final performance play list, the individual playlist should be always a balance of energies and rhythms of the images and actions you will perform.

It is important for participants to understand that often there is no separation between performers and audience in performance art. Since the audience will be in close proximity and the performance will be experienced from various distances and angles, every detail and small gesture makes a big statement. The participants should think about working for a 360-degree view of their images.

PROCESS

The process of activation takes place in three stages.

Stage 1: Internalizing image and movement.
 a. **The costumed participants meet in the center of the space.** If they are carrying several props, they should choose the primal one to begin working with. After they have spent a few minutes in silence to re-territorialize themselves in the space and get focused, the instructor asks participants to distribute themselves evenly around the room.
 b. **Ask them to begin "to embody their personas," slowly, with their eyes closed.** They should first visualize the total image they have created and the issues behind it.

c. **Then ask them to bring their persona into their face, slowly incorporating movement in their facial muscles** (mouth, nose, forehead, cheeks, and tongue). The whole persona should inhabit their face and only their face.

d. **After a few minutes, ask them to bring the movement exploration down to the neck, while the rest of the body remains frozen.** Now, the face and the neck are in performance mode while the rest of the body is frozen.

e. **Then the energy and movement travels down to the shoulders, and then slowly into the arms and hands.** Everything else – torso, pelvis, and legs – remains frozen.

f. **Then slowly the persona begins to invade their torso.** At this point the body is active and "performing" from the waist up.

g. **A few minutes later participants should allow the persona to take over their pelvis, and slowly move down their legs to their feet** until, finally, the whole body is fully activated in "performance mode."

At this point they may open their eyes and fully embody their persona.

Stage 2: Developing a vocabulary for your actions and movement phrases.

a. **Ask the participants to develop (or retrieve from their memory, from the workshop process) a single action** or movement phrase and to keep repeating it until it becomes part of their recent body memory.

b. **Then ask them to develop or recall a second action**, and to repeat it until it has become internalized.

c. **Finally, ask them to develop or recall a third action.** They can now go from action 1 to action 2, and action 3, so that they internalize all three distinct actions.

d. **Once they have developed three clear actions, they can begin to look for possible transitions.** The transitions can involve discrete shifts in rhythm or intention – say, from hard to soft actions, or from heavy to humorous ones, and so on.

e. **Eventually participants can begin to "sample" the actions,** shifting, say, from action 1 to action 3, from action 3 to action 2, and so forth, moving seamlessly between them at will. Then they should continue looking for new actions while revising the prior ones.

Stage 3: "Fleshing out" your performance material.

a. **The instructor/s begin to call out instructions so participants can work through the material at different speeds and lengths, changing the rhythm and delivery style, and experimenting with intention.** Expanding the range of delivery of the performance material will increase the quality and the stylistic possibilities of the material in form and content. In the process of sampling these actions in various "modes of delivery," participants will continue discovering new actions and transitions.
Useful instructions to flesh out material include (instructors can change instructions every three minutes):
- **Run through all your actions in real time**, as you originally envisioned them.
- **Now, try them in ritual time**, somewhere between real time and slow motion, with a strong sense of purpose and clarity.

- **Speed them up** as if you were performing in an old silent movie.
- **Begin to elongate your movements as if you were a tiny person** performing on a huge stage for a distant audience. Go through all your material in this mode.
- **Now, let's experiment with the opposite mode of delivery:** Compress all your movements as if you had only two square feet to perform. Repeat all your material but smaller; same energy and intention, but very small.
- **Let's shift modes again:** Begin to make all your movements more undulating, fluid, and soft. Stylize every action.
- **Go through all your material as if you were a fashion model.** Be aloof and self-consciously casual.
- **Now, let's deal with geometry** and make your actions sharper and more angular, almost robot-like. Find the outer edges of your material. The goal now is to create a geometric structure to contain the material.
- **Finally, begin to sample all your actions** and shift modes of delivery at your own will.

EXPANSION

1. **Try running through the material in pairs, facing your partner.** You should not respond directly to each other's material, but rather perform simultaneously in front of one another. The point is not to consciously influence or mirror each other's material, but rather to see how the proximity of another performer affects the quality of your movement.

2. **Still in pairs, one partner performs while the other gives them commands (similar to those explained above),** and then they shift roles. While watching your partner, note strong images that emerge organically. Tell your partner to freeze if they discover something particularly strong so they can absorb the moment into their body memory. Take a few minutes before changing roles to discuss and choose the more powerful moments.

3. **In full persona you can revisit some of the most advanced levels of certain exercises,** such as creative running blind and gazing, the aikido/chess game, human puppets/ dancing doppelgangers, creating tableaux vivants and the Pocha catwalk. These exercises will help you to dive deeper in the development of your persona. Feel free to revisit the extended sections of these exercises. Refer to Sections 1 and 2 of this chapter.

Note: If there is a planned performance for the end of the workshop, try the exercises in this section in the performance environment or design for the final event. Further instructions for this particular task can be found in Section 7 of this chapter.

Te Pou Rahui – a post to mark a temporary ceremonial prohibition: I was made into a pou and given a function to perform. My form was shaped according to that function and I became an object of culture, my eyes rolled back into their sockets, tongue protruding, hands and body trembling. After every breath, I expelled a noise and willingly accepted instruction. Many marks adorned my

form and I was captured. I was positioned in a place between my function and the world, it transformed me into a rock, then a bird, and I settled on branches that were different. I become unraveled and anxious, prey to difference. I will consume myself and offer up an escape for change. I chose performance to understand restriction, negotiate its

contentious site, and step into accepting my anxiety. The adze can also shape and form a pou, that I desire. Te Pou Rahui was the first research platform I created, a poetic and conceptual response to the pedagogical space of La Pocha Nostra. This provocative encounter has sustained my work with Te Toki Haruru (the resounding adze) and initiated many exciting collaborative pathways towards a practice of understanding indigenous creativity, mediated by a rigorous critique of the individual, communal, and ceremonial body in performance.

(Charles Koroneho, Te Toki Haruru choreographer and director)

FIGURE 8.15 Walk in the Park
Photographer: Herani Enríquez Hache
Performers: Lothar Muller, María VellPart, and Octavio Ahmic Alvidrez
Festival Cervantino Guanajuato, Mexico, 2016

SECTION 6: DEVISING A PEDAGOGICAL PUBLIC PERFORMANCE

Pocha performance workshop: Here we are, exploring the gap between clothed order and nude anarchy.

(Workshop participant)

Why do we feel it is important to open the process to the local community and present these "performance salons" as part of our pedagogy?

The aim of this final performance extravaganza is to combine spectacle and process. The exercise is informal yet intensely focused. The goal of these informal "pedagogical performance salons" is to give members of the local arts community a window into our process, a view into our universe. Essentially, they are invited for a couple of hours to witness an advanced jam session in progress.

If the workshop is running for seven to ten days, and if the conditions feel right, we organize a jam session open to a small group of invited guests including friends and local artists, intellectuals, journalists, and curators.

In this closing event, it is important to note that everyone must go through the physical and conceptual practice during the workshop, but not everyone has to feel obligated to "perform." There are important roles besides performing which are necessary in the realization of a final performance.

If the goal is to create a highly designed evening at a large venue, you have to get much more focused on the performance in the two days prior to the event and create various artistic crews and performance structures inspired by some of the exercises. Otherwise, preparing a straightforward open salon in one day is possible.

The culminating performance event is meant to give participants a sense of how it feels to perform for an audience, and challenges the participants to take their performances to a higher level. When we have a workshop that ends in a public-facing performance, Pocha members get involved with specific pedagogical tasks and help facilitate the experience.

La Saula: The final choice of who will perform must be decided by the participants or artists in dialogue with the producer or curator, along with the facilitators. During this process some might not be ready to perform, and their decision to shape the production through other tasks is its own kind of pedagogical epiphany. While some of the participants perform, others might design the sonic, visual, and technological aspects of the piece. In either case, no judgement is involved. In the Pocha universe, there is no such thing as a small task, as we all co-create the performance event together. We try to avoid any vertical production models inherited from the so-called world of "high art" that render production teams mere "support staff" of the production. Every participant in front of the audience and behind the scenes is at the center of the Pocha process.

Discussing the nature of the performance material

Pedagogical range:
Length of time: Two hours
Level: Conceptual
Practical considerations: Create a circle with some chairs in the space and have handy your
notes regarding the most striking moments (poetic text and images) generated during
the workshop. Assign a scribe to take notes. Ask the participants to have their journals
and personal notes handy.

CONTEXT AND OBJECTIVES
It is important that the participants engage in a discussion about the quality, significance,
and impact of the images and performance personas that have emerged out of the process.
In this discussion, the group can sift through all the images discovered during the work-
shop and make a selection of the strongest, most cohesive material that has the potential
to end up in the performance.

FACILITATION
The instructor(s) will focus on facilitating a group conversation, making sure everyone is
heard and can express their ideas. The aim is to reach a group consensus about the nature
and content of the performance material. Ask the scribe to take notes.

 This is also a good moment to remind the participants that not everyone needs to "per-
form" in the final presentation. Some people can work on the installation, the music, the
lights, or the video design. There will be a place for everyone. That's the democratic nature
of performance.

PROCESS
How do you go about making a "laundry list" of the best images?

1. **Ask participants to review their performance diaries** and consider the most striking
 images created during the process (either by themselves or their colleagues), then note
 the images they would like to see developed further.

2. **Then ask each participant (in any order they wish) to recall interesting and powerful
 images** they've seen emerge from the exercises and jam sessions. This may include
 single images or ritual actions, duets, trios, and groups – "moments" that left a lasting
 impression.

3. **At the end of this brainstorming session, the scribe will have compiled a laundry
 list of potential images and collaborations** on which to begin building a final perfor-
 mance event. The scribe then reads the list back to the group (this can also be done
 on a whiteboard). The goal is for each participant to choose one or two personas and/
 or collaborative actions from this list that are particularly close to their concerns and
 aesthetics.

Choosing the performance event format

Pedagogical range:
Length of time: One hour
Level: Conceptual
Practical considerations: Create a circle with some chairs in the space and have handy your
 notes regarding the most striking moments (poetic text and images) generated during
 the workshop. Assign a scribe to take notes. Ask the participants to have their journals
 and personal notes handy.

CONTEXT AND OBJECTIVES

The aim is to reach a group consensus about the performance format. It is important that
the participants engage in a discussion about the site, the way, and the environment in
which the performance actions and images will be presented to the audience. In this dis-
cussion, the group make a selection of the strongest, most cohesive performance format.

FACILITATION

The scribe should have the compiled laundry list of potential images and collaborations
and the most important details of the previous discussion.

 It is important to point out that in our formats there is no backstage, but rather an
open process that changes as the performance unfolds. Also, there is no beginning or end.
What the audience experiences is a portion of a process, a segment of a universe in the
making!

 Once you decide on the performance format, allocate time to set up the space (prefer-
ably one day before the performance). Refer to "Activating production mode" (p. 185) in
Section 7 of this chapter.

PROCESS

Here are two concrete suggestions for the design of a "mega-jam session."

1. The diorama format
 a. **Setting up the performance environment:** There should be two large platforms
 opposite one another near the wall at either end of the space. Another two
 platforms can be sited along the other two walls with a catwalk 13 to 26 feet long
 (or about four to eight meters) joining two of them. A video screen (or more than
 one) can display unedited images of past jamming sessions and live mixing from
 the veejay. A "sound/composers station" is also set up to one side. Light all the per-
 formance zones, choose a general lighting that enhances all aspects of the image.
 Assign an environment or "set" design crew to arrange the space. The prop and
 costume station should be placed near the performance zone, dimly lit so that the
 costume changes can be visible to the audience.
 b. **Activating the performance environment:** The activation of the environment is part
 of the final process of "*rehearsing*" the final performance. Please refer to Section 7
 (p. 184) for more details.

2. The architectural format
 a. **Setting up the performance environment:** Choose an area of the room with interesting architectural elements (a corner, an area with doorways, niches, or near large window frames, etc.). Five or more adjacent performance areas should be created. Use larger platforms at various heights, a tall ladder, a lectern, some small movable cubes to elevate performers, and open spaces on the floor for traveling images or larger movement pieces. These areas should be continuously lit throughout the performance so that the performers can move from one to the other seamlessly. Choose a lighting design that enhances all the aspects of the image. Assign an environment or "set" design crew to arrange the space. The prop and costume station should be placed near the performance zone, dimly lit so that the costume changes can be visible to the audience.
 b. **Activating the performance environment:** The activation of the environment is part of the final process of "*rehearsing*" the final performance. Please refer to Section 7 (p. 184) for more details.

These are just a couple of models. Feel free to invent your own.

Determining the final roles of the workshop participants

Pedagogical range:
Length of time: One hour
Level: Conceptual
Practical considerations: Create a circle with some chairs in the space and have handy your notes regarding the most striking moments (poetic text and images) generated during the workshop. Assign a scribe to take notes.

CONTEXT AND OBJECTIVES

It is important that the participants engage in a discussion about the nature of people's participation in the final performance. The aim is to create two groups, the performance crew and the interdisciplinary design crew(s). If a participant is not able or ready to perform (for whatever reason), he/she should be supported in this decision. Witnessing and documenting the process at this stage, or helping in production, could be an incredible pedagogical experience.

The interdisciplinary design crew can be formed with parallel groups of visual, media, and/or sound artists. As part of one of these groups, participants choose to develop a specific task related to the overall project: work on a film or video project, design an installation for one of the performances, create a bank of photographic images, design the program or the poster, or compose original music for the performance.

Some members of the performance crew might be also part of the interdisciplinary design crew and vice versa. It is our experience that artists attracted by our workshops like to multi-task. However, our humble advice is for participants to try not to take on too many tasks!

FACILITATION

The aim is to develop an efficient production system for the entire performance salon. The goal of this discussion is to create two major groups: the performance crew and the interdisciplinary design crew.

The two groups (the performance and the interdisciplinary groups) can overlap in the following manner: all participants can work together during the first day or half of the production day in order to develop a sense of community. On the second day or later in the production day, the groups work separately and meet up every two hours to discuss creative discoveries and problems, and share progress. The two groups can work hand in hand at the performance space.

Here are some possible roles and structures for the two crews.

PROCESS

1. **The interdisciplinary design crew:** Participants interested in the performance environment or "set," visual, media, and sound dimensions of the event. As part of this group, participants may choose to:

 * **design the performance environment**, installation or "set" for one or several of the performance spaces;
 * **edit and project a PowerPoint display of photographic images** developed during the workshop;
 * **create a video environment** and VJ live;
 * **design a conceptual printed program;**
 * **design a soundscape** or compose and execute original music for the performance;
 * **create an installation at the prop and costume station.** The ongoing process of editing and adding to this station is over, individual performers have by now chosen their finished looks, and their individual props and costumes now have special places. The crew make sure that everything there is of utmost importance for the piece.
 * **be part of a dramaturgical crew** to revise the laundry list of selected solos, duets, trios, and group moments. The goal will be to draft a simple score or "blueprint" outlining possible groupings of performers. When creating this score, just make sure that there is always a balance of energies and rhythms in the performance zones; i.e., the slow-moving durational solos should co-exist with more kinetic movement pieces and short guerilla interventions.
 * **The members of the design crew have the option of not performing** and strictly concentrating on their artistic task.

2. **The performance crew.** Assign specific performance tasks and images. The possible actions include separating the performance material into:

 * **Durational images:** Those with more developed durational material can inhabit a main platform.
 * **Related images of short duration:** Two or three performers whose material is thematically related but shorter can share or alternate on a platform.
 * **Still images:** Others with compelling still pieces or pieces that involve little movement, using particularly ornate and complex costume, can perform on a

small platform or use a catwalk to develop actions modeled as if for an "extreme fashion show."

- **Traveling images:** Some can perform on ground level amongst the audience. These traveling images move around the room, periodically freezing under a light or inserting themselves into the architecture of the space.
- **Images that involve voice:** One artist, preferably someone good with words, could "manage" a station with an open mic, where performers may sing, deliver poetic texts, and give conceptual instructions to audience members and other performers. The group should carefully decide these parameters in advance. You can refer to "How to use voice in the Pocha Nostra method" by Micha Espinosa, p. 228.

When we – as artists, poets, performers, as activists and magicians and tender-hearted witnesses to this historical moment – answer the call to step more fully into our work, we instinctively look for techniques, tools, images, and collaborators, with whom we can make art, make meaning, make magic, and make our lives whole under the specter of a brutalist body politic and dire ecological emergency. The desire to create, to form connections, to labor for beauty and awareness, under such conditions, is both radical and revolutionary. In art, as in the shamanic quest, to step into the unknown is transformative and perilous. In both, the outcome is never certain, but the rewards are everything: deeper conversation with your own creative spark, the freeing of imagination in ways that evoke both the immediacy of the present moment and ancient traditions of ceremony, ritual, and mystery. Engaging in such a revolutionary practice, the work of La Pocha Nostra and the pedagogy is to provide containment, to hold a safe, strong, conscious space of **Radical Tenderness** and fearless exploration and expression, in which we discover and reclaim the borderlands of our primal imagination.

(Leni Hester, Santa Fe, New Mexico)

SECTION 7: PRODUCING AND "REHEARSING" THE FINAL PERFORMANCE

About Mapa/Corpo in Buenos Aires: "I have to say that I have never been so emotionally impacted and challenged by art before … I am even further inspired to continue adding performance to my studio practice after witnessing the impact that live bodies can have on a viewer.

(Lauren Kalman, artist)

On the day before the public performance, the workshop shifts focus and moves distinctly into "rehearsal" and production modes. If you have only one day to produce the

FIGURE 8.16 The Unorthodox Church
Photographer: Manuel Vason
Performers: Predrag Pajdic and Georgios Bakalos
International Summer School, Athens, Greece, 2015

event, the performance crew and the interdisciplinary design crew(s) can overlap in the following manner: all participants can work on design and technical matters during the first part of the day, and after a lunch break they can "rehearse" in the already somewhat designed space until just before the performance event. If you have two days to produce the event, during the evening of the first day the focus should be on preparing the performance format and environment, leaving the following day for "rehearsal." Alternatively, in the first day, you could advance 50% in the production of the environment and 50% in "rehearsing." Feel free to create the most convenient sequence of these activities according to the specific conditions of the workshop.

The two processes ("rehearsal" and "production mode") can be practiced even if you don't plan to have a final performance open to the public. The implementation of the process can be framed as the final part of the workshop; you could either produce a final performance with some selected guests or do it with none. We also recommend implementing the following process only if the workshop is from seven to ten days long. To implement and activate the "rehearsal" and production modes, it is necessary to understand/experience the entire pedagogical matrix.

"REHEARSAL" MODE

For Pocha, *"rehearsal"* mode has nothing to do with the well-known theatrical model. The aim is not to assign images and performance actions to be revisited several times to achieve perfection and exact reproduction over a series of programed performances. This model, just like our pedagogy, focuses on process, and the process is the performance. A total awareness of present time paired with a sense of total body performativity (**performance mode**, p. 68) is key in this process.

PRODUCTION MODE

Production mode, in the Pocha universe, refers to the work involved in the creation of the environment for the performance event. This could be either a diorama or an architectural format. It could involve the entire group or only the interdisciplinary design crew(s).

La Saula: At this stage, participants get very excited, and some lobby to present a performance that they've been developing outside of the workshop. Or to bring in an outside artist who has a piece that fits but was not part of the workshop. At La Pocha we are softies and have let this happen on several occasions, with mixed results. At this final stage of the pedagogy, is better to make sure that all the material presented was developed during the workshop and not to turn the public presentation into a personal showcase, no matter how cool, strange, or wild the piece is. In this context, "The Pocha Nostra protocol for a performance day" (written in collaboration with Balitrónica Gómez, Michèle Ceballos, and Guillermo Gómez Peña) is a pertinent text aiming to promote tolerance and understanding when an interdisciplinary group of artists is preparing for a performance.

POCHA NOSTRA PROTOCOL FOR A PERFORMANCE DAY

1. **Follow your individual practices and rituals** to prepare for the performance, but always stay present in the community. It is essential that you tell someone if you leave the space, because we are relying on you for the integrity of the production. All the exercises to build trust have led up to this day.
2. **If you get stuck or have issues during the preparation** of your persona, performance actions, or installation, talk to one of the instructors. We want to be there for you. **If you enter into a crisis in the middle of the performance,** just approach one of the instructors and let them know. We will try to help you. Also, you can take time to gather your energies, **practice Aikido and gazing.** Breathe, pause, and take time for yourself. However, we again ask that you do not leave the community without letting us know.
3. **"Private vices, public virtues."** La Pocha doesn't police artists, but please be considerate of others, and be careful and respectful of their personal spaces and fears. Remain clear-minded and respect that a few colleagues might not want to have certain substances used in their proximity.

4. **Be respectful towards different work approaches,** rhythms, cultural traditions and artistic methodologies. Coexistence of extreme difference is our ultimate goal.

5. **Practice radical tenderness and tolerance, and don't impose your personal way of working on your colleagues.** With our extreme differences, it is important that we learn to sit at the same conceptual dinner table without driving each other crazy. In traditional theater, silence is common before a performance. Performance artists are more feral and tend to question authority. Adherents of both approaches must be tolerant of each other.

6. **Switch off your phones and focus on the community,** the preparation of the space, and the consolidation of your props and costumes.

7. **You can be disciplined and enjoy yourself at the same time.** As a Chicanx humor strategy, take your commitment seriously, but, at the same time, open yourself to absurdity and laughter.

8. **If you are using someone else's props,** treat them as ritual objects and ask the owner for permission before inserting them into any human orifices.

9. **Remember, today we are simply opening our temporal pedagogical universe to the public.** It is not a finished performance, it is an open process. Don't be afraid, we are here with you. Try not to panic if your family, colleagues, and friends come to the performance. If they love you and respect you, they will accept you unconditionally. If not, you might give yourself the gift of *not* inviting them so you can focus on your own creative offering.

10. **Don't do something extreme that you have not tested during the workshop.** Total freedom does not mean doing whatever you want. If you want to make a significant change to the production, please consult with the community before the performance.

11. **Most important during any performance, do not force yourself in any way on another person,** particularly if your action involves explicit sexuality, physical aggression, or bodily fluids. Ask first. Consent of collaborators and audience members is a must.

Activating the performance environment

Pedagogical range:
Length of time: One to two hours
Level: Creative
Practical considerations: Using all the material discovered, and with a clear individual and group performance playlist, we recommend that you activate the performance environment the group agreed to produce during the group discussion. Please refer to "Choosing the performance event format" (p. 178) in Section 6. The exercises of "Refining your performance personas" in Section 5 can easily be adapted for this pedagogical activity.

CONTEXT AND OBJECTIVES

We aim to activate the environment, the "set," with simultaneous performance actions. Please note that the activation of the environment is possible only after the performers have done the previous exercises and have ready their total look with makeup, costumes, and props.

La Saula: You are entering one of the most exciting moments of the entire pedagogy. Each participant will find his/her place in the performance event, and this is the time to test what you have learned. You are welcomed with open arms to the Pocha Nostra inter-galactic system. In this final journey, you will find a group of celestial objects (bodies), connected by their mutual attractive forces (performance personas), moving in open-ended orbits (your performance actions and images) around a temporal center (the performance event). Let's jump into the enigmatic and psychomagic abyss of performance art.

FACILITATION

We suggest assigning a dramaturgical crew to take notes of the most powerful images and actions (refer to "Determining the final roles of the workshop participants" (p. 179) in Section 6). The aim of this crew is to make sure that in the final performance play list there is always a balance of energies and rhythms of the images and performance actions in the performance zones.

PROCESS

When you start activating the environment, four simultaneous actions can happen:

- **On the first platform** – a series of ten-minute solo pieces in ritual time (almost slow motion). (This is a good way for the group to develop and test individual pieces.)
- **On the second platform** – a series of ten-minute duets.
- **On the catwalk** – each performer completes a three-minute "conceptual fashion walk."
- **At the multi-media station** – the deejay will continually mix playlists for the exercise, while the veejay mixes assorted video projections.

Activating production mode

Pedagogical range:
Length of time: Six to eight hours
Level: Creative
Practical considerations: The technical needs for the performance event are created by the entire community, not by a specialized tech crew. Make sure you have a schedule of activities for the day.

CONTEXT AND OBJECTIVES

What follows is a description of how to prepare the production of performance salons. The preparation process last around eight hours before the event (if you have only one

day) or two work sessions of six hours divided into two days (day one: production and design, and day two: "rehearsing").

The aim is to assign specific production tasks and to implement a work timeline so as to have the performance environment ready for the final performance.

La Saula: In the history of Pocha, more than 800 performances have been produced during the last 25 years of existence of our troupe. At the end of this section you will find two useful templates. One is a practical schedule on how to organize and coordinate the production along with a specific work timeline. The other one is a text to introduce the final performance event to an audience.

FACILITATION

Make sure that the performance crew and the interdisciplinary design crew(s) are clear on their tasks. Assign the tasks to the two crews, and divide the work, allocating two sessions of six to eight hours per day over the course of two days, depending on the time you have. The interdisciplinary design crew works parallel to the performance crew.

Sometimes we must rely on a professional technician for complex production needs. If there is a specific tech manager as part of the team, try to make them part of the process together with the interdisciplinary group.

PROCESS

Each open salon or final performance follows roughly the same production and schedule pattern. What follows is the schedule for a one-day production. However, you can divide the tasks and reverse the order if you have two days for "rehearsing" and production.

1. **All participants help to clean the space.**
2. **A few ritually prepare the prop and costume station while others set up a "hospitality and refreshment station"** complete with munchies, refreshments, beer, and a few bottles of wine.
3. **The design crew works on the light design.** The aim is a simple, practical lighting look. The final design is generally discussed before this day, please refer to "Devising a pedagogical public performance" in Section 6. The main areas to be lit are the prop and costume station, the hospitality table (usually near the entrance to the space, with drinks/nibbles for the visitors), and the "performance zone/s." If possible, a couple of portable lights should be available for participants to play with the lighting during the session. You can also use tape along the floor to mark the performance zone and the civilian zone.
4. **At the same time, the design crew or two or three volunteers set up any available platforms,** cubes, and/or furniture in the performance zones, following the space design discussed previously.
5. **When everything is in place in the space, the facilitator leads a group warm-up and** "Working in the dark." Refer to the exercises of Chapter 1.
6. **The performance crew get into their personas.** The performers begin to choose props and costumes and mark their bodies with makeup. This is done in complete silence.

Instructors can take this opportunity to remind participants that their own bodies are sites of performance – decorated, marked, made up, and riddled with implications.

7. **Gazing once they are fully decked out in their personas** can be helpful at this point as a group exercise to prepare for the performance.

8. **On some occasions, right before the guests arrive, we have a ritual toast** of mescal and share a few words, but any beverage that sparks courage and community will do, including mystical non-alcoholic teas!

9. **The invited guests begin to arrive** and enter the space.

10. **The instructor welcomes the audience and describes what is about to happen.** It is important to tell them that they can move around during the jam session and experience the performance from different perspectives and distances. They can be as close as they want.

11. **The performance universe and journey begins.** One by one the performers step into the performance zone/s and begin to create an ever-evolving tableau of images as the first action of the night.

TYPICAL POCHA NOSTRA PERFORMANCE DAY SCHEDULE

12–1 PM production meeting
Meeting to make final decisions about the performance score and production, and allocate production tasks.

1–3 PM performance design crew works

- Individual installations created by performers.
- Individual performers prepare their props, costumes, and related materials.
- Designated groups work on the following:
 - Clean and prep performance zones, and remove elements not needed for the presentation.
 - Disinfect performance artefacts with rubbing alcohol.
 - Create a collective installation, if this is part of the performance design. Arrange prop and hospitality stations.
 - Test and fine-tune light design, soundscapes, and video projections.
 - Complete and print the performance score.

3–5 PM performance crew preparations

- Independent fine-tuning; performers work autonomously (individually, with partners, or in groups) on finalizing performance material and prepare personas.

5–6 PM, personal rituals and meal break

- Eat a light meal; hydrate; take care of your body!

6–7 PM, transition into performance mode

- Performers embody personas with costumes, props, and makeup.
- The performance crew does the final test of the performance environment.

7–7:30 PM, group ritual

- Physical warm-up, we recommend speed gazing and some kind of creative Aikido.
- Ritual toast.

8 PM, performance begins!

INTRODUCING THE FINAL PEDAGOGICAL PERFORMANCE TO AN AUDIENCE

Don't forget to stress to the participants (during the last two days) and to the audience that what they are going to see is a pedagogical process, a subversion of the traditional pedagogical experience. The final event is a highlighted showcase of the images discovered during the workshop, but it is not about producing and presenting a professional performance event. Feel free to adapt the following template to the specific circumstances of your workshop.

A TEMPLATE TO INTRODUCE A PEDAGOGICAL JAM OPEN TO THE PUBLIC

Jam session #1214,

Tongues
Good evening dear colleagues, welcome to the Pocha Nostra live art pedagogical open salon.

This is the last day of the seven- to ten-day workshop conducted by La Pocha Nostra. The workshop involves artists and college students. During this process, we have used the entire campus as an extension of the social world, and our own bodies in a politicized metaphorical way, to articulate the multiple crises that surround us.

This event tonight is the birthing process of several live art images resulting from the gathering of 16 artists' minds, bodies, and sensibilities. What you are about to

experience is cut and paste performance pedagogy in the open; process art at its rawest and most dangerous. If we fall, please catch us in the process.

This pedagogical adventure offers an immersive performance art experience with a focus on the human body as a site for creation, reinvention, memory, and activism.

The images are spread throughout the space, and we encourage you to move around, be active audience members, and to visit them all. They will be slowly morphing during the next hour.

Welcome to our madness.

The Pochxs at elgalpon.espacio Lima, February, 201666

KrÓNiK:

0
Situations on a humid summer night
Situ-actions in a shed a wet summer night
In-situ soaked summer actions

1
Night of "exposition" and "exhibition" of fulminating, sweaty and non-hegemonic bodies
"Exposition" and "exhibition" of fulminating, sweaty, fragile and non-hegemonic bodies ex-position and vision of body-axes for one night, fragile bodies

2
A defiant, provocative and proactive atmosphere
An atmosphere without limits between observers and performers, with a challenging, questioning, provocative, incredulous and proactive gaze
A sphere for challenging atoms, unbelievable communities, observers without limits

3
The corpse of a pig in whose interior Saúl receives Lima's public accompanied by Bali and Guillermo directing the night ...
Saúl gives life to a pig, or a pig gives life to Saúl, and both receive the expectant Limeños, Bali and Guillermo direct the concert and the bewilderment of the night ...
With certain bewilderment are the expectant Limeños, in a concerto of pochista pre-essences

4
The night continues to surprise and irritate, there is no longer any sense of time. But yes of the space and communication between the performers and the attending public.
The notes of the performers surprise and irritate, the melodies of the bodies return to space without time, the observers are motivated to play and be part of the melody

The scratchy notes of a viola-nist take us to a violent space without tempo, playing the corporeal melodies

5
and suddenly a colleague artist from Lima decides to physically assault these exposed and willing bodies ...
and suddenly a guest note to share its voice wants to be the most dissonant, and attacks the bodies exposed and willing, breaking the strings, removing their suits ...
The melody is loaded with a heavy metal, an experimental improvisation of garish objects, which explodes in a confused pogo of radical bodies ...
Ex-posed, laid out, re-posed bodies, objects, guests, assaulted all
(un) tender colleagues artists are radical.

6
Confusion, violence and finally the radical tenderness is imposed confronting us with our artistic prejudices, citizens ...
Confusion, violence and a radical tenderness that embraces the fallen bodies, the fallen bodies of art, the bodies fallen by the oil, the fallen bodies of here and there ...
Confused the citizen bodies are, with prejudices that lie here and there, falling between art and oil ...

7
It is imposed confronting us with our artistic prejudices, citizens ...
The beautiful picture of disaster confronts the artistic prejudices and citizens of the expectant, the performers, the leaders, of time and space ...
The performing performers are imposed on the expectant picture of citizens confronted
by their prejudgment

8
The "exhibition" becomes a provocation that questions the befitting parameters of a society as conservative as Lima's artistic scene ...
The "exhibition" of the bewilderment becomes a provocation, a questioning, a river tailing, where the conservative parameters of the Limeño artistic scene float ...
A provocation is thrown into the exhibition, like the tailings of a river on a con-servative society ...
Certain parameters that have already been questioned for a long time ...

9
The space again empty with the fluids and remains of the intense, wet and provoca-tive night, but our minds and bodies are not empty ... rather
full of images, sensations, confrontations of both the executors and the attendees ...

When the bodies leave their remains, archeologies of the collapse ...

Disturbing dreams, longings of sensations, permanent images, will persecute all these attending bodies, resistant, persistent, dissidents ...

Crossed bodies that are not empty of memories, confrontations felt, assisted and resisted on that humid summer night ...

10
Knowledge through the body, the unconscious and those "unique," "extra-ordinary" experiences that pochos generate when they share their pedagogy ...

Our body generated memory, knowledge was extra shared, Pocha pedagogy is not over, lives on the skin and in the unconscious of all ...

Only generating unique and extra-ordinary experiences ...

They make and break, their pocha pedagogy ...

Who lives in us through our bodies, in us as concert of consciousness and Unconsciousness ...

el.galpon.espacio (Lima, Perú). Co-directors:
Jorge KOKI Baldeón, Diana DAF Collazos,
and Lorena LO Peña

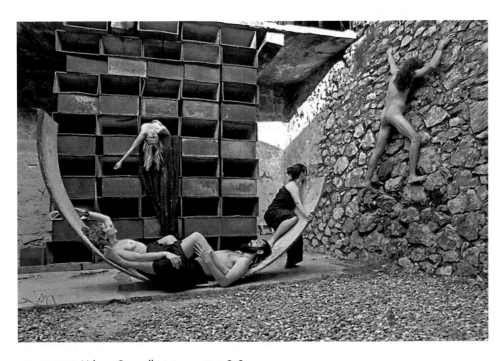

FIGURE 8.17 Urban Guerrilla intervention 3.0
Photographer: Tania Bohórquez
Courtesy of the Pocha Nostra archives.
La Calera, Oaxaca City, 2012

SECTION 8: LA POCHA NOSTRA PEDAGOGICAL MATRIX FOR WORKSHOPS

Besides showing me advanced transskizzo-ways-of-thinking, and of teaching me an introduction into self-awareness and to the care of movement and corporeal discipline, LPN transformed in a technical, theoretical and conceptual background, full of love to an expanded freedom, abnormality and, most of all, full of love and radical tenderness for humanity. It was a poetic example of community construction, just next to the border of my most, in that moment, abstract frontiers; really close to the limits of the personal Weltanschauung I used to have at that moment.

(Andrés Felipe Uribe Cárdenas, Bogotá)

When we plan our pedagogy matrix, we try to get as familiar as possible with the participants, the host institution, the local politics, and the space. We hold every day meetings to plan and create a suitable playlist of exercises for each session. During these meetings, we assign particular roles for each one of the instructors or the pedagogical deejays involved. One of the troupe members might take the role of the main instructor focusing on introducing, explaining, and giving clear instructions for each exercise, another becomes an instructor giving conceptual pedagogical comments, and another might take the role of the "coyote instructor" by participating in the exercises and facilitating the understanding of the methodology from within. These roles rotate and overlap as the exercises and workshop unfold. Keep in mind that pedagogical exercises and instructor roles are fluid and constantly negotiated in situ. We also aim at creating a polyvocal and horizontal structure for teaching. Our pedagogy is also poly-lingual, including some spanglish, gringoñol, and portuñol. We celebrate linguistic hybridity! Please refer to Chapter 7, the pedagogical introduction by Saúl García-López aka La Saula, for more details about how we run our workshops and the pedagogical context and aims of our pedagogy.

Our workshops have a length of one to ten days depending on the activities included, such as a "day rest" with individual outdoors or collective performance tasks, day visits to galleries, photo shoots, or final presentations. What follows is a template for a ten-day immersive pedagogical matrix with six hours a day of teaching. Remember that you can create your very own matrix according to your objectives, the time available, and the length of the workshop.

We invite you to *pochify our pedagogy*, add exercises from your own personal methods, cut and paste, subvert, and "bastardize" this pedagogical matrix!

Agárrense locos! Here we go!

Note: We humble suggest reading the important pedagogical and creative texts in our Chapters 9 and 10, all of which are pertinent to understanding our pedagogy.

DAY 1

WELCOME

- **Welcoming by our hosts:** Why this workshop is relevant here and now.
- **Pedagogical deejays welcome the group:** General aims and why the workshop is relevant in the context in which it is being presented. Refer to the text "La Pocha Nostra workshop welcoming" (p. 72) at the end of Chapter 7.
- **Pedagogical Objectives:** Gather relevant information from "The 2019 Pocha Manifesto" (Chapter 3), "What to expect from a Pocha workshop" (Chapter 4), and "Notes to workshop participants" (Chapter 6). Also, you can refer to the text "Priorities and principles of the Pocha Nostra workshop" (p. 70) at the end of Chapter 7. Don't forget to add your own objectives.
- **Poetic introductions.**

HANDS-ON AND PERCEPTUAL MATRIX SECTION

- **Physical warm-up and stretching.**
- **Working in the dark.**
- **Running blind:**
 - going forward
 - going backwards
- **The gaze:**
 - The primary gaze
 - Gazing with one point of contact
 - Gazing with two points of contact
 - Gazing with distances and levels

BREAK

During the first break we ask participants to organize taxonomically all the props, costumes, and objects.

CONCEPTUAL AND CREATIVE MATRIX SECTION

- **Skeleton dance.**
- **Poetic exquisite corpse:** Select a triggering phrase from the list provided or create your own.
- **Activating the "prop archaeology bank."**
- **Poetic ethnography:**
 - Parts 1 and 2 – multi-sensorial exploration of the human body
 - Part 3 – learning how to handle and carefully manipulate another human body

DAY 2

HANDS-ON AND PERCEPTUAL MATRIX SECTION

- Physical warm-up and stretching.
- **Poetic exquisite corpse.** Select a triggering phrase from the list provided or create your own.
- **The gaze:**
 - distances and levels
 - creative
- **Running blind:**
 - with a partner
 - creative running
- **The Aikido/chess game:**
 - with chairs

BREAK

CONCEPTUAL AND CREATIVE MATRIX SECTION

- **Monkey-breathing dance.**
- **Opening the poetic space:** offering the space for poetic interventions from the participants.
- **Creating tableaux vivants – Series 1: One-on-one: constructing a live image on someone else.** Select a topic from "Suggested themes for Pocha exercises" (p. 153) at the end of Section 3 of this chapter or create your own theme:
 - Round 1: Experimenting with architecture
 - Round 2: Exploring syntax
 - Round 3: Adding movement
- **Compositional triptychs:**
 - Once the system is understood, add one or two of the different variations suggested in the EXPANSION section of the exercise.

DAY 3

HANDS-ON AND PERCEPTUAL MATRIX SECTION

- Physical warm-up and stretching.
- **Creative Indian wrestling.**
- **Advanced working in the dark:** add one or two of the different variations suggested in the EXPANSION section of the exercise.
- **The Aikido/chess game:**
 - o with no chairs
 - o with props
- **Human puppets and dancing doppelgangers.**

BREAK

CONCEPTUAL AND CREATIVE MATRIX SECTION

- Glitch dance.
- **Creating tableaux vivants:** Select topics from "Suggested themes for Pocha exercises" at the end of Section 3 (p. 153) of this chapter.
 - Collaborative tableaux vivants.
 - Group creations: Instant "living museums."
- Staging your own funeral and/or reincarnation.

DAY 4

HANDS-ON AND PERCEPTUAL MATRIX SECTION

- Physical warm-up and stretching.
- Collective choreography.
- **Daily questions about performance art.** Select pertinent questions in the list provided in the exercise explanation.
- Creative gazing.
- **The Aikido/chess game:** Spontaneous props and swapping partners
- **Compositional triptychs:** Begin adding props or costumes and taking the exercise to other indoor and outdoor sites.

BREAK

CONCEPTUAL AND CREATIVE MATRIX SECTION

- **Skeleton dance:** use the variation suggested in the EXPANSION section of the exercise explanation.
- Poetic exquisite corpse.
- Guerrilla interventions into multiple spaces.

DAY 5

HANDS-ON AND PERCEPTUAL MATRIX SECTION

- Physical warm-up.
- Lowrider Chicanx biomechanics.
- **Opening the poetic space:** offering the space for poetic interventions from the participants.
- Daily questions about performance art.
- **The Pocha catwalk:** The different-body catwalk.

BREAK

CONCEPTUAL AND CREATIVE MATRIX SECTION

- **Collective choreography:** use the variation suggested in the EXPANSION section of the exercise.
- **The Pocha catwalk:** Creative catwalk with primary look.
- **Compositional triptychs:** with a primary look.
- **Basic, stop-and-go performance jam with a thematic anchoring.** If the participants understand the process, you can go ahead and facilitate an advanced performance jam. Select topics from "Suggested themes for Pocha exercises" at the end of Section 3 (p. 153) of this chapter.

DAY 6

We suggest a rest day that includes some collective and/or individual performance tasks during the day:

- radical tourism,
- looking for strange objects,
- pair a local and an international participant to explore the city,
- feel free to create your own itinerary for the day, even a day of full resting could be of great benefit.

At the end of the rest day we suggest a performance cabaret, an event for students to showcase their own work (optional), with videos, performance actions, spoken word, dance, or manuscripts. The idea is that they get to know each other much better and create alliances that might spark future collaborations. It is also a very good excuse to chill out and have a good time.

There is also the option of carrying on with the pedagogical process and reducing the length of the workshop to seven or eight days. The final amount of days will also be determined by the production or not of a final event such as a final pedagogical performance event.

DAY 7

From this day onward, the intention is that the two pedagogical parts (HANDS-ON AND PERCEPTUAL SECTION and CONCEPTUAL AND CREATIVE SECTION) breathe into each other and the workshop becomes a continuum process. Participants also gain more autonomy.

- **Physical warm-up and stretching.**
- **Poetic exquisite corpse.**

- Guerilla interventions into multiple spaces (indoors/outdoors): Guerrilla interventions allocating group categories.
- **Our planet as a human body.**
- **The illustrated body.**

BREAK

- Forty performance actions pulled out of a hat
- **Creating tableaux vivants:** Group creations: instant "living museums". Select topics from "Suggested themes for Pocha exercises" in Section 3 (p. 153) of this chapter.
- **Advanced performance jam with a thematic anchoring.** Select topics from "Suggested themes for Pocha exercises" at the end of Section 3 (p. 153) of this chapter.
- **Human collective altars.**

DAY 8

- Physical warm-up and stretching.
- Daily questions about performance art.
- Poetic exquisite corpse.
- **Human puppets and dancing doppelgangers / The Aikido/chess game / Lowrider Chicanx biomechanics** with primary look.
- **The Pocha catwalk:** Catwalk with photo karaoke.
- **Ultimate performance jam with a thematic anchoring, capoeira style.** Select topics from "Suggested themes for Pocha exercises" at the end of Section 3 (p. 153) in this chapter.

BREAK

- Guerilla interventions into multiple spaces (indoors/outdoors): Guerrilla interventions in a public plaza or a museum.
- **Magical chess.**
- **Creating and inhabiting your post-apocalyptic home and barrio.**

DAY 9

Start the day by choosing different advanced variations from any of the exercises. You will find those in the EXPANSION section of each exercise. At this stage of the pedagogy, multiple exercise combinations overlap as the process continues. This is an opportunity to revisit some exercises so the participant can internalize them.

Make a selection of exercises for clarity of the pedagogy, the instructor's objectives, and the group's pedagogical and aesthetic interests. By this day, the participants are very familiar with the pedagogical process, so it's time to let them exercise total autonomy and their own creative intelligence.

BREAK

- **Devising a pedagogical public performance** or the final open or closed pedagogical activity, if any. Refer to Section 6 of this chapter and follow the process described there.
 - Discussing the nature of the performance material
 - Choosing the performance event format
 - Determining the final roles of the workshop participants

We finish the day with an ultimate performance jam using the selected images and actions chosen in the previous discussions. Make sure that the group understands that the jam is not a "rehearsal." The images at this stage are only a blueprint, a starting point to keep sharpening our skills and looking for new material.

We usually employ the following sequence to kick start the jam:

1. **Each participant creates their primary look or persona (15 minutes).**

2. **The participant spends time revisiting actions and images (15 minutes).**

3. **Select any of our exercises that could be practiced with a primary look (20 minutes).** Refer to the EXPANSION section of each exercise. Some examples of those exercises are "Lowrider Chicanx biomechanics," "The Pocha catwalk," "The Aikido/chess game," "Human puppets," and "Dancing doppelgangers."

4. **Activation of the ultimate performance jam.**

Important note: Irrespective of whether you produce a final performance that's open to the public or not, you can implement the activities suggested here as part of the process of learning the many aspects involved in making live art.

DAY 10

For the last day, the focus shifts to production and "rehearsing" mode.

For further details on how to activate primary looks and produce an open performance salon or final performance, refer to Sections 5, 6, and 7 of this chapter, where you will find a detailed explanation on how to run this day.

We usually employ the following sequence for the final day:

1. **Make sure the participants read the text** "Useful suggestions to develop your performance persona for a performance" (p. 170) at the beginning of Section 5 of this chapter.

2. **Share at the start of the day the text** "Pocha Nostra protocol for a performance day" (p. 183) at the beginning of Section 7 of this chapter.

3. **Make sure to explain what is meant by production and "rehearsing" modes** (p. 183) in the Pocha method.

4. **Activate production mode.** Have handy a schedule for the day to share with everyone. For a detailed plan, directions and a Pocha Nostra performance day schedule refer to

"Activating production mode" (p. 185) in Section 7 of this chapter. Generally, the performance crew and the interdisciplinary design crew work together during the first four hours of the day. This activity can be performed the day before in the case that you have two days to prepare for the performance.

5. **Activating "rehearsing" mode.** Refer to Sections 5, 6, and 7 of this chapter for a detailed explanation that includes:

 - "Stylizing" your performance persona (p. 170)
 - Activating your performance persona (p. 172)
 - Activating the performance environment (p. 184)

6. **Final preparations just before the performance.**

To introduce a pedagogical event, feel free to adapt our document "A template to introduce a pedagogical jam open to the public" (p. 72). You will find this document at the end of Section 7 of this chapter.

When the moon
will scream
into my face
I will understand it now
and scream back
to turn it into a song
a duet
you did not teach me the screaming
you taught me the singing

(Andrea Zittlau, Universität Rostock)

A FINAL MESSAGE FROM SAÚL GARCÍA-LÓPEZ AKA LA SAULA

This is the end of our pedagogical section. I hope you have found practical tools and pedagogical insights to inspire your artistic journey. Let's keep exploring the Pocha Universe, breaking walls, crossing borders, and seeking new pedagogical and performance frontiers with radical tenderness and artistic authenticity.
July 2020: A last minute note before publication: from lockdown in my mex-igloo in Norway, I wish you good health and fortune. I hope to see you when the pandemic is over and carry on with our pedagogical locuras.
RADICAL LISTENING + RADICAL TENDERNESS + RADICAL HOSPITALITY = DIPLOMAT OF RADICAL DIFFERENCE.

With love from the trenches
Further techniques and reflections from Pocha and our partners in crime

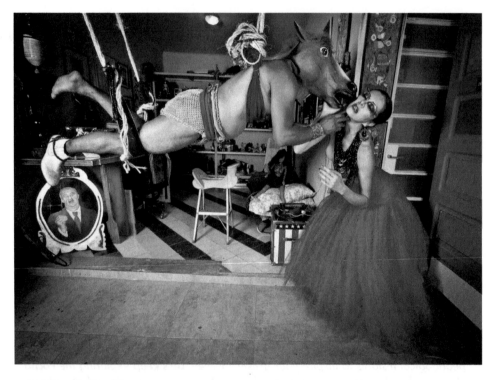

FIGURE 9.1 Horse and Señorita
Photo: Herani Enríquez Hache
Performers: Norma Flores and Gerardo Juarez, Mexico City, Mexico, 2014

We simply could not launch our new pedagogy book without including the voices of our prominent partners in crime, who have created performances, toured, experimented, played, cried, and laughed with us in and out of the performance zone. Their energies as radical artists are part of what sustains us, but rather than being selfish and keeping them to ourselves, we wanted to offer their unique voices and useful techniques to you here. The following pedagogical texts are authored by Annie Sprinkle, Beth Stephens, Reverend

Billy, Savitri D., Dragonfly, Fotini Kalle, Claudia Algara, Sally Molina, L. M. Bogad, and Micha Espinosa among other dear collaborators. They offer everything from practical strategies to poetic inspiration and performance challenges to practitioners at all levels of engagement with live art in times of crisis.

SECTION 1: CANDID CONVERSATION AMONGST LA POCHA NOSTRA MEMBERS ON THE SPECIFIC CHALLENGES WE ARE FACING IN A POST-DEMOCRATIC SOCIETY

TRACK 1: POCHA PRODUCTIONS IN THE THROES OF THE TRUMPOCALYPSE

The core Pocha Members and Paloma gather in a conceptual conference room slash lowrider museum slash camping tent with a guest appearance by Jack Daniels somewhere between the Santa Fe Art Institute and the Mexican Museum of Modern Art (MAM) residencies. It's early morning in "Pocha time" (1:00 pm in the rest of the world). Bali, Saulita, Guillermo Mad Mex, Emma, and Michèle are doing their personal performance rituals to prepare for a long writing session.

PALOMA MARTINEZ-CRUZ (PMC): The stage has been set. Orange Garbage Fire Number 45 flies in the face of every last constitutional right while slithering under the lowest bar of human decency. Daring doula of new public identities, the stage is set for Pocha performance, for Pocha live art conversations on the brink of ... on the brink of ... *(she snaps her fingers)*

GUILLERMO GÓMEZ-PEÑA (GGP): ... emerging from the ashes of the Museo de Arte Moderno performance as a phoenix in the barrio, deejayed by Ricardiaco, brainstorming about how to make our book accessible while remaining hard core ... and theoretically savvy.

SAÚL GARCÍA-LÓPEZ (LA SAULA): ... on the brink of Lovarin, *alivio de los síntomas asociados con rinitis alérgica* and my Seroquel for my mental allegorical condition. And, YES, on the brink of despair!

BALITRÓNICA GÓMEZ (BG): ... on the brink of some chili stew GP just gave me. No pictures, please. I haven't "produced" myself yet today.

PMC: ... on the brink of total alienation! I see La Pocha as a live art dialysis machine for political anguish. Congress can't be bothered with the train wreck of the democratic process. We're on our own, locas, and La Pocha is on the front line.

BG: No shit. Performance workshops have become magnets for the frail communities which are under attack by the far right including immigrants, refugees, queers, artists of color and activists, Muslims, and radical feminists. It's the whole anti-Trump entourage.

MICHÈLE CEBALLOS MICHOT (MCM): And that entourage includes anything that makes sense for the survival of humanity and the planet: environmentalists, protectors of animals and wildlife, people with mental disabilities, artists who have been recently

evicted … Unfortunately, the Trump mindset seems to be against anything, everyone with integrity at all, so the workshop participants are increasingly frail, and we are, too.

GGP: I feel like Mother Teresa from Calcutta … We are becoming a charity organization and a sanctuary for the victims of indifference … And then of course there's the pervasive culture of environmental catastrophes. That being said, the orphans and victims of these epic dramas need a break, and performance art can help them. Our workshops are like islands for temporary relief.

MCM: True. Our workshops are needed, they are healing. The most frequent feedback we get is that participants feel empowered to tackle the challenges they are facing.

PMC: So, 45 and his regime of incompetents usher in a heightened need for live art to create empowered communities of radical inclusion. At the same time that the need is increased, the funding is slashed. How does this impact your pedagogical methods and strategies at a time when the cry for your work is so urgent?

LA SAULA: As organizer of some self-produced workshops, I can tell you the people that need us the most can't pay the tuition anymore, and we simply cannot reject them. Already what we charge is not that much, and still, half of our workshop participants cannot pay. How do we solve this issue if we wish to continue offering our pedagogy and also pay our bills?

BG: Yes, we are working three times as much for half the budget!

MCM: Not to mention that the universities, colleges, and museums are all in survival mode, protecting their budgets and censoring any creative expression and ideas that may create a controversy and threaten their institutional relationships, or awaken the rage of the local conservative communities.

LA SAULA: Paradoxically, this has helped to expand our community and our self-produced feral workshops, as we offer emerging artists what these "educational institutions" can't offer them anymore.

GGP: This brings us back to the whole money dilemma. *How* do we create a sustainable pedagogical practice that is entirely self-produced, when half of the workshop participants have been recently evicted or are currently squatting?

LA SAULA: The pinche money … somehow the actual project starts months before the first day with an intense round of negotiations. In times of economic challenges, we are constantly creating new sustainable models of production in which we involve the local community and producers. We look for donations, access to spaces, and resources in exchange for an activity, a lecture or a performance in the city where we are.

BG: This applies as well to our participants and close collaborators. For example, we reach out to one of our more than 60 close collaborators that have been working with us for more than six years in different projects and countries, and we ask for their support at any level they can. With the participants we create "group conversations" online and exchange information looking for ways to gain and share resources to support the workshop.

GGP: We try to ask for tuition from those who come from so-called First World countries and who are sponsored by universities or funding sources. But we also give scholarships to the local artists, especially the indigenous and working-class artists. But these scholarships are given in exchange for something: if they have a car, they can help us

drive around town. They can also help by cooking, cleaning, organizing our prop and costume station, scouting potential public sites for performance interventions …

EMMA TRAMPOSCH (ET): The work of scholarship students becomes a very important strategy for combating financial scarcity. For example, as GP mentions, often if someone is not able to pay full tuition they are able to contribute in extremely beneficial ways to the daily operations of the workshop, including helping with daily set-up and clean-up, helping organize and refurbish the prop and costume table, lights, sound, local transport, and even by cooking and providing hospitality support. These are not menial roles! They become crucial to the daily workshop environment. LPN strives to keep workshop fees low, but also by providing multiple scholarship opportunities, our hope is that artists from diverse backgrounds can still attend.

MCM: Every person has something different to offer, and working together, sharing the labor, the total project, the idea with the same objectives, creates a functioning community. Pocha works this way. We all are responsible for holding up the universe. I'm stating this based on our current president's disdain for exactly this type of structure. We don't stop what we are doing because of lack of funds.

BG: We also need to be more adaptable than ever before. What happens when suddenly we discover two months before the project that the funds that the local hosting organization applied for didn't arrive? Or when suddenly three days before the workshop, as happened to us recently in Tucson, five participants decided to defect due to their precarious economies and fragile mental health situations?

LA SAULA: We have encountered these issues in almost every long workshop we have produced during the last three years. And when this happens, we need to reinvent the project *in situ*. We reach out to our allies and artistic community for help, we ask the participants to help us with simple tasks and try to relegate instant responsibilities across the members of the troupe. We rarely cancel a project and in fact these new challenges contribute to create a strong sense of community between everyone involved.

GGP: And often we come out even, but that's OK. In that case, we try to even out the budget by selling books and CDs on site, or by adding a Pocha performance or lecture in a local museum or gallery for additional money. We have become really good at self-producing, but it's always a challenge.

MCM: We can't predict budgets, but what bothers me is when people who are clearly upper class and well-funded end up not paying … Se ve chafa!

ET: I truly believe that a main reason LPN has survived all these years is due to our ability to shrink and expand as needed in multiple ways. For example, in settings with budgets that can afford it, we can offer multiple workshop days and a large-scale performance by the troupe. Alternatively, we can offer smaller residency models like a solo performance by Gómez-Peña or a performative lecture. There is the feeling that in each instance we are creating something specific to that place, and I think this is something that is a strength of LPN's, especially during challenging times in the arts … and in the world.

PMC: With funding being identified as a constant struggle for Pocha productions and pedagogy workshops, this book strikes me as an incredibly generous way for you to offer your practices broadly. Anyone can pick up this book (whether or not they buy it – and

most don't), and then call it a Pocha workshop and even charge for admission. How do you want us to reference your work and apply it in our practices? The book encourages all types of arts practitioners to take everything they need from Pocha methods. When is something a "Pocha-inspired" workshop, and when does it cross the line into the misappropriation of intellectual property?

LA SAULA: Many ex-Pocha members and associates are still teaching the "radical pedagogy for rebel artists" book as if it were their own method. Most of the time we don't mind, unless they cross the line …

MCM: Cross the line?! You mean, when they make a bunch of money off of our work and we are still figuring out how to pay the rent! When it comes to our exercises and images, we always frame it with "use anything for your work but please say where it comes from." Do they always do this? No. Do they get caught? Yes. Why? Because the performance art world that we work in is very small and Guillermo is one of the masters in this work, so everyone knows him and writes to him. We have gotten so many calls from directors and producers of conferences and festivals that tell us so and so was just here "representing la Pocha" and we had no idea!

GGP: We just need to bite the silver bullet. The border between appropriation and expropriation is very thin. Besides, in the Trump era, we simply don't have the time to worry about these matters. We must fight the real battles and help others sharpen their critical and performance skills to fight their own battles. That's what our pedagogy is about.

With this, the Pocha corps break to eat New Mexican sopapillas to carb up for their photo shoot against the wastescapes of the Tijuana border under the twisting shadows of Voladores de Papantla.

TRACK 2: EXTREME SURVIVAL, REINVENTION, AND THE NUDE BODY

The core Pocha members and Paloma gather in the cyber pulquería and nopal dispensary in Tepito (the capital of Mexican stolen and smuggled goods) where GP has told them to meet. He arrives carrying a metaphorical machine gun that he holds across his chest with a look that is both solemn and resigned. This particular writing workshop will simultaneously involve extreme personal sleep deficits, multiple travel itineraries, underpaid inner demons, the joys of being reunited after several months, and a cluster of hallucinatory migraines brought about by the complexities of the upcoming performance.

GGP: [Brandishes metaphorical weapon] I think it's time Paloma learned where we really get our funding! The Mexican Crime Cartels … plus …

LA SAULA: José Cuervo, Google, and Televisa! They got tired of being boring, so they commissioned us to experiment with the "phobia of physical proximity to Mexicans who suddenly engage in durational kissing and public nudity."

MCM: "Boring" is never an option in the Pochaverse.

BG: Welcome to an era of extreme survival tactics.

GGP: History begins when you wake up and ends when you go to sleep.

MCM: The daily struggle is real! The liberal art world is poor and we are getting a lot of calls from conservative cities with communities under attack by the current administration. On a recent gig, we had to face white supremacists. Remember?

GGP: Yes, I remember being accosted by skinheads in Providence, Rhode Island and Liverpool. The sight of a bunch of queer artists of color was threatening to those Neanderthals. Most recently, while touring "red America" and crime cartel-controlled regions of Mexico we have to ask ourselves how to remain safe. And how do we take care of international participants who may not be aware of the local dangers? Sometimes the producer has to hire bodyguards for a bunch of performance artists, a contradiction in terms.

BG: We keep these extremes in mind when we start a new pedagogical project, which kicks off when we respond to two challenges: who to invite to partake in the experiment, and where to locate the project. When we work with "local communities" we take the political issues that they are facing, the history of the place, their economic situation, and even their geographical location into account. Is it the desert or an international metropolis? Are we in the epicenter of a crisis or at the edge of it?

GGP: We rely heavily on local colleagues, curators and Pocha associates who perform the role of "Pocha ambassadors" to help us select the right art space and the right mix of participants. The group we form in any specific location, whether it's Mexico, the USA, Brazil, Greece, or Italy must be, and I quote from a Pocha document, "multi-racial, poly-gendered, trans/generational and activist-minded." This is not mere "grantese" (grant language). We really walk the walk. Besides, the site we choose to work in must be receptive to our politics and aesthetics, and preferably "autonomous," which means not scrutinized or surveilled by the flashlights and drones of academic or capital art world institutions.

ET: The ultimate goal is that this "utopian pedagogy" can extend beyond the physical space and time of the workshop and permeate daily life in lasting ways, most notably in the cultivation of new connections and collaborations between artists from strikingly different backgrounds and nationalities.

PMC: Speaking of utopias, the participants' relationship to nudity is one of the pedagogical elements that can be both a trip wire and one of the highest expressions of emancipation. Many find it utopian to be nude in the performance zone, and others … not so much. What are some of the ways that participants work with nudity as a technology for reinvention?

GGP: We depart from a simple concept: the wars that take place in the world, also take place in our bodies. So the first step is to politicize our bodies … by decolonizing them.

LA SAULA: Young performance artists also remind us that their bodies are their only home; the only site they have control over, and sexuality, when politicized, can become a powerful force of contestation.

GGP: I remember the famous opera singer who signed for a Pocha workshop and told me the first day. "I saw your photo blogs. If you expect me to get nude you are out of your mind! Are we clear?" And I answered, "Nudity is never mandatory." The next day, she showed up topless to the workshop and never put on a blouse for the whole week. Every pinche workshop is different; a total adventure into the unknown.

LA SAULA: I find that nudity in my work functions as a way to confront my own demons and insecurities, and also to confront the viewers with the colonial and stereotyped projections onto the Mexican, Mestizo, and Indigenous Queer body. My skin, and the centuries of history that it represents, is the ultimate territory for resistance and emancipation …

GGP: Cálmate Congelado de Uva!

LA SAULA: Well let's not get caught in the middle of the vast and endless performance debate about "wee wee" or not "wee wee" or "chichi or not chichi" … that is an entire other conversation!

MCM: A woman my age (62) never shows her nude body and it is a myth that she has no sexuality. When I get naked in performance, it's like when a woman says her age out loud – it's liberating and empowering, not just for her but for all women. It's a rush, especially within the dynamics of the workshop: 24 humans from all parts of the world, economic levels, complex genders, races, and ages are communicating and creating powerful imagery and content that expresses their relationship to their alternate selves and to the social world at large.

BG: We ourselves have to relearn all this because racism, sexism, and homophobia also exist inside of each of us, and the project of facing these demons and fears is a lifetime project.

GGP: You're telling *me*! I'm still engaged in the daily process of deconstructing my prejudices towards white Americans and upper-class Latin Americans.

BG: Not to mention your logocentric macho tendencies. You might claim your queerness but your upbringing as a privileged Catholic Mexican boy is still present. I have to keep you in check, cabrón.

Upon refilling their nopal prescriptions, the Pocha corps synchronize agendas to make an electromagnetic appointment which brings us to the following minefields. Kindly watch your step.

TRACK 3: ANARCHIC UTOPIAS AND PEDAGOGICAL URGENCIES

A gathering of minds on the internet, a cyber meeting dealing with the loose ends of the conversations, five screens open, Bali and GP in Mexico City with their chihuahua Alonsito who trembles with impatience for his turn to intervene; Emma in San Francisco freezing Pocha Nostra accounts in the wake of fresh Equifax scandals; Saula is in Toronto sharpening his norteño boots; Paloma is in Columbus ordering a Speedy Gonzalez combo plate from Amazon; Michèle is in Phoenix stitching sequins onto her terry cloth headband.

PMC: I'm so happy to be home, but what passes for Mexican food in Ohio makes me long for the Pocha combo platter of spicy identities in defiance. I can't eat one more Señor Sucio's Chimichanga Plate!

ET: I think "hunger" is a very relevant metaphor. The workshop participants are definitely starved for real communication, the kind of exchange and dialogue that comes from

within embodied exercises. Only by returning to the body, listening to hunger, can people participate in a more intuitive way. We put a time limit in our pedagogy on verbal interaction. But there is also plenty of time for talking in a more casual and organic manner outside the sessions in local restaurants and bars. Should we make a reservation for Señor Sucio's next time we're in the Midwest?

BG: I'm conceptually already there!

LA SAULA: Why is the tequila waitress taking so long? Doesn't she realize that art institutions are "re-discovering" performance art and its political relevance? It's time for a Pocha Nostra body shot!

GGP: Saula, now you're talking. Every time that the artworld is in crisis, they suddenly re-discover live art for their salvation. Same with the theater world. When there was a crisis of social or psychological realism and narrative representation, the devised theater movement emerged and "re-discovered" the basic principles of performance art. Real time, real space, non-narrative texts, auto production, new media, etc. Now, in the last ten years, new Belgian, French, and German choreographers are also re-discovering these principles for the first time ever. We just have to get used to being deported to oblivion and then re-discovered for the 200th time.

BG: Now, with so-called "social practice," performance studies departments are paying attention to what communities of resistance (feminists/queers/Chicanos/people of color/the indigenous) have been doing for the last 50 years. We never take ourselves too seriously, and we fully know that it might be the last time we are ever invited. We have to take the body shots where we can!

GGP: I totally agree that we must work audience body shots into the Pocha equation. It's very in keeping with the ethos of a troupe performance by La Pocha Nostra: a fully sensorial manifestation of an equitable world view that does not exist in reality, where audience participants are not only invited to transform the outcome of these gestures and actions, but at times to even become instant performance artists. They are hungry for this shit! When I see audience members exercising their civic, artistic, and political muscles in a performance; when I see them engaging with us in our dangerous border games and rituals, I go: "It's working!" My hope has been restored ... even if only for a few hours.

LA SAULA: It's also a clumsy process. We are all trying to make sense of the universe that unfolds in front of our eyes. It is in this territory of chance and challenge where both sides meet and engage and redefine themselves. It's border art at its best and worst!

PMC: But within this emphasis on radical horizontality and utopian redefinition, how do you deal with the participants and collaborators who re-enact political privilege and entitlement when Pocha work emphasizes the liberation of marginal and "illegal" identities?

LA SAULA: Hey loca! Wow! What a sharp ACA-DE-MIC question! Vamos, éntrale, GP! I need another cup of coffee before being able to offer an answer. And where is the tequila?

GGP: You mean, how do we apply the understanding of "privilege" to our pedagogy? First and foremost, when selecting participants we go out of our way to locate and invite indigenous and so-called "artists of color" of working-class origin. If they are queer, even better. But at the same time, as professional performance artists we also have to pay

attention to the quality of their work and their degree of understanding of the culture of collaboration. An ideal workshop for us is constituted by an eclectic array of artists spanning various ethnicities, gender complexities, artistic disciplines, and generations. We wish to work in a universe that looks and feels like the imaginary country we would like to live in.

ET: Our performance models help us to challenge traditional, vertical hierarchies. We create site- and context-specific work that responds to the conditions and tries to speak to the heart of current issues and concerns. For example, if headed to a college campus in rural Vermont, we ask in advance what are the current issues being discussed on campus among students and incorporate this into our selection of performance scripts and content. Trying to maintain a balance between hyper-local specificity and international awareness makes each performance and project totally unique. Having a menu of options – from solo keynotes to large performances – provides flexibility and multi-vocality.

GGP: And like Saula has already mentioned, there is also our bittersweet relationship to the Art World, in capitals, where we deal with the continued insistence on a star-driven production model, which has always been ambivalent and awkward from both ends. However, this love/hate relationship has been good for both: THEY can claim they are open enough to be able to contain our madness and WE can claim the romantic positionality of being necessary "outsiders" and partial and strategic "insiders."

BG: True. Our desires never truly align but we somehow need one another. It's a macabre dance, a Faustian pact, in which we hope to not get burned.

MCM: We are conceptual coyotes. It's like dancing a Colombian cumbia with the devil ... in drag!

Michèle gamely demonstrates her cumbia into the webcam; Paloma disconnects to open the door to Señor Sucio's delivery gnome; Guillermo and Balitrónica's inner children are kidnapped by Mexican Juggalos in Santa Claus uniforms; Emma and Saula hurry off for their National Balero League tryouts. If you don't know, that's the Mexican game where you try to pop a ball swinging from a string onto a stick. They've been making real progress with their wrist work.

TRACK 4: BLIND NATIONALISM AND THE REDEMPTIVE GIFT OF RADICAL HOSPITALITY

A gathering of Pocha corp in the family home of Guillermo, Balitrónica, and Alonsito. The fideos and albondigas have been cleared. The room is pregnant with impending farewells – the stock trait of the Pocha museum of deterritorialized identities and spoken-word passports.

PMC: They got my wallet, but they didn't get my US passport. Those pickpockets were *so* good to me. I'm going to give them five stars on the Mexican petty crime app. I had to cancel my credit card, but at least I get to go home!

ET: But what does home mean these days? Is it a geographical place? A national identity? The in-between time in the airplane between countries at cruising altitude?

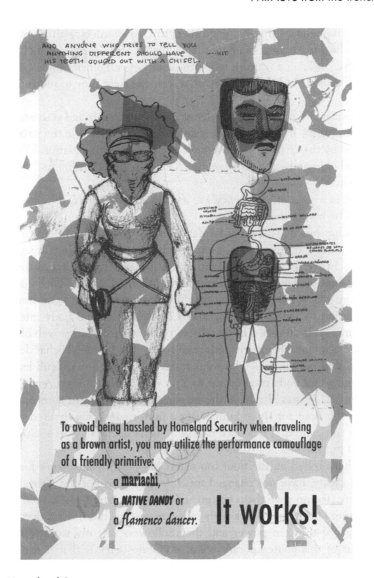

FIGURE 9.2 Homeland Security
Illustration: Perry Vasquez
California, 2019

GGP: Let me refer to an interview that artist and theorist Elena Marchevska did with us. She asked: "You state that 'all nation states are dysfunctional and dated.' And while I strongly agree with this, we see the resurgence of a blind nationalism."

BG: The fact is that now, our troupe is being forced to reinvent itself once more. The Trumpocalypse has inaugurated a new era of ultra-nationalism, xenophobia, homophobia, and censorship, and artist communities are being forced to step up and talk back.

LA SAULA: Pocha believes that helping others to cross borders with a sense of compassion and radical tenderness can potentially create a third space in which we can get to understand each other a little bit more, and look beyond binary models. I don't want to sound pretentious but I think that is what we need right now to reinvent our political models.

GGP: As a Mexican, I witness the daily deportation of migrants and activists. As artists, it's life or death for us. Trump's cabinet is determined to dismantle the structure and culture created by the civil rights movement and to destroy the National Endowment for the Arts and Humanities, the Corporation for Public Broadcasting, and the Department of Education.

We are living in a state of emergency. We are forced, once more, to reinvent our artistic practice; to be bolder than ever before.

PMC: That Pochas practice a dangerous dance on the front line of political crisis is truly one of the most exciting, but also one of the most challenging, aspects of creating radically inclusive art. This post-truth state has ushered in a new fervor amongst participants and collaborators to really throw themselves into Pocha jams and other interventions like it's the last thing they'll ever do, but at the same time there needs to be attention to radical listening and a discipline around body intelligence, or it devolves into a self-absorbed fit that doesn't play with the larger web of the ensemble or take into account when their performance expires. I notice Pochas deal with politically exhausted participants who want to give their all, but are still learning how to bring listening and body intelligence to a project. While there is zero desire to arrest these impulses, Pochas also have the responsibility to prevent someone from rolling around on the floor for three hours after a performance has expired. And I say this humbly as someone that has once had two Pocha deejays escort me out of a kinetic action that put me in a near-trance.

MCM: Lol! I have rolled on the floor too sister! My performance work for example, the personas I create, have not changed much with the rise of the alt right. They were always there. Trump gave them the green light to resurface, like an old wound. Since this Trump era began, my work feels more dangerous, more risky, that my life could be in danger if those in power and their followers saw my work. But the positive coming out of this contemporary political circumstance is that it has created more collaborations, sharing of resources, recycling, reusing, reinventing and reclaiming of public spaces.

LA SAULA: I remember that in the same interview with Elena Marchevska, she introduced the notion of "radical hospitality" inspired by the concepts of "radical tenderness" and "radical compassion" coined by Pocha.

GGP: I remember her idea of "radical hospitality" but I would change Derrida's concept a bit; adapt it to the times. I believe that any stranger, and this includes migrants and refugees, should be allowed to cross borders and occupy any public space they desire. It should be a human right. But I would develop this concept even further and apply it to performance art. Performance artists create "autonomous border zones" where the transit of ideas, radical art, nationalities, and human bodies is not only allowed but encouraged. In our performance universe, there are no passports, no border patrol men, and no social classes. There is no heteronormativity. We know it is perceived as an

imaginary space, a utopian space, but we also know that it actually exists, even if only for the duration of a project. We call our project "imaginary activism."

BG: The concept of "radical hospitality" seems to be aligned with the American idea of "holding space." By hosting workshops and teachings, we can essentially create a safe space for the oppressed and the outsider. When the workshop ends, we always hope that the local participants continue to create space for one another in their own community. It works most of the time. As of now, La Pocha Nostra has spawned over ten different artistic collectives and loose associations of radical artists in different countries, including La Perrera in Oaxaca, the Smelly Girls in Athens, and several groups of trans-feminists and anarcho-queers. We are currently helping to build a robust community of performance artists in Santa Fe, New Mexico and Tucson, Arizona. In both places, for the first time, indigenous artists are collaborating with so-called "white" university-educated artists. This is our most important political project: to help build trans-national communities of resistance.

LA SAULA: Recently, during the pedagogical cross-pollination at the Venice Performance Week in the summer of 2017, we were inspired by an exercise of the Italo-German duo VestAndPage. The exercise asked participants to build their own house and then inhabit it. The results were outstanding. Later on, we pochified it and asked participants to think of an apocalyptic time where displacement is forced and homes have been destroyed. They need to build a new house in a new place. We asked participants to build their own house from found materials and inhabit their houses with performative actions. Most of the houses were connected. It was such a beautiful tribute to "radical hospitality."

BG: We are currently creating new performances in direct relation to the state of affairs in the world. For instance, we have recently been conducting "foot-washing" ceremonies to purge the racist sins of audience members when entering the performance space, and other times, to welcome recent immigrants to the country in which we are performing. This piece was inspired by the Pope's actions. We also recently performed, in Mexico City, a petroleum ritual bath "to purge the sins of Trump's cabinet."

MCM: Purging is very important to us. I purge when I perform *The Border Puta Trumped* – it feels like an exorcism. She's everything Trump fucks or fucks over. She's his perfect product, he molds her into Mrs. Republican. Yes, she's a good girl 'cause "grab my pussy? Well no harm, it's locker room talk! Boys will be boys!" I love this work, which is so different than the work I did as a ballerina. Two extremes. White supremacy (ballet has been the most non-inclusive of race) to Pocha, all-inclusive.

GGP: We are also restaging classic projects and adapting them to the new times. For example, *Mapa/Corpo*. We began working with "political acupuncture" in 2003 as a response to the US invasion of Iraq. We first started working with nude Arab bodies as a metaphor for the wounded territory of the Middle East, utilizing 44 needles bearing flags of the countries involved in the much touted "coalition of the willing." Then, in 2004–2007, we used corporate flags as an act against corporate power. During 2007–2014, when the bloody territorial drug wars took Mexico by surprise, we started using flags either of the countries occupied by crime cartels in Latin America or by the states in Mexico controlled by crime cartels. This series of performances were presented in over 20 different countries and was originally titled *Mapa-Corpo* or *Body Maps*.

LA SAULA: One of the current live art images that we have been using in the last three years is the image of huge pig and/or cow carcasses from the slaughterhouse subjected to intervention by the nude bodies of me (García-López), Nayla Altamirano, and Balitrónica. In Mexico the title of this piece is *Adam and Eve in Times of War*. In Mexico and other Latin American countries audiences understand the metaphor very clearly and we have no problem presenting the performance. Even in Canada (Montreal, Quebec) where we performed it in March of 2017. However, in the USA and Europe we haven't found one producer or cultural institution willing to take the risk of producing such a piece.

BG: We are currently facing our ultimate fears: We are touring "red America" and the states in Mexico that are controlled by organized crime. It's a dangerous project, we know, but we have to do it. We need to do it precisely because we have been told by our students that our radical pedagogy works and that it can be useful to generate community and sharpen the intellectual and artistic skills of young activists and artists to help them face the scary immediate future.

TRACK 5: THE CLOSING RITUALS OF LA POCHA NOSTRA

Google jam: An astral encounter that does not rely on texts or screens. Below, the Pocha Corp communicate through telepathic emails that rise up and reach towards each other, a whispered webbing of smoke after candle flames are snuffed. In this final online conversation, La Pocha tackles its own internal demons and proposes "closing rituals."

PMC: Hello? Helloooooooo? [*silence from Pocha*] Do you copy? Is this thing on?

GGP: Bali, did you hear something? [*Excited barking from Alonsito, their micro-tea cup Chihuahua, always on the road with LPN*]

BG: I told you astral Paloma was going to be pinging us! We're here! We copy!

PMC: Hey, so this is pretty embarrassing, but after the last Pocha workshop, I dove so deeply into the gaping wounds of political and patriarchal violence, into the wounds of memory and trauma, that I became totally disembodied and spectral. I'm thinking I didn't have the right closing ritual to fend off the four horsemen of the Trumpocalypse. I don't want this to happen to anyone else! Can you talk about some ways to close the wounds that we explore in this practice?

GGP: Shit! That's the ultimate question: When you open the Pandora's box of our times, and the demons come out to dance with us, how do you bring them back to the box at the end of the performance or the workshop?

LA SAULA: Híjole, we almost forgot to talk about that! How do you close wounds of race, gender, class, and the systemic effects of crime cartel, corporate, and social violence that we deal with in our pedagogical practice?

BG: During the past years, La Pocha had to develop closure rituals at the end of every performance or pedagogical adventure. Why? Because of the work we do against racism, sexual and domestic violence, and the anti-colonial body work we do … whether it is the participants of the workshops or the audience, they project their body memories and traumas onto us and these traumas linger in our own bodies after the workshop

or performance. If we are not careful, we bring these demons into our own personal relationships and they surface in our own lives, especially under the influence of drugs or alcohol.

GGP: I've been dealing with racism for 35 years in my own work, and for me it hasn't been a theoretical exercise but a daily experience. From being beaten to a pulp by LA and San Diego racist cops, to being feared by racist airplane attendants and bartenders who pretend to ignore me, to my inability to hail a cab in the streets just because of the way I look. This racist shit never ends. And I have had to develop strategies to fight it on a daily basis.

PMC: Give me some concrete examples, Mad Mex.

GGP: My main strategies are mostly my verbal skills, my written texts, my understanding of law and my performance art practice where I get to talk back to White America. But check out my "criminal identity profile" in the *Unplugged* anthology for a longer take.

PMC: Just give me a *concrete* example. Remember? I'm trying to become corporeal again, so real-life closing rituals are urgently needed.

GGP: Last week I was accosted by three scary white dudes when coming back from a bar. They just wanted to fuck with me. It was clearly a racist moment. I suddenly started speaking in tongues and doing some shamanic punk dance. They flipped out and ran away.

But, yes, I still need to fight my inner demons through closing rituals. The sad thing about it is that I know and advise young artists to practice these closing rituals and survival strategies, but on the road LPN rarely has time to enact them. Immediately after every workshop and performance we take off our makeup and hit the streets of the city we are touring with the escort of local friends and begin the infamous bar-hopping ritual of LPN. It is only weeks later when we least expect it that Bali and I are in a local bar or restaurant and our demons emerge.

MCM: I don't think the wounds can be closed, but we can hone tools to express them so they don't completely throw us off balance. Throughout our workshops they are dug out and placed in the light. After the workshop, we have acquired a very major tool: a powerful community and the exercises to extend that community outward even further. Pocha offers community through performance, music, movement, unembarrassed self-expression. We move on with the means to release and carry our wounds with less weight and pain; with greater strength and an open heart.

LA SAULA: For me a simple way to end a work day is for the group to form a circle and hold hands in silence … then we turn to the right and begin massaging the back of the next person.

BG: If there's a shaman in the room, and we often invite shamans into our practice, we ask them to sage us or use palo santo before and after the performance.

GGP: For me what works the best is just taking a cold shower for ten minutes and drinking lots of water before hitting the streets.

BG: Rubbing our bodies with rose water or alcohol after the shower works even better.

PMC: The powerful invitation to claim our post-apocalyptic demons, to dance with them and learn from them, is a such a compassionate way to take stock of our broken places. But I'm seeing that we also need a way to thank the demons for showing up and then

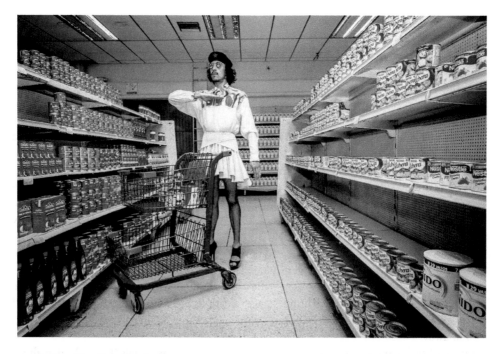

FIGURE 9.3 Che Gay-vara's shopping spree
Photo: Herani Enríquez Hache
Performers: Hugo Alegria
Guanajuato City, Mexico, 2016

let them know it's time to go home, to close off their all-points access to my body and mind so that I can govern my bodily boundaries again.
If we don't have a limpia to clean the demons off, they can lower your immunities, contaminate your inner sanctum, throw you off your game. Pochas, thank you for being on the frontline of this dance with our political and personal phantoms.

With these words, the Pocha corps perform their multi-layered ritual of farewell purifications, restoring untethered bodies back to the terrestrial plane ... until the next time.

SECTION 2: SOME ADVICE FOR EMERGING PERFORMANCE ARTISTS

We love the following advice, rules, and suggestions. Sometimes we break them. When we do, we shake our heads with a sigh and say, "We should have followed them." We offer you this advice not because we think we are role models, but because we hope someone will find the "existential warnings" useful. In the end, we hope you will create your own tenets for a sustainable journey of transformative performance practices. LPN

1. **Travel to other countries** and stay for extended periods of time.

2. **If you cannot afford to go to other countries – and even if you can –** open your eyes to the different communities that surround you. Visit them, de-familiarize yourself with your city or community, and become a border crosser!

3. **Learn other languages,** especially those that will help you understand and communicate with your surrounding cultural "others." Imagine if we were all fluent in at least three languages! Robo Esperanto counts, but also pocho esperanto!

4. **Use your acquired language loud and proud in the public square,** even if you just know three words, and especially if it means you will be laughed at. For people experiencing linguistic vulnerabilities and migrants of all stripes, your sincere effort lets them know that you think their language is valuable.

5. **Challenge all forms of (political, religious, gender, artistic) authority with a critical and open mind.** Assume the consequences with bravery.

6. **Don't create work in a bubble.** Make your art relevant to the entire world, not just the art world.

7. **Create an intergenerational group with like-minded peers.** Meet with them at least twice a month. Exchange work and ideas.

8. **Learn to ask for help when you need it** (economic, aesthetic, intellectual, practical, etc.).

9. **Use online groups and blogs to connect to colleagues** and create collaborative bridges. Don't just advertise your success and upcoming plans.

10. **Veterano artists, go ahead and "like" an intervention by an emerging artist.** Quote down the food chain, not just up. Celebrate your younger peers. Empower, ignite, incite!

11. **Discuss politics and culture daily** with friends and colleagues. Remember to have a sense of humor and gratitude in troubled times.

12. **Be culturally sensitive,** but not to the point of becoming paralyzed by the fear of cultural appropriation.

13. **Practice intelligent skepticism.** Question simplistic formulas, easy answers, one-sided narratives, dogmatic solutions, self-righteous positions. Question power. Question everything, *coño*, even this advice. Ask a lot of questions, irritating questions – the questions that others aren't asking.

14. **Don't be anti-intellectual.** Articulate your ideas. Always state your case, speak up, write, and engage in dialogue. If you don't speak for yourself, someone else will speak for you … or worse, no one will.

15. **Be prepared to defend your work** with humility, grace, open-mindedness, and thoughtful preparation.

16. **Distrust mainstream media.** Go out of your way to remain informed. Subscribe to various alternative magazines. Read the foreign press as much as possible. Scan the internet regularly. Get as many points of view as possible, and contribute your own.

17. **Don't be a purist.** A "performance purist" is a contradiction in terms. Challenge yourself to reinvent your practice on an ongoing basis. Use your peers and colleagues to open up to this process.

18. **Be a conceptual Coyote!** Be an "outsider/insider," a temporary member of multiple communities. Artists need to be everywhere: in the media, online, in academia, and in the major art institutions as well as in the community-based ones. We also need to be in the streets.

19. **Try to make arrangements to devote equal energy and time to work and your art!** We all have to deal with the challenge of having several jobs to be able to survive. Fight against the forces of capitalist work that suck your creative forces. Make this your everyday activist act.

20. **Add a performative dimension to your daily life.** Experiment constantly with your identity and your sexuality. Have performance parties at your place or organize a performative gathering at your favorite plaza, bar, or restaurant.

21. **Don't be a mindless bohemian.** Practice responsible and intelligent hedonism. Re-vindicate the sacred right to party, and fight puritanism in all its forms – puritanism is a form of political control.

22. **Be humbly accessible to others.** Share your knowledge and connections with others. Support your peers and less fortunate artists. See their work, write about it, reference it. Collaborate. Don't be selfish.

23. **Deliver critiques to your fellow artists gently but deliberately.** Remember, we artists have frail egos. You should expect the same in return.

24. **Don't be a prince(ss). Get your hands dirty:** get involved in every aspect of production, from fundraising to designing lights and sound, to mopping the floor after the performance and getting the pizzas or the burritos down the street.

25. **Be open with your partner or lovers about your performance madness.** If your lover is too possessive or intimidated by your practice, don't bring them on tour. They might get jealous and set fire to your costume or precious props!

26. **Try to avoid being sexually involved with your immediate collaborators.** Uncontrolled desire can turn the sanctuary of the collaborative process into hell for others. This is the most commonly broken rule. If this happens, try not to bring the emotional issues involved in the relationship into the creative space. It's toxic and uncomfortable for your peers. Now, outside of the immediate circle, you can do whatever the hell you want.

27. **Rely on community.** Get involved with and make yourself useful to several local ethnic, gender-based, professional, or activist communities. If you are not grounded in your community, the wind will blow you away.

28. **Confront the oppressive and narrow-minded tendencies in your own ethnic-based or professional communities** with valor and generosity. The "enemy" is everywhere, especially inside ourselves.

29. **Respect and connect with your elders and predecessors.** Treat us with tenderness, and then, when the time comes, kill us ritualistically in a performance art piece or at the end of a workshop.

30. **Keep a balance** between the beautiful quantum physics dimension of your creative universe and the discipline and focus needed for the practicalities of managing your artistic practice in the "real world."

31. **Don't take yourself too seriously.** If you stop laughing, you are dead.

DAILY PLAN TO SAVE US FROM FADING AWAY IN POST-DEMOCRATIC TIMES

Dedicate between two and four hours a day to your art! Adapt the plan as needed.

1. 45 minutes of physical exercise.
2. 15 minutes of Chicano Feng Shui to connect with your home or any other personal ritual or a psychomagic action you have. Refer to "Radical psychomagic acts for personal change" on p. 146 in Chapter 8.
3. 30 minutes to work on personal matters.
4. 90 minutes to promote your work and prepare for upcoming performances.
5. Two hours to be creative and develop artistic material (writing, creating a new costume, a performance script, a playlist, a performance action).

Note: If your everyday time is scattered due to the demands of our contemporary times, make the most of our millennial high-tech connectivity and do items 3 and 4 in the above list during your commute, during work breaks – whenever the opportunity appears.

SECTION 3: CITIES OF THE "APOCALYPSE": PRODUCING SELF-SUSTAINABLE CREATIVE ZONES. ATHENS, GREECE; TIJUANA, MEXICO; AND SAN JOSÉ/HEREDIA, COSTA RICA

Fotini Kalle, Claudia Algara, Sally Molina,
and Saúl García-López aka La Saula

In every international project, La Pocha Nostra advocates for the creation of temporary zones where artistic freedom is allowed. But this is not always is as easy as one would imagine. To curate a border territory for creative autonomy requires intense negotiations between the institutions, organizations, local community, and curators involved in a project. Most of the time there is a "macabre dance" or a "balancing act" that happens as the project unfolds. To achieve a free zone of total pedagogical and artistic freedom, the resources need to be generated from within, from the people committed to the project, and so it has to be self-produced.

With no institutional funding, Fotini Kalle (theorist and performance artist based in Athens), Claudia Algara (writer, poet, and performance artist based in Tijuana), and Sally Molina (producer and performance artist based in San José/Heredia, Costa Rica), have produced three self-sustainable international workshops in their cities in close coordination with Pocha Nostra co-director Saúl García-López.

To achieve this, Pocha Nostra implemented a production model inspired by the prehispanic indigenous concept of the "tequio" (a non-monetary collective work exchange).

Under this principle, each person involved in the Pocha project shared their resources and work. The commitment and hard work of the community, including the workshop participants, towards the implementation of this curatorial model blew us away!

In the following chronicle, Fotini, Claudia, and Sally – three of our bravest producers of the last five years – share their experience in the hope that you will find the inspiration you need to create your own free zone of artistic autonomy.

CHRONICLE 1: ATHENS IN FLAMES! BEING UNDER THE RUINS OF THE EUROPEAN UNION FINANCIAL CRISIS

Fotini Kalle, Athens, Greece, 2013 and 2015

I was a co-producer of the La Pocha Nostra live art laboratory that took place in Athens in June 2013 and 2015. Being a producer of a Pocha workshop during the financial crisis in Greece was a big challenge. I did not have any financial resources, and most people thought it was an impossible task. I only had a workshop space and access to equipment provided by the Athens School of Fine Arts. I had no access to state or private funding or any other kind of resources to cover the budget involved to bring Pocha Nostra, and, to make things worse, most of the Greek participants interested in the Pocha workshop were unable to pay their tuition fees. I reached La Pocha Nostra, I explained the situation, and we decided, against all odds, to find alternatives to make the school self-sustainable. Qué locura!

We started by negotiating beneficial agreements with the local artistic community to provide food and accommodation for the troupe while remaining affordable to the local participants. For those unable to pay the full amount of the workshop fee, we made 30% or even 50% reductions in exchange for performing certain production tasks. For example, preparing snacks, helping participants with special needs, providing local transport, offering shared accommodation to workshop participants, or providing help with lights, sound, and costumes. Each local participant that was struggling to pay for the workshop needed to perform a production task in order to provide in-kind services equal to the full workshop fee. We made contact with other institutions to negotiate any possible co-sponsorships of materials, human resources, and technical needs. If a *temporary community* is one of the basic notions that La Pocha Nostra has worked on during the last two decades through their performance workshops, in our case this was not just an idea. We had to make it happen.

CHRONICLE 2: TIJUANA IN WAR! BEING IN THE TRENCHES OF THE US ANTI-IMMIGRANT LAWS AND THE DRUG CARTELS' INSIDIOUS VIOLENCE

Cali (Claudia Algara), Tijuana, Mexico, 2015

To bring Guillermo Gómez Peña and La Pocha Nostra to Tijuana is something unusual. This is the reason why the project was gratifying in every aspect. I believe that every

independent initiative requires a solid foundation based on true passion and communion with the work of the artist that you are producing, and this will prepare you for everything that is necessary for the success of the project. In many contexts, self-producing is a lot harder. Plans can fall apart, and conditions may change at the last minute, or even during the project. You have to invest all kinds of resources, time, money, solve many details, and it is necessary that you work and dedicate full time (or at least half) to the production of the project. In Tijuana 2015, the artists and I shared the commitment of making the workshop mostly independent. Together with Pocha Nostra and the workshop participants (locals and internationals), we created a network of people where the exchange of production tasks and resources was a key factor in achieving success. It is essential to create an environment in which the artists, producers, and participants think all the time in different ways to support each other. To facilitate this, it is primordial to maintain equilibrium among local, national, and foreign participants.

Gómez Peña and La Pocha Nostra are a group of rebel, professional, and intellectual artists. They are super locxs! So you need to be open to understand their needs as radical pedagogues. They work for the liberation of the body and mind, and that's what they will leave in your community: seeds of rebellion and liberation. It may happen that many people in the community (workshop participants and supporters) don't understand the process at the time. Be patient. They will absorb it at their own rhythm, and the experience will definitely change or add something new to their perspectives.

CHRONICLE 3: COSTA RICA FLOODED! AVOIDING DROWNING IN THE TURBULENT WATERS OF REPRESSIVE CATHOLIC MORALITY

Sally Molina, San José/Heredia City, Costa Rica, 2014

I got to know the work of Gómez-Peña through one of the members of the troupe I co-fund and co-direct, the Grupo Sotavento Teatro+Performance. After hearing about the Pocha Nostra workshop, I had the idea of producing a similar one in Costa Rica. After several negotiations with Pocha Nostra and local producers, I decided to take the challenge and bring an international Pocha performance workshop to a "small" country with a Catholic state and in one of the most conservative provinces in the country, Heredia. ¡Ay dios mio!

I worked so hard preparing all the necessities and started to negotiate accommodation, per-diems, scholarships, food, workshop space, and so on. Unfortunately, I had no luck. I was desperate because I knew how important it would be for my community of local artists to live an experience like the Pocha workshop. I kept working, and I managed to resolve important aspects of the production, but when the arrival of the Pocha was very close, things fell apart. I realized that there was no option other than doing the workshop totally independently. At that time, I was also opening a family business, a bohemian bar where local artists and intellectuals could gather, have good conversations, eat, and drink. The place had an enormous basement which became the workshop space. Así a la brava,

I opened my house to the members of La Pocha and I resolved the accommodation for them, with my family business providing the food. I managed to negotiate some public places for performance interventions in the Municipalidad de Grecia and with the Art City Tour. The local community of artists helped me to find the technical resources for the workshop. It was an act of total courage and locura!

The workshop was a success, thanks to the collective work, tasks, and resources provided by the local and international participants. The 24 local and international participants started to gather in my family business, mi casa, and the workshop started. It could have been "better" in terms of resources, but the creative work generated, the controversial conversations, the social interaction among participants, the solidarity, and the trust generated was incredible, unique, critical, and amusing. The entire group protected a humble and simple but powerful creative space in a "small" country. We all were transformed by the experience, we accepted the circumstances, we ran, we crossed borders, and reached a new and previously unimaginable place.

FIGURE 9.4 La Pollera – the he/she protector of all immigrants
Photographer: Juan Carlos Ruiz Vargas
Dress design: Cecilio Orozco
Performer: Saúl García-López aka La Saula
Mexico City, Mexico, 2018

SECTION 4: "RITUALS FOR DEVISING RESISTANCE": A POCHA PERFORMANCE MENU

The urgent subject matter for LPN's 2019 troupe performances came from the virulent neo-nationalism and xenophobia emerging throughout the world, as well as the pervasive culture of violence in the schools and streets of the USA, Mexico, and beyond. How are these phenomena affecting our notions of nationality, identity, language, and artistic practice? Our answer was an invite to our curators and producers to help us to devise the content of the performance.

La Pocha invites daring curators and producers to choose the content and nature of our upcoming performances and be co-creators of the final performance!

Beginning in early 2018, La Pocha Nostra started offering highly customizable site- and theme-specific troupe performances. It's our "Taco Bell menu" designed for the daring collaborative curator in the Trump era. Following the ethos of our pedagogy, we are now challenging our local producers and curators to be co-creators and jump into a creative performance jam with us!

Our new work aims to offer a series of "live art psychomagic rituals" to combat the culture of hate and violence and provide performative strategies to rebuild radical communities, often involving local artists and audiences in the fate of the performance. Other themes we tackle include, but are not limited to, the impact of new technologies on the human body, censorship, gentrification, and the needs of varied and intersecting communities of difference.

This interactive live performance can include from two to four members, depending on the space and budget. La Pocha Nostra is particularly interested in working with presenters on selecting the space and content of the performance, which always varies depending on the cultural and political context. In this sense the performance will be different each time it is presented. This is consistent with our pedagogy: we want presenters and curators to be active collaborators and to make our work more pertinent to the local community. The potential combinations are almost infinite.

EXAMPLES OF OUR LIVE ART IMAGERY FROM WHICH PRODUCERS AND COLLABORATORS MAY SELECT

- **Political acupuncture** on a nude body including needles bearing flags (from corporations affecting our communities, far-right US organizations, crime cartels, or tech industries) that are symbolically extracted by the audience. Performed by Balitrónica or La Saula.
- A **"Shooting Gallery"** where we invite audience members "to shoot at a Mexican," deconstructing violence against immigrants and refugees.
- **A foot-washing ritual by a performance deviant nun** for white men to purge their sins and/or for newly arrived immigrants, to welcome them to their new country

- **A ritual performance of mourning and exorcism of violence** utilizing a pig or cow carcass against colonialism and state violence in the Americas. These carcasses are subjected to intervention by nude bodies, creating symbolic imagery. Performed by Balitrónica or La Saula.
- **The Crucifixion Project.** A restaging of an iconic Pocha performance. A revolving image in which members of LPN and the public can stage their own crucifixion for their particular cause.
- **Xochipilli, The Az/tech God of Corn.** An edible and interactive performance/installation about transgenic food and indigenous rights. The body is covered with corn kernels and we invite audience members to eat from it in an action of "conceptual cannibalism" to acknowledge that we are all implicated in today's dystopia. Performed by La Saula.
- **The history of Western art in ten minutes.** An ironic and humorous art lesson involving live dioramas parodying the history of Western art and a rubber-stamping ritual by the audience. Performed by Michèle Ceballos and La Saula.
- **Staging your own funeral.** A revolving image where people can occupy a coffin and reinvent their identity.
- **The Phantom Mariachi.** Public interventions with photo karaoke in your city by the "live comix" Phantom mariachi, a performance persona "against eviction, deportation, and gentrification" who occupies symbolic public spaces in the city where the performance takes place. Performed by Balitrónica.
- **The illustrated woman/man/trans person** visits the local art world.
- **Pocha Illegal Alien** makes public appearances and takes selfies with locals.
- **Town meeting/talk show** in "robo-esperanto."
- **500 years of macho power.** A "cannibalistic" and edible (tacos and milk) performance against repression and violence. Performed by Balitrónica or La Saula.
- **The megaphone piece.** A solo performance on the impossibility of talking back to power by Gómez-Peña.
- **The orchestra conductor.** Gómez-Peña performs as a deranged conductor of an imaginary orchestra to live images of political acupuncture, Xochipilli, and/or the cow/pig carcass.

The interactive live art imagery is often accompanied by **a solo spoken-word** "pagan sermon in robo-esperanto" by Gómez-Peña and local poets.

PERFORMANCES MAY ALSO INCLUDE A PEDAGOGICAL COMPONENT

This residency model begins with a workshop (can be anywhere from **three to five days**) and culminates in a performance by two or three troupe members involving workshop participants. The content of the performance is created in dialogue with the presenter and collaborating artists. The main goal is to create a site- and theme-specific performance, and to collaborate with presenters and local artists on the fate of the final performance.

SECTION 5: MAKING THE MOST OF YOUR BEAUTIFUL ARRESTS

L. M. Bogad

Sometimes, an enthusiastic participant in a Pocha Nostra workshop gets very excited, runs out into the street naked, and performs some amazing transgressive act. Then, to their dismay, they get arrested. When questioned by the police about what they were doing, they make the strange error of saying "I am doing this for Pocha Nostra!"

Deliberately taking an action that results in arrest, as a political choice, is beautiful civil disobedience, but being arrested unintentionally and without preparation is just unfortunate (especially if you drop someone else's name and implicate them!). Here are a few humble suggestions on staging performative interventions in public space.

1. **Know the land you stand on:** The rules and laws are different depending on what kind of land you stand on. Is it Federal? Private? State? Your friend's backyard? Indigenous land (that is currently administered by an indigenous authority)? A shopping mall? An anarchist autonomous zone? All of this affects how your action may be categorized, be it transgressive, incisive, offensive, or illegal. The level of illegality (and its consequences) are also determined in large part by the status of the ground you are standing on.

2. **Know the cultural terrain you're working in:** Just as it's important to know the literal legal status of the land you're performing on, you want to have a sense of, and respect for, the cultural mores and values of the space where you're intervening. Nothing is more heinous in a performance artist than a kind of careless, lazy, and unspecific invasion of others' territory. Get to know the locale so you can respect it, even while transgressing it in a challenging and wise way. Also, study the local police and how aggressive or tolerant they have been in recent history, so you know what to expect. Study how they usually react to provocation, and incorporate their habitual behavior into the design of your own action. If you are surprised or dismayed by the negative reaction and penalties you incur, you didn't do enough research.

3. **Make radical research sexy:** Whether you or your colleague are looking into the legal aspects or the cultural terrain, this is serious, thoughtful, and time-consuming work. Reward the members of your group who do this hard work accordingly: respect their effort, listen to them, and exult exuberantly in the erotic appeal of their intellectual labor.

4. **Know the inequalities within your group and incorporate them into your plan:** All performance happens, of course, in a power matrix of racial, class-based, and gendered identities. Locate all your performers' position within that matrix, taking into account their different vulnerabilities, privileges and protections, and resources. To ignore the differences in privilege, resources, and precarity in your group is to reinforce those inequalities. A wealthy upper-class white celebrity should not be scolding a working-class person of color for not taking the same legal risks! (In fact, that celebrity should offer to pay everyone's bail and pay for a good lawyer, if needed.)

5. **Create escalation, de-escalation, and exit strategies:** You should be prepared for many different responses, scenarios, or contingencies. Rehearse and play with different ideas … if you're being ignored, how will you raise the stakes? On the other hand, if things are getting too hot, how will you calm things down? Finally, a good exit strategy is always useful and important to have prepared.

6. **Be confusing and playful:** Disarm the police with surprising and serious playfulness. Rebellious clowning, absurd but charming simulacra, and excessive, bizarre obedience, are all proven techniques in many cultures for lowering the odds of arrest.

7. **Be transgressive and prefigurative:** Try to think of an action that doesn't only break the moral code or law you are opposed to, but also gives a vision of the world you want, thereby offering something important and positive to the public space.

8. **Raise the cost of repression:** After research and experimental rehearsal, decide on a culturally resonant, symbolic figure to embody that may make it more costly to arrest you. It doesn't look good when the police arrest Mickey Mouse in Times Square, or Saint Francis in a devout Catholic town. There is no guarantee against arrest; it is up to the police, not you, whether or not you get arrested, but you can make it less likely, and politically more expensive, for the state to arrest and punish you. For example, it is politically more expensive to club a clown than to club a person.

9. **Rehearse confrontations with police:** One of your group can play a policeman in realistic (not cartoonish or satirical) fashion, and play out the encounter with your fellow performance artists. This is a great way to think through what you are doing and how you will resolve the police encounter, and also to get a sense of what the police may be thinking from their angle.

10. **Visible documentation:** If they are surveilling, you are counter-surveilling! We, too, have the tools (phone cameras, etc.) to counter-surveil, so be sure to have lots of friends filming – both to document and, in case things go awry, as a visual deterrent for police or vigilante abuse.

You still might get arrested: Please have a fabulous and brilliant plan for that contingency. If you're going to be arrested, make the most of it for your cause! Prepare a fantastic performative moment that makes your arrest a magical image, an irresistible image, an ARRESTING IMAGE. Be cheerful for the cameras to take the sting and fear out of it for others and PERFORM COMMITMENT to your cause and joyful defiance. The USA's civil rights movement activists were masters of this art and it helped to change history.

Closing technicalities: When confronted by hyped-up or agitated police … move slowly and calmly. Do not reach for anything quickly. Speak slowly and calmly.

In terms of moments of possible danger, be calm, and de-escalate. It can help to have a trained "street diplomat" talk to the authorities as your liaison, someone who knows how to give authority the acquiescence it wants in a tactical way. It's great to have someone good at talking to the police as part of your group, as well as a media liaison, a legal observer, and scouts who can tell you when it's time to go!

To avoid infiltration, work in an *affinity group* – a small group of friends who can all vouch for each other. This is a great and simple way to avoid having an infiltrator or agent provocateur in your group. It's a great way to have security without paranoia – a line we all must walk delicately in this post-democratic moment we inhabit together.

BE WISE, WILY, AND JOYFULLY RESIST!

FIGURE 9.5 Caribbean Same Sex Wedding
Photographer: Ana Diez
Performers: Gómez-Peña and local artists who chose to remain anonymous for obvious reasons
Buena Vista Arts Center, Curacao, 2010

SECTION 6: THE UNNOTICED CITY: URBAN RADICAL INTERVENTIONS AGAINST INVISIBLE BODIES

Reverend Billy and Savitri D., with an addendum by Dragonfly (aka Robin Laverne Wilson, aka Miss Justice Jester)

This writing is dedicated to Savitri D., Monica Hunken, and Dragonfly, who ascended into Trump's silver globe above Columbus Circle in midtown New York, as thousands of commuters and police and probably immigrants, too, looked up to see their banner.

This is New York? Vast crowds bowed over squares of light in the palms of their hands? This isn't passive-aggressive, this is passive-apocalyptic.

We don't see the physical city anymore, and so unfortunate things go on for a long time without stopping. Right now cops are pulling parents out of their living rooms and taking them to jail because they are Hispanic or Muslim. If someone looked up from their screen and saw this, they would know I'm not exaggerating.

The bodies of the city go unnoticed. Therefore, the performances of all public figures – from the arts, politics, religion – have been minimized in our consciousness. The messengers are still talking, but in the form of tiny pixelated simulations.

Can this really be? Is the figure in the landscape really finished? If we look for expressive public figures, there are a host of them looming from our past, you just have to look up. The pedestals in the park and the edifices of old buildings are stages for a highly expressive bio-sphere. Well, Gandhi down at Union Square, and Eleanor Roosevelt up at 72nd Street are the only ones I can think of that are modestly walking at eye-level. Maybe an iPhone would bump into those two. But just a few feet from Gandhi, George Washington and Abraham Lincoln are raised up into the trees. Higher still, Duke Ellington at his piano up in Harlem. Highest of all, Chris Columbus at his circle. No, highest of all, Lady Liberty, 22 stories high with her torch and book of justice.

Up in the living funerary we can find forest spirits and Athena and cupids and griffins and goddesses of justice and satyrs and Jesus and eagles and angels. Lots of stone folks up there above us, and they are highly committed performers, but they are suspended in the air above the bowed heads, above the glowing screens.

Did someone say that we must have a past to have a future? But we are stuck in a false present moment. Can anyone look up from their hands? The crowds mill by, descending into tunnels, emerging through doors to stand in elevators, gazing down. When the fathers and mothers and sisters and brothers are handcuffed, the screaming children are silenced by the not-looking-up people in the streets.

The laws and traditions that were made by the stone personalities above us are still on the books. Friends of the people now being arrested find these laws written down in libraries. Eighty-year-old attorneys from the Civil Rights Movement can recite the 1st Amendment word for word. The statue called Lady Liberty promises that you can be poor and tired and you can be free. But the jails are filling up with families, even toddlers. The mayor and the city council have declared New York a "sanctuary city." But that is only rhetorical. We are left to re-train the New York police that they should not support the racist kidnappers, the Immigration Customs Enforcement (ICE). But first we would have to look up from our little screens.

This passivity didn't happen overnight. New Yorkers felt a shift take place some time ago. The city's self-cognition began dying before the iPhones, tablets, and Ubers. No one can pinpoint the exact moment it happened. There was a conspiracy of banality that finally overwhelmed us: too many glassy condos and not enough laughing and loitering, too many chain stores and not enough gazing over the flower pots from the stoops.

I have seen some screenless people climb up into the old monuments to try to draw some eyes up into the city's memory. These protesters shout the words of the laws that guarantee freedom down upon the heads of the bent-over crowd. Will the city notice itself? Once we look up, we will see Duke Ellington sit at his piano again over Central Park and we'll see Lady Liberty walk across the water and stop the arrests. The satyrs

will leap across the air-shaft and land on Trump's balcony. Our city will come back to life.

We will notice our city again. And we will see ICE and we will become the loving law enforcement of the Sanctuary City and we will melt ICE like the wicked witch.

LOVE NOT BORDERS – NO DEPORTATIONS

METAPHYSICAL MUSINGS AND EMPIRICAL EXPLORATIONS: TURNING THE BODY VISIBLE IN THE CITY

Dragonfly [aka Robin Laverne Wilson, aka Miss Justice Jester]

METAPHYSICAL MUSINGS

- Suppressing voice as a radical artist at any stage of development is to invoke a deep disquiet upon your life.
- Trauma and truth are each buried in the body. One is antidote for the other.
- Unabashed non-commodified storytelling is likely the most ancient, radical, and healing thing to do in public space.
- Creative disruption spawned from truth and love is shamanic.
- Public rituals transmute trauma into elevated consciousness.
- Radical art is overcoming your spiritual gag reflex and swallowing your chicken-shit ego to just do the damn thing. Then do it again. And again, but louder. Or softer. Or higher. Or lower. Or wider. Or … or … or … think about it … then don't overthink it. And keep doing it until you stumble into bewildered psycho-spiritual exhaustion. Well done.
- Individual energy and empathic capacities could quickly overload if you are not working within some sort of collaboration, community, coalition, company, or otherwise collective permutation.
- Don't be afraid to NOT do it alone.
- If a radical performance artist farts in the woods and no one is around to smell it, can they still put it on their CV?
- We are just as afraid it will suck as we are that it will succeed.
- To break through the inertia of whichever fear is to remember that it is all a work in progress, on-the-job training.
- It will never go as planned, nor should it.
- Instinct always prevails, but don't forget the plan and keep practicing until it's like butter. Or else it will likely suck. But do it anyway.
- Radical artists devour embarrassment for breakfast.
- Let us thank the fear, embrace the embarrassment, and slather ourselves in that butter because it means the soul is about to growth spurt. Awomen.

EMPIRICAL EXPLORATIONS

Artists are researchers-in-action. I have no answers – only questions to pose. This is a living document, subject to amendment, and I expect it to be overwritten by intuition at any time.

I include all thought, sound, image, and movement created through the body as "performance." I include any place/space of transmission as "public." Alliteration of letter **P** incessantly recurred as I **p**ondered factors to **p**repare for ·**p**ublic **p**erformance. I leaned in and listened.

Who is abusing **POWER**? How can it be challenged through **PEACEFUL PROVOCATION**? What is your **POSITION** to it?

What is the medium and **PURPOSE** of the **PERFORMANCE**? Is it **PERSONAL** enough to incite **PASSION**? Is it **PLAYFUL** enough to enjoy? Through how many senses can you **PROJECT** the message? Who are the **PEOPLE** you intend to impact? Who is vulnerable and needs physical / legal / spiritual / emotional **PROTECTION**?

Which are the internal and external boundaries to **PUSH**? Is there a final **PRODUCT** or is this based in **PROCESS**? How will you know you are **PLEASED** with what you've done?

Finally, don't forget the **PEP** talk – YOU CAN / SHOULD / WILL DO IT!!!

SECTION 7: HOW TO USE VOICE IN THE POCHA NOSTRA METHOD

Micha Espinosa

The Elements: relationship to self, relationship to others and space, relationship to technology, and relationship to writing:

Start with a ritual: You have to call on your voice to want to be seen and heard. Be aware of your body and its sensations, be conscientious, be open to the experience: these are the elements you need to begin sharing your vibration.

Take your time and be curious. Begin exploring, going from silence to sound. Let the silent body sing until your desire takes over. Then, begin to feel the breath and your voice/ sound as one – one breath/one voice. Find your spine, open your arms, breathe in the space, make your gaze find the horizon so that everything is equal to you. Open your arms and feel the length of your spine and the breadth of your wingspan. Allow any of these phrases or mantras to enter, swim, and tickle your chakras. Remembering your mouth, the curiosity of your tongue releasing, your jaw opening, and the breath giving in to gravity. Find your desire and then whisper, then speak, sing, laugh, scream, shout, cry, and explore the phrases below in any way the body desires. It will vary from day to day. These are phrases to inspire and make up your own as these are just doorways into your dreams: "I AM HERE," "I AM," "I INVITE YOU TO SEE ME," "I WANT YOU TO SEE," "I WANT YOU TO HEAR ME," "INSERT YOUR NAME."

RELATIONSHIP TO SELF

- **Screw aesthetics!** Using your voice has nothing to do with having a beautiful voice.
- **Be brave, bold,** and brutally honest.

- **Babel: If you are multi-lingual use it!** Use your multiple identities and then throw in some made-up language using all the sounds that are available to you from your glottis (vocal folds) to your lips. You can smack, pop, trill, tap, buzz, and glide.
- **Modulate:** Have at your disposal the ability to mix up many elements of your voice so that you can have facility with volume, tempo, rhythm, and quality – all in emancipation of your performance and text. Nothing is more annoying than someone using these elements just to use them without them having meaning.
- **Play:** Go from creaky to plummy and from low pitch to high pitch, use the image of an eagle flying/falling … all at the same time. This can make for some crazy vocal effects and very low-tech fun.

RELATIONSHIP TO THE SPACE AND OTHERS

- **Your voice is a limb** – learn to reach out: Repetition of voice as gesture can be used in any composition or vivant tableaux; coughs, ingressive sounds, pants, sighs, cries, blows, sneezes, fluffy-sounds, sirens, hums, and any other repeatable sound, word, or phrase.
- **Use a music stand** – when reading performance text and make eye contact with your audience. This way you can place your text at eye level where you can work your eye, mouth, and belly coordination. No one wants to watch papers move – they want to hear your words.
- **Caminar – walk the space and find your power positions.** Where can you direct your voice to a specific point into the space? Think of the voice landing, punching, painting, or whipping a point outside you. Think in terms both of the aural and of the visual points of focus. This will change from space to space. So, check it out each time … you will vibe differently in each space. Your body will actually breathe differently each time in relationship to the size of the space.
- **Things to consider when working outside:** Don't pan and scan/point and shoot your sound. Is there anything to bounce off? Can you place yourself physically higher/lower than the audience? How does that change your relationship to self and other?
- **Working inside:** What are the acoustics? If it is a really bright space, you may need to focus a lot on the beginnings and ends of words to be understood. If the acoustics are not so great, you are going to have to open the space in your throat and mouth to generate sound in your mouth, nose, chest, and head.
- **Vocal skill:** Singing, yodeling, beat boxing, cow calls, overtone or throat singing?
- **Create an extended voice operatic corrido (story song):** Possibly in response to the real possibility of a supersize me wall of xenophobia and fear on our Southern border or a response to Harvey Weinstein or the Boko-Haram. Pay extra attention to how you begin and end your sound story or story song. Example: maybe you begin with calls to announce the beginning of the performance and end with cries to seduce the party to take action.
- **Create a breath-scape:** This is best done on a microphone … as a vocalist you can incorporate a prop. This is all about feeling the breath in the body. Be curious about your body – sacrum, sex organs, navel, ankles, xiphoid process, earlobes, all of it!
- **Play:** create a five- to seven-minute breath-scape with a lollipop and a DJ.

RELATIONSHIP TO TECHNOLOGY

- **Working low tech:** Pick up a $25 voice changer with effects, a microphone, and an amp from a pawn shop and play.
- **Working high tech:** Work with Art/Media Engineers at local universities – there is some mind-blowing technology out there and the performance world and these techies are a match made in heaven.
- **Make friends with the sound guy** – shake hands, introduce yourself, and you might even bring chocolate.
- **Make friends with a kickass DJ** – your voice is another element and it wants to play with others. Believe me, this can make or break your performance!
- **Listen! Don't hog the microphone in a jam session.** This is less an exercise of doing and more an exercise of *listening* for the right moment and expression of intervention.
- **Do a real sound check before the show** – many performers bring their own microphones. They always know where the action is taking place in the performance area, make sure their cables are neat, know how to turn on and off their microphones, and raise and lower their stands. Even if everything is set up correctly the acoustics of the space, your voice, and the system need to be checked. Do a full voice "check 1, 2, 3 check." Louder is not better! Do the actual material and the levels you plan on doing. Now is not the time to be shy, you want to make sure you won't get feedback and can be heard. Remember that sound guy setting up the cables? You brought him chocolate and tequila! He can help!

RELATIONSHIP TO WRITING

- **Your voice and an image** – your sound could match and/or synchronize (dub) an image but it does not necessarily need to. Interfere, be curious, how might you use your voice and body to comment, disrupt, enhance, enforce, distort, and obstruct?
- **Your voice in writing** – begin blindfolded – move – let every part of the body become sensitive to the touch of the air. Find the floor and choose a personal shape on the floor, come out and back from it several times, include breathing, sound … explore the sound of the shape, the words for the shape, the micro-movement within, memories that it evokes, take off the blindfold, and on a large piece of paper free-flow write. Listen to your body – there's a universe inside when you write. Make sure to include some soothing aftercare with yourself or a partner – some touch, food, and libations.

Finally, don't be afraid of silence.
 Feel the breath in your body as therein lies the power of your voice.

Sound outs for radical inclusion

Poetry and testimony unleashed by the Pocha method

FIGURE 10.1 USA–MEX Post-global relations
Photographer: Eduardo Baez
Performers: Lechedevirgen Trimegisto, Micha Espinosa, and Martin Renteria
La Pulquería, Mexico City, Mexico, 2019

As the Pochxs have noted in different ways throughout this volume, the creation of new communities of radical inclusivity, rather than theoretical or aesthetic novelty, lies at the heart of Pocha productions and workshops. Thus, we felt that the following "sound outs" were valuable to our pedagogical handbook on two levels. First, they serve to extend the "workshop" space into the practice of writing by sharing the voices of collaborators that embrace the theoretical and interpersonal borderlands as a catalyst for new expressive

practices. Here, the themes of eco-sexuality, the aging body, trauma, new technologies, curatorial interventions, and parenting are held up and honored as radical practices our community members bring into the mix. Secondly, these Pocha-inspired writings are also offered as an invitation to jam with text as a site of performance. What kind of conceptual collage – what kinds of manifestos and anti-manifestos – might your collaborators come up with at the conclusion of a workshop, or as an exercise in the poetics unleashed by performance practice?

SECTION 1: POETIC/PERFORMANCE TEXTS GENERATED BY WORKSHOP PARTICIPANTS

The following texts were developed from 2008 to 2017, during various workshops utilizing the techniques of the "Poetic exquisite corpse" exercise found on p. 134. Questions were posed by La Pocha instructors, and the answers were generated collectively by workshop participants.

The authors were participants of Pocha Nostra workshops in Oaxaca, Guanajuato, Tijuana, Mexico City, and Mérida (Mexico); Athens and Delphi (Greece), Lima (Peru), São Paulo, Belo Horizonte, and Rio de Janeiro (Brazil), Chicago, San Francisco, Tucson, Santa Fe, and New York (USA); Montreal, Vancouver, Toronto, and Winnipeg (Canada), Venice (Italy), Barcelona (Spain), Berlin (Germany), Graz (Austria), and other venues.

We suggest a conceptual layout for the following poems and texts:

<div align="center">

WHY DID I COME TO THIS WORKSHOP?
To confront myself on the other side of the mirror
To build a bridge to a community of like-minded performance artists
To get out of the "theatrical mode"
To learn how to think from the body
To experience the risks inherent to performance
To understand how to cross the borders between
our conscious and unconscious selves
To experience border issues in a border town
To learn how to apply performance art techniques in political actions
To be inspired by the madness of others
To be hyper-conscious, every day, of my self and my artwork
To raise questions, irreverent questions …

PERFORMANCE IS …
To dare to love people you don't quite know
The space between each breath
The utopian space between self and other
A way to feel the blood in my veins
Exhausting freedom; re-enacting adolescent freedom
Leaving it all out in the space

</div>

Powerful, scary, uncertain, loose
An accident resolved aesthetically
Pure presence; invisible at times
Constant negotiation
Undefined ...
(when it gets defined, it's no longer performance)
Un-learning theater and dance techniques
Standing on the edge of a volcano next to my peers and
jumping into the void
A Mexican trying to understand a Spaniard speaking English
A Croatian speaking English trying to understand
a Mexican immigrant in Arizona
A Chicana trying to understand a Belgian artist speaking Spanish
Centered/decentered
Energy, pure energy
A full-body female orgasm
Pleasure, pure pleasure against the existential malaise of everyday life
My life here and now
Transfusion, transformation, interaction
Emotion, endurance, transformation
Flying and not stopping until I vomit my inner fixed conventions
Conceptual nausea
Super-tacky and incomprehensible
Contradictory; a space for ambiguity and ongoing contradictions
A conversation in an alien language
A collective mirage, dream, or nightmare
Practiced hope
Un coche bomba en un centro comercial
Una fuga de petróleo en medio del Golfo de México
A question that hurts

PERFORMANCE IS NOT ...
Police brutality
Exclusion
On Facebook ... or is it?
Censorship of alternative views and different bodies
A conventional monologue for hipsters
Predictable and safe
Carefully scripted
Unreal/real
What politicians do on TV
Another way to privilege conventional beauty
Staged lies
Bureaucrats performing bureaucracy
Dogma

A military strategy
Academic jargon
Yellow, red, or blue paint
Just teeth, tears, hair, semen, boots

MY COMMUNITY IS …
To be chosen … by me
Getting evicted as we speak
Somewhere else
Living graffiti on my skin
A group that limits you, censors you
A floating planetary system
Definitions that change everyday
Inclusion/exclusion … ad infinitum
Acceptance/rejection … ad infinitum
Identifying with the land, not with the state
Incarcerated
A bunch of footprints going South
Inside me, my inner ghosts, my ancestors
A bilingual kiss
Alive, ephemeral, transitory
Poly-dimensional, poly-cultural, poly-gendered
Transparent like a utopian democracy
The glue that bonds outsiders
Energy transmission systems
Acknowledging the abstract, the subjective, and the paranormal
Acknowledging the person in front of me in the street
Together/separate
Full of ghosts
Nomadic, wild, ineffable
Waiting to be born
Always on the edge of the precipice; always about to free-fall
Discovering holes inside itself
A flowing river of metaphors
The contours of my cuntography
An amoeba; a unicellular organism
A multilingual chant
A sudden eruption
A stain on an empty page
A weapon, the word, the body
Shared vulnerability
Sitting in a patio in the middle of a war zone
Hanging by its toes
A piece of fractured poetry

A Bohemian theme park
Infected,
Unable to get health insurance

MY COMMUNITY IS NOT ...
Judgmental, self-righteous, or silent
A table game, a video game, a table dance
Surveilled
Cops on the run
Frat boys speaking mock Spanish
Hipsters moving to my neighborhood to be self-ironic
The army; homeland (in)security
On Facebook and Twitter ... or is it?
A vanity exercise
On Broadway, Hollywood, or TV
A demonic cult ... or is it?
A Trump rally
Disposable, recyclable, and repackaged for your leisure
A tourist trap

MY IDENTITY IS ...
Fluid, fragmented, and ever-changing
Constant metamorphosis
Sweat after sex
A Pandora's box found in the attic
A full costume and prop room
Always late; always tired
Still inside the womb
A ghost with jetlag
In my DNA; my ancestors
Constantly fighting with live art madness
Free from subjugated stereotypes
Centrifugal not centripetal
Mexican as fuck
Arab to the bone
QUEER in capitals
Trying to learn the language of "your identity"
A cartography of mysterious villages not shown on Google maps

MY IDENTITY IS NOT ...
For sale, for consumption, or to be reproduced by corporations
For rent
My nationality
My last name and passport number

A sports team
A corporate logo; a brand
My perceived gender
Un mapa geopolítico
The last word in a collective poem
One single image or text
Found in an anatomy book
Shipwrecked
Found in the Yellow Pages
My genitals
Heartbreaking in the refrigerator

MY BODY IS ...
A sacred map
Secreto, memoria, imaginación,
Pure resistance
Incomplete/broken/mutilated
Highly, HIGHLY political
Many continents
A Mexican temple
You
Flexi, sexy, divine,
An ongoing conversation w/other bodies
Intertwined with my voice
A time machine
A forest of symbols
Bilingual, multilingual
Your tongue
Tu sombra, your shadow
Espejo, a mirror

MY BODY IS NOT ...
Myself
Yours
For sale ... well, not today
Empty
Illegal, undocumented
An option
An object
A flag
A punching bag
Un asunto legal
Any of your business
Abismo
Interested

I MAKE ART IN ORDER TO ...
To avoid deportation
To remain visible at times, and invisible other times
So I don't forget who I really am
Para escapar por un día, o dos, o más
Para romper el silencio
To avoid boredom and silence
To get off
To flex the muscles of my imagination
To remain "sane"
Para provocar, celebrar
To live and enact my many identities
To accept madness
Para encontrar aún más libertad de la que he logrado
To be big, huge ... or tiny
Para crear líneas de fuga
To make revolution inevitable
Because the world needs help
Because I need help
Para cuestionar sistemas y estructuras
To give voice to one another
To listen to my multiple ancestral inner voices
To hear something other than a newscaster's voice
To bring back the colonial ghosts of the past
To exorcise those ghosts
To face my own fears
To become my worst fear
To experience humility in ten different languages
To untangle myself
To seek resurrection
To take the inside out and the outside in
To be compassionate and tender with people I don't know
To purge the hate I inherited from my family
To run blind
¡Por la patria y contra la patria!
To celebrate vice and virtue
To find a job, a home, and a community
To be a witness to the barbed wire
and to the scars left by dozens of wars
To be my genuine self after all these years
To honor the moment; the present tense

I MAKE ART BECAUSE IF I DIDN'T ...
I would literally go mad
I would kill someone

I would be alone in the world
I might become a rich asshole
We might be silenced
I'd be bored to death
I would hate life and traditional art
I wouldn't have a body
I might succumb to the desires and aspirations of Tío Sam
My source of food would be wonder bread, coke, and spam
I would become a farting cockroach
I would not be friends with death

EACH DAY I WAKE UP AND FIGHT AGAINST …
Christian modes of reality
Making coffee
Birds and words
Patriarchal society
Institutions
La tristeza y nostalgia for fictional identities
Free falling
Walls, fences, institutional surveillance
La pregunta ¿qué es el arte?
What the fuck is performance art
Explaining to art administrators and CEOS about performance art
Capitalism
Internalising colonialism
My inner demons
Material culture
Trash food
Progress and nationalism
The smell of my socks and body
Misoginia y violencia de gender, doméstica y de raza y sin palabras, conceptual, crimen
organizado, from the curators …
Pronouns
State of fear
Gentrification and competition
Denial
Exhaustion
Historical amnesia

TODAY, I WOKE UP THINKING ABOUT …
My body as a weapon
Pastiche of cultures
A belly full of jelly worms
The pain in my knees
The demonstrations against the ultra-right

The flooding in Houston
Native plants
A strange dream
Dust in my eyes
My pelvis
Kissing
La cabra
Running backwards
Dry rivers
Thinking aloud my diarrhea
Unrest and sweet dreams
Los niños en la calle
Lifting a child in the air to make her fly
Closing the open portal
People that don't think about me
The ghosts inside my skeleton
The voices that I don't remember
Giving birth
The many masks we have to delete
The madness in Thursday

IF I COULD LIVE IN A DIFFERENT COUNTRY IMAGINED BY ME …
IN MY COUNTRY …
No borders, no private property, no money
University for everyone
Healthcare
Clean water
Language will be a robo esperanto
Family will be a contemporary contract
No street dogs
Only anti-racist education
No politicians
Radical VIP social hedonist economics fully communist capitalism
All performance artists will be employed
Gender complexity
Silence won't be pathologized
Laughter is mandatory
Nudity will be normalized
Difference will be never be a death sentence
Everyone learns an indigenous language

VIOLENCE IS …
Indifference
Othering
Ignorance
Imposing religious belief systems

TV and media
No healthcare access
Sexual harassment
Impertinent jokes
Emotional
Rooted in our past precious own pain
When your local politician isn't listening
Catholic, Jewish, Muslim, and bourgeois guilt
The impossibility of crossing borders for animals, humans, and the art world
Demonizing the black, queer, brown body
No intersectional feminism
Discriminación intelectual
Withholding citizenship of a refuge for religious reasons

ACTIVISM IN THE TRUMP ERA/THIS TIME IS …
Bringing new vocabulary to widen the space of opposition
Tearing down statues and putting them in a museum
Replacing confederate statutes and with turbo art
Confronting everyday microaggressions
Desestabiliza everyday life
Solidarity with the underdog – the one that has fallen from the table
Radical listening
Gazing at the self in the other
Recognizing that space is not something
for white activists to hold for brown, black, and indigenous
Redefining protest
Strategic silence for white activists
Bringing Eros and play to the activist agenda
Erotic not sexual
Sex positivity versus imposed sexuality
Consensual
Institutionalized racism
Learning your own history and the ones that are not yours.
Radical shelf-lifting

SECTION 2: MY TRANSFORMATION FROM PRIMA BALLERINA TO DEVIANT PERFORMANCE ARTIST

Michèle Ceballos Michot

I started studying ballet when I was six years old. I was born with my feet turned in, and when corrective shoes didn't help, the doctor suggested ballet since it works to turn out the leg from the top of the hip.

FIGURE 10.2 Deviant Ballerina
Photographer: Herani Enríquez Hache
Performer: Michèle Ceballos Michot
Mexico City, Mexico, 2015

In the 1960s and 1970s when classical ballet dancers of color were few and far between, a director of one of the major ballet companies in New York City said he'd consider offering me a contract if I would have a breast reduction. "I want the audience to see my choreography, not shaking breasts and hips." Weighing his offer, I asked my friends who had already undergone breast reductions to show me their breasts, and I was horrified. Something clicked, and I sensed deep down something was wrong. Why was my body, our womanly bodies, always a problem, a site that needed intervention and correction to be the "right" [way?]

Then came the world of professional dance, where I subliminally wondered why I was always the Spanish dancer in the Nutcracker, or why I was always chosen for the high-energy "sexy" roles, never the softer more lyrical roles. When, while training in Colombia for the 1983 Varna International ballet competition in Bulgaria, I asked my coach if I could do the *Giselle* 2nd act *pas de deux*, she said, "No, no, that's not you. You aren't a Giselle, you are a Kitri (Don Quixote)." I danced until 31 in the world of classical ballet with many different major ballet companies, and kept experiencing the same issue of typecasting. I didn't become aware of the objectifying and stereotyping that was being imposed and reflected onto me until I met Gómez Peña.

In the late 1980s I moved to Phoenix, Arizona to work with Ballet Arizona. By then I was dealing with a lingering back injury produced by authoritarian teachers pushing the

body to extremes, so I branched off and started my own company. I started to explore the technique of ballet, mixing it with all forms of choreography, and I also decided to personally explore everything I could that had to do with movement. I started to visit, and eventually performed in, topless bars, gay bars, the underground art scene, and alternative galleries, where identity was much more fluid, playfully experimental, risky, and politicized.

Many had found this underground world of performance and underground entertainment a more welcoming place for their difference, and two identities started to take shape. There was my underground work, which I found to be collaborative, playful, powerful, and emotional – the use of the total body and spirit in ways that were not accepted in my overground world. And then there was my overground world, which was based on interpreting roles that already had been written and filled by many others before me, with the objective of trying to do it better within a specific, rigid structure. In the overground world, a quiet ballerina is an easier ballerina to work with. Don't talk! Don't you dare talk!

My first project with Guillermo Gómez Peña was the *Temple of Confessions* in Scottsdale, Arizona (1995). At night I was doing underground work as "Michel Cote" or "MICO," the drag king, and during the day I was engaged in arts and education, teaching ballet, point, and choreography as Michèle Ceballos. When I met Gómez-Peña he was mentoring Roberto Sifuentes, and I was at a point of transition. Two divorces, two young children, two identities.

In *Temple of Confessions*, we kept the audience moving through the space, performing actions such as cleaning their shoes, whispering in their ear to have them confess, or cleaning a body bag where a dead chicken hung from above and dripped blood. The audition was sitting face-to-face looking each other in our eyes and saying welcome, so happy to meet you again. We discussed the identities, the personas that Chicana actress Norma Medina and I would inhabit as the "keepers of the temple." We weren't told what we were going to wear, or how we were going to represent ourselves. It was another world: the horizontal structure of Pocha performance art.

In the world of Ballet, too thin does not exist. We starve ourselves, binge eat, make ourselves throw up, take laxatives – it's normal and accepted. Throughout my career I lived this way; even when I left the Ballet world, I continued to struggle with eating disorders. Then 2011 was one of my "fat ballerina" moments and I developed a persona, "Mrs. Hot Arizona," a statement on beauty pageants and the perception of the ideal woman. I wore a gorilla mask and a costume made of chains. My Pocha collaborator, Saúl García-López (aka La Saula) commented after a show, "What an amazing image! So grotesque! With your skin and fat bulging from the chain holes, so ugly and so pinche powerful!"

This was hard to hear, but I realized how powerful the nude body is, and how it can be used to express issues of weight, gender, and identity. It is our canvas. I've since developed a series of personas that involve nudity because after menopause, a woman, per society's notion, has no sexuality; she does not show, love, or honor her body. I've never made interventions in my body with plastic surgery and purposely tell my age and show my nude body as part of my performance work. It is my most intimate yet public feminist statement. Every time I teach, jam, and perform with Pocha, I come home with more knowledge, understanding, questions, and feelings of support and love. My "imperfect body," fully nude and at the age of 62, is finally giving voice to the quiet ballerina. In

the Pocha universe my body doesn't need correction, and my various identities at odds find a place of creative coexistence. My physical wounds, hanging breasts, wrinkles, and scars are my armor, my medals, my proof of battle and source of continuous creative transformation.

SECTION 3: ARTAUD ON STEROIDS: MY JOURNEY FROM ACTOR TO PERFORMANCE ARTIST

Juan Ibarra-Isunza aka Robo-Xolotl

I started to collaborate with La Pocha Nostra in the 1990s. My attraction to the Pocha universe originated from my need to break away from the constrictions of formal acting training.

I was desperate to boost the power of imagination beyond the imposition of aesthetic ideas and specific political positionalities contained in the vertical structures of theater-making.

I was tired of dealing with a pyramidal structure in which the actor's place as an artist is placed at the bottom, leaving on the top the script, the director, the designer, the producer, the choreographer. I was worn out from trying to equate good acting with perfect repetition of the representation of the scene, and the obsession with understanding the psychology of the character as the legitimate way to become the character.

As an active member of society back in Mexico, it was urgent to use my artistic training as a tool to promote change in the post-9/11 political/social landscape at the end of the PRI's period of political power in Mexico, and to use my art to tackle the social challenges promoted by corruption and poverty in Mexico City. I wanted to dismantle the way theorists and art curators have controlled art aesthetics and artists' representation in festivals.

The theory and training tendencies imposed on me and my generation were subject to a false sense of "security" aligned to training and artistic creation legitimized by high art and institutions. I learned that the system was co-opted, not only in theater but at all levels of our complex society, to intentionally avoid new forms of artistic creation and experimentation. Under these circumstances, any artistic training would suffer from addressing the necessary and urgent contemporary changes that we as local and global citizens have to face.

Many times during the rehearsals of a play I couldn't stay still. I was fully aware of the multilayered meaning of the entirety of the creative elements involved in the production. I was always looking to be invited to express and use this energy as part of the process or the final staging, to be able to jump, do an acrobatic movement, or make a grotesque expression.

I wanted to mix and match different expressions to use all the creative possibilities offered by the rehearsal process. I wanted to give a kind of a metaphysical manifestation of my condition as a human being in the interpretation of the character. I dreamt of a hybrid border where the actor can exercise a healthy trial and error process offering a more open, healthy relationship with the craft of making theater, address his/her own human condition as part of the theatrical experience, and fully reflect this to society.

I was looking for a new frontier where the actor's point of view about depicting the feelings linked to the character's intimate life, as prescribed by the text or director, become visible, reflecting the actor's realizations at the time of the rehearsals. I consider this the ultimate act of rebellion by the actor to reclaim their place as a true artist. But many actors do not follow this path, and succumb to fear and pressure to avoid being harshly criticized by the theater status quo and jeopardizing their future career prospects.

Over time, I realized that traditional theater and acting never would address a model in which the expression of the inner and intimate life of the actor becomes fertile soil for debate, free experimentation, and creation. This was hard to accept – that this kind of expression cannot be contained in mainstream theater dictated by the lords and keepers of high art traditions and techniques that render actors a mere interpretive tool in the hands of the producer, director, and writer.

As a consequence of these political conditions, I isolated myself. I immersed myself deeply in my acting training, focusing on breaking away from formalistic teachings. I tried experimental ways to experience theater from both sides: the artist and the observer. I became an autodidactic rebel artist crossing the borders of acting training towards the territory of performance art. I did not know this at the time!

I declared and reclaimed a free territory for innovative proposals where my body, my experiences, and my politics would find a prominent place and become the igniting power of my performances in front of an audience. I started to train myself on how to use my body as a kaleidoscope of selves embracing their always changing meanings, and explored how to refract this back to the audience.

During this solitary experimentation, I met Guillermo Gómez-Peña in Mexico City. When I met the Pocha Nostra universe, my first reaction was overwhelming; it took time for my experience to settle in my mind. I saw a space and a place where irreverence for high aesthetics is a common ground to create a strong spell against the dark forces of institutionalized power. I saw my conceptual territory for the creation of a total reality.

La Pocha Nostra's radical creative space would give me the opportunity to look deeper inside myself, to look into my shadows. I understood how my inner demons are projected in the social fabric, regardless of socioeconomic and cultural circumstances. I found a creative synergy that legitimizes and privileges my very own personal and social concerns as an artist.

I discovered what Pocha pedagogy calls a performance "persona," an embodied image in the permanent process of reinventing its identity that feeds from our social and emotional "innards" – the antithesis or macabre brother/sister flipside of the so-called "character" in theater.

When I started to collaborate with La Pocha Nostra as a pedagogue in the creation of a methodology, I discovered my passion for guiding students with the unlimited creative potential of their bodies. I was surprised to find out that students felt empowered by their need to express their true feelings and creatively share what was inside themselves. La Pocha Nostra pedagogy is the call to open one's eyes to create artistic communities and to empower ourselves by practicing a radical democracy so much needed in the world.

"Artaud on steroids" is an honest way to relate to my life experience with La Pocha Nostra.

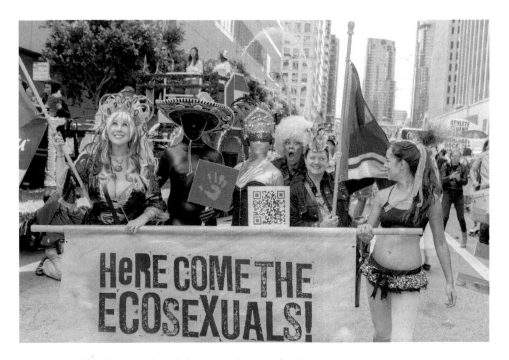

FIGURE 10.3 The Ecosexuals collaborate with La Pocha Nostra
Photo courtesy of Seth Temple Andrews
Pride Parade San Francisco, California, 2015

Note: My gratitude to the great Honcho of San Franpsycho and his tireless efforts to expand the limits of Radical Experimental Art. My appreciation to all the collaborators in Pocha Nostra, and the beautiful, courageous students and professionals of the arts communities that have given me/us the opportunity to open the Pandora's box to create and overcome the sort of spell that our world is in right now.

SECTION 4: THE ECOSEXUAL MANIFESTO 3.0

Annie Sprinkle and Beth Stephens, in cross-pollination with Guillermo Gómez-Peña

We are Ecosexuals: the Earth is our lover.
Fiercely in love, we are permanently grateful for this relationship.
To create a more mutual and sustainable union with our lover, we collaborate with nature.
We treat the Earth with respect, affection, and sensuality.
We are aquaphiles, teraphiles, pyrophiles, and aero-philes.
We are skinny dippers, sun worshippers, and stargazers.

We are artists, sex workers, sexologists, academics, environmental and peace activists, feminists, eco-immigrants, putos y putas trans/humanistas, nature fetishists, gender bending gardeners, therapists, scientists and educators, revolutionaries, dandies, pollen/amorous cultural monsters with dogs and other entities from radical ecologies …

Whether GLBTQI, hetero, asexual or Other, our primary drive and identity is being Ecosexual!

Viva la ECOSEXUAL REVOLUTION!

SECTION 5: ABOUT A JOINT METHODOLOGY AND EDUCATIONAL EXPERIENCE WITH LA POCHA NOSTRA AND VestAndPage

Francesca Carol Rolla

A message to our curators: Here, we share a very powerful letter of invitation that Francesca Carol Rolla wrote to La Pocha Nostra and VestAndPage in the frame of our recent pedagogical collaboration in Venice 2017. We include it here to elevate the tremendous work that curators, producers, and their staff perform in creating the circuitry through which live art travels. Truly, our lives depend on their victories in the unsung battles they wage to create space to unleash our macabre experiments.

(With Gratitude, Grace, and Grit – LPN)

On our world's stage, where social systems move deeply into relations of capital, La Pocha Nostra and VestAndPage's generous theory and practice stress the complexity of being human – the pleasures and the pains.

Passing through your respective artistic practices and works, having had myself the chance to work and share with you your non-hierarchical horizontal methodologies and inspiring must readings – from VestAndPage's catalogues of the first two editions of the Venice International Performance Art Week and Andrea Pagnes' *The Fall of Faust. Considerations on Contemporary Art and Art Action* to La Pocha Nostra's *Exercises for Rebel Artists: Radical Performance Pedagogy* and Guillermo Gómez-Peña's *Conversation Across Borders: A Performance Artist Converses with Theorists, Curators, Activists and Fellow Artists* – in my perspective you embody the potential *surplus* (Georges Bataille), offered to individuals and at the disposal of a diversified and inclusive community, cause of agitation, critical energy, and commitment. You give and provoke.

You call us to listen and improve, to be rebels and contribute to betterment. With both of you, I saw the audience singularly engaged. You were giving voice and shape to generative resources, calling for lost ideals and new imaginary realities.

Your territory seems to be the one where structural and intimate changes occur while witnessing your archetypal images and actions. I can tell that you are able to produce bonds.

The signs of your body and your material and virtual presence address the personal, the unspoken and the unseen. I know you trust the unknowable.

Putting at stake the entirety of space – physical, mental, emotional, spiritual, social, and political – a reality across boundaries of difference, race, culture, and gender is here presented. You cross boundaries of privilege.

You embody the necessary and troubling questions:

why are you here? who are you?
what is our potential when we finally are together?
who am I?
can I say that my hope is located in your arms?

You make us recognize that our body can be our first poetic *materia prima* – unpredictable kaleidoscopic mirror, through which we are called to critically and radically confront ourselves, entities in constant evolution and transformation.

As La Pocha Nostra ritualize the body through a shared bank of implicit and explicit costumes, masks, meat, and disguises, *reconfiguring our poetic colonized cartography – temporary space for utopian possibilities* – the potential of such continuous change is of the same substance that I recognize in VestAndPage's capability to lead their temporary community to a more profound consideration about *what is destiny in our time, […] beyond what is enrooted into the collective imaginary, by bringing back to simplicity what our deceptive mind sees as hybrid, synthetic, troubled, diverse, different.*

Before knowing you, I was wondering what motivates artists to give, to share initiatory processes.

To me, you have been the experience that embodies what art can do, assigning sacred tasks to the human imaginary.

You showed me that I might be able to live my life as a work of art.

I understand that efforts are required, as well as sacrifice – but everybody has their own part on the stage.

The liminal space you open and inhabit is to me the heritage of our noble identity obligations.

This is why I deeply hoped to have you back together in Venice once again – the world needs you, now more than ever.

Note: From my experience with La Pocha Nostra and VestAndPage in December 2014, during the II VENICE INTERNATIONAL PERFORMANCE ART WEEK, "Ritual Body – Political Body," and on the reasons that motivated me to conceive and take care of a parallel formative workshop experience with La Pocha Nostra and VestAndPage, again together, in Venice, 2017.

In the framework of the Educational Learning Program of the VENICE INTERNATIONAL PERFORMANCE ART WEEK, which takes place every late spring since 2013 at C32 performingartworkspace (Parco del Contemporaneo, Forte Marghera, Venice, Italy), Francesca

Carol Rolla has conceived and coordinated the joint immersive performance art class led by La Pocha Nostra (Guillermo Gómez-Peña, Balitrónica Gomez, Saúl García-López) and VestAndPage (Verena Stenke, Andrea Pagnes). The artists have been invited to merge their unique pedagogical practices to the benefit of 25 participants, emerging artists and students, thus inaugurating a brand-new pedagogical campus.

SECTION 6: YOU, YOU'RE MY UNDIGESTED TRAUMA: A FEMINIST MANIFESTO BEFORE #METOO

Micha Espinosa

This is a sample of my poetic results as applied to writing and voice after learning the Pocha pedagogy. The freeing practices of both body and mind during a Tucson workshop in 2013 allowed me to listen to my deepest inner truths, and I have never looked back.

You, you're my undigested trauma
your image has hijacked my internal ok-ness
you created a foundation of anger that I hold on to lest I fall
I keep bumping into you in the middle of the night, in the middle of my class, in the
 middle of the meeting
I should be with others but I am with you. I skillfully managed my flight, fight, and freeze
 a long time ago but you, my undigested trauma …
You are hiding in me. Waiting, for my next opportunity only to
manifest days, months or even years later …
Like at the doctor's office when I freaked on the nurse …
Trauma, you have no problem publicly humiliating me.
No problem with double standards
No problem with fear as a weapon
No problem glorifying gender constructs and impossible forms of beauty
You feed on your ego and grandeur
You leave me to pick up the pieces of dignity I have left
You left me with the aftermath of your narcissism
You, my undigested trauma, there is no stopping you
I'm always in dialogue with my dis-regulated system,
I'm poorly modulated, I have emotional incontinence,
But I will not fall within the conventionally accepted range of emotive response, I will not
 fit into your patriarchal story.
I am not compliant. I will not be tamed.
I may love, I may honor …
But I will NOT obey.

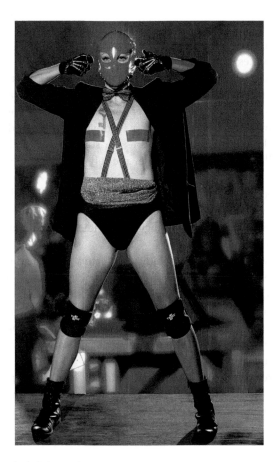

FIGURE 10.4 Red Headed Cyborg 3.0
Photographer: Zoe Zimmerman
Performers: LROD
TAOS, New Mexico, 2019

SECTION 7: ON THE IMPACT OF NEW TECHNOLOGIES IN LIVE ART: THE NECRO-TECHNO COMPLEX

Praba Pilar

The technosphere surrounding our biosphere is massive. Preliminary calculations published in 2016 reflect a mass of all living matter on Earth at 4 trillion tons, and all technology we have created at 30 trillion tons. The technosphere, a superorganism of deepfake reality, is a necropolitical simulacrum that I call the Necro-Techno Complex [1].

How does one "do" resistance or find safety in this environment, when this complex is leading us straight to the sixth extinction event? How do we operate in an environment

of the virtual, the cyber, the cypher, and the artificially intelligent, all of which are dealing cascading blows to agency, resistance, and transgression?

Baudrillard [2] writes, "Capital doesn't give a damn about the idea of the contract which is imputed to it: it is a monstrous unprincipled undertaking, nothing more." This is more clear than ever today, when revolution can be rebranded by a website selling Che Guevara t-shirts run by a gig economy entrepreneur who is an automated bot, when the use of digital tools by activists to spread their work via their networks immediately turns activists into surveilled informants for repressive states, when activists are imprisoned for teaching surveillance security, and when the left is asking the security apparatus to re-establish order.

In the Necro-Techno Complex, cyber technologies, synthetic biology, and artificial intelligence have corrupted the capacity to differentiate between the illusory, the material, the immaterial, the fascinating, the intelligible, the idiotic, the unintelligible, the passive, the inconceivable, and the obscure.

In 2014 I began working with Anuj Vaidya to create a musical group called Larval Rock Stars. In concrete terms, we do not exist, as we do not work with music, release songs, or have followers. All we have is our larval scream, which is itself our fake imaginary of what larvae sound like. We are larvae of something post, the incomprehensible screams of microbiomes transiting signs to puncture optics and escape the prison of language. We celebrate the concrete materiality of our secretions and crawling with publics willing to join us in planetary engagements.

Ask yourself, are you non-human, semi-human, cyborg, corporeal, human, non-corporeal, sacred, profane? Are you creating a scene, a scenario, a virtual frame, a framed virtuality, a myth, a truth? Are you a head, a tail, a trunk, a leg, a slippage? Are you transgressive? Are you an inversion?

REFERENCES

[1] Praba Pilar, "Situating the Web of the Necro-Techno Complex: The Church of Nano Bio Info Cogno." *Performance, Religion, and Spirituality*, Vol. 1, Issue 1, 2017.

[2] Jean Baudrillard, *Simulacra and Simulation* (Ann Arbor, MI: The University of Michigan Press, 1994).

SECTION 8: LETTER TO A RADICAL MOM

Anuradha Vikram

Introduction by Paloma Martinez-Cruz: I first met the Mad Mex at the inaugural Encuentro offered by the Hemispheric Institute of Performance and Politics that took place in Rio de Janeiro in 2000. There I was, a single parent in graduate school, staying at a hotel with my then five-year-old son when the opportunity to be a docent in the Mexterminator Project was offered. I was thrilled to accept, but then came the

daunting task of locating a babysitter in a foreign country who could watch my son. Drawing on contacts I had made at the conference, a lovely Brazilian family appeared who took on my crabby son for the night. I can say that the performance truly changed my life, but following the performance, instead of decompressing and celebrating with the other docents and the Pochas, I had to rush off in a taxi to get my son from the sitter. On many evenings the conference goers explored the famous nightlife of Rio while I played hide-and-go-seek in the hotel room, and while my son was robustly welcomed in and around Pocha activities, there were plenty of engagements and performances that simply were not going to work for his needs or theirs. As a young single mom FOMA (Fear Of Missing Out) was more than a fear, but a daily reality. The Pocha members were appreciative of what I could contribute, and what I needed to skip. And while the work of parenting in the mainstream art world might be seen as counterproductive, in my community, Chicanas have not been willing or able to buy into the schism between creating art and having children. Life getting in the way of life? Nel, we don't die, we multiply!

You will never be cool again. You're not going to be the last one at the party, the first one at the bar, the expert on new music and films. You're not "on trend." Your life is now a wave of endless fluctuation between the fear of the worst thing that could happen and the fear of missing out.

But there is hope! You have become a machine of ruthless efficiency. You can stroke a child's temple tenderly with one hand and solve a pending production catastrophe with the other. You are an island of stability and tenderness in a sea of abject political terror. You read Habermas and *Hop on Pop*. You are a small person's entire universe. You have made a tiny genius with your body. You contain multitudes.

I often feel a sense of loss for the radical woman I was. She slayed the night, a motorcycle-riding, smoke-ring-blowing firecracker. But she was a bulldozer too. Better at talking than at listening. She lacked discipline. She was a jagged lump of carbon.

I am a diamond. Faceted by the violence of original sin. Mata. Metta. Mahadevi. My cut is the sharpest.

In cities like Los Angeles and San Francisco, where we live, it can seem like the public does not desire the presence of children. As mothers, we're supposed to apologize for ourselves on airplanes, in restaurants, anywhere we might offend the childless for whom our offspring are but an inconsiderate extension of ourselves into their rightful space. Wombspreading.

What could be more narcissistic than birthing a child?

What could be more generous?

Parents in the United States are hectored and abused people whose goals and self-image have taken a beating in a society where children are a magnificent burden. Rich or poor, they struggle with high expectations and low self-esteem. We're not supposed to need or want help, and when we can't work enough hours for enough wages to cover all the costs, we're supposed to cash in our assets to pay for horseback riding lessons so our children don't have to feel the sting of their class position. We're not supposed to want

our own parents either, lest we become them, as we inevitably do. Parents instill in children the same tangle of issues and hang-ups. We need to have children because we want to make sure there will be cool people in the next generation, not just to pass on the special ways we're each fucked up.

My parents worked tirelessly to become physicians and accrue enough money and prestige to emigrate to the USA. I took the education and comfort they provided me and used it to shape, direct, and preserve this culture that I was born into, that they were not, to try to make a place for myself where none exists. Making a family had the same motivation. My children will probably be doctors and engineers. Artists' kids often don't want to be artists, but they usually are despite themselves.

People think you abandon your dreams when you have children. That's a cover story. You abandon your dreams, then you have kids, so you don't have to take responsibility for giving up. I never look at my children and think, "I could do this or that, if not for you." I always think of what I do as being for them. My being the very best that I can be at what I do, and doing what I need to independently from them, is showing my children that I value myself and that they can and should place themselves in the same high regard. Not only that, my value is neither because of nor in spite of the fact that I am their mother.

Now think of the gorgeous variety of sexually fluid and fearless individuals in the community that we share. So many of these shining lights were nearly extinguished in youth and adolescence, almost snuffed out by fear and ignorance if not for the one friend with a kind and understanding parent who gave a youthful flame vital oxygen. While LGBTQI identities enjoy unprecedented visibility, bigotry is forever, and very much on the rise. Future queers and misfits will need a radical mom's understanding and refuge. The artists who keep our hope alive need someone just like you to keep their torches lit.

See you on the barricades,
A Radical Mom

SECTION 9: "IT IS TIME FOR US" AND "NOTES FROM A REVOLUTION YET TO BE WITNESSED"

Zulfikar Ali Bhutto

IT IS TIME FOR US

In a world where the sound of air raids is as common as the azaan, where the disappeared outnumber those of us accounted for and demons are celebrated as heroes and heroes mocked for their bravery.

Where nations are divided by arms folded or hanging loose and bullet holes become crowns on a martyr's skull.

Where the leaders of yore, tall like mountains, are toppled, blown to the ground like a tower of cotton balls and those who survive simply betray you.

Where stones, bricks and carved marble containing generations of stories become the rubble that paves the road to Damascus.

When we have become so sure of our impending downfall that we watch as a people lusting for colonization destroy our neighbor's home and use its people as target practice.

When Isis becomes the name of a mysterious horde of lost Anglo-Saxon youths and not the name of a great Goddess, and when an Imperialist force mistakes its occupation as liberation and human beings are called collateral damage.

It is only then that you realize that those you have always looked up to and the systems you trusted so deeply have failed you.

It is time for Gog and Magog to emerge from the desert, so we may meet them and plot our revolution.

It is time for modern civilization to crumble as it was always destined to, so we may rise from its ashes.

It is time for us to evolve into monsters unseen since humanity has proven itself arrogant.

It is time for us to flip the dome of Al-Aqsa upside down and use it as a satellite to contact alien life. Surely they have the answers?

It is time for us to take the Ka'aba back from the house of Saud, an American puppet and an embarrassment to the Muslim world.

It is time to look beyond the illusions presented to a long-gone world and create realities unheard of.

It is time for the earth to open and release its children, so dead martyrs may rise and join the ranks of the living.

It is time for us

It is time for us to Inherit the Earth.

NOTES FROM A REVOLUTION YET TO BE WITNESSED

They're scared of us.
The Anglos are scared of us.
Of us brown folk,
Of us Muslims.
With our piercing gaze
Our androgynous features
Even when we're veiled,
they're scared we might be looking
right at them
But is it really about Muslims?
Or is it about being different?
Different politically and ideologically
Eating differently, speaking differently.

In fact, these things we talk about: Islamophobia, Orientalism, fearing and desiring of the exotic other.

These ideas and concepts were first brought up, written about and spoken about by writers like Edward Said and Amin Ma'alouf.

They were Arab Christians and, ironically, they too felt what I like to call The Muslim's Burden

That hot, judgmental gaze of the so-called "West" on the so-called "East."

Burdening us w/ a weight of colonialism, violence, and imperialism.

Did you know? The first ever suicide bomber was a teenage Palestinian Christian woman who belonged to Lebanon's communist party?

She was frustrated with Israeli apartheid and the nation's genocidal politics, she was tired of the fact that the world watched as we died.

Our bodies left decaying on the streets of Sabra and Shatila and countless towns and villages.

Her name was Shaheed Sana Mahedli.

Nonetheless, this society has found Muslims to be the enemy.

It really does not matter if you are actually Muslim though.

We have become racialized,

We no longer act,

We simply exist

And that's enough to scare the shit out of an Anglo.

I will say it again,

It is our piercing eyes,

Androgynous features,

Sharp tongues,

Guttural Khhhhhs and ghhhhhs,

Heaving h7h7h7h7h7h7hs,

Nauseating 3a3a3a3a3as,

Rolling tds, ds, and rs

Our sharp tongues that can twist and turn into every sound imaginable because,

We are everywhere at once,

We have no nation, your nation is our nation.

It is our piercing eyes

Even when you cannot see them

you know they are looking right at you.

Judging you.

What is behind these veils?

Sensuous lingerie

Versace skintight dresses

Fishnets from Gucci

Garters from Fendi

A dildo by Abercrombie and Fitch

In what way would you like us to satisfy your imagination?

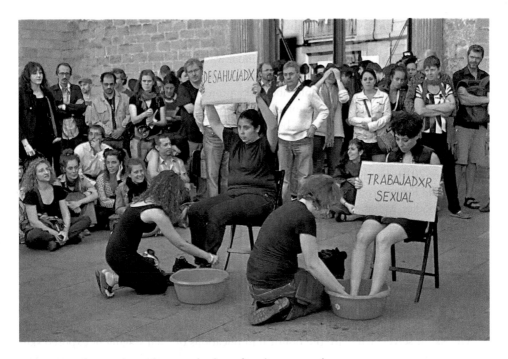

FIGURE 10.5 Sex workers cleaning the feet of audience members
Courtesy of MACBA and Pocha Nostra archives
Barcelona, Spain, 2015

SECTION 10: STAGING FOR INCLUSION: WORKING WITH THE NUDE BODY

Paloma Martinez-Cruz

A work of art is not a totalizing project. If it were, this "art" would instead be a device of totalitarian propaganda accompanied by bayonet jabs at the dissenting audience member that doesn't laud its maker with cries for more.

The relationship between experimental performance and hegemonic power is a core area of inquiry for the Hemispheric Institute of Performance and Politics, which was founded in 1998 at New York University by Diana Taylor and fellow pioneering scholars, artists, and activists from across the Americas. Between 2000 and 2019, the "Hemi" brought collaborators together for international gatherings to connect the most urgent movements in human rights advocacy to the most innovative currents in experimental performance. La Pocha Nostra has been a seminal presence at these conferences since the Hemi's inception, fearlessly engaging the human body to bring dialogue and visibility to the bordered circumstances of the Americas through provocative actions and images that inspire some while repelling others, and this is fine. Art is not a totalizing project, and La

Pocha Nostra's work has never sought to be above the fray, but perpetually in it and of it, learning from voices of approval and discontent alike.

As such, La Pocha Nostra has faced continual waves of censure and reproach for their unapologetic staging of nude bodies in the most raw and vertiginous interstices of hemispheric experience, where multiple liberatory projects intersect with multiple wounds born of political, sexual, and psychological trauma. The scandalized grumbles about the body's "appropriateness" have always been, and will continue to be, the materia prima, the raw material at the construction site where Pocha Nostra molds and shapes their semi-nomadic, multi-sensorial diorama creations.

At the 2019 Hemi, some conference participants held that LPN's *Posnacional 2: Glosolalia Remix* production included images that were disrespectful or violent towards women's bodies. Members of La Pocha have issued detailed remarks about the feminist collaborators who appeared in *Posnacional 2*, pointing out that all of these artists were entirely in control of their decisions to perform fully or partially nude.

This last blast of our pedagogy book is not going to repeat what's already been exchanged publicly about *Posnacional 2* (or, for that matter, the preceding 25 years of related parries and thrusts aimed at LPN's inclusion of the nude form). Instead, the authors have asked me to lovingly steer the conversation back to the pedagogy, which I do by posing a few questions related to the significance of dramaturgical choices in radical performance.

We ask ourselves: what are the political implications of each staging of exposed skin? What societal structures frame the unclothed, uncovered body, given some artists are not as safe as others, and the exposed, conventionally beautiful body elicits different reactions than the marginalized body? To make radical art, we must always be decolonizing our aesthetics and interrogating hegemonic masculinities, continually re-framing the body so that the logics of coloniality, homophobia, and patriarchy are not uncritically re-centered. This is why the performance zone's sequences need to be curated, blocked, and spatialized with as much research, consideration, and discernment as the artist's persona and actions.

These questions about Pocha dramaturgy need to be accompanied by the following major revelation about La Pocha Nostra's early history: Guillermo Gómez-Peña is a man. It's true. Even though he has been hailed as a "godmother" by scores of drag and trans performers, and metaphorically labored as the round-the-clock performance midwife to many creative and interpersonal interrogations of heteronormative sexuality, the fact remains that he, and former Pocha member Roberto Sifuentes, share the Pocha Nostra origin story that often centered on two men's bodies in space in positions of performatic privilege, who, even when encircled by the most inventive and radical women collaborators, might conduct reasonable observers to interpret Pocha performance zones as heteronormative and masculinist phallus-scapes.

Over the years, the amplification of collaborative work, the inclusion of new core Pocha members such as Balitrónica and Saúl García-López aka La Saula, and the primacy of pedagogical practices have resulted in dramatic shifts in how brown and black bodies are activated in the performance zone, and expanded the inclusion of queer, trans, disabled, migrant, and abject bodies that have come to represent the axis on which today's Pocha interventions turn.

In the Pochaverse, the role of dramaturgy, or the study of dramatic composition, is to put the main elements of live art in the performance zone in contact with each other in ways that do not uncritically reproduce the violence of the Western disease load, signaled by the privileging of elite bodies and identities and the corresponding disappearance of bodies that might not be deemed "hot" in today's media streams. On the other hand, it's not the goal to oust bodies that approach elite norms, since the flows and disruptions of power across diverse embodied identities are at the center of Pocha's creative energy. In my twenty plus years of witnessing, participating in, writing about, and producing Pocha pedagogy workshops and performances, I've seen non-normative bodies and aesthetically elite bodies alike receive central focus in the Pocha performance zone. However, remembering the context, it's not strange that Pocha's origin story continues to influence interpretations of Pocha dramaturgy, and often, when sexually charged and aesthetically privileged women's bodies are revealed, participants and observers might imagine that this is in the service of a pornographic Gómez-Peña phallus-scape.

If we agree that art is not a totalizing project, then this interpretation doesn't need to go away. Al contrario, this interpretation merits compassion and gratitude, particularly in this moment in which women collectively take inventory of the ways that sexual violence and social trauma have impacted our alignment as human beings, and we struggle to come to terms – in literal voicings of new vocabularies – to name the harm and denounce it openly.

If the goal is to stage inclusivity, then the dramaturg's questions about how and when the main dramatic elements are revealed need to be at the forefront of our work: what are the dramaturgical consequences of a normative aesthetic appearance, and what are the consequences of non-normative bodies in space and time? Does the performance zone privilege one over the other? How does the spatialization, lighting, sound, and timing narrate the value of one body over another? Where are the less safe bodies of queer, trans, ethnically marginalized, and disabled people placed? How are normative aesthetics associated with the objectification of women positioned in relation to less commercialized body types and dispositions? How do these relationships unfold in real time?

While asking these basic questions about the dramaturgical interplay of time, place, and audience related to the body's positioning in a given performance, we also need to keep in mind that presenting carefully curated bodies is no guarantee that audience-participants will find themselves in a "safer" situation. As women, the violence written onto our bodies in service of the many pathologies associated with Western masculinity is so encompassing that trauma is pervasive, and the imagery addressing the continuum of sexual liberation, eroticism, and political positionality will be, for some (for many?), indistinguishable from the etiology of sexual aggression.

In the pedagogy, what risks will be encouraged, and what risks will be tempered like delicate glass? In the womblike Pocha carpa, new authors of performance personas mingle with seasoned artists; hungry phallus-scapes jut up against fearless, feminist porn; caged human specimens coil up next to liberated inner beasts. It's not safe art, but I think we're safer because these live art workshop spaces and dangerous performance zones bring us into a more authentic assessment of our own mythologies and pathologies. Who do we allow ourselves to be in the dark? What happens when our hidden bodies are uncovered? Will we give the beast its day?

SECTION 11: THE ANTI-MANIFESTO 2018 (AN EXAMPLE OF A COLLECTIVE GROUP PERFORMANCE TEXT)

Edited by Alessandra Santos and designed by Gabriela Aceves Sepúlveda

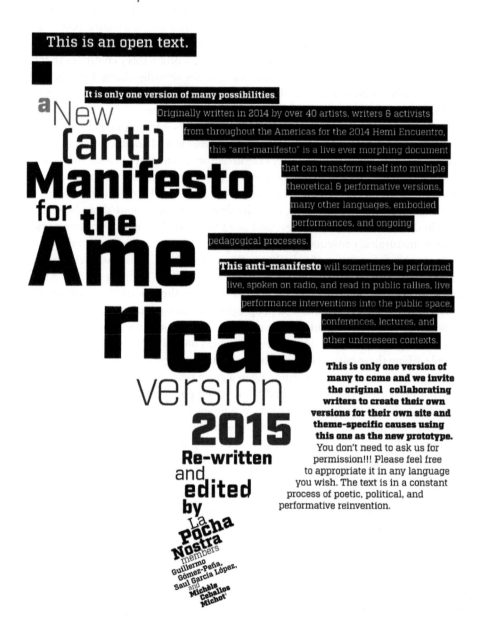

FIGURE 10.6

We are the dots connecting race, gender, ideology, and aesthetics.
We can be the power defying generation. Our bodies outlive these ravenous monsters.

Our bodies respect the planet. We are lovers of the earth; eco-sexuals. Save the earth one performance at a time, one gesture at a time.

~~We dance without captions.~~ Our bodies shake, requebram, rebolam, arrocham, they sweat and feel pain. Our bodies can rest, but can't stop. We can be tools to stop the machine. We can dance on utopia, stop in inertia, or just wait. But we can't wait to act, we just can't wait to stop. Our methodology is love, acceptance, radical tenderness & radical listening. This is our form of radical democracy!

We believe the performance artist is a trickster; questioning, problematizing, infusing humor and radical strategies alongside the activists and educators. The domain of the trickster is ambivalence, ambiguity, chance, ephemerality, and multiplicity... Like the trickster, the artist conveys the value of fluidity. Coyote-shaman-artist-nanabush/es are subversive, create chaos, disrupting the colonial world and word, forcing a shift or re-

We can also hurt, collapse. We can be rusty sharp spikes of rotten handmade punk clothes, piercing old values and penetrating the magical ancestral world.

Realidade mágica contra a calamidade trágica.

Local dreams; continental nightmares

We are committed to fight with our art: We fight intolerance, narrow-mindedness, hetero/normativity, sexism, racism, all forms of state violence, binary models, Eurocentric academic jargon, monolingualism, liberal ideology, fundamentalism, and all narrow-minded nationalisms... including ours.

We fight with our bodies.
We fight with radical tenderness, generosity, imagination, sensuality, creativity, bravery, unexpected shamanic strategies, psychomagic actions & listening... listening was & continues to be the source of this text.

We oppose the Olympics, the World Cup, the Oscars, the space programs of NASA, the space agency in Alcântara city in Maranhão, the doctrine of discovery, the state itself, the capital art world. We oppose genocide, Chase, any regime based on unlimited growth & bad hair, preemptive strikes & premature ejaculation, drug cartel violence, femicides &

feminicides, the militarized apparatus, technological dystopias, all industrial complexes (the military, the neoliberal university, the prison system, beauty pageants, cheap cosmetics, mainstream news tyrants, you name it, we fight it...).

We fight to defend the environment from ecocide, forests and mountains from metallic machismo; water from oil spills, overfishing & sand banks. But we love to drink, get stoned, and have orgasms.

We also denounce the hyper-specific such as the Keystone Pipeline as the keystone to a policy of betrayal of the social contract between government and Indigenous peoples.

We denounce all borders as by-products of capitalist productions of the neocolonial state and erase them from the maps of our bodies, minds, and souls. Instead of a "reconquista," we call for an immediate "de/conquista" of all borders, geographic or economic, capillary or psychological, in perpetuity.

FIGURE 10.7

IMAGES OR PERFORMATIVE ACTIONS THAT CAN BE DEVELOPED AS THE EMBODIED
PART OF THE MANIFESTO AND COEXIST WITH THE TEXT

- **Columbus drinking tequila to death**
- First Nations pietas
- Performative ritual or blessing with Listerine
- Corporate policeman/woman dancing pow wow
- A nude body having an oil bath Corporate Aztec sacrifice (instead of roadside chief, roadside executive)
- **An Indigenous body eating white bread, drinking deodorant, and spam. Cooking Spam for the audience? Yes! with pickles and frybread...**
- **A businessman or a president fist fucking an Indigenous body** ^^yes, but needs^^^an intervention-^like... maybe showing the Indigenous body resisting and later winning -i.e., a pipeline penis that is unable to penetrate
- **Monsanto Childs in a soya field with the shirts of Brazilian national football team**
- The last pan-Indigenous dinner or Thanksgiving
- A version of 100 marilyns, but instead 100 missing Indigenous women. "We need permission from the women's families to use these women's imagery"
- Sweat lodge in the boardroom
- The canonic "Primeira Missa no Brasil" redesigned with Indigenous taking pictures with iphones & ipads

- *Museos humanos*
- Indígenas como bancos de oro

- **A really long anal bead cord with small soccer balls being pulled out from someone's asshole**

- A bull whip, made of bible skins
- White mascot sports t-shirts (reverse psychology like the fighting whities all NDN basketball team)
- Sad reality of watching youtube trying to learn how to sing traditional hand drum songs or how to clean gut fish, how to skin hides, hunt how to............all the Indigenous knowledge skills
- Indigenous World Cup selection Zapatista kicking balls at crowd and getting kicked
- Illustrated body (triggering phrases on the body)
- Acupunctured body with corporate flags
- Bison head mask dancing pop music
- Fighting to speak at the mic
- **White corporate person / washing feet**

FIGURE 10.8

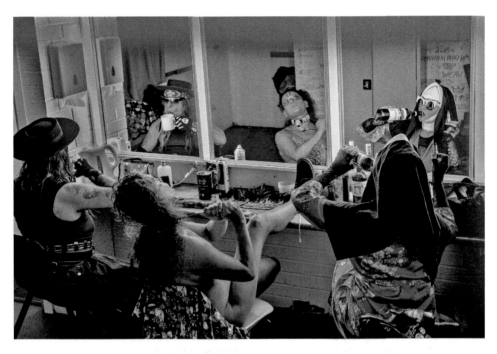

FIGURE 10.9 Waiting in the dressing room for the Coronavirus pandemic to pass ... what would be next? ... no pinche idea ...
Photographer: Donatella Parisini
Performers: La Pocha Nostra – La Saula, Balitrónica, Gómez-Peña
Byron Bay, Australia, 2018

Index